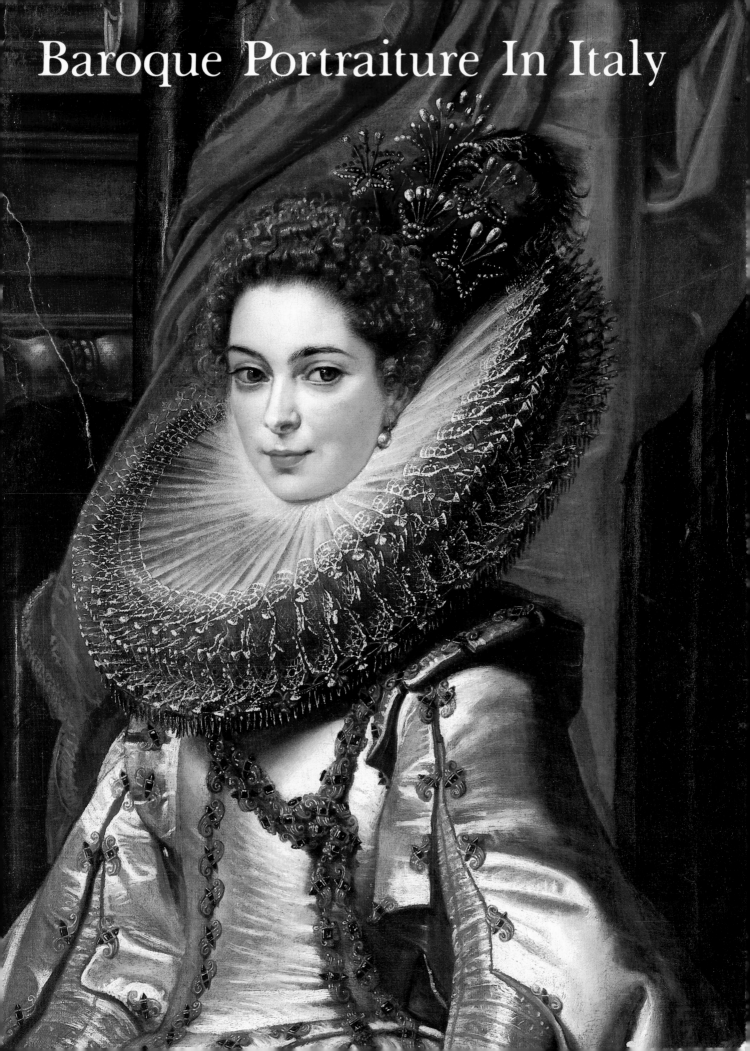

# Baroque Portraiture In Italy

# Baroque Portraiture in Italy:
# Works From North American Collections

John T. Spike

**The John and Mable Ringling Museum of Art**
**December 7, 1984 - February 3, 1985**

**Wadsworth Atheneum**
**March 20 - May 20, 1985**

The John and Mable Ringling Museum of Art
Sarasota, Florida
December 7, 1984 - February 3, 1985

This exhibition has been supported in part by the
National Endowment for the Arts, a Federal agency.

Text Copyright: John T. Spike

Library of Congress Catalog Card No. 84-82128
ISBN No. 0-916758-16-8

Text Editor: Michele K. Spike
Graphic Design: Jim Waters and Cynthia Figgatt
Typesetting: Graphics Design Center, Inc.
Printing: Joe B. Klay and Sons, Inc.

Dimensions in this catalogue are cited in inches
followed by (centimeters).

**In Memoriam
William H. Wilson**

# Table of Contents

# Author's Preface and Acknowledgements

This exhibition is dedicated to a little known but unusually challenging aspect of Italian art history: the portraiture of the age of the Baroque. In common usage, this epoch is understood as roughly synonymous with the seventeenth century. The seventy-five exhibits in this show range in date from about 1590 to about 1720. As it happens, the two works of these dates, paintings by Ludovico Carracci and Francesco Solimena, have been selected as examples of the transition into and away from Baroque portraiture.

For several reasons, there has never previously been a major museum exhibition of Baroque portraiture in every medium, from prints to paintings, sculptures to drawings, and more. In the first place, the appreciation of Italian art of the seventeenth century has only been revived in America since the Second World War. Secondly, a rather narrow conception of portraiture has prevailed throughout the twentieth century, according to which portraiture is considered to be the special province of painting. Finally, the subject of Baroque portraiture in Italy encompasses too much territory to allow its comprehensive treatment in a selection of examples. Assuming universal participation by lending museums around the world, the only venue for a "comprehensive" exhibition on this theme would be the basilica of St. Peter's, Rome, so that the papal monuments with their memorial portraits could be seen as well.

When the late Bill Wilson proposed the idea for the Ringling Museum to organize an exhibition of Italian Baroque portraits (and it was always his hope that the Wadsworth Atheneum would collaborate, as it has so helpfully), his thought was to present a selection of paintings from American collections. I accepted Bill's invitation to curate the show but along different guidelines. Although a good number of masterpieces of portrait paintings have entered American museums in recent years — and can be admired on this occasion — the acquisition of such works is still too new a development to support an exhibition of paintings alone. Instead, it was decided to designate Baroque Portraiture in Italy, Works from North American Collections as an opportunity to take stock for the first time of the finest portraits from this relatively neglected period that have come to America to date. Moreover, the historical justification for the inclusion of portraits in all media was too compelling to resist. One of the purposes of the four introductory essays in this catalogue — they are structured as "case studies" of exhibits in this show — is to underscore the prominence of sculpture and prints and drawings within the tradition of Baroque portraiture in Italy.

It has been understood from the onset of this project that our selection of seventy-five Baroque portraits could only propose to represent the diversity of the theme at hand, and

would not constitute an outline of the subject itself. If we grant that portrait medals or engraved frontispieces offer as much insight as the major art forms into the importance and usage of seventeenth-century portraiture, then the list of omissions from our selection would go on and on. Another factor that bears on every exhibition is, of course, that of conservation. Two achievements of the highest order in Baroque portraiture are claimed by Gian Lorenzo Bernini and G. B. Foggini for their portrait busts carved in marble. Examples of these exist in America but could not be lent to an exhibition out of concern for the fragility of their material. In sum, anyone who visits this exhibition in search of an encyclopedia will be dismayed to find many volumes missing.

On the other hand, we hope that our visitors will be excited by the profusion of portraits of virtually every scale and character that the seventeenth century could produce short of the colossal (a dimension of preference, by the way). The common ground for this selection has been of intrinsic artistic quality, nothing more. Portraits from Rome and Florence predominate not only because of their real eminence in this regard but also because it seems images of power, of popes and grand dukes, have appealed more to American collectors than have portraits of the petty nobility of, say, Bergamo. Multiplicity has been taken as the theme of this exhibition, and towards this aim, the exhibits have not been segregated according to medium in the museum installations and are listed alphabetically by artist in this catalogue. The visitor and reader are invited, with a certain allowance for poetic license, to view these juxtapositions of family likenesses and images of state as a metaphor for the portraits on canvas, in marble and bronze, in medals and prints which cram the descriptions of room after room of contemporary travellers and the archival inventories of the furnishings of Baroque palaces.

This catalogue has been designed with the intention to serve both the visitor to the exhibition and the armchair traveller. In recent years exhibition catalogues have grown in thickness and weight in recognition of their singular value as the most current discussions of art historical issues and in acknowledgement of the international audience of scholars who will consult the catalogue without actually viewing the show. As a result, catalogues have tended to become of less and less an aid inside the exhibition itself. Herewith our effort towards a solution: the seventy five entries below are intended to answer the questions which will come immediately to the mind of the observer who stands before the work of art: the identity of its subject, the identity of the artist, and the relationship of this portrait to other portraits by the same artist. The reader is referred to four introductory essays at the head of this book if he

desires more detailed notices on some of the thorny and almost endless problems of the purposes, kinds, and meanings of Baroque portraiture.

The four introductory essays are cast as case studies on cross-sections of exhibits in this show. These groups were chosen as exemplars of four interpretive rubrics: Naturalism; the Life of the Mind; the Impassioned Soul; and the Court Portrait. The premise behind this system is that every Baroque portrait can be related in varying degree to these four concepts. It is hoped that the titles are self-explanatory: they refer to the aspect of the personality that the artist has set out to interpret in his portrait of the sitter. Perhaps it is too much to hope that the narrow focus of these essays, which are truly no more than extended entries (a term precluded by its dreariness), will reveal fuller definitions of these four categories for the reader of them. The rubrics are not themselves the subjects of these essays, because the conscious effort has been made to confine the horizon of these discussions to the works present in this show. Optimally, the interested visitor to the exhibition will have the opportunity to read the introductory essays prior to viewing the exhibits so that he or she may test their value as approaches to the meaning of Baroque portraiture in Italy.

As the list of lenders to the exhibition points up, this project has been made possible by the collaboration of hundreds of people. To the directors, curators, conservators, registrars, and other persons who serve the public collections that have lent portraits, I should like to express my gratitude for their participation in this undertaking. I should like to thank no less the private collectors who have consented through their confidence in this project to share their treasures with the public and often incurred personal expenses in the arrangements for photography and the like.

Walter L. Strauss, publisher of Abaris Books, Inc., kindly donated the photography of the books lent by the New York Public Library.

My research for this catalogue was undertaken at several libraries, at each of which the professional staffs extended exceptional courtesies of assistance. I am deeply grateful for the facilities offered me by the Frick Art Reference Libary, the Study Center at the Watson Library of the Metropolitan Museum of Art, the New York Public Library, the Rare Book Room of the New York Academy of Medicine (repository of the Cole Collection of Rediana), the Library of the American Numismatic Society, the Biblioteca Hertziana, Rome, and the Kunsthistorisches Institut in Florenz.

I must not omit mention of the invaluable correspondence of scholars in America and abroad who took time from their own studies to reply to my inquiries (which often succeeded one after the other) and to share their advanced knowledge with me. In particular, Miss Jennifer Montagu, Sir Ellis Waterhouse, and David Ditner replied ever faithfully and always helpfully. My sincere gratitude for exceptional assistance is owed also to Susan Barnes, Robert P. Bergman, Bernard Barryte, Suzanne Boorsch, Keith Christiansen, Cynthia Clark, Michael Conforti, Alan P. Darr, James David Draper, Inge Dupont, Gerhard Ewald, Everett Fahy, Italo Faldi, Oreste Ferrari, Sydney J. Freedberg, Ronald Fritz, Hilliard Goldfarb, George R. Donger, Marco Grassi, Michael Hall, Marion Hirschler, Colta Ives, Corey Keeble, Mimi Kotner, Myron Laskin, Jr., Ellen W. Lee, Patrice Marandel, Sallie Morgenstern, Mary Myers, Pinckney Near, Otto Naumann (who offered constant tea, sympathy, photocopies, the Thieme-Becker), Ann Percy, Sir John Pope-Hennessy, Robert Rainwater, Joseph T. Rankin, Sue Reed, William W. Robinson (who read Tessin's diary to me over the phone), Allen Rosenbaum, Charles Ryskamp, Scott Schaefer who contributed the entry on Guido Reni, Erich Schleier, Jane Shoaf, Thomas Sokolowski, Timothy Standring and Susan Tamulonis (whose installation of PC with Wordstar on the Via del Pellegrino, Rome, made possible the completion of the last twenty entries), David Steadman, Michael Stoughton, Carl Strehlke, Ann Sutherland Harris, Peter Sutton, Pietro Torriti, Nicholas Turner, Arthur Wheelock, Jr., Eric M. Zafran.

My colleagues at the Ringling Museum in Sarasota have been unfailingly encouraging and helpful. The untimely passing of William Wilson saddened all of us. Anthony Janson deserves credit for adopting this exhibition with full enthusiasm and seeing it through its successful conclusion with the efficient assistance of Elizabeth Telford. I should like to thank Wendy McFarland, my liaison at the Ringling Museum, who became my lifeline into the administration of this show. Jim Waters designed this beautiful catalogue. At the Wadsworth Atheneum in Hartford, I was often helped by Gregory Hedberg and Jean Cadogan; Jean played a crucial role during the coordination of the loans and thereafter. My thanks also for the aid of those persons omitted here through inadvertence.

This journey has made many stops over the last three years. Certainly these interruptions are known best of all to Michele K. Spike, my wife, and to Nicholas N. Spike, who came on board after this project was already underway. For their love and patience and for Michele's expert collaboration as editor of this catalogue, I am eternally grateful.

J.T.S.

# Lenders to the Exhibition

Baltimore: The Walters Art Gallery
Boston: Museum of Fine Arts
Brunswick: Bowdoin College Art Museum
Cambridge: Fogg Art Museum, Harvard University
Chicago: The Newberry Library
Cleveland: The Cleveland Museum of Art
Dallas: Meadows Museum and Gallery, Southern Methodist University
Dayton: The Dayton Art Institute
Detroit: The Detroit Institute of Arts
Forest Hills: Mr. and Mrs. Robert L. Manning
Hartford: The Wadsworth Atheneum
Indianapolis: Indianapolis Museum of Art
Larchmont: Mrs. John H. Steiner
Los Angeles: Los Angeles County Museum of Art
Malibu: The J. Paul Getty Museum
Minneapolis: The Minneapolis Institute of Arts
New York: Mr. David Daniels
New York: Mr. Michael Hall
New York: The Metropolitan Museum of Art
New York: The Pierpont Morgan Library
New York: The New York Public Library
Norfolk: The Chrysler Museum
Ontario: Royal Ontario Museum
Ottawa: The National Gallery of Canada
Philadelphia: Philadephia Museum of Art
Princeton: The Art Museum, Princeton University
Princeton: Professor and Mrs. Jonathan Brown
Providence: The Museum of Art, Rhode Island School of Design
Richmond: Virginia Museum of Fine Arts
Rochester: Memorial Art Gallery, University of Rochester
San Francisco: The Fine Arts Museum of San Francisco
Sarasota: The John and Mable Ringling Museum of Art
Washington, D.C.: National Gallery of Art
Washington, D.C.: National Museum of American Art

**Introductory Essays on Four Aspects of Baroque Portraiture**

# Ottavio Leoni's Portraits *alla macchia*

*The Cavalier Ottavio Leoni, the son of Ludovico Leoni, Padovano, was likewise known as Padovano, although he was born in Rome. His father desired him to devote himself to painting and particularly to make portraits* alla macchia, *a skill in which Ludovico was practiced himself; Ottavio did so but specialized in portraits of reduced dimensions, and he became outstanding in this profession. In truth, there was no one of his age in this art who could equal him.*

The biography of Ottavio Leoni (ca. 1578 - 1630) which was published in 1642 by Giovanni Baglione is the sole contemporary commentary on the artist that has come down to us. Baglione, whose words are quoted above,[1] records that Ottavio Leoni was the leading portraitist in Rome during the first three decades of the seventeenth century. To judge from the hundreds of drawings by Leoni that are known today, not to mention the forty portraits that he engraved, this conclusion is eminently sound. It comes as a disappointment, however, to learn from Baglione that our knowledge of Leoni's career is only fragmentary. The artist's painted portraits seem to have comprised at least half of his activity in this field, yet none of these paintings have been identified. With respect to Leoni's method of portraiture Baglione again provides the only first-hand acount. His reference to portraits made *alla macchia* is brief but illustrative, as we shall see.

Baglione also compiled a biography of Ludovico Leoni, in which he uses the same term and defines its meaning. Ottavio's father, he writes, was "distinguished during the time of Pope Paul V [1605 - 1621], for his portraits in wax relief, almost always *alla macchia,* which is so called because they are done after having seen the subject only once, and rapidly, in which field he was renowned."[2] In the presence of Ottavio Leoni's drawings, three of which are exhibited on this occasion (several others are reproduced in the Appendix to this catalogue), we should not have assumed, minus Baglione's testimony, that they had been drawn from memory. Ottavio's drawings are characterized by their vivacity, both in the touch and in the expressions of the subjects, and by Leoni's keen attention to detail — two qualities that are customarily associated with portraits observed from life in the presence of the sitter.

The drawings are themselves the best evidence that this impression of immediacy was Ottavio's principal goal for his portaiture (or at least his portrait drawings). Above all, Ottavio habitually sketched the costumes of his sitters with only the briefest, most rapid strokes. As a result, his sheets have the appearance of head studies, which are drawings made by an artist during an actual sitting in order to capture the subject's facial features and expression. In such drawings, which have existed as long as portraits have been made, the costume is hardly indicated, because the treatment of the clothes does not require the attendance of the sitter. And very often the sitter does not pose in the same clothes as will be painted in the final portrait.

Every other aspect of Ottavio's style contributes to the impression that his drawings portray their subjects at rest during a moment in their daily rounds. Part of the fascination of Leoni's approach to portraiture is that he drew popes and children alike without the accompaniment of rhetoric. No one raises his eyes in rapture or regally brandishes a baton. Instead, Ottavio's poses predict the invention of the Polaroid snapshot, with frontal stances in half-length and the eyes unpretentiously engaging the viewer's. Ottavio's standard materials, black and red chalk on blue paper, occasionally with traces of white heightening, were of course transportable, so that in our mind's eye, we see him working rapidly on his feet, perhaps detaining his subject for an instant longer with a practiced patter.[3] In the seventeenth century especially, it could hardly be expected that an artist possessed of any imaginative powers at all could produce or would care to produce such uncalculated images in the solitude of his studio. P.J. Mariette, the great connoisseur of the eighteenth century, praised the freshness of Leoni's style and pointed out that "There is not one among them which has not been worked with care... but the ones that are more finished I find to be cold as well, and it could hardly be otherwise. As drawings become more labored, they become less spirited as well."[4] This marvelous illusion of spontaneity no doubt lies behind the admiration that Baglione tells us both Ludovico and Ottavio Leoni received for their genius in this curious art of portraiture *alla macchia.*

The naturalism for which Ottavio strove was certainly not unprecedented. His career had begun circa 1600 at the moment when this particular conception was held by many to be the most vital direction in contemporary art. Interspersed amongst the random notices that have come to light concerning Ottavio Leoni's career there emerge some shreds of evidence to suggest that he was personally associated with the vanguard of the new naturalism.

The personification of Baroque naturalism was Michelangelo Caravaggio, a rebellious personality whose turbulent life pursued every opportunity for disaster as surely as Leoni's appears to have been directed towards social respectability and advancement. Caravaggio was perhaps eight years the senior of Leoni. It has been postulated that Leoni lived in the house of Cardinal del Monte at the same time as Caravaggio at the end of the sixteenth century. In a letter of 1599 Cardinal del Monte wrote to Christine of

Lorraine in order to recommend a portrait by a young artist under his protection; Heikamp has proposed to identify Ottavio Leoni as the artist at issue.[5] A portrait drawing of Cardinal del Monte by Leoni is in the Ringling Museum of Art (App. 26). It is numbered 53 and dated 1616, and thus appears towards the beginning of the sequential series of drawings which Leoni began the year before and continued for the rest of his life (see below). We have Caravaggio's own statement in 1603 that he knew of Leoni. He made a response to this effect during a libel suit brought against him by Giovanni Baglione. Caravaggio went on to say that he had never spoken to Leoni, but his testimony is replete with suspect denials of this kind, as has often been pointed out.[6]

In an argument which bears on style the primary documentation must always remain the works of art. A case in point for the confluence between Leoni's and Caravaggio's naturalism is provided by a controversial portrait of Pope Paul V in the Palazzo Borghese, Rome. Scholars have expressed varying opinions with regard to the attribution to Caravaggio of this painting. Maurizio Marini is the most recent critic to endorse his authorship unreservedly.[7] Denis Mahon's view that the style of the Paul V is not reconcilable with Caravaggio's works post 1605 seems to be the most sound.[8] Roberto Longhi first proposed in 1943, then again in 1963, to recognize in this portrait the "objective tendency" of Ottavio Leoni.[9]

Ottavio Leoni's residence in Rome during the first three decades of the century is amply documented in the archives of the Accademia di San Luca, Rome. In 1604 Leoni was already a member of the Academy, and in 1614 he served for a year as Principe. Ann Sutherland Harris has kindly made available to this writer unpublished documentation from these archives which establishes that Leoni took part in meetings or made contributions to Academy projects in each of the following years: 1607 - 08, 1612 - 15, 1618 - 19, 1624 - 30. (The interruptions most likely reflect lacunae in the archives, which are incompletely preserved prior to 1633.) A memorial mass was sung for Leoni's soul after his death in 1630. This documentation of Leoni's date of death is of considerable importance as a corrective to the recent literature on the artist, in which Leoni's hand has been seen in drawings bearing dates subsequent to 1630.[10] Ippolito Leoni, the eldest son of Ottavio, will be advanced below as the author of some of these later drawings.

The association between Leoni and the Accademia di San Luca has suggested to Hanno-Walter Kruft that Leoni's attitudes towards portraiture can be deduced from the writings of Armenini, Zuccari, Agucchi, Bellori and other "academic" critics of the late sixteenth and the seventeenth centuries.[11] Kruft sees in Leoni's drawings a tendency to

idealize his portraits, that is to select the best features in his subjects and to minimize their blemishes in accordance with the strictures of the authors just cited. These observations are not shared by the present writer. The visitor to this exhibition is invited to form his own judgment as to which camp may lay claim to Leoni's sympathies, that of naturalism or idealization. However, the attempt to draw a connection between Leoni's participation in the Accademia di San Luca and a concommitant necessity to embrace classical esthetics must be refuted. The Academy at this date was an organization of artists dedicated to their mutual protection without any philosophical bias whatsoever. Leoni's ostensible adherence to the classical school begs the question, moreover, as to why none of those authors —not Agucchi, Mancini or Bellori — devote a single word to his career. Baglione's comments on Leoni's portraits refer rather pointedly to their remarkable fidelity as opposed to their beauty, which quality is the sine qua non of academic esthetics. In fact, Baglione's awareness of Leoni's disinterest in idealization can be read into the following passage, which will serve as well to introduce a specific discussion of the artist's drawings.

> The drawings are now in the possession of Prince Borghese. The greater part of these are in black pencil on turquoise paper with adroit touches of chalk; they are extremely faithful ['similissimi'], and some are touched with red pencil, so that they appear colored and made of flesh; they are thus so natural and so alive, that in that genre one could not do better.[12]

In 1747 a corpus of about 400 drawings by Leoni and some by Ippolito Leoni was dispersed in Paris with the sale of the collection of M. d'Aubigny. One of the most enthusiastic bidders at the event was P.J. Mariette,[13] who acquired fifteen portrait drawings of artists. Fortunately for our reconstruction of Leoni's career, Mariette published an extensive account of the d'Aubigny drawings.[14] In the first place, he reasonably concluded (and perhaps there was some circumstantial evidence still in existence) that this collection of Leoni was the same as that mentioned by Baglione in the collection of Prince Borghese in 1642. Mariette supposed that Borghese had managed to assemble a collection of every drawing that Leoni had made in his life, an unlikely idea on its face. In addition to the portraits that Mariette acquired for himself, he noted the other portraits of artists in the d'Aubigny sale, and he remarked that several of these were dated 1614, while the remainder were not dated.

Mariette evidently did not know that in 1614 Leoni had been elected Principe of the Accademia di San Luca. This honor was surely the inspiration for Leoni to compile his

own gallery of artists' portraits, such as already existed as oil paintings in the Accademia. Thanks to the list provided by Mariette we can note that Leoni only inscribed the date of 1614 on drawings of artists who were alive in that year. Leoni exhibits the same concern to cross-reference his likenesses against the current date in his series of etchings of famous men, which he began in 1621 with a portrait of Cavalier d'Arpino.[15] Every one of the eighteen portraits in this series of prints, which are recognizable by their ornamental cartouches, is dated and none of them are posthumous, except that of his father.

The portraits of artists doubtless inspired Leoni in the next year to begin the series of portrait drawings for which he is best known today. By common consensus, the dates and numbers inscribed in pen on the bottom of the great majority of existing Leoni drawings are in his own hand. These notations follow an invariable formula. In the center of the lower margin of the drawing Leoni placed the year; on a number of drawings, subsequent collectors have trimmed the lower margin and with it the indication of the year. At the lower left, Leoni habitually inscribed the month and directly above it a number, which marked the sequence in which the drawing was executed in this series. These last numbers have been the occasion of much confusion because it is impossible to reconcile numbers larger than 31 with a date in a month; they were not intended for that purpose in the first place. Leoni's system becomes clear immediately once a sample of sufficient size is assembled, as is provided at the end of this essay.

If the reader will refer to this list, he will note that the sequential numbers coincide with breathtaking consistency with the progression of the months and years. In the instances where one or other of these data have been removed from the sheet, the drawing's place in the sequence can still be found.[16] An example at hand is the drawing of Cardinal del Monte to which we referred above (App. 26). The year was unfortunately cropped at some time in the past. Through reference to the sequential number, however, the drawing may be assigned with confidence to Leoni's production for September of 1616. Indeed, the two curves from the tops of the missing sixes can still be seen at the lower edge of the sheet. As further confirmation of the internal logic of the numbering, it is worth mentioning that the dates on Leoni's engravings always correspond to the year, or in some instances to the following year, inscribed on the corresponding drawings, when they are known.

It seems reasonable to conclude that Leoni could have maintained this sequential numbering on more than four hundred drawings over a period of fifteen years only if he had retained them in his possession. This rules out the

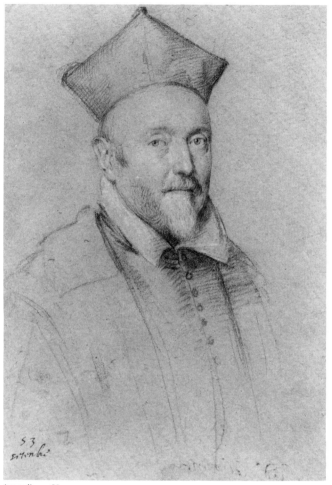

Appendix no. 26

supposition that the resourceful Prince Borghese had managed to trace the whereabouts of four hundred sitters (or their heirs), including a sizable contingent of cardinals and dukes, and persuaded them to relinquish their portraits. Certainly it would have been easier to acquire them as a group from Ippolito Leoni, some of whose drawings in the manner of his father were included in the d'Aubigny sale. Mariette was the last writer on Leoni to have had the opportunity to see these portraits collected in one place. He remarked that Leoni must have been particularly attached to the Altemps family in Rome. Seemingly every member of that house from its masters to its domestics was portrayed, sometimes more than once.[17] This observation occasioned some research into the possibility that Leoni had undertaken this pictorial anthology of Roman society on commission from the Altemps. Under such an arrangement, the numeration could have been preserved. As it happens, Mariette could have seen in Baglione's biography that Leoni had received a prestigious commission to paint some sacred stories in the chapel of the Palazzo Altemps in

Piazza S. Apollinare. We know, too, that the Altemps family was in decline after 1620. Already in 1613 they had sold their Villa Mondragone in Frascati to Cardinal Scipione Borghese.[18] But there is no documentation of a sustained relationship between Leoni and the Altemps. Furthermore, Baglione, who attended thirty years of meetings with Ottavio Leoni at the Accademia di San Luca, cannot be expected to have forgotten to mention such a singular episode in patronage.

T.H. Thomas in an article on Leoni as a printmaker hypothesized that the artist used his drawings as a pattern book for progressive clients.[19] It is impossible to imagine as Thomas did that there was sufficient demand in seventeenth-century Rome for informal pencil sketches of nonrelations. Such a practice should have left some trace besides in the form of copies of these drawings. On the other hand, in at least one instance a drawing in the numbered series was made by Leoni as a fair copy of an earlier rendition. The example in question is on view in this exhibition (no. 34) alongside an etching by Leoni of the same composition (no. 33). The portrait drawing of Mao Salini dated November 1620 and numbered 174 is demonstrably a copy of Leoni's portrait of Salini in an album of drawings preserved in the Biblioteca Marucelliana, Florence.[20] The album in Florence contains 27 undated drawings, mostly of artists, of which nineteen were used by Leoni as models for engraving. There is little reason to doubt that these drawings are to be identified with Mariette's reference to a group of drawings by artists, apart from his list of those dated 1614, which were "the drawings of the portraits of the artists that Padovano engraved."[21] Kruft proposed that several of the drawings in the Biblioteca Marucelliana album had been copied from their counterparts in the numbered series.[22] It is difficult to draw any conclusions from photographs, but if the two portraits of Mao Salini are representative of Leoni's procedure, then the Marucelliana drawings were in fact the models for the numbered drawings just as they were for Leoni's prints.

If in the future some energetic historian should compile the photographs of every one of Ottavio's dated drawings, the resultant image of the artist's stylistic development, documented month to month over fifteen years, will be of an unparalleled clarity. Even the small selection of drawings illustrated in this catalogue as exhibits or as figures in the Appendix allows the observation that the portraits in the earlier drawings tend to occupy less of the page and to recede more from the picture plane than is noticeable in the late sheets, which have a tendency besides to suggest broader effects of color and light. Compare the 1624 drawing of a boy from Ottawa (no. 37) with the Salini of 1620 (no. 34) or with the undated, but early, Giovanni Garzia

Millini (if the identification is correct) (no. 32) or with the drawing of Mons. Porta of 1615 in the Morgan Library (App. 25).

To refer again to the list of Leoni's portraits below, we find that the numeration eliminates at once the misconception about drawings dated after 1630.[23] Even if the inferiority of these sheets is not recognized — although they clearly are not up to Ottavio's standard — their numbering follows only the form, not the actual sequence of the original scheme. Moreover, the handwriting is demonstrably different.[24] The identifications given in the attached list represent in most cases published transcriptions of names written on the reverses of these drawings. In many cases, the drawings have been laid down on other papers and the names on the reverse can no longer be read. A number of drawings bear penned identifications on their rectos in a different hand from Leoni's. In my opinion, these additions are to be attributed to Ippolito Leoni, since they appear to be by the same hand as that responsible for the inscriptions on the post-1630 drawings attributed here to Ippolito Leoni. Other scholars have cited Ippolito's name in this regard based on Baglione's testimony in 1642 that he was attempting to carry on his father's work.

According to Baglione, Ottavio Leoni was survived by sons. The eldest was Ippolito, who "imitates the vestiges of the father, and comports himself rather well; it is to be hoped that he will make a success of this, because he is an intelligent youth of good appearance, who desires to do well, both in portraiture as in other things." Ippolito Leoni (?? - died 1694?), like his father, was an active, if somewhat testy participant in the business of the Accademia di San Luca. He received his honors, moreover: in 1651 he was admitted to the honorific Congregazione dei Virtuosi del Pantheon, and in 1664 he was elected Regent. Ann Sutherland Harris has kindly shared with me unpublished documentation from the archives of the Accademia di San Luca concerning Ippolito's long involvement with that body. By 1627, he was already a member, which suggests that he was born earlier than has been supposed. During the period ca. 1630 he was resident in the house of Paolo Giordano II, Duke of Bracciano. Ippolito's presence in Rome is documented in Accademia papers for the years 1627, 1630 - 33, 1639 - 43, 1645, 1648, 1651 (as secretary) - 60 (when he walked out of the meeting in protest of the choice of Morone as Principe), 1662 - 73. In August of 1667 the record duly notes that Ippolito refused to come to a general meeting of the academy because it had not been called according to the correct procedure.

A drawing of a young man in the Steiner Collection, Larchmont, is dated 1632. Its style represents a dry imitation of Ottavio's works in 1620. Rather than a miraculous

apparition from the grave the sheet is best understood as a good example of Ippolito's closest approach to the manner of his late father. The same may be said of a charming *Girl Illuminated by a Lamp,* again dated 1632, which was exhibited a few years ago from the Ames Collection. The later drawings in our list of Ippolito attributions derive from the broader qualities of Ottavio's late works and in Ippolito's hands become noticeably slovenly. The most familiar of these are a pair in the Musée Wicar, Lille, in the recent catalogue of which Ippolito's authorship has already been suggested. Of better quality is an uninscribed drawing in the Ringling Museum, which seems a reasonable attribution to Ippolito at date unknown (App. 32).

1) Baglione, 1642, 321.
2) *ibid.*, 144. Baldinucci, F., 1681, *sub voce* confirms this usage: "Painters use this term with respect to portraits that they make without having the subject before them, calling it 'portraiture alla macchia' or saying, 'this portrait was made alla macchia.' "
3) Ottavio's use of the technique of *deux crayons* is directly inspired by the portrait drawings of Federico Zuccari as Heikamp, 1967, 56, points out. Zuccari's portraits anticipate the naturalism of Leoni's, moreover.
4) *Abecedario de P.J. Mariette,* 1854 - 56, III, 180.
5) Heikamp, 1966, 62-76. *cf.* Marini, 1974, 65 note 116.
6) Caravaggio claimed not to have seen his confederate Orazio Gentileschi in some years; Gentileschi testified as to three months. For an English translation of Caravaggio's testimony, see Friedlander, 1974, 270-79.
7) Marini, 1974, 192, with illustrations.
8) Cited in Cinotti, 1983, 563.
9) Longhi, 1943; Longhi, 1963, 89-91.
10) For example, Rebecca Zurier in Oberhuber, 1977, no. 20; Byam Shaw, 1983, I, no. 155; Laura Giles in Johnson, 1983, nos. 8 and 9. Thomas, 1916, 340 had already cited a reference in the register of S. Maria del Popolo to Leoni's burial in that church in 1630. The article on Leoni in Thieme-Becker, also gives the correct date based on Accademia di S. Luca archives.
11) Kruft, 1969, 454-56.
12) Baglione, 1642, 321.
13) *cf.* Françoise Viatte in Paris, 1967, no. 77.
14) *Abecedario de P.J. Mariette,* 1854-56, III, 179-81.
15) For illustrations of Leoni's prints, see Buffa, ed., 1983, 160-98.
16) This same observation about Leoni's system of numbering was made by "P.C.S.", the author of an entry in Dartmouth, 1971, no. 20. This contribution unfortunately eluded subsequent students of Leoni, and the present writer came across this text in the course of compiling material to prove the same point.
17) *Abecedario de Mariette,* 1854-56, III, 180.
18 For 300,000 scudi; see Laura Tarditi in *Villae Paese,* 1980, 109-10.
19) Thomas, 1916, 329-30.
20) Kruft, 1969, 450-51, fig. 14. Kruft did not know the Metropolitan Museum drawing dated 1620.
21) This was first remarked by Thomas, 1916, 334. Kruft, 1969, 448, doubts the connection, but is unaware that Mariette mentions two series of artists's portraits.
22) *ibid.*, nos. 24 and 26.
23) Laura Giles in Johnson, 1983, 36, correctly distinguishes between Leoni's autograph inscriptions and the tighter style of the later annotator who left a long inscription on the front of a portrait of one of Ottavio's sons as a swaddled infant (Ashmolean Museum, Oxford). The later *anonymous* annotator is undecided as to whether the child is Lodovico Antonio or Antonio Francesco Maria Leoni. Such uncertainty would be odd in the case of the father, but not by Ippolito, the eldest brother.
24) Oberhuber, 1977, no. 20, reproduced.

# Numbered and Dated Drawings by Ottavio Leoni

| NO. | MONTH | YEAR | LOCATION | SITTER |
|---|---|---|---|---|
| | | n.d. | NY, PML | Federigo barocio d'Urbino |
| | | 1600 | L, C, 18 iv 67, 43 | Young Lady |
| | | 1602 | L, C, iv 62, 80 | Young Man |
| | | 1606 | Leningrad, no. 1046 | Lady |
| | | 1607 | Berlin | Man |
| | | 1607 | Berlin | Man |
| | | 1607 | Berlin | Cardinal |
| | | 1607 | Berlin | Lady |
| | | 1611 | L, C, 2 xii 69, 57 | Signor Vincenzo di Nobili |
| | | 1611 | Oxford | [Princip.a Peretti] |
| | | 1611 | Berlin | Man |
| | | 1612 | Berlin | Boy |
| | | 1612 | Berlin | Cardinal |
| | | 1614 | Darmstadt | Man |
| | | 1614 | Darmstadt | [Amerigo Passaro] |
| | | 1614 | Vienna | Orazio Borgianni |
| | | 1614 | Oxford | [Franc. Mignanelli] |
| | | 1614 | Paris, Louvre | Camillo Graffico |
| | | 1614 | NY Market, 1967* | Carlo Saraceni |
| 6 | genaro | 1615 | Hamburg | Lady |
| | August | 1615 | L, S, 19 iii 47, 73 (not ill.) | Figlia del Conte di Castro Ambasciatore di Spagna |
| 18 | maggio | 1615 | New York, PML | Mons. Porta |
| 20 | giugno | —— | Paris, Petithory Coll.; Dessins, 1971, 63 | Young Man |
| 33 | decembre | 1615 | Cleveland | Conte Annibale Altemps |
| 43 | magio | 1616 | New Haven, Yale Univ. | Cardinal |
| | June | 1616 | L, S, 20 vi 51, 47 (not ill.) | Piermarino Bernardo |
| 53 | settembre | 1616 | Sarasota | Cardinal del Monte |
| 56 | decembre | 1616 | New Haven, Yale Univ. | La Damigella d'Angiò |
| 61 | genaro | 1617 | Berlin | Cardinal |
| 62 | genaro | 1617 | L, S, 20 iv 67, 50 | Signora Ottavia Palusela |
| ** | 11 febraro | 1617 | Providence, RISD | Madalena |
| **(?) | 13 agosto | 1617 | L, C, 10 vii 36, 109A (not ill.) | Signora Eufrasia |
| 73 | agosto | *** | Paris, Lugt Coll. | |
| 75(?) | —— | 1617 | Paris, Dollfus Sale, 20 v 12 * | Chiara Altieri |
| 80 | setembre | 1617 | Vienna | |
| 81 | setembre | 1617 | New York, PML | Pietro Altemps |
| 87 | novembre | 1617 | NY, PB 14 iii 63, no. 145 | Duca Santo Donato |
| ** | | 1617 | Edinburgh | Signora Domitelli |
| 90 | genaro | 1618 | Vienna | |
| 101 | magio | **** | Berlin | Lady |
| 104 | magio | 1618 | Berlin | Man |
| 108 | giugno | 1618 | Vienna | |
| 110 | giugno | —— | New York, MMA | |
| 111 | giugno | —— | Copenhagen, NMA | Lady |
| 112 | luglio | 1618 | Berlin | Young Lady |
| 113 | luglio | 1618 | NY, PB, 30 iii 61, 7 | Caterina Cartola |
| 114 | luglio | 1618 | Edinburgh | D. Madalena f.a del Duca di Cesi |
| 115 | luglio | 1618 | Anderson Gall, NY, 16 ii 28, 65 | Cardinal |
| 123 | novembre | 1618 | Berlin | Lady |
| 128 | genaro | —— | Rotterdam | Young Lady |
| 129 | genaro | 1619 | Hannover, Kestner Mus. | Lady |
| 130 | luglio | —— | New York, MMA | Man |
| 132 | settembre | —— | L, S, 4 vii 77, 96 | Girl |
| 134 | aprile | —— | Lille, Musée Wicar | Man |
| 137 | aprile | 1619 | Berlin | Man |
| 151 | setembre | 1619 | Berlin | Man |
| 154 | January | 1620 | L, S, 29 xi 61, 18 (not ill.) | Pimpa Saponara |
| 157 | aprile | 1620 | New York, MMA (pencil inscription appears autograph) | |
| 164 | febraro | —— | Paris, priv. coll.; Dessins 1971, 64 | |
| 167 | setembre | 1620 | London, BM | Young Man |

| NO. | MONTH | YEAR | LOCATION | SITTER |
|-----|-------|------|----------|--------|
| 170 | ottobre | 1620 | Darmstadt | Domenico Ambrosia |
| 174 | novembre | 1620 | New York, MMA | Mao Salini |
| 179 | decembre | 1620 | Vienna | |
| 180 | decembre | 1620 | Berlin | Lady |
| 182 | febraro | 1621 | London, BM | Gregory XV |
| 188 | magio | —— | Hannover, Kestner Museum | Cav. d'Arpino |
| 189 | magio | 1621 | Karlsruhe | Giovanni Baglione |
| 192 | giugno | —— | Rouen | Man |
| 200 | luglio | 1621 | Berlin | Lady |
| 202 | agosto | 1621 | Rotterdam | Young Man |
| 206 | setembre | 1621 | Edinburgh | D. Elena fig.a del Duca Altemps |
| 211 | novembre | 1621 | Vienna | |
| 222 | marzo | 1622 | Vienna | |
| 228 | giugno | 1622 | Berlin | Young Lady |
| 232 | giugno | 1622 | Oxford | Paolo Sforza |
| | June | 1622 | L, S, 20 vi 51, 47 (not ill.) | Young Nobleman |
| 240 | settembre | 1622 | Newberry Coll exh Detroit 1949 * | Boy |
| 243 | novembre | 1622 | Paris, Louvre | Filippo d'Angeli Romano |
| 249 | febraro | 1623 | Oxford | Cardinal Marco Gozzadini |
| 252 | marzo | 1623 | Karlsruhe | Marcello Provenzale |
| 253 | aprile | 1623 | Paris, Lugt | Cav. Altieri |
| 255 | aprile | 1623 | Paris, Ecole B-A | |
| 265 | agosto | 1623 | Washington | [Innocentia alias Censia] |
| 271 | ottobre | 1623 | Berlin | Young Lady |
| 275 | novembre | 1623 | London, A.Stein cat., 1981 | Bianca Costanza Sforza |
| 277 | decembre | 1623 | Berlin | Lady |
| 281 | febraro | 1624 | Berlin | Man |
| 282 | marzo | 1624 | Berlin | Boy |
| 288 | aprile | 1624 | Berlin | Lady |
| 297 | maggio | 1624 | Vienna | Tomaso Stigliano |
| 298 | maggio | 1624 | Karlsruhe | Self-Portrait |
| 299 | maggio | 1624 | London, BM | Self-Portrait |
| 302 | setembre | 1624 | Ottawa | Conte Filippo Spinola |
| 304 | setembre | 1624 | San Francisco, Achenbach Found. | Franco Tenturcine |
| 305 | setembre | 1624 | London, BM | Card. Francesco Barberini |
| 311 | novembre | 1624 | London, BM | Card. Antonio Barberini |
| 312 | novembre | —— | Ottawa | Boy |
| 318 | genaro | 1625 | L, C, 5 iv 77, 119 | Verginia (Young Lady) |
| 324 | marzo | 1625 | Vienna | Pierfrancesco Paolo da Pesaro |
| 326 | aprile | 1625 | Karlsruhe | Simon Vouet |
| 334 | maggio | —— | Vienna | |
| 341 | ottobre | —— | Rouen | Boy |
| 348 | novembre | 1625 | Berlin | Man |
| 352 | marzo | 1626 | Oxford | Card. Luigi Caetano |
| 359 | giugno | 1626 | Berlin | Cardinal |
| 360 | luglio | 1626 | Berlin | Lady |
| 376 | luglio | 1627 | Berlin | Lady |
| 380 | settembre | 1627 | L, S, 5 xii 77 3 | Cardinal Cesarino |
| 382 | ottobre | 1627 | Berlin | Man |
| 384 | decembre | 1627 | Vienna | |
| 386 | decembre | 1627 | Berlin | Young Lady |
| 393 | aprile | —— | Sale A'dam 27/8 May 1913* | [Vincenzo della Marra Napoletano di Varletta] |
| 401 | luglio | 1628 | London, BM | Man |
| 403 | agosto | 1628 | L, C, 8 xii 76, 5 | Lady |
| 406 | agosto | 1628 | Paris, Lugt Coll. | |
| 417 | febraro | 1619 | Berlin | Girl |
| 432 | setembre | 1629 | London, BM | Urban VIII |
| 434 | setembre | 1629 | New York, PML | Settimia Manenti Salernitana |

# Attributed to Ippolito Leoni

| | | | |
|---|---|---|---|
| 18/marzo/o | 1632 | Larchmont, Steiner Coll. | Young Man |
| 23/novembre | 1632 | Ames Coll. Vassar exh., 1961, 34 | Girl Illuminated by a Lamp |
| 130/luglio | 16(5?)1 | NY, Seligman Gall., cat. 1925* | Man |
| 91/--mpra/o (tempra?) | 1639 | L, Parsons & Sons, cat. no. 38* | Marchese Caranga |
| n.o/febraro/r | 1638 | Lille, Musée Wicar | Young Lady |
| n.o/febraro/- | —— | Lille, Musée Wicar | Man |
| 132/settembre/ | —— | Rudolf Coll. no. 38 | Girl |
| | | Corpus Gernsheim 03 526 | |
| 256/novembre/o | —— | Hannover, Kestner 1905.41 | Young Lady |

Location references are to public collections of prints and drawings. Sitters' names within brackets refer to recto inscriptions in a later hand, possibly Ippolito Leoni's.

\*　　Photograph, Frick Art Reference Library, New York
\*\*　　Dated drawing without sequential numeration
\*\*\*　　Correct date, 1617, added in a later hand
\*\*\*\*　Date cut off below, later inscription in different hand *1628*

# The Portraiture of Francesco Redi (1626 -1697), Physician, Philosopher and Poet

This exhibition includes portaits in three different media of Francesco Redi (1626 - 1697), a native of Arezzo, who was physician to two Grand Dukes of Tuscany and one of the outstanding personalities of his age. (Exh. nos. 24, 46, 64). Redi's place in the history of science and in Italian letters is assured on the basis of accomplishments which will be sketched below. The coincidence that three portraits should have been selected of a man who was neither pontiff nor despot has suggested the theme of this essay, which takes the form of a case study of the portraiture of an intellectual during the Baroque Age. Some conclusions will be drawn with regard to the initiatives through which these portraits came into being, the audience for whom they were created, and of course Redi's own outlook on the publication of his features.

Famous thinkers have been the subjects of portraits since antiquity. With the emergence of philosophical schools as cultural forces during the 4th century B.C., the preeminent artists of Greece, sculptors above all, were called upon for portraits of poets and philosophers, and of humanists in every field of learning. In the absence of effigies observed from life, as was most often the case, Greek artists drew freely upon their powers of invention: the strongly characterized portraits of such personalities as Homer and Aristotle, although imaginary, soon acquired the sanction of tradition. These heads have been preserved in innumerable Roman copies. For the Romans, the brooding countenances of the Greek sages were the ideal adornment for their libraries, public and private, and this idea has never gone out of fashion.

The rediscovery during the Renaissance of Roman portrait sculptures and medals, as well as literary portraiture, was an essential aspect of the cult of antiquity, which stood at the center of European culture until the nineteenth century. Nowhere in post-medieval Europe were the fires at the altar of antiquity tended so faithfully as they were in Florence. The High Renaissance papacy of Leo X de' Medici allowed the Medici to realize one of their dynastic dreams: in September, 1513, their claims to Roman ancestry were afforded *de jure* recognition by the proclamation of Giuliano, brother of the pope, as *civis romanus*.[1] Afterwards Leo X likewise obtained from the *Conservatori* Roman citizenship for himself and for others of the Medici family.

The role played by portraiture during three centuries of Medici dynasty politics has been vividly documented by Karla Langedijk.[2] The recurrent theme in Langedijk's exhaustive survey of Medici portraiture is the continual reference back to antique antecedents. The earliest verifiable portraits of a Medici are two medals of Cosimo *Pater Patriae* (1389 - 1464), whose posthumous title itself is a reference to Cicero. During the sixteenth century, the Medici encouraged Paolo Giovio's ambition to collect a pantheon *(templum virtutis)* of portraits of famous poets and scholars, each to be represented by an authentic image *(vera effigies)*. As Langedijk points out, there was nothing novel about Giovio's plan, although the scope was impressive: the concept of such a series of portraits of famous men had been in practice for at least a millennium. (It is not by chance that the terminology of humanist portraiture is cast in Latin.)

> But the accent now came to lie on the recognizability of the facial features as those of a given person, in contrast to the Medieval series which depicted types, but not individuals. There had gradually grown up a desire to have those moral *exempla*, which were contained in the biography, the literary portrait, before one's eyes in the literal sense too.[3]

At Giovio's death in 1552, Cosimo I de' Medici, the first Grand Duke of Tuscany, sent Cristofano dell'Altissimo to paint copies of the portraits in the Museo Gioviano at Lake Como. By 1568, Vasari counted 280 of these portraits in Florence, and Altissimo was not yet finished.

A perusal through the plates published in *The Portraits of the Medici* by Langedijk illuminates very clearly the predicament faced by the Medici at the close of Alessandro Allori's activity (died 1607): for thirty years, until the arrival in 1620 of the Fleming, Justus Sustermans, there was no painter in Florence who could satisfy the needs of the Court for competent and promptly-delivered portraits. It is hard to say, though, that Sustermans revived Florentine portraiture; his Flemish naturalism made no impression on the local school, and over the next half-century no one seems to have been inspired to challenge him for his post as official portraitist to a singularly unbeautiful family tree.

Francesco Redi's entrance into the Medici household occurred during the waning years of Sustermans's career. Even so, Baldinucci records that "Giusto Subtermans" painted three "truly stupendous portraits" of the young doctor. At the time that Baldinucci was compiling his biographies of artists, Redi was firmly ensconced as Archconsul (director) of the Accademia della Crusca, the final arbiter of everything literary in Grand Ducal Tuscany. Hence, Baldinucci's enthusiasm could not have been wholly disinterested, but he was well motivated to be accurate:

> Turning now to Sustermans, whom I ventured above to qualify with the encomium of "painter of great men," I must not omit to make particular note of the three truly stupendous portraits that he at different times colored from life of the renowned Francesco

Redi, the noble Aretine and the glory not only of his country but of our century for the profundity of the science which he has made known in his learned books to date. The first of these portraits was painted by our artist at the time that Redi in the full flower of his youth had already brought to light, both in our city and abroad, the great treatises of his knowledge; as a sign of which, the painter depicted him with his right hand on a book: and this painting turned out so well, that I have no qualms in placing it among the most beautiful works by him. The second portrait he made some time later: in this work, he again has a book in hand, and this picture too is very handsome. Finally, the last portrait was painted in very small proportions, since it was intended to serve, as it did serve, as a model for Domenico Temperani [Tempesti], our valorous engraver, to engrave a copperplate in the style of the celebrated Nanteuil, his master.[4]

None of these paintings are known today, although one of the compositions was etched by Adriaen Haelwagh in 1673 (Fig. 1) and another seems to be recorded by a half-length portrait of Redi at about the same middle-age, book in hand, in the Fraternità dei Laici, Arrezzo.[5] Ugo Viviani reasonably suggested that this latter picture was the copy painted after Sustermans by Pietro Dandini in 1695 (see below).[6] The plate by Tempesti (Fig. 2) derives from a composition much like Haelwagh's, although it would seem most likely that Tempesti would have preferred to show off his own capabilities as a portraitist in the fancy style he had brought back from France in 1679. Redi liberally distributed impressions of Tempesti's engraving, as we shall see, and it was bound into the memorial edition of Redi's sonnets, 1702 (Exh. no. 24). On the basis of Baldinucci's description of events, the Grand Duke Ferdinand II spared his court portraitist to paint Redi's portrait following the success of Redi's first publications, which were *Observations on Vipers* in 1664, and *Experiments On the Generation of Insects* in 1668.

Historians of science might justifiably protest that to invoke Redi's treatise on spontaneous generation as a *terminus post quem* for some lost paintings by Sustermans rather misses the point. Redi's slender volume upset the order of centuries; in fact, it achieved for biology what Galileo had done for physics, which was to sound the death knell of Aristotelianism as an authority superior to controlled observation. In the Foreword to an English translation of Redi's *Experiments on the Generation of Insects*, Mab Bigelow wrote:

To the student of the history of biology, the book is a milestone marking the beginning of a great epoch. It records the first, and therefore the most important, statement supported by experimental evidence of that

great generalization named by Huxley *the theory of biogenesis,* a theory, which in its application has probably been of more benefit to mankind than any other result of scientific investigation.[7]

Following an investigative method of unimpeachable empiricism, Redi demonstrated through a series of experiments that spontaneous generation was a non-existent phenomenon, that decaying flesh could not generate flies nor any other living creatures, and finally, by implication, that flies could only come into being from eggs deposited by other flies.

In reviewing the life of Francesco Redi, we find that he was born into the life of a gentleman of ease and convenience. These were not perhaps the circumstances of a revolutionary thinker, but in the event he was both. It seems indubitable that Redi's embarkation into experimental science was the direct result of the extraordinarily conducive situation in Florence at mid-century. Fifteen years after Galileo Galilei's death in 1642 while under house arrest imposed by the Inquisition, Prince Leopoldo de' Medici, supported by his brother the Grand Duke, was prepared to extol in

Fig. 1    **Adriaen Haelwegh,** *Portrait of Francesco Redi.* New York Academy of Medicine, New York.

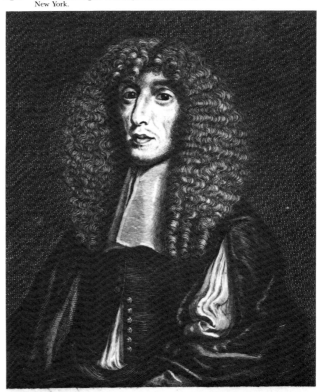

FRANCISCVS REDI ARRETINVS

*Justus Supterman pinx:*                    *Adrianus Halluech Sculp:*

21

public Galileo's writings and scientific method. A biography of the great astronomer was commissioned from his last pupil, the mathematician Vincenzo Viviani (whose portrait is in this exhibition, no. 65). Most important, the Medici founded the first scientific academy in Europe, the Accademia del Cimento, in 1657. The most flexible minds in Florence were invited to participate in the Academy, which was wholly dedicated to the pursuit of knowledge according to the principles propounded by Galileo. The name of the Academy means in Italian, "experimentation, testing", the implication being without prejudice of the results. The thirty-year-old Francesco Redi, who was making a name for himself in ancient and modern languages, was among the founders of the Accademia del Cimento.[8]

Redi came of a noble family of Arezzo, but he was raised in comfort in Florence. His father, Gregorio Redi, was personal physician to the Grand Duke Ferdinando II. Francesco was educated by the Jesuits, whose schools had the best reputations (they were rigorously anti-Galileian, as it happens), and he proceeded to study medicine at the University in Pisa, receiving his degree in 1647. After leaving the university, Redi began to keep an account book of *ricordi*, in which he recorded his expenses uninterruptedly for the rest of his life.[9] These records, in addition to several volumes of his correspondence with other scholars and with his patients (much of which was published during his lifetime), provide us with an unusually complete picture of the life of this man.

Over the next decade, Redi devoted himself to completing his education according to his own inclinations. His *ricordi* for the year 1648 note that in January he began lessons in French; in May he began to study Spanish and also to take lessons in drawing from Remigio Cantagallina, the drawing master to the Court. Lessons in fencing and in the flute were added in September and December. He seems to have had already a perfect knowledge of Greek and Latin. In 1650 Redi travelled to Rome to take part in the Jubilee celebrations. During the ensuing four years, he was frequently absent from Florence, mostly in order to study in Rome. Evidently he was working independently, but not in obscurity, for in July of 1655 Redi was appointed by Prince Leopoldo to the Accademia della Crusca, the tireless guardians of the Tuscan linguistic purity. In 1658, Redi was given primary responsibility pertaining to the usage of Greek and Latin in the new edition of the Accademia's dictionary, which was in a state of perpetual compilation.[10]

In 1666 Redi replaced his father as first physician to the Grand Duke; he was also named custodian of the dispensary. In the main, his exercise of the latter appointment took the form of the efficient procurement of chocolates for the ducal family and its favorites, as any number of his existing letters attest.[11] To the best of our knowledge, Gregorio Redi had practiced medicine as it had always been practiced thereto, and as most doctors continued to do so until the nineteenth century, namely, as an adjunct to alchemy. To Redi goes the credit for applying Galilean empiricism to his own practice. He declined to prescribe potions if he could not foresee their effect, an unheard of departure from traditional procedure. The Grand Duke Cosimo III, who succeeded to the throne in 1670, credited Redi with prolonging his life. Prone to obesity and gastric upset, Cosimo's health improved dramatically after 1681, when Redi put him on a regime that is familiar to anyone living in the 1980's: eat less; drink less alcohol and more water; exercise regularly. Cosimo III died an old man in 1723.[12] The story is told that Cosimo conceived the idea to bring the Venus de' Medici and other irreplaceable antiquities from Rome to Florence so that he would have something to look at as he took his constitutional through the corridors of the Uffizi.[13]

The Medici cultivation of their public image through portraiture has been studied extensively, as noted above, Suffice it to say that although Cosimo III was personally a tower of ignorance, without appreciation of the arts or literature and positively distrustful of science, he had a firm grasp on his responsibility to preserve the dynastic legends concerning the Medici's protection of the humanities. The international reputation of his physician and confidant must have been extremely satisfying. Redi was given complete freedom to cultivate his experiments, his poetry, and his library. Among numerous published researches, Redi's treatise of 1684, *Observations on Animals that live in other Animals*, invented the discipline of parasitology.[14] The next year saw the first edition of his dithyramb, *Bacchus in Tuscany*, which is one of the classics of Italian literature. The poem is a paean to the wines of Tuscany as narrated by Dionysus in an inebriated first person. Character sketches of contemporary personalities, classical allusions of the greatest erudition, and nonsense syllables are juxtaposed in rhyming verses which have been recognized as *tours-de-force* of comic poetry since the day of their publication. Had his activity been confined to his personal library, Redi's name would yet be writ large in the annals of European culture for the manuscripts that he preserved for posterity. Among the treasures in his collection, now contained within the Biblioteca Laurenziana, Florence, was the manuscript of one of the principal documents of the Cinquecento, Benvenuto Cellini's *Autobiography*.

It occurred to the Grand Duke on more than one occasion to have Redi's portrait made. Presumably, at least one por-

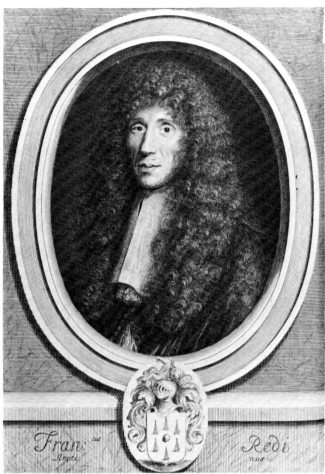

Fig. 2    **Domenico Tempesti,** *Portrait of Francesco Redi.* New York Public Library, New York.

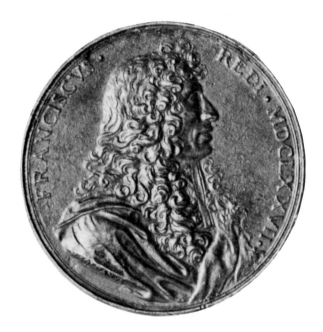

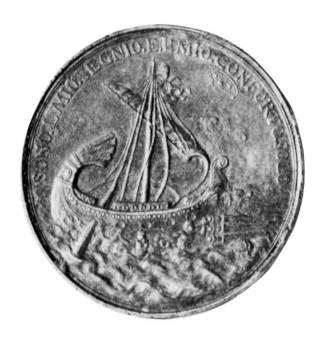

Fig. 3    **Massimiliano Soldani-Benzi,** *Portrait Medal of Francesco Redi* (recto). Bargello, Florence.

Fig. 4    **Massimiliano Soldani-Benzi,** *Portrait Medal of Francesco Redi* (verso). Bargello, Florence.

trait by Sustermans is the subject of a letter of April 1672. Writing to Padre Aprosio Vingtimiglia, a family friend, Redi remarks that he will try during the coming summer to have a copy made of "one of his portraits," if the Reverend could again inform him of the desired measurements.[15] Redi's meticulous *ricordi* inform us that in October of the next year he gave the final payment to the engraver Adriaen Haelwagh for the execution of a "portrait engraved in a copperplate, taken from that which Monsù Giusto Subtermann had painted." (Fig. 1) The commission and the choice of the engraver were calculated efforts on the part of Redi to identify himself with a major project of Medici iconography which was then underway. Cardinal Leopoldo (formerly the Prince) had engaged Haelwegh to engrave a series of Medici portraits based on paintings by Bronzino and Sustermans and other paintings in which the identification of the sitter could be established beyond question. The impetus behind this series was removed with Leopoldo's death in 1675. In all, Haelwegh produced thirty-one prints; since Redi's portrait was likewise based on a Sustermans, the resultant print bears an unmistakable family resemblance to the Medici series.[16]

In 1677 Redi used portraiture to make a public declaration of his allegiance to the Medici house. He commissioned the fledgling sculptor, Massimiliano Soldani Benzi, to cast a medal bearing his portrait. (Figs. 3 and 4) The reverse of Redi's medal is allegorical, with at least two levels of meaning: on a stormy sea, a ship is depicted, navigating by the multiple beacons of the planet Jupiter and its four

satellites. The legend which arcs like a rainbow from one horizon to the other states *SONO.L'MIO.SEGNIO. E.L'MIO.CONFORTO.SOLO.*[17] ("They are my only sign and comfort.") The interpretation of this emblem derives directly from the politics of the day. In 1610 when Galileo published his discovery of the satellites of Jupiter, he dedicated his account to Cosimo II de'Medici, and he named his discoveries the *Sidera Medicea,* the Medici Stars, in honor of Cosimo and his three brothers. Galileo's dedication goes on to compare the moons of Jupiter, which never leave the planet's side, with the four cardinal virtues, which are similarly inseparable from the Grand Duke.[18]

Redi's medal therefore declares at once his dependence on the Medici and his credence in Galilean science. Langedijk points out that the Medici had had to put aside this glorious imagery after Galileo's condemnation in 1633, but that the Medici Stars made a triumphant reappearance in Medici portraiture during the 1660's. Two medals by Francesco Travani of Prince Cosimo III, dated 1661 and 1666, bear an emblem on their reverses from which Redi took his model. For that matter, the conception may have been Redi's in the first place: under the confident legend, *CERTA FULGENT SIDERA* ("Surely the stars shine."), a ship is guided by the Medici Stars.[19]

Massimiliano Soldani's execution of Redi's medal is unremarkable except in respect of his youth. In 1677, Soldani was only twenty-one years old, and had not yet made any works that have come down to us. The rarity of the medal and the absence of references to it in Redi's correspondence suggests that it was viewed in this light. However, with Redi's medal, Soldani demonstrated sufficient promise to inspire Cosimo III to send him to the Florentine academy in Rome in the hope that he could eventually take over the Florentine mint, which had fallen on hard times.

It is even possible that the Grand Duke had mentioned Soldani to Redi as a likely candidate to cast his medal. A curious coincidence regarding the next recorded portraits of Redi gives rise to the impression that Cosimo employed Redi as a subject to test the mettle of the young artists in his care. Ugo Viviani published a letter written by Redi in December 1679 to his brother, Giovanni Battista Redi, in Arezzo, in which he gives detailed instructions as to the disposition of three portraits which he had just sent by coach.

> In that wagon which took the first pictures, I have sent to you another bundle with another three pictures, three of my portraits, wrapped in the same carpets. For these three portraits, look behind the painting, where there is written the name of the painter who made it: that made by Gabbiani, you should

put in [our villa of] the Orti, that made by Bimbacci, you should have the ornament gilt and then send it on my behalf to Sig. Giannerini [Redi's agent in Arezzo]. The third, made by Marmi, give to Sig. Diego [another brother].[20]

We find here that Redi has come into the possession of three portraits of himself. All three of these portraits are the work of untried artists who were recent alumni of the Grand Duke's academy in Rome. Anton Domenico Gabbiani and Atanasio Bimbacci had been two-thirds of the original delegation sent by Cosimo to Rome in 1673 to study with Ciro Ferri, the painter, and Ercole Ferrata, the sculptor. Bimbacci returned home ill in 1675, and eventually became a specialist in landscape murals. Gabbiani proved to be a real talent, and became the leading painter in Florence by the turn of the century. His is the only picture that Redi elects to keep, even if only in his rarely visited family seat. Little is known of Giovanni Battista Marmi, who died young in 1686. His father, Diacinto Marmi, was an architect who often asked Redi's intercession with the Grand Duke.[21] None of these paintings are identified today.

A few words on the physical appearance of our subject are undoubtedly in order. He was not handsome: by his own admission, his most distinguishing trait was his extraordinary thinness. His friend Count Lorenzo Magalotti described him in 1682 as "an Aretine, who looks like the portrait of Hunger."[22] In every surviving image of Redi, he is seen wearing a tall wig of the most ceremonial stripe. In his letters, he refers contentedly to his own hypochondria. In cool weather Redi must have been an incongruous sight in the streets of Florence, as can be inferred from the satirical self-portrait contained within the soliloquy delivered by Bacchus in his *Bacchus in Tuscany.*[23]

> *And when the sky is snowy*
> *I have no fear of the chill,*
> *Nor do I ever wrap myself in*
> *Muffler and cloak,*
> *As does always,*
> *From his handsome wig*
> *Down to his feet,*
> *The wiry and shivering Redi*

Surely he presented a challenge to the idealizing tendencies of later seventeenth-century portraiture, which reveals the theory no doubt behind Cosimo III's use of Redi as his test case for aspirant portraitists. Baldinucci confirms this pattern in his 1681 account of how Tempesti came to engrave Redi's portrait. A native of Fiesole, Tempesti had been sent by Cosimo to France in 1676 to learn the fancy style of the portrait engraver Robert Nanteuil. Shortly after Nanteuil's death in 1678, Tempesti returned to his own country

Fig. 5 **Massimiliano Soldani-Benzi,** *Portrait Medal of Francesco Redi.* Michael Hall, New York.

Fig. 6 **Massimiliano Soldani-Benzi,** *Portrait Medal of Francesco Redi* (verso with *Bacchus in Tuscany*). Michael Hall, New York.

where he was received by Cosimo III [and] was immediately charged to make works relative to his art. [The Duke] wished that the first item from his burin should be the portrait of the erudite doctor Francesco Redi, nobleman of Arezzo, his first physician, of whom there have been many occasions to make mention in these writings, who, as I write these things, in all his glory and benefaction to Florentine literature, most worthily [etc.].[24]

When Soldani-Benzi returned from his apprenticeships in Rome and France (1682), he had fully grown into his capabilities. Already in 1681 Cosimo III had been compelled to extract his charge from the grasp of Queen Christina of Sweden, who had resolved to use Soldani for a series of medals dedicated to the subject of herself (*cf.* Exh. no. 66). The Grand Duke immediately committed the artist to cutting dies for a new minting of silver coins; these are dated 1684.[25] The same date appears on Soldani's portrait of Francesco Redi of which he cast medals with three different reverses in recognition of the sitter's equal distinction in Philosophy, Medicine, and Poetry (Fig. 5). (*cf.* Exh. no. 64, the specimen of Philosophy.) Soldani's composition in honor of Redi's poetry illustrates a moment from the author's masterpiece, *Bacchus in Tuscany:* amidst a throng of cavorting maenads, the narrator stands, just barely, with his thyrsus in one hand and his bowl in the other (Fig. 6). Over the ensuing four decades, Soldani personally directed a Florentine renaissance of the art of casting medals. The

medal of Redi with its three reverses which initiated this period is his most famous work in this field. It was necessary to cast additional examples in 1690 and 1696 in order to meet the demand of collectors throughout Europe.[26]

The chief distributor of these medals was Redi. His letters are filled with references to his gifts of various examples "with different reverses" to his many correspondents. He also received many requests for his medals from dignitaries whom he had never met. In 1691 he began to make notes in his account book of such disbursements, because he could not remember anymore to whom he had given his medals or how many. Between 1685 and 1696 Francesco Redi personally gave away more than seventy-nine casts of his medal (not to mention a good number of the Tempesti engravings) to friends, collectors, and visitors. The last entry but one in Redi's *ricordi* concerns Soldani's delivery of twenty-six more medals with the three different reverses. For his memory's sake he notes, "I put them in the large white chest."

From the copious documentation concerning Redi's practice in this wise, it becomes clear that the seventeenth-century man of accomplishment regarded portrait medals and engravings in much the same way that our own time looks at autographed copies of books. Everyone then as now was pleased to be remembered by a presentation copy, and books (as well as medals) have an intrinsic value. The earliest reference in print to the Redi medals occurs in a letter of April 4, 1685, in which our subject writes to Mons.

Spon, a leading publisher in Lyons, "in the same package I shall include some of my portraits, as per your request; I shall also enclose some of those medals of mine which the *Serenissimo* Grand Duke, my Lord, had made by Soldani."[27] Three years later Redi's correspondence with Giuseppe Valletta, a Neapolitan, who had requested his assistance in obtaining items for his collection, contains the following remark about his portraits. "In this parcel of books I have placed two of my portraits [evidently prints] so that I shall always be in your presence, if not in person, at least in my image. I am going to include also some medals for the service of your museum."[28] Towards the end of 1690 he was obliged to request the patience in this regard of his Ferrarese friend Giuseppe Lanzoni: "As for my medals, I am not sending any, because I do not have any. In recent months I have sent many of them to friends in France, as in Holland. I expect to have more medals soon."[29]

Redi, of course, was himself an avid collector of medals. To one of his correspondents in France he wrote as an adjunct to his habitual request for books his desire to have as many medals as could be found of *Virtuosi moderni, ... Capitani e Principi ...* And don't pay any attention to the expense, you know my nature."[30] Even so, there seems to have been an etiquette to the sending of unsolicited medals. In 1695 Redi received from Ippolito Fornasario, an abbot in Bologna, a cast of the latter's portrait medal.[31] In his *ricordo* at that time, he coolly notes that this person had made a gift to him of one of his medals but had not written an accompanying letter. Five months later, Redi replied to Fornasario with a note of thanks, pledging his eternal devotion and so forth, without reciprocating with a medal of his own.[32] On another occasion, Redi annoyed the misanthropic Antonio Magliabecchi, deliberately it seems, when he forgot to send some of his medals to one of the latter's acquaintances in Venice.[33]

The installation of this exhibition is presided over by a marble bust of Francesco Redi in his monumental wig (Exh. no. 46). The authority in the study of Florentine sculpture, Klaus Lankheit, has attributed his work to Antonio Montauti, who worked for Cosimo III in the second decade of the next century prior to transferring to Rome. It is tempting, however, to hold out hope that future research will discover some relation between this sculpture and one or possibly two documented commissions from Giovanni Battista Foggini, sculptor to the Grand Duke, for portrait busts of our subject observed from life. Both of these works were executed during the 1690's, and both are untraced today.

In 1692 Lorenzo Bellini conceived of a plan in cooperation with Foggini to create in his house a gallery of marble

busts of twelve famous scholars and *virtuosi* of the day (including himself and Foggini), all of whom were friends or kindred spirits.[34] Galileo, Marcello Malpighi, Vincenzo Viviani and Redi were to be portrayed. (Bellini was Redi's student, as well as successor as physician to the Grand Duke.) In two letters that have come down to us, Bellini describes this project to Malpighi. The busts were to be arranged in four triads in an architectural setting. Bellini had a personal motivation, apart from the venerable Florentine tradition of such portrait collections, which was that his eyesight was failing. Through the sense of touch he hoped to keep his confreres' images distinct in his mind's eye.

Prior to Bellini's death in 1703, Foggini completed seven of these busts. The series was bequeathed intact to Senator Pandolfo Pandolfini, who engaged Foggini to sculpt additional portraits for the group. We know from a contemporary description of the group that the portrait of Francesco Redi was among those executed during Bellini's lifetime.[35] In 1971, Klaus Lankheit published photographs from a private collection of six of the original busts and one of the works contributed by Pandolfini. Only the bust of Redi has yet to be identified. There is little to add to Lankheit's comprehensive account of this commission, save for a note on its chronology. In the absence of documentation for Foggini's commitment to these sculptures, Lankheit proposed a general dating for the six busts in the first group of ca. 1700. As noted above, Redi's published *ricordi* contain Foggini documentation which has not hitherto come to the attention of art historians. On November 18, 1693, eleven months following Bellini's second letter to Malpighi, Redi was visited at home by "Sig. Foggini, the sculptor, who is making my portrait in marble." Evidently the series of "famous men" had been immediately set into motion.

It is significant that this memorandum of 1693 does not suggest that Redi was obligated to compensate Foggini. As a result, and in consideration of the passage of time, it is reasonable to conclude that this first encounter between sculptor and sitter was related to the Bellini commission and not to the commission described by Redi in his accounts for March 1695. To wit, "Sig. Giovanni Battista Foggini, sculptor of the *sereniss.mo* Grand Duke, made my portrait in marble, so that I could send it to Arezzo to my Villa degli Orti. Today Foggini came here to the house, and I gave him forty scudi for which he made me a receipt." Two months later Redi noted that his bust by Foggini had safely arrived at his Villa in Arezzo. According to Ugo Viviani, Redi's devoted biographer in the early twentieth century, this bust stood on a pedestal in the

atrium of the Villa Redi degli Orti until the 1920's, when it was replaced by a stucco copy.[36]

As Redi's life approached its end, he was increasingly disabled by ill health, but he was not forgotten. In January of 1695 he received at Court the happy news that the literary society of his native Arezzo, the Fraternità dei Laici, had resolved to place a portrait of him in their library alongside their portraits of other distinguished sons of Arezzo.[37] Redi responded with his gratitude and commissioned Pietro Dandini to paint this portrait, which was finished by May of the same year.[38] Dandini declined to accept money for this assignment (as happened frequently in these negotiations between gentlemen), so Redi made him a gift of a silver glove-box and some pairs of gloves made in Rome. His notation of this expenditure makes the valuable observation that Dandini's picture was a copy of his portrait from the hand of Sustermans.[39] Evidently he saw no reason why his public representation should be of his appearance in his old age. The portrait is still on view in the library of the Fraternità dei Laici in Arezzo.[40]

In August, 1699, a memorial service was held in Florence for the late Francesco Redi. The principal elegy was delivered by Anton Maria Salvini, whose oration invokes the portraits of Redi and thereby touches on the ramifications for sitter and donor (but not artist) that were implied in the seventeenth century by the creation of a portrait. The admiration that Redi's native city has shown towards him was singled out by Salvini to the eternal credit of Arezzo. Salvini's words may be quoted by way of conclusion for this essay:

> So great was Francesco Redi, that you (Arezzo) did not wait until his death, rather it was during his lifetime that you placed his portrait in the public hall amongst the most famous of your noble citizens. In this way you were imitating the glorious example of your sovereign and ours who during Redi's life caused three excellent medals to be imprinted with ingenious reverses alluding to the three faculties, Philosophy, Medicine, and Poetry, that Redi possessed to an exalted degree. The Duke caused these medals to go swiftly throughout the world: noble, singular, eternal signs of his esteem for the great men of letters, which quality he received as an inheritance from his glorious elders.[41]

1) Langedijk, 1981, I, 49.
2) ibid., 1981, I, and 1983, II.
3) ibid., 1981, I, 65.
4) Baldinucci, F., ed. 1975, V, 503-4.
5) The Haelwegh portrait was bound in several Florentine publications by Redi. Viviani, 1928, part 1, pl. 4, cites only the *Bacco in Toscana*, 1685. However, it appears earlier in the *Osservazioni intorno agli Animali Viventi...*, 1684, and first in the *Lettera intorno ... occhiali*, 1678. The Cole Collection of the library of the New York Academy of Medicine contains all of Redi's publications in virtually every edition; in working with this material several eighteenth-century additions to the Redi iconography compiled by Viviani, 1928, part 1, were observed.
6) Viviani, 1928, part 1, 91-95.
7) Redi, 1909, 11.
8) A useful, if excessively jocular, account of this epoch in Florentine science can be found in Cochrane, 1973, 165-246, *passim*.
9) The *Vacchetta* or *Libro di Ricordi* of Redi were published in full by Viviani, 1931, part 3. The entries are chronological, and where the date is given in this text a separate footnote has been deemed superfluous.
10) Viviani, 1928, part 1, *passim* is my principal source for Redi's biography. Viviani's account is based on careful reading of the documents, especially the *ricordi* and the published correspondence. The standard edition for Redi's letters is the *Opere omnia* published in Milan [Classici], 1811. The lengthiest biographies in English are the Introduction by M. Bigelow to Redi, 1909, and Cole, 1926, 347-359.
11) *cf.* two amusing letters in Redi, 1811, VI, 86-87; VII, 214-15.
12) Cochrane, 1973, 251-52, devotes two pages to Redi's dialectics.
13) This anecdote is frequently told. See Goldberg, 1983, 231 for its sources. *cf.* Rudolf, 1973, 214, 223.
14) Not to mention helminthology.
15) Redi, 1811, V, 81.
16) Langedijk, 1981, I, 213. *cf.*, for example, Haelwegh's Cosimo III, no. 29, 31-a.
17) The word *segnio* in this context recalls its usage in the sense of a zodiacal sign.
18) Langedijk, 1981, I, 202.
19) For illustration, *ibid.*, no. 29, 117 rev.
20) Viviani, 1928, part 1, 87
21) *cf.* Redi, 1811, VI, 264, 270-74, 301-3. The only source for G.B. Marmi (1659 - 1686) is the biography by F.M.N. Gaburri; see Lankheit, 1962, Doc. 23.
22) Viviani, 1928, part I, 6, cites Magalotti's letter of February 6, 1682.
23) The only English translation of Redi's poem is an unsatisfactory attempt in verse by Leigh Hunt, London, 1825.
24) Baldinucci, F., ed. 1975, V, 298-299.
25) Lankheit in Detroit, 1974, nos. 85b-c.
26) As indicated in the text below, Redi (1811, IV, 440-41) wrote to Giuseppe Lanzoni in October 1690 that he had no medals on hand, but that he hoped to have more soon ("Io spero contuttociò fra qualche poco di tempo di averne"). In his *ricordi* for October 1696 Redi notes that Soldani has delivered 26 more medals for which he was paid. It is my assumption that Soldani cast additional medals on both of these occasions.
27) Redi, 1811, VIII, 161.
28) *ibid.*, V, 306-7.
29) *ibid.*, IV, 440-41.
30) Letter of 1670 in *ibid.*, VI, 81-2.
31) Fornasario's medal is illustrated in Norris & Weber, 1976, no. 104.
32) Redi, 1811, VIII, 216.
33) *ibid.*, VII, 237. Redi and Magliabecchi were not friends, as can be deduced from the constrained tone of their correspondence.
34) See Lankheit, 1971, 22-39, for the documentation and illustrations.
35) F.S. Baldinucci in Lankheit, 1962, 235.
36) Viviani, 1928, part 1, 90; part 2, Tav. VI (an illegible photograph).
37) *ibid.*, part 1, 91-95; part 2, Tav. IV.
38) *Ricordo* of May 27, 1695 in *ibid.*, 1931, part 3.
39) *Ricordo* of December 30, 1695 in *ibid.*, 1931, part 3.
40) *ibid.*, 1928, part 2, Tav. IV.
41) Redi, 1809, I, p. XLI.

# Notes on Baroque Portraits of Counter-Reformation Saints

Since 1556 a very particular portrait of Ignatius of Loyola has occupied a place of honor in the private office of the General of the Jesuit Order in Rome. The painting is from the hand of Jacopino del Conte, one of the leading artists in Rome in the mid-sixteenth century. On the reverse of the canvas a lengthy inscription records the circumstances surrounding the execution of this portrait:

> True effigy of the Blessed Father Ignazio Founder and first General of the company of Jesus made by Giacobino del Conte, excellent painter of those times, on the same day that the Blessed rendered his holy soul to God, the last day of July 1556, at the age of 65 years.[1]

It is clear that this information was set down at some remove from the execution of the painting but prior to 1622, the year in which Ignatius was canonized as a saint in the Roman Catholic church.[2] In fact, the care taken to substantiate that this portrait is an authentic likeness, a *vera effigies,* suggests a connection between the inscription and the Jesuits' campaign for the canonization of Ignatius, which began in earnest after the first general congregation of the order in 1593 - 94. If this were the case, the inscription of these lines could be understood in the sense of the labelling of an exhibit in a judicial action; such was the character of the formal process of appeal for canonization during the seventeenth century. As one requirement among many in the process of canonization, the presentation of a *vera effigies* was as important as the authentification of the relics of the holy one.[3]

At the death of Ignatius on July 31, 1556, his successors in the Order were struck by the realization that no portrait of their Founder existed.[4] Laínez,, the General at that time, was ill and the Secretary, Juan de Polanco, was in charge. Polanco acted at once. In the following week, on August 6th, he already refers in a letter to "some portraits in painting and of the face."[5] Among these must have been the painting by Jacopino del Conte; the "portrait of the face" refers to the death mask that was made. Both works became a *vera effigies* — one painted, one sculptured — and the two bases for the innumerable representations of St. Ignatius which have come into existence since his death and canonization.[6]

Nevertheless, the Jesuits were not complacent about this issue. In December of 1600, about the time that we suppose the inscription was placed on the back of del Conte's painting, the Jesuit Manares wrote to the then General of the Society of Jesus, Claudio Aquaviva, with regard to this matter of the true likeness.[7] Manares reports that two portraits of Ignatius, drawn from the image in the General's chambers, had been sent to Brussels. Among the Jesuits in Brussels there were living still some fathers who had known Ignatius in his lifetime. These authorities were asked to regard the portraits from Rome in order to ascertain the quality of the likeness and to offer suggestions for improvement. A Flemish artist was duly commissioned to execute a portrait with the guidance of the fathers, and said portrait was dispatched to Rome (where, however, it never displaced del Conte's picture).[8]

These events have been outlined in order to illustrate one of the most distinctive aspects of Italian Baroque art, namely the convergence of portraiture and sacred images. This development was inevitable on two accounts. In the realm of art, naturalistic observation was one of the bases of the emergent Baroque style. In contemporary Roman Catholicism, the intense reaction against the Protestant Reformation during the sixteenth century had manifested itself in world-wide missionary work and often in martyrdom, in the founding of charitable and monastic orders, and in the dedication of countless individual lives to religious observance and self-sacrifice. This period in the history of the Roman Church is known as the Counter-Reformation. As Emile Mâle pointed out in his landmark study of the influence of the Counter-Reformation on seventeenth-century art, the Protestant denial of the role of saints as intercessors had provoked the Roman Church into its customary response to such challenges: the cult of the saints was therefore exalted.[9]

Between 1523 and 1582 no saints had been canonized. This pattern began to be reversed during the papacy of Clement VIII. However, following the extraordinarily rapid proceedings in the canonization of Carlo Borromeo by Paul V in 1610, the rolls of the saints experienced an expansion as has never been seen before or since. The imperious cardinal archbishop of Milan, Carlo Borromeo had died less than thirty years before, in 1584. Fifty-three saints were canonized between 1610 and 1746, in comparison to fifteen canonizations during the previous two centuries. In March of 1622, Ignatius of Loyola and Francis Xavier, both Jesuits, were canonized on the same day, along with Isidoro Agricola, Teresa of Avila, and Philip Neri. Save for St. Isidoro, this party of new saints predicted the canonizations that would occur into the next century, being composed of mystics, missionaries, and founders of orders who had waged the holy war of the Counter-Reformation.

Beyond their numbers, the advent of the Counter-Reformation saints posed an unprecedented situation for artists. Unlike the Apostles and the early Christian martyrs, the personalities of these saints were not wrapped in the obscuring shroud of time. They had only recently departed this earth; their features and personal qualities

were recorded in chronicles, portraits, and even in living memories. With regard to portrait statues of saints, Keutner has succinctly differentiated Renaissance practice from the attitudes that were demanded of Baroque artists. In the sixteenth century, the foremost sculptors saw themselves as primarily challenged by the esthetic precedent of antique sculptures, the forms of which they emulated to the greatest possible extent.

> The seventeenth century masters were virtually compelled to be accurate in reproducing the costume or clothing and the relevant physiognomy whenever statues of modern saints were called for: notably those of the Counter-Reformation, whose ecclesiatical appointments and orders were still common knowledge and whose likenesses had been incontrovertibly established by paintings or death masks. Statues of this type include St. Ignatius by Montañes, St. Philip Neri by Algardi, St. Teresa by de Mora. These are literally portraits of saints, whose sanctity is meely implied by means of geneal gestures and attitudes of rapture and devotion.[10]

The insistence on portrait-like fidelity in the portraiture of saints was subject to firmly held (and not unreasonable) views on artistic decorum. Artists were expected to conform to pictorial tradition and to be aware of the best sources that were available regarding the costume and appearance of earlier saints as well. For most seventeenth-century writers on art, and for some disappointed patrons, it seems that the objections against the paintings by Caravaggio lay in the artist's perverse flouting of decorum and not in his naturalistic style *per se*.[11] The story was told that the features of the Virgin in Caravaggio's painting *Death of the Virgin* (Paris, Louvre) were modelled after those of a contemporary courtesan. Exactly this sort of impropriety — probably this very episode — was condemned by Cardinal Federico Borromeo in his *De Pictura Sacra* ("On Sacred Painting") of 1624: "While we praise the usage of portraiture from life, we must reprove those artists who put the faces and aspects of persons of irrepute on the images of Saints.... I fervidly exhort artists not to portray anyone from life who is not of upstanding reputation."[12]

In the same work of art criticism, Cardinal Borromeo praised the custom of the ancients, who painted the portraits of distinguished men during their lifetimes. He regretted the dearth of portraits of St. Carlo Borromeo taken from life. In view of our familiarity with St. Carlo Borromeo's distinctive pate and proboscis as represented in countless early seventeenth-century paintings, it is surprising that to the best of the knowledge of Cardinal Borromeo, the saint's nephew, only one portrait existed that could be considered a *vera effigies*. The painting in question is attributed today to Ambrogio Figino. It is a simple profile of the saint, and is conserved in the Pinacoteca Ambrosiana, Milan, to which it was given in 1618 by Cardinal Borromeo himself.[13]

The example of portraiture in antiquity was invoked in *De Pictura Sacra* in order to provoke seventeenth-century artists into this noble practice. In the course of these admonitions, Cardinal Borromeo touched on another theme of interest to our present study: the contemporary demand for portraits of the saints of the Counter-Reformation.

> We have recorded these facts so as to inspire painters not to lose the images of those persons who are famous for their civic skills or military bravura or for saintly reputation or for literary glory. It would be suitable in fact if the best artists competed amongst themselves in the conservation of such images and not be so dedicated to personal gain instead of public service and exalted spirit.... In fact to name only one case, that of St. Carlo, will suffice to prove how useful and even gainful such a practice would be. I believe that a huge sum of money has been spent in the painting of infinite images of him since his death. While he was living among us, there was hardly anyone who thought to portray from life the features of the Holy Pastor.[14]

St. Carlo Borromeo and his ostensible attitude towards portraiture are the subjects of a curious anecdote recounted in a seventeenth-century dissertation on artistic decorum. The joint authors of this *Treatise on Painting and Sculpture, Their Use and their Abuse*, published in a single edition in Florence in 1652, were Gio. Domenico Ottonelli, a Jesuit, and Pietro da Cortona, the painter.[15] The authors write in defense of portraits of illustrious men, and with happy indifference to chronology, they describe the embarrassment felt at first by Carlo Borromeo when a great man of the time ("un gran personaggio") indicated his desire to have a portrait of the cardinal. A friend revealed to Carlo that if he refused this honest request it would be taken as a sign of haughtiness. Borromeo thereupon dispatched this dilemma in an ingenious manner: he commissioned the great painter Perino del Vaga to paint his portrait, which represented him in the exemplary act of meditating on morality. Although illuminating as a contemporary justification for the portraiture of holy men — Ignatius's modesty had forbidden it, after all — it is difficult to reconcile this story with the fact that Carlo Borromeo was nine years old when Perino del Vaga died in 1547.

St. Philip Neri (1515 - 1595), the beloved "Apostle of Rome" and a man of perfect humility, was evidently not disturbed by the proliferation of his portraits during his lifetime. During the hearings held in 1609 - 10 as part of the canonization process, the demand for portraits of Neri was

invoked by witness after witness as proof of the veneration of the Roman populace towards his sanctity. A number of these statements were culled from the depositions published by G. Incisa della Rocchetta and examined in a recent iconographical study by Elena Parma Armani.[16] For example, "I know for certain that while the blessed Filippo was alive, many portraits were made of him as of a person renowned for his sanctity." Another witness added, "...and many more have been made after his death." In a contemporary diary of the posthumous honors paid to Neri, which led ultimately to his canonization, it is noted that "the same day that Filippo Neri ascended into heaven his portraits were seen being sold in public for the devotion of the people." About a month after the death of the founder of their order, the Oratorians commissioned a portrait print of Philip Neri; within a few months, 950 impressions of this print had been distributed.

This exhibition includes six portrait sculptures of four Counter-Reformation saints. In order of canonization they are St. Carlo Borromeo (1610), St. Ignatius Loyola (1622), St. Philip Neri (1622), and Pope St. Pius V (beatified 1672, canonized 1712) (Exh. nos. 5, 1, 2 and 4, 55 and 61). By coincidence, the relief plaque of St. Ignatius and the two portrait heads of St. Philip Neri are all bronze casts after designs by Alessandro Algardi. They are also works of unusual significance to the cults of these saints, since they are related to commissions executed by Algardi for the principal churches of the orders founded by these two men: The Gesù of the Jesuits and the Chiesa Nuova[17] of the Oratorians, Rome. The individual histories of each of these three sculptures are set forth in the catalogue entries. Here these works will be discussed as examples of three different interpretations by a single artist of the possibilities inherent in a portrait of a saint.

The life-size portrait head of St. Philip Neri in the collection at Providence is the sole work among this trio for which the casting may have been overseen by Algardi himself. The work is dated 1640 in the cast, which means that its design at least was contemporary with the triumphant unveiling in the sacristy chapel in the Chiesa Nuova of Algardi's monumental statuary group of *St. Philip Neri and the Angel.* Jennifer Montagu has established a date of ca. 1635 - 38 for the execution of the Chiesa Nuova statues.[18] The second portrait of Philip Neri in this exhibition is, in fact, a reduction in bronze modelled after the head of the Chiesa Nuova marble (Exh. no. 4). Notwithstanding its fine craftsmanship, there is little indication to conclude that Algardi was himself responsible for the modelling of this small work. Nonetheless, this bronze sensitively conveys the expression of Algardi's portrait in marble and can be taken as an eloquent surrogate in our exhibition for the immovable original.

This diminutive head of St. Philip characterizes the saint in a moment of spiritual enrapture; the glance and movement of the head evoke the subject's communion with Heaven. Antonia Nava Cellini has already remarked of Algardi's prototype in Chiesa Nuova that "the sculptor has sought a particular drama in the St. Philip Neri, which can be considered a portrait."[19] V. Golzio addresses in similar terms the question of posthumous portraiture in relation to Algardi's statue. "Therefore we must consider it an idealized portrait, but even if it is idealized, it does not cease to be a portrait due to the powerful individuality which emanates from it, neither can it be excluded that the sculptor availed himself of portraits from life and perhaps even of death masks."[20] Montagu has commented more specifically on Algardi's fastidious research into Philip Neri's appearance: "In his image of the Saint Algardi followed the well-known death-mask, either one of the available casts, or the silver mask which Tomasso Contini had derived from it [1603] to cover the face of the saint's body. What remained to be done was to charge the features with life, to alter the angle and expression (the expression depending to a remarkable extent upon the angle)...."[21] The serenity, nobility, and dignity of the Chiesa Nuova sculpture have been compared by Golzio and others to the style of the Bolognese school of painting. In fact, even prior to the canonization of St. Philip Neri, the Oratorians had decorated their church with a magnificent portrait of him, ca. 1614, by Guido Reni.

In contrast to the monumental conception of the Chiesa Nuova marble, the bronze head of 1640 is pensive and subdued in its characterization. Nava Cellini writes of its "pathos."[22] The pose is frontal, the gaze inward and impenetrable to precise interpretation. Algardi here makes full use of the potential for surface detail in the medium of bronze casting: the skin appears to be thin and taut over the cheek bones; the saint's age is evident in the creases under the eyes. In all, this portrait represents Algardi's transformation of the death mask into a work of art through hardly more than the suggestion of texture. Whereas the Chiesa Nuova marble and its bronze reduction in this exhibition are images of religious inspiration, the 1640 portrait of St. Philip evokes mortality in the manner of a *memento mori.*

Is it through chance that the principal images in the iconography of St. Philip Neri, to wit the painted and sculptured portraits in the Chiesa Nuova by Guido Reni and Alessandro Algardi, are majestic works of art, while the sources for the iconography of St. Ignatius Loyola have the character of historical documents? The earliest portraits of Ignatius were scrupulous in their replication of either del Conte's model or the death mask; thus the tradition of their

inviolable authority as *ur*-images was established and was never challenged by later interpretations of the saint's features, although it was augmented of necessity by Rubens's portrait of St. Ignatius in full-length. The contemporary portrait prints of St. Philip Neri, on the other hand, exerted negligible artistic influence after the decisive interventions of Reni and Algardi.[23] Reni's painting was the model, in fact, for the portrait of St. Philip which appears on the engraving issued in 1622 in commemoration of the five simultaneous canonizations.[24] Algardi's statue in the Chiesa Nuova likewise eliminated the motivation for subsequent artists to refer to the saint's death mask.

A provocative example of Algardi's influence — a subject which could fill a monograph — is provided by an altarpiece painted by Carlo Maratti in the early 1670's.[25] If we look closely at one of Maratti's preparatory drawings (Fig. 7) for the painting in the church of San Domenico in Pescia, we can observe that a studio assistant posed in priestly vestments for the reference of the artist, who sketched at upper right his conception of the head of St. Philip Neri as it would be portrayed in the canvas. In the opinion of this writer, the sculptural qualities of this little sketch, that is to say its emphatic modelling in the round, the projection of the solid mass of the beard forward of the neck, and so forth, are not solely attributable to Maratti's prowess as a draftsman. One gets the irradicable impression that Maratti was holding in one hand a portrait head of St. Philip, a cast after Algardi such as we have discussed above, while he drew with his pen in the other.

At some point prior to July, 1637, when the remains of St. Ignatius were placed in an urn under the altar dedicated to the saint in the Gesù, Alessandro Algardi executed the bronze relief that ornaments the side[26] of that urn. One of two closely related casts of this relief is in the collection of the Metropolitan Museum and has been lent to the present exhibition (Exh. no. 1). It is not possible to date the Metropolitan Museum cast more specifically than to the same century. The prototype in the Gesù must have been designed concurrently or only a year or two earlier than Algardi's statue of *St. Philip Neri and the Angel* in the Chiesa Nuova. The works could not be more dissimilar if they had been executed by different artists.

It merits recalling that the attribution to Algardi of the St. Ignatius urn dates back to Pascoli in the early eighteenth century. Bellori, notably, does not mention this assignment in his 1686 biography of Algardi. The relief was described as recently as 1954 as presenting "clearly eighteenth century qualities unlike the art of Algardi," but Heimbürger Ravalli and Montagu in their catalogues of Algardi's sculptures strongly uphold the attribution to him.[27] Finally, Algardi's responsibility for the design has been

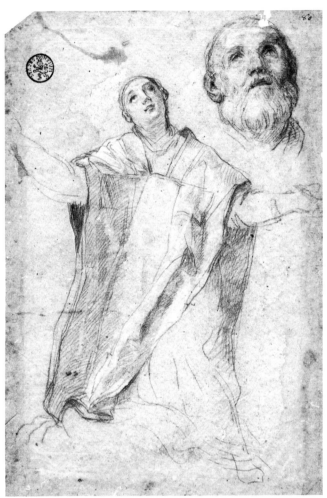

Fig. 7    **Carlo Maratti,** *Study for a Painting of St. Philip Neri.* Stuttgart.

proved incontrovertibly by Neumann's publication of Algardi's preparatory drawing in the Hermitage, Leningrad.[28] However, Neumann's arguments that the relief on the urn was only cast in 1735 are unpersuasive. Furthermore, Neumann's lengthy explication of the iconography of the relief is confounded by his misidentification of the figure of St. Ignatius Loyola as St. Francis Xavier (and vice versa).[29]

That Algardi's relief has been the object of such an odd critical history is a result of its own peculiarities of design. The most descriptive title for this work would be *St. Ignatius of Loyola and Saints and Martyrs of the Society of Jesus*, in deference to the artist's arrangement of nine major figures and many lesser actors in a sort of frieze. The figure of St. Ignatius of Loyola, the founder of the Order, whose reliquary urn in fact this relief was intended to decorate, is given no compositional emphasis other than its central position. Commenting on this with some amazement, Heimbürger Ravalli writes, "Calm, almost immo-

bile, each one of the figures assumes an individual pose. The continuous repetition of static figures confers a certain monotony to the representation, which is not relieved very much by the accents provided by the subdivision of the figure into groups."[30] Nor does Algardi display any of his customary ingenuity in the illusion of depth receding into space.

Since Algardi's genius for the modelling of figures in relief is a matter of historical record, we must look elsewhere for an explanation of the relative artlessness in this relief for the St. Ignatius urn. If we consider the work from the point of view of its thematic content, then the insistent equilibrium of its design becomes an aspect of the meaning of the work. Actually, the composition is structured as an allegory on several levels of the history and abiding concerns of the Society of Jesus.

Where attributes are provided, the identifications of the personages in this relief are straightforward (cf. Exh. no. 1). The two kneeling acolytes (the Blessed Aloysius Gonzaga at left, the Blessed Stanislas Kostka at right) comprise the ends of the essentially rectangular arrangement of six principal figures. St. Ignatius and St. Francis Xavier, grasping his tunic, are paired in the center as they were in countless double portraits propagated by the order. In the background, three crosses and lances are references to the three Jesuits martyred in Japan in 1597.

Neumann is the only writer to have postulated allegorical content in Algardi's relief.[31] In his view, Algardi placed the Jesuit missionaries in the right half of the composition and the spiritual theorists in the other half. In large part, Neumann was misled by his dependence upon Algardi's preparatory drawing, which similarly represents the actors in a planar scheme, but grouped entirely differently. In the drawing, one of the Japanese martyrs occupies with his cross most of the right foreground, and other missionaries stand in close proximity. Algardi was inspired by recent developments in affording such prominence to the missionaries. In August of 1627 Pope Urban VIII had recognized the twenty-six martyrs of Japan, including three Jesuits.[32] On the first Feast Day to be celebrated for the Japanese Martyrs, February 4, 1628, the Gesù was bedecked with fabrics and candles and a new painting by Cavalier d'Arpino of the *Three Jesuit Martyrs of Japan* was displayed over the High Altar.[33]

At this point in the creative process we must assume that Algardi received some guidance in the form of suggested content. The disorderly "group protrait" of the preparatory drawing does not anticipate the completeness of the program as realized. In the relief, the outstanding personages of the Society are not merely present and accounted

for, they are portrayed in archetypal actions which are meant to symbolize the multiple functions of the Society itself. At left, Cardinal Roberto Bellarmino guides the Blessed Aloysius Gonzaga, as he did in life, in his catechism. St. Francis Xavier, the Apostle to the Indies, personifies the world-wide missions of the Jesuits. St. Ignatius also looks heavenward for inspiration; his gesture is one of intercession for this collected body. To the immediate right of Ignatius, Francis Borgia, third General of the Order, fulfills his duty as a priest as he administers the chalice for the Blessed Stanislas, who entered the novitiate during Borgia's tenure. It is notable in this connection that a painting of *Francis Borgia in Adoration of the Holy Sacrament* by Anteveduto Grammatica was on view in the Gesù until at least 1642.[34] Finally, the pair of figures at the far right are engaged in an act of education: one Jesuit uses a painting of the Madonna and Child in order to teach the Christian story to an eager listener.

Indeed, education appears to have been the assignment that Algardi received from the Jesuits. Charged with the representation of a crowded iconographical program, it is no wonder that Algardi dispensed with artistry in this sculpture. He had good reason to assume that his patrons prized legibility above all else. The Jesuits had already attracted attention to themselves for the explicit renderings of martyrdom with which the painter Niccolò Circignani had embellished the walls of their novitiate churches. G.P. Bellori noted in the margin of his copy of Baglione's artists' biographies, 1642, that Circignani had two manners: the ordinary he used for Jesuit colleges, the good style for other commissions. (Bellori then crossed out this note and concluded that in both styles Circignani was a bad painter).[35]

The question, "Can we identify Jesuit style in art?", has occupied for some time many of the leading scholars of this period. The current consensus holds that the answer is negative. For example, it has been amply demonstrated by Haskell especially that the choice of artists for the decoration of the Gesù and of the new church of St. Ignazio could not be determined by the Jesuits unilaterally but were subject to the interests of the patrons who held the purse strings. Freedberg pointed out that the artists employed in the original decorations of the Gesù were alike only in their unqualified diversity; he states that the role played by the Jesuits in the art of the late sixteenth century was unspecific but profound in the sense that the Society was greatly responsible for the Counter-Reformational climate which gave rise to that art. Abromson has recently taken exception, however, to Freedberg's observation that Girolamo Muziano's and Scipione Pulzone's paintings for the Gesù are indistinguishable in style from their works for

berg Glyptotek, Copenhagen, and the Musée Jacquemart-André, Paris, it is a safe assumption that this carefully matched pair was exhibited together in the Palazzo Borghese. Scipione Borghese doubtless wished to have a memorial of the Pope who had made his fortune, and he thought it prudent besides to show his respect for the new order.

It was the Barberini Pope, Urban VIII (1623-44), who provided Bernini with the opportunity, with himself as subject, to elevate the papal portrait bust to the quintessential sculpture form of the seventeenth century. Over the two decades of this frenetic papacy, Bernini sculpted at least nine busts of Urban VIII, as well as portraits of the pope's mother, father, uncles, brothers, and nephews. From the vivid accounts of visitors, we learn that for the duration of the century a forest of pedestals crowded the galleries of the Palazzo Barberini.[3] These Barberini portraits might be profitably studied as a sort of series, but make no mistake, there is only one Pope represented in it.

In reaction against Urban VIII's monopolization of Bernini, the succeeding pope Innocent X Pamphili initially turned to Alessandro Algardi for authorized interpretations of his image and of his court. Four busts of Innocent X are today commonly accepted by scholars as autograph works by Algardi. Three of these busts are still found in the Palazzo Doria-Pamphili in Rome. They represent the gamut of possibilities as regards monumental sculpture: marble, bronze, and bronze and porphyry (with contrasting head and torso). Rudolf Wittkower deserves the credit for recognizing the hand of Bernini in two other marble busts of Innocent X in the Doria-Pamphili collection. A fourth bust of this pope by Algardi, in terracotta, was discovered in the Palazzo Giustiniani Odescalchi in Bassano Romano in 1958 by Italo Faldi.[4] In recognition of the pope's assistance during the Jubilee Year of 1650, the fathers of the Hospice of SS. Trinità dei Pellegrini erected a memorial to Innocent X in their refectory. A bronze bust by Algardi was cast by Ambrogio Lucenti,[5] the whereabouts of which have been untraced for more than a century. Presumably during the French occupation of 1649, when the hospice was converted into a military hospital,[6] the wealth of papal memorials in this refectory was removed, later to be replaced by plaster busts of modern design. In addition to Algardi's bust of Innocent X, the losses included a bronze bust of Urban VIII by Bernini as well as Bernini's half-length statue in marble of Clement X (on which more later).[7]

Most scholars agree that the bust of Innocent X which the Cleveland Museum of Art has lent to the present exhibition was cast from the same model as was the Doria-

other orders. In his analysis, the Jesuits "fostered an elimination of drama and forcefulness in favor of restraint and a bland, naive piety." Hibbard has established that the Jesuits carefully devised the dedications of the altars within the Gesù to constitute a programatic expression of the Society's principles. Moreover, the Jesuits maintained their designations for these chapels throughout the process of eliciting fiscal patronage.[36]

The above remarks on Algardi's bronze relief of St. Ignatius Loyola suggest that Jesuit ideology did exert a quantifiable influence on the works under their purview. It cannot be demonstrated that the Jesuits (prior to the association of Padre Oliva and Bernini in the middle of the century) inclined to any one stylistic tendency. However, there is every indication that the Jesuits were convinced of the educational applications of art.

1) See König-Nordhoff, 1982 175 note 541, for the original Italian.
2) Ignatius was beatified in 1609, but the term *beato* was broadly applied at this time for holy persons and need not refer directly to his formal beatification.
3) König-Nordhoff, 1982, 73.
4) *ibid*, 66. The contemporary biography by Ribadeneyra specifically confirms that Ignatius did not allow portraits of himself to be made. The Spanish edition, 1578, of Ribadeneyra, sees this dearth of portraits of Ignatius as an act of God's will.
5) *ibid.*, 67.
6) The iconography of St. Ignatius of Loyola is examined exhaustively in the recent study by Ursula König-Nordhoff to which the reader is referred.
7) *ibid.*, 68.
8) The original was lost, a copy is illustrated in *ibid.*, Fig. 101.
9) Mâle, 1932, 97.
10) Keutner, 1969, 20.
11) In fact, Caravaggio's naturalism receives notable praise in the rather orthodox treatise of 1652 by Ottonelli and Cortona, 1973, 26. "Michelangelo [da Caravaggio] observed the natural in painting, and arrived at such a level of perfection that the works by him are marvelous, as is seen in the chapel of St. Matthew in Rome, in the church of S. Luigi de' Francesi."
12) Borromeo, 1932, 100.
13) Ciardi, 1968, no. 13.
14) Borromeo, 1932, 99.
15) Ottonelli and Cortona, 1973, 100-101.
16) Parma Armani, 1977, 131, and 143-44 notes 1-6, who draws on sources unavailable to this writer, especially, G. Incisa della Rocchetta, "Contributo all'iconografia di S. Filippo Neri" in *Studi di Storia dell'arte, bibliologia ed erudizione in onore di Alfredo Petrucci*, Rome, 1969.
17) More formally known as S. Maria in Vallicella.
18) Montagu, 1977, 79.
19) Nava Cellini, 1964, 33 note 8.
20) Golzio, 1968, I, 404.
21) Montagu, 1977,90. For the date of Contini's mask, see Enggass, 1960, 299 note 4.
22) Nava Cellini, 1964, 33 note 8.
23) The third most influential image continues this connection with Bolognese style: Guercino's painting of *St. Philip and the Angel*, 1643, in the Oratory of the Chiesa Nuova, Rome.
24) This anonymous print entitled *Theatrum in Ecclesia S. Petri in Vaticano* has been often reproduced, perhaps most accessibly in Mâle, 1932, fig. 57.
25) The painting and preparatory drawing were published together by Rudolf, 1978, 253-64.
26) Heimbürger Ravalli, 1973, 130. Miss Jennifer Montagu has kindly

informed me that the foundry contract for the urn, which does not mention Algardi, is dated January 2, 1629.
27) *ibid*. Montagu's Algardi catalogue is forthcoming; I should like to express my gratitude to this scholar for her generosity in sharing much information prior to the publication of her book.
28) Neumann, 1977, 318-19, fig. 4, in the proposed date of 1637. The drawing was published with the correct attribution but not illustrated by Dobroklonski, 1961, no. 11.
29) See König-Nordhoff, 1982, *passim*, for exhaustive documentation for the iconographies of SS. Ignatius and Francis Xavier. "From the beginning Francis's Vera Effigies was not only a head but also a gesture. In 1583 Valignano, the Jesuit visitor to India, sent a picture of Xavier from Goa to Rome; he wrote in the accompanying letter that it represented the deceased as he very often had been: the eyes raised to Heaven, grasping die Soutane von der Brust with both hands." (75)
30) Heimbürger Ravalli, 1973, 130.
31) Neumann, 1977, 322-25.
32) Gigli, 1958, 98.
33) *ibid.*, 100-1. The painting is mentioned by Baglione, 1642, 373, as adjacent to the chapel of St. Ignatius. Its present whereabouts are unknown, nor is its appearance recorded.
34) Baglione, 1642, 293.
35) Abromson, 1981, 242, prints out Bellori's remark which is published in the 1935 Mariani edition of Baglione's *Le Vite*, 1642.
36) Haskell, 1980, 63-68 and *idem*, 1972, 51-62; Freedberg, 1975, 660; Abromson, 1981, 266-68; Hibbard, 1972, 29-41. See these authors for additional references and for a complete picture of this debate.

# Notes On Four Papal Portrait Busts In Bron[ze]

This exhibition is privileged to include four magnificent bronze busts of four different popes who lived during the second half of the seventeenth century. Summary biographies and other data on each of these sculptures can be found under the individual entries in this catalogue. In chronological order according to sitter, the four busts represent Innocent X (Pope from 1644 - 1655) (Exh. 3); Alexander VII (1655 - 1667) (Exh. 12); Clement IX (1667 - 69) (Exh. 40); and Clement X (1670 - 1676) (Exh. 28).

The question arises as to whether these four sculptures might not comprise a series of some kind. It is an interesting coincidence that the subjects of these portraits are four popes who reigned in chronological succession, from 1644 to 1676. Moreover, the four bronzes share a common provenance, albeit only a relatively recent one in view of the span of time that has elapsed since the seventeenth century. These papal busts came to be in their respective American museums following their acquisition as a group during the 1950's by a New York art dealer from a private collection in France. The dealer, Rosenberg & Stiebel, was able to give some indication at that time to the effect that the sculptures had been in the French family for at least two generations previous, which would therefore account fo their whereabouts since the turn of the century.[1] Th silence which shrouds the earlier history of these consider able works of art may in itself be valuable evidence toward the reconstruction of their original contexts, as we shall se below.

The provenance of a bronze sculpture is of crucial signif cance to our understanding of it for reasons that app specifically to sculptures produced by casting or strikin in other words, sculptures produced by processes in whic multiple examples can be derived from an original mod These models, from which the casting forms are made, a usually works in terracotta, although marbles can be us as well. (The casting forms are in essence copies that a destroyed in the casting process.) The terracotta or marl models are unique works of art which have been created the artist's hand. Bronze sculptures stand apart in that artist almost invariably requires the intervention of a s cialist in casting, which must take place, moreover, i suitably equipped foundry.

Once the artist's model is in existence, it is possible bronze casts to be made *ad infinitum*. It happens, howe that the finishing of a cast once it has cooled, the incis of details to indicate features, such as pupils and beard to indicate textures of fur or cloth, will necessarily be d by the artist in a manner distinctive to his own tale This work with a pointed chisel is called "chasing". definition that the artist's own chasing gives to the su of the bronze contributes decisively to the final appear

have his monumental effigy in their midst. In October of 1632 citizens in the ancient Etruscan town of Velletri awoke to find their principal square graced by a full-length statue of their pope, the gift of Urban himself.[11] Bernini was the sculptor of this bronze, which unfortunately was destroyed during the French invasion of 1798. Urban soon followed up on the success of Velletri: in a letter of 1634 he abnegated a decree adopted in 1590 (during a papal interregnum) by the Roman Senate which prohibited erecting a statue of a living pope on the Capitol. "A Pope such as himself could not have been meant by it," he wrote.[12] At the end of the next year, the Senate ratified this resolution and Bernini's marble statue of Urban VIII, again full-length, seated, and pronouncing a benediction, was installed on the Capitoline Hill, *during the night* of June 24th, 1640.[13]

To return our argument to the sculptured bust, Urban VIII commissioned from Bernini in 1640 a bronze bust for presentation to the Cathedral in Spoleto, where the pope had been Bishop prior to his election. After four years of work with the assistance of the bronze caster, Ambrogio Lucenti, Bernini delivered a magnificent portrait of the pope attired in the full regalia of his office. This bronze bust, which Wittkower has described as the "grandest surviving portrait of the pope," was installed over the entrance of the cathedral, where it remains today.[14] The rule rather than the exception with regard to sculptured portraits is that these works were executed on commission and envisioned for public display (including in the public rooms of a palace). Unlike easel paintings, we can reasonably assume that the four papal bronzes in the present exhibition, as major examples of this genre, have left some traces for our eventual rediscovery in archival documentation or among the many contemporary accounts of art treasures published by seventeenth-century guide books and travellers to the Eternal City.

As it happens, there exist real links, if for the moment of very fragile fibre, between these four American museum busts and the only seventeenth-century Roman commission for a sequential series of papal bronzes that has come to the attention of this writer. Already in 1965, Olga Raggio, writing in the catalogue of that year's exhibition in Detroit of Italian Baroque art, had observed that in the Roman church of S. Maria di Montesanto there exists a plaster bust of Clement IX Rospigliosi which derives from the same model as the Clement IX in bronze in the Detroit Institute of Arts.[15] The latter work is exhibited on this occasion, as it was in 1965, with an attribution to Girolamo Lucenti. Miss Raggio did not venture to suggest that the plaster copy in S. Maria di Montesanto might have actually been cast from the Detroit bronze, because the availa-

ble evidence is not sufficient to support such a conclusion; it only allows us to raise the possibility. Moreover, there seems to be another viable candidate for the missing original. When Valentino Martinelli published in 1956 a photograph of the plaster cast in the church, he reported that a bronze bust of the same model had been lent in 1930 from the Pallavicini Rospigliosi collection to an exhibition in Rome.[16] The plaster casts of Alexander VII and Clement X are both derived from different, otherwise unknown, models than those of the bronzes of these popes in this exhibition.

What other circumstances, if any, link the bronzes in this present exhibition with the series of papal busts that originally stood in the roman church of S. Maria di Montesanto? In 1984, this church holds on four pedestals in the choir, two on each side of the High Altar, four plaster busts in place of the four bronzes that represented Popes Alexander VII, Clement IX, Clement X, and Innocent XI (reigned 1676 - 1689). The story behind the construction of this church is well documented for the most part, although some new information can be presented on this occasion.[17]

The church of S. Maria di Montesanto stands on the south side of the Piazza del Popolo, which is the principal entrance to Rome from the north. This diminutive church constitutes one-half of one of the most marvelous achievements of seventeenth-century urban planning. Adjacent to S. Maria di Montesanto, across the avenue of the Corso which continues south, stands the twin church of S. Maria dei Miracoli with matching cupola and portico. The effect is of some unprecedented sort of triumphal arch. When S. Maria di Montesanto was open to worshippers in 1679, the patron of the new edifice, Cardinal Girolamo Gastaldi, arranged for the prominent display of bronze busts of the four popes under whom and with whose assistance the long process of construction had been accomplished. The project had been given its initial impetus in 1658 when Alexander VII assigned responsibility for a systematization of the Piazza del Popolo to the architect Carlo Rainaldi.

To Rainaldi must go the credit for the brilliant idea to frame the southern egress of the piazza with paired churches. The plan failed to make much progress after the death of Alexander VII in 1667, but construction recommenced in 1671 with the involvement of Mons. Gastaldi, who was himself raised to the purple in 1671 by Clement X. From 1673 to 1675, the name of Bernini appears in place of Rainaldi's in the surviving documentation.[18] Bernini is known to have modified the plan for the cupola of the church, and his principal assistant, Mattia de' Rossi, whom Bernini frequently employed as his on-site surrogate, was entrusted with the scheme for the altar. The exterior of S. Maria di Montesanto was essentially completed

in 1675, and in 1676 work began on S. Maria dei Miracoli under the supervision of Carlo Fontana. In 1678 Cardinal Gastaldi sent a memorandum with instructions for de' Rossi on the subject of the completion of the decorations around the High Altar in S. Maria di Montesanto.[19] The Cardinal informed his agent that the bronze busts of three popes (Alexander VII, Clement IX, and Clement X) had been cast by Girolamo Lucenti (the son of Ambrogio) and were already in Gastaldi's house. The fourth bust of the "living pope," Innocent XI, was being made by Travani (an unspecified member of a well-known family of bronze casters). Every guide book published subsequent to the consecration of the church assigns the authorship of all four papal busts to Lucenti. These busts are described *in situ* continuously until well into the nineteenth century; the date at which the originals were removed and replaced by the stucco casts is not known.[20]

Rainaldi's early designs for the plan of S. Maria di Montesanto make no provision for the display of papal busts in the choir — after all, he could hardly have anticipated the succession of pontiffs that would occur before the realization of his design. The inspiration for this group memorial to popes who would not have associated in person must have arisen during the period of Bernini's involvement in the church, and it is a fair supposition to assign the credit for this imaginative development to Bernini himself. The paired portraits of popes are afforded center stage in a drawing by Mattia de' Rossi which depicts the decoration of the choir; this plan was reproduced in an engraving in a volume of architectural plans published in Rome in 1713 (Fig. 8).[21] Undoubtedly as a result of the dispersal of the original bronzes, the papal memorials in the choir of S. Maria di Montesanto have never been discussed in context by scholars, nor has Bernini's probable responsibility for this installation ever been mentioned before.[22]

It is notable that Rainaldi's ground plan of S. Maria di Montesanto has been repeatedly illustrated by writers on the church, as though the Bernini/ de' Rossi niches had never in fact been executed.[23] In Rainaldi's plan, the walls on either side of the High Altar are minimally adorned by paired pilasters. The memorials which in the engraving are attributed to de' Rossi constitute an immeasurably more expressive decoration that is in every respect evocative of previous designs of the great Gian Lorenzo Bernini. The engraving provides both the side elevation and the ground plan of the proposal for the right side of the choir (as seen by the viewer facing the Altar). Both the coats of arms above the portrait busts and the inscriptions beneath them are depicted and clearly identify the illustrated sculptures as Clement X, nearest the Altar, and Alexander VII.[24] The niches are thus identified in the church today. (Only

Fig. 8    Side elevation of the High Altar, S. Maria di Montesanto. From De Rossi, *Disegni di Vari Altari.*

the plaster cast of Clement X stands in its appropriate place, which has led to much mislabelling of photographs. No bust of Innocent XI is included amongst the plaster replacements; the fourth plaster is incongruous, being related to Bernini's bronze bust of Urban VIII in the Louvre.)[25]

The pedestals for each pair of busts were designed as raised platforms on opposite ends of a single dais set several feet off the ground. Behind this dais opens a semi-circular niche of considerable depth. The engraving of 1713 makes it clear that the busts were intended to be turned to face towards the altar. It is easy to imagine the dramatic effect of this scheme when its original statuary was in place: through the proxies of their effigies, the four popes were represented in eternal adoration of the Host. Even with plaster copies, the presence of the sculpture is emphasized by the unexpected opening in the walls behind the busts. As a result, the choir appears very much as if two pairs of popes are observing the proceedings from private boxes.

The theatrical connotations of this decorative plan naturally bring to mind Bernini's sensational decoration of the Cornaro Chapel in S. Maria della Vittoria (completed in 1652), in which dignitaries of the Cornaro family are seen,

37

rather at their ease, as witnesses to the miraculous vision of Santa Teresa. From 1661 until the death of Alexander VII in 1667, Bernini worked closely with the pope on the planning for a new, expanded installation in both transepts of the Cathedral in Siena of monuments to the Sienese popes. The principal problem in this project was essentially the same, on a grander scale, as that which was to be addressed with the bronze busts in S. Maria di Montesanto, i.e. how to arrange a number of individual portrait sculptures so that their expressions and attitudes would interrelate as a cohesive ensemble. It has been well documented that Bernini designed the model for and supervised Antonio Raggi's carving of the marble statue of Alexander VII. Presumably he was likewise responsible for Melchiorre Cafà's receiving the commission to execute the statue of Alexander III.[26] A recent study of the papal memorials in Siena has offered evidence for Bernini's contribution to the (eventually unrealized) plan for the arrangement of these statues together with the earlier memorials in the Cathedral.[27] Extracts of Alexander VII's diary were published in 1981: under 27th May 1663, the pope recorded a visit by Bernini to whom he gave some drawings received from Siena for "our statue in the Duomo of Siena in the niche adjacent to our Chapel."[28]

The coincidence that one of the plaster copies in S. Maria di Montesanto represents the same subject as the Detroit Clement IX does not allow a definitive conclusion, for reasons stated above. In fact, the carelessness with which the plaster busts were placed on the pedestals without regard for the identities of the original tenants, not to mention the inappropriate inclusion of a plaster of Urban VIII, imbues the whole phenomenon of these replacement casts with a palpable aura of randomness. On the other side of the balance, of course, the fact of Lucenti's authorship of the Detroit bronze must be reckoned with. H. Lee Bimm has argued persuasively in favor of Lucenti's authorship of the Detroit bust of Clement IX and provocatively, besides, in favor of Bernini's responsibility for the original portrait of the pope.[29] During this period, Lucenti was Bernini's favored bronze caster and was employed for many important and delicate assignments in the Vatican, including the Tomb of Alexander VII.

The engraving published in 1713 of the Bernini/ de' Rossi design for the choir of S. Maria di Montesanto has already been referred to as providing invaluable evidence for the original disposition of the portrait busts of Clement X and Alexander VII (Fig. 8). Nor is it without interest that this engraving, in order to make this demonstration, must perforce illustrate the busts themselves. Because architecture, not sculpture, was the concern of the anonymous engraver, it would be risky to put too much credence into the indi-

vidual lines of his representation. Nonetheless, it does bear noting that the configuration of the bust of Clement X closely resembles that of the portrait bust of Clement X (Minneapolis Institute of Arts) in this present exhibition. The similarity seems especially compelling with regard to the accentuated creases of the pope's *mozzetta*, or jacket, where the sculptor intended to indicate the movement of the pope's proper right arm. Again, if this identification were regarded as convincing, the conclusion could not be drawn further than that the Minneapolis bronze was cast from the same model as that which Lucenti used for the church, even while the possibility would have to be recognized that the two works might be one and the same.

At this juncture it should perhaps be noted that the representation of the portrait of Alexander VII in the engraving does not significantly resemble the bronze bust of that pope by Melchiorre Cafà which has been lent to this exhibition by the Metropolitan Museum of Art. The Cafà bust is fully signed and dated 1667 in the cast, details which Lucenti would presumably have eliminated from the model prior to making his cast for S. Maria di Montesanto. The plaster bust of Alexander VII in the church today does not bear a notable relationship to the engraved illustration either. However, the plaster is based on an otherwise unknown portrait of the pope; both Martinelli and Wittkower remark that the design appears to be worthy of Bernini. To return to the Cafà momentarily, there have not been found as yet any early references to untraced casts of this bust, which was the most important portrait executed by the artist before his untimely death, although Pascoli refers to the many that were done.[30]

In 1676, that is at just the moment when the designs must have been under development for the decoration of the interior of S. Maria di Montesanto, Bernini was deeply involved in the creation of a series of marble portraits in half-length of Pope Clement X Altieri. Out of this period of activity may have come the bronze bust, unknown to us today, of the then deceased Pope which Nicodemus Tessin, Swedish architect, traveller, and indefatigable diarist, saw in the Palazzo Altieri during a visit in 1688.[31] Tessin was a great admirer of Bernini, with whom he had associated closely during his studies in Rome, 1675-1678, and can be counted as a reliable witness of the latter's works.[32] The same bronze bust is cited in the Palazzo Altieri in a Roman guide book of 1725.[33]

Bernini's series of portrits of Clement X is germane to our present discussion because it illustrates the circumstances behind the commission for one of these statues which he received from the hospice of SS. Trinità dei Pellegrini. As mentioned above, the refectory of this charitable institution is decorated on either side of its long walls with sculp-

tured memorials to its papal benefactors. The hospice was founded in 1550 by St. Philip Neri to provide shelter and sustenance for the thousands of destitute pilgrims who made their way to Rome in that Jubilee Year. During the twenty-five year intervals between Jubilees, the hospice thereafter gave shelter to convalescents who had been able to leave the hospital but were still unable to care for themselves. It became a tradition on Tuesday during Easter week of every Jubilee Year for the pope to visit the hospice with a retinue of cardinals in order to wash the feet of some of the pilgrims. In gratitude for their gifts in 1625 and 1650, the brothers of the hospice erected memorials to Popes Urban VIII and Innocent X: both were busts cast in bronze after designs by Bernini and Algardi. During the Jubilee of 1675, the brothers made plans to acquire and exhibit a memorial bronze of Clement X; for unknown reasons, Bernini elected to carve a portrait marble instead, and to depart from the earlier pattern by depicting the arms of the pope raised in benediction. The known facts about Bernini's portraits of Clement X are as follows.

On January 10, 1675, the directors of the hospice passed a resolution calling for the construction of a marble monument in honor of Clement X, which would include a bronze portrait of the pontiff.[34] A year later, Bernini was visited in his workshop by Carlo Cartari, archivist of the Castel S. Angelo and librarian to Cardinal Altieri. Like Tessin, Cartari was a tireless taker of notes. In his words, "On the 5th of May, 1676, I was with Monsignor Montecatini in the room where the Cavalier Bernini works at sculpture; he was working in the room on the bust of Pope Clement X, and said that Cardinal Altieri wants it, to have in his room. Another marble was being roughed out to make one like it to be placed in the Refectory of the Holy Trinity of the Convalescents, and he said that one will be made for the library [of the Palazzo Altieri]."[35]

Clement X died on July 22, 1676. The pope's passing evidently altered the projected disposition of Bernini's portraits, as emerges from a pair of documents which have escaped the attention of Wittkower and of every subsequent writer on these works. In December of that same year, a craftsman in stucco submitted a bill for his completed work on the ornamental surround, in the shape of a fluttering drapery, for a marble portrait of Clement X, "which is placed in the library."[36] After reducing the craftsman's fee somewhat, Mattia de' Rossi, whom we have seen before as Bernini's superintendent, authorized payment of this bill. The record of payment, dated December 10, 1676, likewise states that the portrait is already in the library.[37] Because of the brief passage of time since Cartari's visit to Bernini's studio, there can be no question that the sculpture being worked on in May was the same one which was installed in

the library of the Palazzo Altieri by December. The work was rediscovered in 1956 by Martinelli, and it remains the only sculptured portrait of this pope by Bernini that is known to us today. When Tessin saw the sculpture in 1688, it was on exhibit in the principal gallery of paintings, although he remarks that it was going to be placed in its niche over the entrance onto the gallery in the library. The same observer noted helpfully that the architectural setting for the bust was designed by Bernini and that the bust had been left "not quite finished" at the death of the pope.[38]

Contrary to the conclusions drawn by earlier commentators on Bernini's busts of Clement X, a careful reading of the published documentation reveals that the commission for the memorial in SS. Trinità dei Pellegrini was executed steadily and was fulfilled in good time. In June of 1677, funds were appropriated to Bernini for the marble with which he was to "make a copy of the portrait of Clement X."[39] Presumably the bust in the Palazzo Altieri was the prototype in reference. The same document informs us that the ornate niche of mixed marbles had already been completed. During the course of the next year, 1678, Cardinal Gastaldi wrote his memorandum to the effect that the bust of Clement X was among those which had already been cast and delivered by Girolamo Lucenti.[40] In April of 1680, Bernini informed the brethren of the hospice of SS. Trinità that he intended to make a donation of his statue of Clement X. The same record of this gift notes that Bernini had also designed the ornament of mixed marbles, although a certain G.B. Contini was the architect of record.[41] By the 27th of April, 1680, the sculpture was installed in the rectory. In gratitude, the brethren resolved to sing annual masses in Bernini's honor during his lifetime and, after his death, to offer a mass annually in his name on the anniversary of his passing *in perpetuo*.[42] The SS. Trinità archives in the Archivio di Stato, Rome, record that masses were sung in Bernini's name on November 28th of every year without interruption until 1861 (the last year for which the archives are on deposit).[43]

At the outset of these notes, we formulated the question as to whether the four papal busts in this exhibition, which share a modern provenance, might have comprised a series of portrait busts in their original contexts. The little that we know concerning the incidence of such series in Roman collections during the seventeenth century has been discussed. Two memorial series have come to the fore, those of S. Maria di Montesanto and of the rectory of SS. Trinità dei Pellegrini, both of which remained intact until a relatively late date. Antonio Nibby's guide book of 1838 — which is not infallible — describes both of these installations as still *in situ*.

On the basis of some coincidences the possibility has been raised that the busts of Clement IX and Clement X (now in the art museums of Detroit and Minneapolis) might originally have stood in the choir of S. Maria di Montesanto, Rome.

Close comparison of these casts during the course of this exhibition may help to confirm or reject this hypothesis. It seems unlikely that the Alexander VII signed by Cafà could have belonged to a group of bronzes cast by Lucenti, and the inclusion in this series of the Innocent X by Algardi is ruled out by virtue of its subject. (Other than that it was a bust or bronze, we do not know the appearance of the Algardi portrait of Innocent X which was formerly in a niche in the refectory of SS. Trinità dei Pellegrini.) For the record, no bronze bust of Innocent XI is to this writer's knowledge in an American or French collection. An unattributed bust of this pope in the Palazzo Odescalchi, Rome, appears from the photograph to be a work of the period and appropriate in composition for the S. Maria di Montesanto commission.[44] A photograph of this Innocent XI is here published for the convenience of scholars (Fig. 9).

Fig. 9   Anonymous Roman Portrait Bust. Principe Odescalchi, Rome.

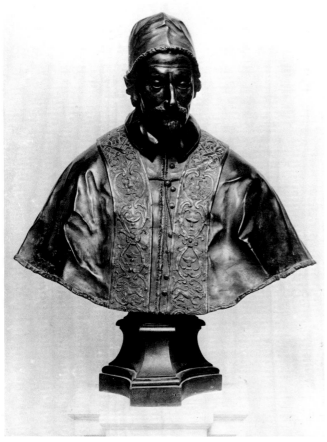

In any event, it can be concluded that these four busts were not originally constituted as a series in themselves, if only because the bust by Cafà, which we accept as an autograph cast, was among the last works executed by the artist before his premature death in 1667. For the moment, the circumstances of patronage that would have extended in time from before Cafà's death to at least the election of Clement X (1670) are difficult to imagine. Moreover, if any of these four busts can be firmly identified with one of the memorial series described above, it would be demonstrated that these four bronzes were not executed as a series of their own, but were collected at a later date.

1) According to information kindly provided by the Minneapolis Institute of Arts, two generations separate the given provenance of Baron Gustave de Rothschild, Paris, and the Palais Lambert, Brussels.
2) Passeri, 1934, 206, "He had left his studio of models to his pupils, among whom were Domenico Guidi, Ercole Ferrata and Girolamo Lucenti."
3) See the pertinent pages in Sirén, 1914, for Tessin's picturesque impressions of his visit to the Palazzo Barberini in 1688.
4) For illustrations of various busts see Wittkower, 1981, cat. no. 51, and Heimbürger Ravalli, 1973, pls. 52-56.
5) Montagu, 1977, 97 note 33.
6) Pietrangeli, 1980, 32.
7) Fraschetti, 1900, 146, suggested that the bust of Urban VIII might have been destroyed by Napoleon's soldiers. Other writers have suggested that this work is identical with the bronze by Bernini in the Louvre; cf. Wittkower, 1981, cat. no. 19-4, who concurs with Fraschetti.
8) Hawley, 1962, p.80f; Olga Raggio, in Detroit, 1965, no. 41; Heimbürger Ravelli, 1973, 118; and Jennifer Montagu (in a letter, July 22, 1984). This same view will be treated at length by David C. Ditner in his forthcoming catalogue of Seventeenth and Eighteenth Century Sculpture in the Cleveland Museum of Art.
9) cf. Wittkower, 1981, 222. Bershad, 1970, 806-9, advances the sweeping hypothesis that all these bronzes of Innocent X, including the Doria-Pamphili bust with the 1666 attribution to Algardi, were cast and worked by Domenico Guidi after Algardi's death.
10) See Thiem, 1974, 35-40, and Langedijk, 1981, I, 124-125.
11) Gigli, 1958, 132. In his travel diary for June 27-28, 1645 (but compiled later), John Evelyn wrote, "Thence to Velletri, a Towne heretofore of the Volsci where is a publique and faire Statue of P:Urban the 8 in brasse, and a stately Fountaine in the streets." (II, 317).
12) Hager, 1929, 60.
13) Gigli, 1958, 192-93.
14) Wittkower, 1981, cat. no. 19-5.
15) Exh. no. 41.
16) Martinelli, 1956, 48 note 96.
17) The voluminous article by Hager, 1967/68, 189ff., has been usefully summarized by Buchowiecki, 1967, II, 776-83, and Blunt, 1982, 97-99. My account of the construction history derives from these sources and Golzio, 1941, 122-148.
18) This point is brought out most clearly by the documentation published by Golzio, 1941, 128f.
19) This crucial document bears no date. Golzio assigned the date of 1687 based on the other documents bound in the same volume; ibid., 126.
20) The bronzes are described in Nibby, Roma nell'anno MDCCCXXX-VIII, 1839, I, 442, and even in Forcella, IX, 1877, 194-95, but the possibility of confusion between these bronze-colored plasters and the originals must be considered.
21) De Rossi, G.G., Disegni di Vari Altari e Cappelle nelle Chiese di Roma, undated, pl.31, "Fianco dell'Altare Maggiore della Chiesa della Madonna di Monte Santo. Archit. di Mattía de Rossi." From internal evidence, this volume post-dates 1689; Blunt, 1982, gives the date as 1713.

22) Bruhns, 1940, 381 note 152, does not regard this decoration with any enthusiasm. He finds a lack of cohesiveness among the elements in the choir, the design of which he ascribes to "Bernini's *Famulus* [amanuensis], Mattia de Rossi."

23) For example, Hager, 1967/68, reproduces both de Rossi's plan of the choir (see note 21 above) in his Fig. 168 and Rainaldi's ground plan for the whole church, Fig. 162, without comment on the variations between the two. Hager does not cite the source for either print; the Rainaldi is found in Rossi, D., *Studio d'Architettura Civile*, Part Terza, Rome, 1721, plate 30.

24) In the print, notwithstanding the Chigi arms, the engraver has inscribed *AVIII* (the Odescalchi pope, 1689-91) instead of *AVII*.

25) The wayward plaster induced Wittkower, 1981, cat. no. 19-4a, to postulate the anachronism of an untraced cast by G. Lucenti of a bust of Urban VIII.

26) Bernini's influence on artistic policy during the papacy of Alexander VII was universal. At the end of 1665, Bernini directed to Cafà the important commission from the Knights of Malta to execute a monumental statuary group in bronze of *The Baptism of Christ* for the apse of the Conventional Church of St. John, Valetta. See E. Sammat in Valletta, 1970, 59-60; W.L. Zammit in Azzopardi, J. ed., 1978, Doc. nos. 12-17. The statues of Alexander III and of *The Baptism* were uncompleted at Cafà's death. The former was executed many years later in marble by Giuseppe Mazzuoli.

27) Butzek, 1980, 15-78.

28) Morello in *Bernini in Vaticano*, 1981, 335.

29) Bimm, 1974, 74-75.

30) Pascoli, 1730, 257.

31) Sirén, 1914, 181.

32) Canestro Chiovenda, 1966, 171 *passim*, including many quotations from the rare book by Sirén, 1914.

33) Martinelli, 1956, 53 note 106, first noticed this reference in G.P. Pinaroli, *Trattato delle cose più memorabili di Roma*, III, Rome, 1725, 152.

34) Aleandri Barletta, 1965, Doc. 1.

35) For the original Italian, see Martinelli, 1956, 49.

36) Schiavo, 1965, 87, where the document is transcribed in English translation. It seems, if almost unimaginably, that Bernini was influenced by Domenico Guidi in adoption of a half-length pose of benediction for this sculpture instead of a simple bust, such as he had executed years before in the Barberini Library (now Vatican Library). Bershad, 1977, 20 fig. 4, dates to ca. 1661 Guidi's half-length statue of Alexander VII in the Biblioteca Alessandrina, Rome.

37) *ibid.*, 87-88.

38) "...wegen seinem tode nicht ist gants fertig geworden," in Sirén, 1914, 178. B. Canestro Chiovenda, 1966, 178, reads this passage as referring to the death of the sculptor, but Wittkower, 1982, 263, is surely correct to read it with reference to Clement X.

39) Martinelli, 1956, 222-23.

40) See note 19 above.

41) *ibid.*, 223 note 45; Aleandri Barletta, 1965, Doc. 4.

42) Aleandri Barletta, 1965, Doc. 5.

43) *ibid.*, 283.

44) Nibby, 1839, I, 442 and II, 152. See note 20 above and Martinelli, 1956, 50 note 104.

# Catalogue of the Exhibition

# 1. ALESSANDRO ALGARDI (Bologna 1595 - 1654 Rome)

*Relief Sculpture of St. Ignatius Loyola with Saints and Martyrs of the Jesuit Order*
Bronze, dark brown patina. 11 3/8 x 18 5/8 (28.9)
References: Neumann, 1977, 319, fig. 6.
The Metropolitan Museum of Art, New York, NY
(Rogers Fund, 1938.152.20)

This relief sculpture in bronze is closely related to the bronze relief executed by Alessandro Algardi for St. Ignatius's reliquary urn in the church of the Gesù, Rome.[1] The Founder of the Society of Jesus and one of the outstanding personalities of the Counter-Reformation, Ignatius was born into the Basque nobility in Loyola, Spain, ca. 1491. Trained as a soldier, he determined during a period of convalescence and reflection to dedicate his life to his religion.

In 1534 Ignatius completed his studies at the University of Paris. He was the inspiration of a group of students, among them Francis Xavier, who took vows to be missionaries to the Palestinian Moslems. In Venice, their passage to the Holy Land was thwarted by war in 1536; the group of ten thereupon offered their services to Pope Paul III in any capacity. At this time, Ignatius was ordained as a priest. In 1540 Paul III recognized Ignatius's group as a regular religious order with the name of the Society (or Company) of Jesus. Until his death in 1556 Ignatius supervised the expansion of the Jesuit order from ten members to a thousand. The dual challenges of resistance to the Protestant Reformation and of proselytism to far-flung continents led to Jesuit emphasis on missionary and educational activities. Most martyrs of the Roman Catholic Church after this date were Jesuits. Ignatius published in 1548 his *Spiritual Exercises* on which he had worked since his studies in Spain. As a landmark of philosophical literature, this volume has left an indelible impression on European culture.

The allegorical overtones of this composition showing St. Ignatius and several generations of Jesuits are discussed in the introductory essay, *Some Notes on Portraits of Counter-Reformation Saints*. From left to right the figures in the front plan can be identified by their attire and customary attributes: Bernardino Realino;[2] the Blessed Aloysius Gonzaga, kneeling with crucifix and book;[3] Cardinal Roberto Bellarmino;[4] St. Francis Xavier,[5] grasping his tunic with both hands; at center, St. Ignatius,[6] holding the Rules of the Order; Francis Borgia,[7] holding a chalice and addressing the kneeling Blessed Stanislas Kostka;[8] and at far right, the Blessed Ignatius de Azevedo[9], showing a miraculous image of the *Madonna and Child* to a follower. The three crosses of the Jesuit Martyrs of Japan can be seen behind the front rank, along with other martyrs bearing palms.[10] At right,

Andrea Oviedo, patriarch of Ethiopia, is represented wearing a mitre and holding the crozier of his office.

Algardi's preparatory drawing in pen and ink for this composition is in the Hermitage, Leningrad.[11] Except for the gestures and central positions of SS. Ignatius and Francis Xavier, the artist's first conception of the composition varies notably from the relief as executed. In place of a relatively open arrangement, the final version presents the figures in tightly compacted and carefully reasoned juxtapositions.

The present bronze and a similar one in Kraków[12] were presumably cast from molds taken from the completed relief in the Gesù. The much restored terracotta model for the cast of the St. Ignatius urn is in the Museo di Palazzo Venezia, Rome.[13] In 1638 the relics of the saint were deposited in the urn;[14] the contract for the casting of the urn dates from 1629.[15] These two dates must circumscribe the period of Algardi's activity on this project. Although this commission should have carried with it great prestige by virtue of its prominent position in one of the most active churches in Rome, it was mostly ignored by the early writers.[16] The 1630's would remain a decade of obscurity for Alessandro Algardi, who only emerged at its end as the one sculptor of sufficient mettle to challenge Gian Lorenzo Bernini.

1) Gilt bronze, oval, 11 3/8 x 20 (29 x 51). Heimbürger Ravalli, 1973, no. 43, fig. 63.
2) Neumann, 1977, 324. Died 1616. C. Bricarelli in *La Civiltà Cattolica*, 1922, vol. 4, 410f, identifies this figure as Peter Canisius (1521 - 1597).
3) (1568 - 1591). Beatified 1605, canonized 1726.
4) (1542 - 1621). Canonized 1930.
5) (1506 - 1552). Beatified 1619, canonized 1622.
6) (ca. 1491 - 1556). Beatified 1609, canonized 1622.
7) (1510 - 1572). Canonized 1671. Francis Borgia holds a monstrance instead of a chalice on the urn relief. A crown at his feet in the same bronze, which is also seen at right in the Leningrad drawing, refers to the titles that he abdicated when he entered the Jesuit order. It appears therefore that the figure who holds a monstrance in the drawing does not represent Francis.
8) (1550 - 1568). Beatified 1605.
9) Missionary to Brazil, Ignazio de Azevedo brought with him a copy of the miraculous image in S. Maria Maggiore. See Neumann, 1977, 324.
10) Of twenty-six missionaries and converts who were martyred by crucifixion and lances in Japan in 1597, three were Jesuits: John de Goto, Paul Miki, and James Kisai. Canonized 1862. Pope Urban VIII formally recognized these martyrdoms in 1627; an impressive celebration of the first feast day of the martyrs in Japan took place in the Gesù the next year.
11) Neumann, 1977, fig. 4. ca. 1632.
12) Muzeum Norodowe. *ibid.*, fig. 7.
13) *cf. ibid.*, figs. 2 and 3, before and after its drastic restoration.
14) Heimbürger Ravalli, 1973, 130 - 31.
15) This information was kindly shared with me by Jennifer Montagu in correspondence, who also informs me that the urn is described *in situ* in 1658.
16) Only Pascoli, 1730-36, II, 262, remarks that the remains of St. Ignatius were deposited "in un'urna fatta dal celebre Algardi."

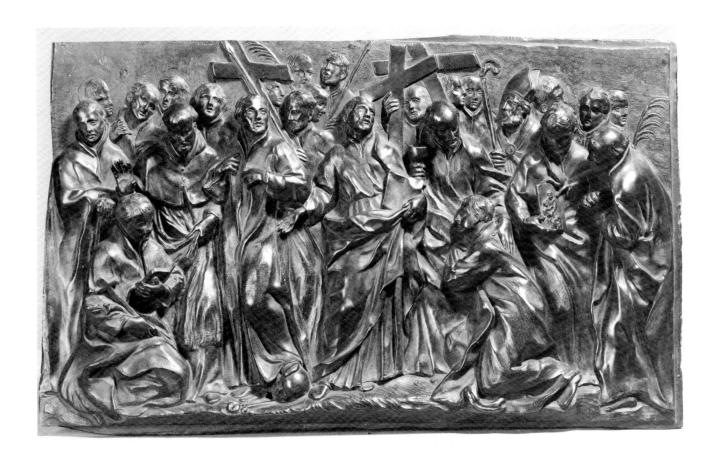

## 2. ALESSANDRO ALGARDI (Bologna 1595 - 1654 Rome)

*Portrait Head of St. Philip Neri*
Bronze. 16 1/4 x 14 3/4 x 10 1/4 inches; Height, including base, 24 1/4 (61.6)
Dated in the cast: 1640
References: Providence, R.I., 1969, no. 9; *Five College Roman Baroque Festival,* Amherst College, 1974, no. 50; Montagu, (forthcoming catalogue of Algardi sculptures), no. 77.C.3.
Collections: Father Generaso Calenzio, Rome (sale, U. Sanmartini, via della Chiesa Nuova, 1915, cat. 94); Eduardo de Scuffi, Rome (1916); John Marshall, Rome (after July, 1916).
Museum of Art, Rhode Island School of Design, Providence, RI
(Gift of Mrs. Gustav Radeke, 51.002)

Early in this century, this admirable bronze passed through several hands following the dispersal of the estate of an Oratorian father, Generaso Calenzio. This provenance was traced by Heimbürger Ravalli who, unaware of the Providence cast, misidentified the Calenzio bust with a similar bust which entered the Galleria Nazionale d'Arte Antica, Rome, in 1960.[1] This confusion is clarified by J. Montagu in her forthcoming catalogue of Algardi's works.[2] As Montagu points out, the Providence bust is clearly the same sculpture as appears in an 1894 publication of the Roman Oratorians (without indication of ownership), as well as in a photograph taken in 1925 by the Gabinetto Fotografico Nazionale, Rome. Moreover, there is no indication, contrary to the assumption of Heimbürger Ravalli, that Father Calenzio obtained his sculpture from the Oratory of St. Philip Neri in Rome, where no such work by Algardi is mentioned in earlier archives or guides.

W. Chandler Kirwin made the important observation for the catalog of the 1974 exhibition that the Providence bust is dated 1640 in the cast. Algardi's design of this piece therefore immediately followed the execution of one of his most important religious commissions, the statuary group in marble of *St. Philip Neri and the Angel* in the sacristy of the Oratorian church of S. Maria in Vallicella.[3] All writers have observed that the present portrait is based on the death mask of the Saint.

The reader is referred to the introductory essay in this catalogue, *Notes on Portraits of Counter-Reformation Saints,* for a comparison between the exacting realism of this portrait of St. Philip Neri and the more idealized conception of the miniature head of St. Philip in the Daniels Collection (Exh. no. 4) which is based on the Algardi's marble in Rome.

1) Heimbürger Ravalli, 1973, no. 15c.
2) I would like to express my gratitude to Miss Montagu for her generosity in providing me with her catalogue text on this work.
3) See Montagu, 1977, 75 - 100, for a full account of this commission, executed ca. 1635 - 38, unveiled 1640.

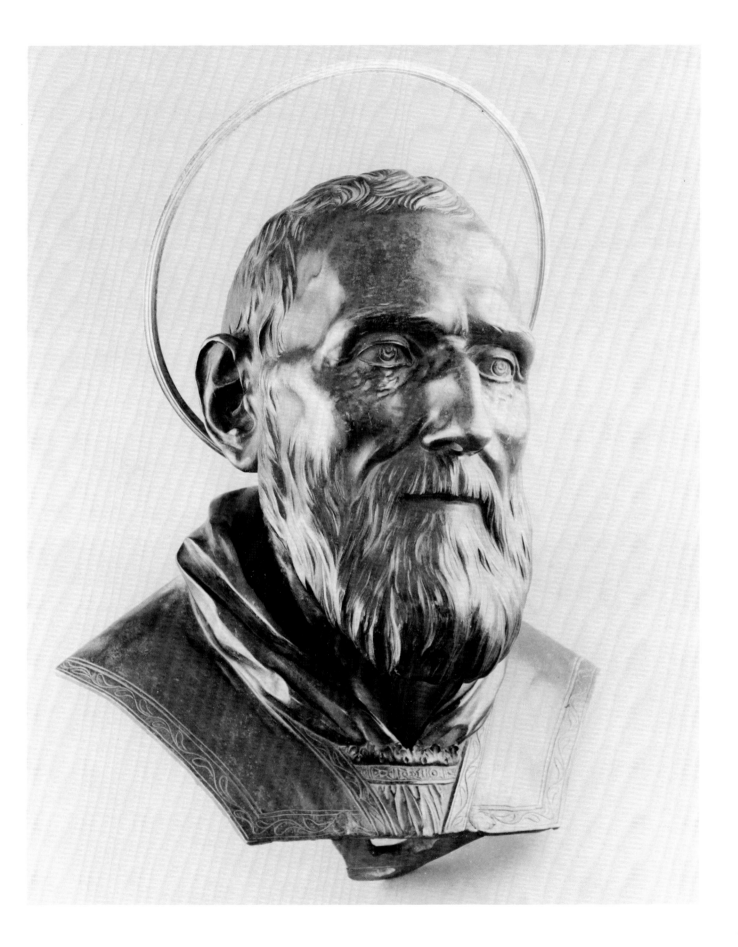

## 3. ALESSANDRO ALGARDI (Bologna 1595 - Rome 1654)

*Portrait Bust of Pope Innocent X*
(Giovanni Battista Pamphili, Rome 1574 - Pope 1644 - 1655)
Bronze. Height without base, 30 3/4 (78.1)
Collections: Baron Gustave de Rothschild, Paris; Palais Lambert, Brussels.
References: Hawley in *Cleveland Museum Bulletin*, XLIX, 1962, 80-82; Pope-Hennessy, 1964, II, 625; Nava Cellini, 1964, 32 note 4; Raggio in Detroit, 1965, no. 41; Heimbürger Ravalli, 1973, 118; Wittkower, 1981, 222.
The Cleveland Museum of Art, Cleveland, OH
(Gift of Rosenberg & Stiebel, Inc., in honor of William Mathewson Milliken, director 1930-1958)

Giambattista Pamphili was born May 7, 1574, in Rome into an ancient and noble family. In the course of an ecclesiastic career he ascended to positions of increasing prestige. He was papal nunzio in Naples in 1621, then Spain in 1626. Urban VIII made him Cardinal in 1629. Upon Urban's death, Pamphili was elevated to the papal throne as his successor on September 15, 1644, taking the name of Innocent X.

The qualities of intellectual vigor and personal magnetism expressed in this bust of Innocent X by Algardi should perhaps be viewed in the light of idealized portraiture. The reign of this pope was notorious in Rome and abroad for the pontiff's indecisiveness and inability to control the politics in his own household. His principal advisor was the formidable donna Olimpia Maidalchini, the widow of the pope's brother.

The initial actions taken in office by Innocent X were well received by the Romans. He called on the Barberini family to account for the deficit spending policies of Urban VIII. Their response was flight to France, and Gian Lorenzo Bernini, whose career had been personally directed by Urban VIII, was likewise out of favor for several years. Bernini's eclipse made possible the emergence of Alessandro Algardi, a Bolognese sculptor who had been active in Rome since 1624. Algardi's credentials were impeccable as far as the classicists' taste were concerned; he had even begun his career as a specialist in the restoration of antique sculpture. In 1640, Algardi's sculptural group of *St. Philip Neri and the Angel* was unveiled to great acclaim in the Chiesa Nuova. [cf. Exh. nos. 2 and 4]

Scholars are in accord that the model for this bust of Innocent X must have been executed ca. 1647 - 48.[1] Another cast in bronze of the model is in the Galleria Doria-Pamphili, Rome. This other bust, which is cited as the work of Algardi in a Pamphili collection inventory of 1666, is generally assumed to have been cast prior to the present one.[2] Minna Heimbürger Ravalli has commented that

Algardi's sculptures of Innocent X and of donna Olimpia represent the apogee of the artist's portraiture. The same writer has astutely observed that Algardi's portraits in bronze are distinguished by a more realistic conception than is found in his work in marble. The technique of modelling in terracotta, from which the bronzes were cast, is more suitable for the reproduction of details, and in any event seems to have been preferred by Algardi to carving in stone.[3]

For additional information on Algardi's portraits of Innocent X, see the introductory essay, *Notes on Four Papal Portrait Busts in Bronze.*

1) This dating was first proposed by Nava Cellini, 1964, 16-17. It finds confirmation in the comparison with the portrait on Innocent X's annual medal for 1648 which is clearly based on an Algardi model, conceivably this one. For this medal by Gaspare Moroni, see Whitman and Varriano, 1983, no. 73. The contrast with Moroni's portraits of Innocent X from the preceding years could not be more striking.
2) See Heimbürger Ravalli, 1973, Cat. no. 36a for an illustration and the documentation.
3) *ibid.*, 38-39; Nava Cellini, 1964, 17.

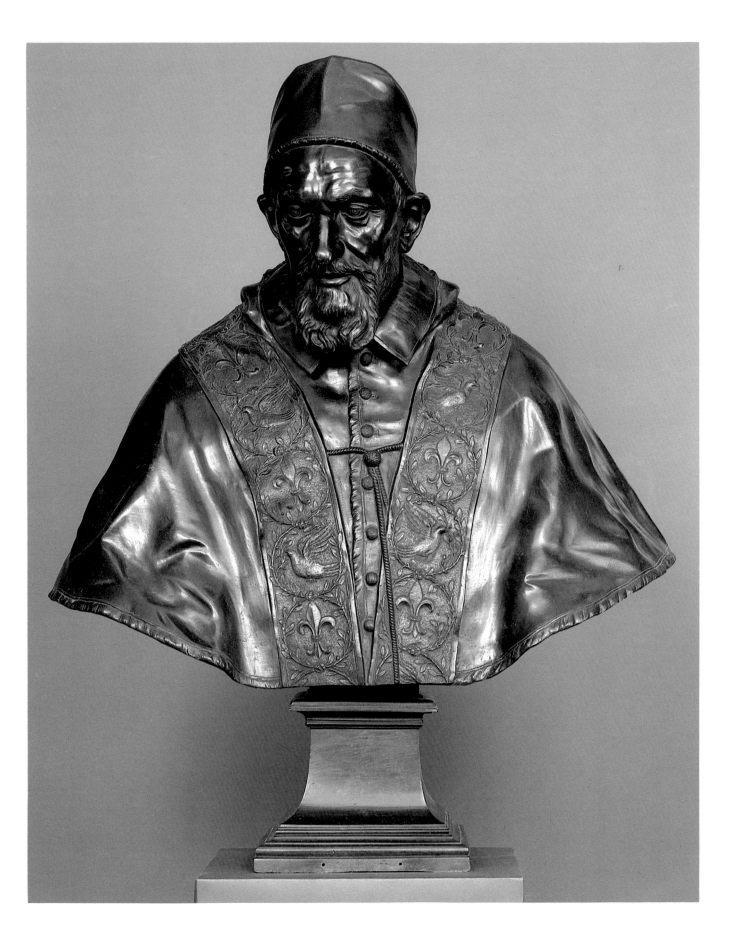

## 4. After **ALESSANDRO ALGARDI**
(Bologna 1595 - 1654 Rome)

*Portrait Bust of Saint Philip Neri*
Bronze, copper alloy; lost-wax cast; dark patination.
Height without base, 7 1/4 (18.4)
References: *Five College Roman Baroque Festival*, 1974,
Smith College, no. 5; Montagu, 1977, 99 note 69; Minneapolis, 1980, no. 20.
David Daniels, New York, NY

Philip Neri (1515 - 1595) was born in Florence, the son of a notary of good family. He left this calling and went to Rome at the age of eighteen. For seventeen years Philip supported himself as a tutor, wrote poetry, and studied philosophy and theology. During this period he founded a brotherhood of laymen who met for worship and to perform acts of charity. During the Jubilee year of 1550, Neri's brothers organized and maintained a hospice for thousands of pilgrims who could not provide themselves with shelter. The institution was named SS. Trinità de' Pellegrini, and its service to pilgrims was renewed every quarter-century during Jubilee years; in the interim, the hospice gave care to convalescent patients, and in time grew into an important hospital.

In 1551 Philip Neri was ordained priest, and soon made a name for himself as a confessor, being credited with the gift of reading hearts.[1] His brotherhood of laymen became known as the Oratorio in 1561. Performances of choral music took on particular prominence in their services, and the name was eventually lent to the modern word, *oratorio*. Philip was confessor to Pope Gregory XIII, who recognized the Congregation of the Oratorio in 1575 and bestowed on them the small church of S. Maria in Vallicella. Philip preached humility, love, and the promise of redemption to laymen as well as clerics. His fame spread to every quarter of the city, and he became popularly known as "the apostle of the city of Rome." By the end of the sixteenth century the Oratorians were the most influential religious order in Rome. The last years of Philip's life were devoted to the construction of a new church, the "Chiesa Nuova".[2] He lived to see much of the decoration complete, and is said to have often wept before the altarpiece of *The Visitation* by Federico Barocci.

This bronze portrait head of St. Philip Neri is based on Alessandro Algardi's statuary group of *St. Philip Neri and the Angel* in the Sacristy of the Chiesa Nuova. The life-size marble group was executed about 1635 - 38, and was publicly unveiled in 1640.[3] Its success launched the career of Algardi, who had previously been completely eclipsed by Gian Lorenzo Bernini. In this bronze, as in its model, Philip Neri is represented in ecstasy. Even so, Algardi's adaption of the features from the Saint's death mask has been often remarked.

Jennifer Montagu considers this bust to be a reduction by an anonymous artist after Algardi's statue.[4] Its origin is clearly Roman. No other casts of this bronze are known.

For additional information, see the introductory essay, *Notes on Portraits of Counter-Reformation Saints.*

1) This biographical sketch, as for most of the saints portrayed in this exhibition, is based on Attwater, 1965, *sub vocem.*
2) *cf.* Haskell, 1981, 68-72.
3) Montagu, 1977, 75 - 81.
4) *ibid.,* 99 note 64.

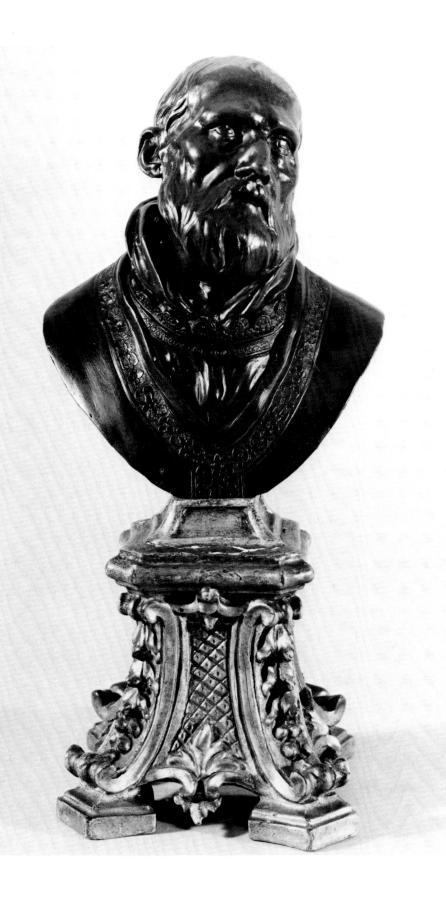

## 5. Attributed to **ALESSANDRO ALGARDI**
(Bologna 1595 - 1654 Rome)

*Portrait Bust of St. Carlo Borromeo*
Silvered bronze. Height without base 7 1/4 (18.4)
References: *Five College Roman Baroque Festival*, Amherst, 1974, no. 49, repr.
David Daniels, New York, NY

Carlo Borromeo (near Lago Maggiore 1538 - 1584 Milan) was one of the quintessential figures of the period of religious ferment that is known as the Counter-Reformation. At the age of twenty-two, Borromeo was named Cardinal, although he was not yet a priest, and was called to Rome by his uncle, Pope Pius IV. At the last sessions of the Council of Trent Borromeo distinguished himself for his fervor. In 1564 he was appointed archbishop of Milan, whereupon he broke with the practice of his predecessors and departed Rome to tend to his diocese. Carlo worked unceasingly to set an example of virtuous and selfless living for his clergy, and his efforts were often resented. Borromeo was beloved however by the needy and infirm, and he became known throughout Italy for his courageous service to his parish during the severe plague of 1576. Carlo Borromeo died greatly venerated at the age of forty-six years. The appeal for his beatification in 1601 was granted the next year; his canonization followed with extraordinary alacrity in 1610.

The portraits of St. Carlo Borromeo executed in his native Lombardy during the seventeenth century are too numerous to recite. Within months of his beatification the Duomo in Milan had commissioned a series of twenty immense canvases (each one, 15 x 19') depicting scenes from his life. The cult of St. Carlo Borromeo attracted an important following in Rome as well, and not only with the sizable Lombard community. Carlo's residence in the Eternal City as a young man had not been forgotten; his succor to victims of the plague struck a sympathetic chord in every capital of Europe. Immediately upon his canonization, construction began on three churches dedicated to this saint, and each one became a notable repository of Baroque decorations: S. Carlo ai Catinari; S. Carlo al Corso; and S. Carlo alle Quattro Fontane, called S. Carlino, the first masterpiece by the architect Borromini. The first Roman addition to Carlo's iconography seems to have predated even his canonization: these were the altarpiece and frescoes painted by Antonio Carracci in a chapel in S. Bartolomeo all'Isola.[1]

The silvered surfaces and finely wrought details of this bust of St. Carlo Borromeo lend the air of a reliquary to this superb work. Unfortunately, our knowledge of the numerous ateliers in Rome that produced sculptures for the delectation of private collectors (as opposed to public decorations) is essentially nil. The attribution to Algardi has been maintained for want of suitable alternative. In any case, the style of this small sculpture reflects a similar culture to Algardi's, namely the widely practiced amalgam of Bolognese dignity with Roman monumentality.[2] No other casts of this bronze are known, nor has any source for its design come to light as yet.

For information on Baroque portraits of Counter-Reformation saints, the reader is referred to the introductory essay on this theme.

---

1) Antonio Carracci's altarpiece of *St. Carlo Borromeo in Prayer,* which was praised by Baglione, 1642, 150, has been presumed lost. However, it is presently behind some furniture in the church sacristy.
2) The attribution to Algardi is not accepted by Jennifer Montagu, who has very kindly corresponded with me on this question.

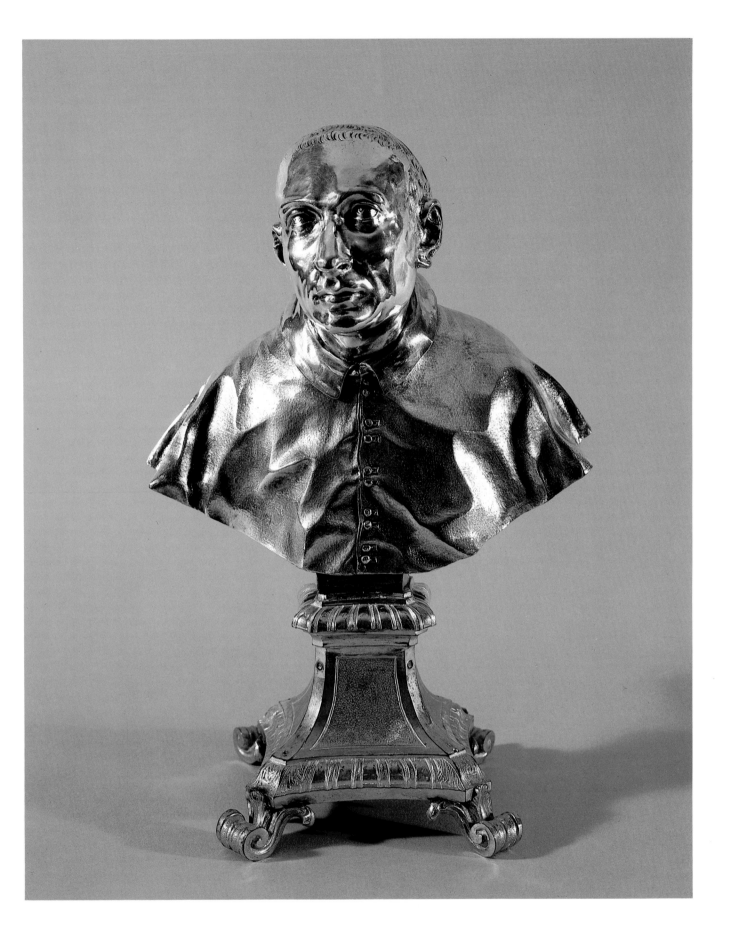

## 6. GIOVANNI BATTISTA GAULLI, called Baciccio
(Genoa 1639 - 1709 Rome)

*Portrait of a Man*
Black and red chalk drawing. 12 1/16 x 8 11/16 (30.6 x 22.1)
References: Newcome, 1972, 112; Gealt, 1983-84, no. 28.
Professor and Mrs. Jonathan Brown, Princeton, NJ

Giovanni Battista Gaulli, called Baciccio, was a transplanted Genoese in the Eternal City. He arrived in Rome at an early age during the middle 1650's. Within a few years Baciccio found his metier as the protégé of Gian Lorenzo Bernini, whose preeminence in the Roman school was undisputed. Their association was mutually beneficial: Baciccio's patronage was assured, while Bernini had found a gifted artist who could translate his ideas into paintings.

The middle period of Baciccio's career, 1672 - 85, was primarily occupied with his greatest achievement, the nine frescoes in the vaults and cupola of the church of Il Gesù. The Swedish traveler Nicodemus Tessin wrote in his diary in 1688 that Baciccio had few followers among the other artists in Rome, but that he was greatly envied on account of his work for Il Gesù.[1] The decline in papal patronage towards the end of the seventeenth century curtailed Baciccio's decorations on a grand scale. Portraiture took on an ever greater prominence in Baciccio's activity — he painted seven popes — and he vied with his great rival, Carlo Maratti, for supremacy in this field among Roman painters.[2]

Portrait drawings by Baciccio are rare, especially in view of the large number of his figure studies that have come down to us. This drawing of an unidentified man, who appears to wear a clerical collar, is an important example of Baciccio's work in this field. It demonstrates at once that here, too, the artist looked to Gian Lorenzo Bernini for direction. Moreover, he has made good use of his lessons. This man's features and the intelligence behind his expression are described with a spare, yet sure application of the chalk. This technique evokes the steel net of Bernini's late style of draftsmanship. Similarly it is a favorite device of Bernini's to concentrate our attention on the eyes above all, as can be seen in his drawn *Self-Portrait* of about 1665 at Windsor Castle.[3]

A suggested dating to the late 1660's for this portrait by Baciccio has been advanced by Mary Newcome.

1) Quoted in Canestro Chiovenda, 1966, 175-76, *q.v.* for many interesting notices on Baciccio during this period. Tessin's original text is published in the rare volume by Sirén, 1914, 192-93.
2) Pascoli, 1730, I, 207, writes that Baciccio painted every pope from Alexander VII to Clement XI.
3) Windsor, 5539. Illustrated in Sutherland Harris, 1977, no. 84.

J Gandli fece

## 7. GIOVANNI BATTISTA GAULLI, called Baciccio
(Genoa 1639 - 1709 Rome)

*Portrait of a Man*
Oil on canvas. 27 1/16 x 21 3/4 (68.7 x 55.2)
References: Zeri, 1976, no. 325.
The Walters Art Gallery, Baltimore, MD
(No. 37.1832)

The attribution of this engaging portrait to Baciccio, ca. 1700, is due to Federico Zeri, who has also pointed out that the young man's suit has the appearance of a uniform. That observation led Zeri to propose the attractive hypothesis that the unidentified young man may have been a member of a foreign diplomatic delegation, perhaps Polish, and perhaps of royal lineage in view of the ermine trim to his jacket. (The problem must remain open.)

Portraits of this kind, in which the artist has made every effort to present a candid and animated image of the sitter, were commonly known as "speaking likenesses." Baciccio followed the example of Bernini, who was a master at portraying in marble, as in any other medium, his subjects in seeming movement. Pascoli describes Baciccio's method: "In making portraits he had a manner completely contrary to the one in common practice. He said he learned it from Bernini, who in making portraits did not want the person portrayed to stay motionless and quiet, but instead wished them to speak and move. He said that precisely in those motions people are the most like themselves."[1]

Cross-Reference: Bernini, Exh. no. 9.

---

1) Pascoli, 1730, I, 207. English translation adapted from Enggass and Brown, 1970, 150.

**8.** Attributed to **GIOVANNI BATTISTA GAULLI,**
called **Baciccio** (Genoa 1639 - 1709 Rome)

*Portrait of a Lady with a Dog*
Oil on canvas. 45 3/4 x 34 (116.2 x 86.4)
References: R. L. Manning, 1962, no. 36, repr. (as Francesco
Solimena).
Suida Manning Collection, New York, NY

The lady portrayed in this striking image of *noblesse
oblige* has alas not been identified. Indeed, the attribution
of this portrait is frankly problematic. Robert L. Manning
has published this painting as a work by Francesco Soli-
mena, the leading artist (and portraitist) in Naples at the
turn of the century. The possibility of Neapolitan author-
ship cannot be ruled out, although Solimena would
appear to be the only artist in that sphere capable of paint-
ing a portrait with the psychological intensity of the pres-
ent work.

On the other hand, the drapery style, in particular the
pattern of folds in the vividly orange mantle, suggest to the
present writer the direct influence of G.B. Gaulli, Il Bacic-
cio. However, Baciccio painted hands according to an idio-
syncratic pattern that is not noticeable in the simple, firm
modelling of this lady's hands. Neither is Baciccio recorded
as ever painting a female portrait.

The difficulty in establishing the identity of this painter is
symptomatic of the spare state of knowledge concerning
late Baroque portraiture. As regards Roman portraits of this
period, only the works of Carlo Maratti and Baciccio have
been studied to any extent. However, the volume of surviv-
ing portraits of noteworthy quality is immense. These
paintings are not likely to find their authors until the
many pupils of these masters — the little known Giacinto
Calandrucci (1645 - 1706) comes to mind in the present
instance —receive due attention.

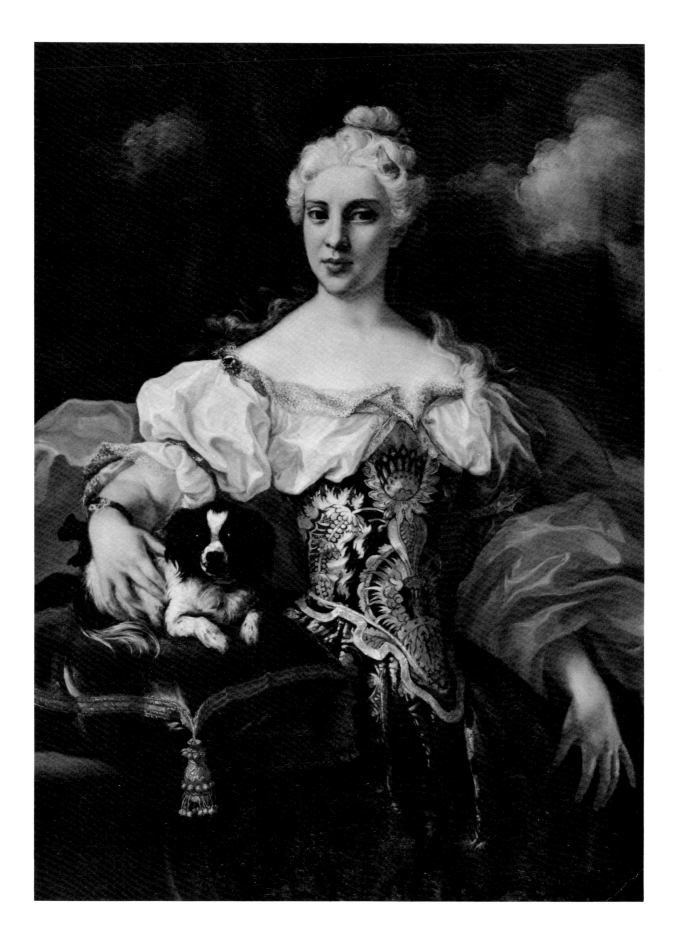

**9. GIAN LORENZO BERNINI** (Naples 1598 - 1680 Rome)

*Portrait of a Young Man*
Red chalk with some white heightening on buff paper.
13 x 8.6 (33.0 x 21.8)
References: Sutherland Harris, 1977, no. 10.
Collections: J. Petit-Hory, Levallois-Perret.
The J. Paul Getty Museum, Malibu, CA
(no. 82.GB.137)

This informal study of a young man demonstrates both the portrait style and the draftsmanship of Gian Lorenzo Bernini at their most spontaneous. Bernini was an avid portrait draftsman, and numerous examples by him are known. His usual manner consists of a more even stroke and presents a more finished appearance.[1] In general, Bernini's portrait drawings reveal the precedence of the naturalistic portraits drawn by the Carracci school in Bologna and Rome. On occasion a relationship can be traced between Bernini's drawings *à deux crayons* and Ottavio Leoni's extensive production in this technique.[2] When merely sketching, however, as in this sheet or in his famous study of Cardinal Scipione Borghese,[3] Bernini's hand is unlike any other artist's.

Ann Sutherland Harris proposes a date in the mid-1620's for this drawing. The same scholar points out that drawings in red chalk without the addition of black chalk are relatively rare in the artist's oeuvre,[4] which further suggests that this sheet was executed on the spot, without rehearsal.

Cross-Reference: Chéron, Exh. no. 18.

1) Compare the ex-Avnet drawing, now in the National Gallery, Washington, which is probably contemporary in date: see Bean and Staempfle, 1967, no. 67.
2) Compare the drawing in red and black chalk in the Fondazione Horne, Florence: Ragghianti Collobi, 1963, pl. 5.
3) In the Pierpont Morgan Library, NY. See Appendix 24.
4) This drawing will be included in the forthcoming catalogue by Sutherland Harris and Braham of Bernini's drawings. I am grateful to Ann Harris for sending me a copy of the catalogue entry in advance of publication.

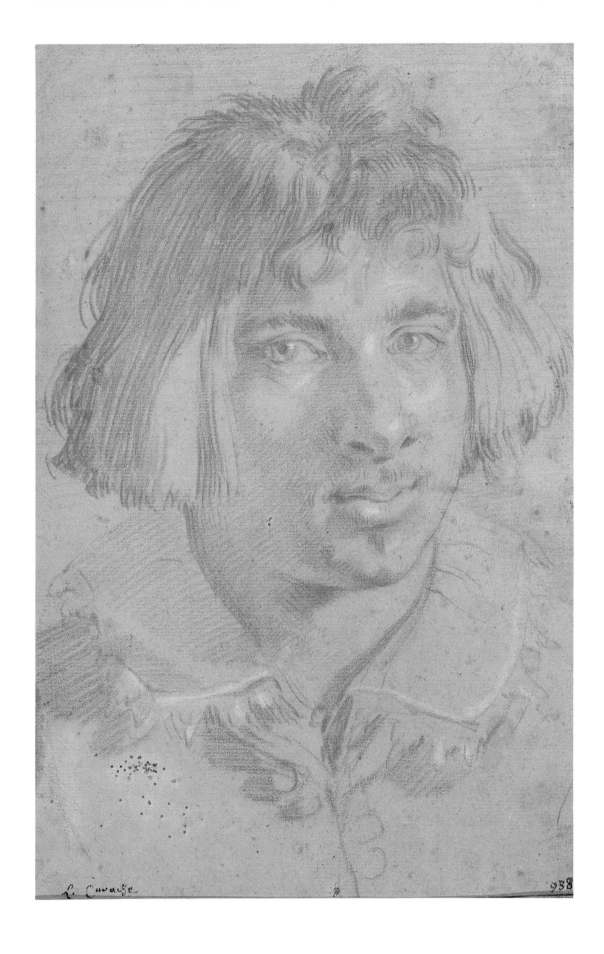

L. Cavedo                                          938

## 10. After GIAN LORENZO BERNINI
(Naples 1598 - 1680 Rome)

Engraving by Claude Mellan (Abbeville 1598 - 1688 Paris)
*Portrait of Pope Urban VIII*
(Maffeo Barberini, Florence 1568 - 1644 Rome)
Bound in Urban VIII, *Poemata*, Rome, 8 9/16 x 6 1/16 (21.7
x 15.3)
Dated: 1631.
References: P.S.M. Mannino in *Bernini in Vaticano*, 1981,
no. 53 (with additional bibliography).
The Newberry Library, Chicago, IL
(no. WingZP635.C691)

The long, controversial papacy of Urban VIII impressed its
parabolic form upon the Baroque epoch as a whole. In his
military and political preoccupations this pope imagined
himself the descendent of Julius II, the High Renaissance
prince of the Church. Nevertheless, Urban VIII's campaigns
were invariably futile. He left the treasury bankrupt and the
papacy finished as a temporal power.

Historians of art have great tolerance of Urban VIII, how-
ever. Within the space of twenty years Rome, the seat of
Christendom, was transformed into the most splendid capi-
tal in Europe, mainly through the employment of Gian
Lorenzo Bernini, the greatest sculptor of the age who
revealed himself as the greatest architect as well. As Pastor
noted, the three bees of the Barberini coat of arms as it was
sculpted or painted over countless portals and monuments
became the distinctive emblem of the Baroque. Urban
VIII's Florentine heritage undoubtedly encouraged the
impulse to adorn the salons of his palaces and the public
fora of Rome with his sculptured effigies; and through
Bernini's genius, the papal bust was developed into the
epitome of Italian Baroque portraiture.

The present portrait is one of the most familiar images of
Urban VIII. It was engraved by Claude Mellan, a French
artist in Rome, after a drawing by Bernini, as the inscrip-
tions make clear. The print was commissioned for inclu-
sion in the 1631 edition of the pope's Latin poems.[1] P.J.
Mariette recorded in the next century that Mellan's print
was widely known as "the portrait du pape pointillé" in
respect of the engraver's subtle use of pouncing in order to
render the shading in the face.[2] Martinelli has remarked on
the Carraccesque character of Bernini's lost drawing for this
portrait, as well as the artist's emerging interest in psycho-
logical characterization.[3]

Cross-References: Chéron, Exh. no. 18; Mellan, Exh. no. 43.

1) Pollak, 1928, I, 385, publishes a payment to Mellan on 26 March 1631
"Per una testa di ritratto intagliata in rame per servitio di N[ost]ro.
Sign[ore]."
2) *Abecedario de P.-J. Mariette*, 1854-1856, III, 339.
3) Martinelli, in *Commentari*, I, 1950, 179.

# VRBANVS VIII BARBERINVS PONT·MAX·

Eq.ᵗ Io·Lauren·Bernini· del .      Claud· Mellan· Gall.ᵗ F. 1631·

**11.** Attributed to **GIAN LORENZO BERNINI**
(Naples 1598 - 1680 Rome)

*Portrait Plaque of Pope Gregory XV*
(Alessandro Ludovisi, Bologna 1554 - Pope 1621 - 1623
Rome)
Obverse: Bust to right, wearing cap, mozzetta, and stole.
Inscribed: *GREGORIVS.XV.P.O.M.CREATVS*
*DIE 12 FEBRVARII.1621.*
Bronze, without reverse. Diameter, 12 1/8
References: *Five College Roman Baroque Festival*, Smith
College, 1974, no. 21; Hiesinger in Philadelphia, 1980,
no. 116 note 2.
Michael Hall, New York, NY

Alessandro Ludovisi (1554 - 1623) was educated by the
Jesuits in his native Bologna, where he subsequently took
his doctorate of laws. He was promoted in ecclesiastic service
by Clement VIII in recognition of his expertise in judicial
questions and controversies. Pope Paul V conferred the
cardinal's hat on him on September 19, 1616. Alessandro
Ludovisi ascended the papal throne on February 9, 1621,
assuming the name of Gregory XV. This pope was of ailing
health, devout by nature, and sparing in his words. For
affairs of government he greatly availed himself of the
services of his nephew Ludovico Ludovisi, whom he named
Cardinal on February 15, 1621. Gregory XV's concern for
the spiritual interests of the Church is evidenced by his
foundation of the 'Propaganda Fide' (the Congregation of
Propaganda), and the canonization of Saints Ignatius Loy-
ola, Philip Neri and Francis Xavier.[1]

The inscription on the plaque refers to the election of Pope
Gregory XV on February 12, 1621. This portrait in bronze
may therefore have been cast soon after that occasion.[2]
However, at the present time this magnificent work raises
many questions for which definitive answers cannot be
found.

The work is unsigned, nor is it known in any other versions.
The attribution to Gian Lorenzo Bernini was published
upon its exhibition in 1974, but has never been commented
upon by scholars. The present writer attributes this portrait
relief to Bernini, but proposes that the work was designed as
a posthumous memorial. The documented portraits of
Gregory XV by Bernini, which are busts in marble and
bronze, represent the pope in the massive, ceremonial cope
of his office. The warmth, intelligence, and vitality of this
interpretation are indications that Bernini has already had
the benefit of much of the development that his conception
of portraiture would undergo in the service of Pope Urban
VIII (1623 - 1644). The style of drapery would appear to rule
out a later date.

In view of the unprecedented dimensions, format, and illu-
sionism of this bronze it should perhaps be considered
within the context of sculpture in bas-relief as opposed to

medallic art.[3] Following the cast, the sculptor has worked
the cold bronze with extraordinary care. Every strand of hair
that emerges from beneath the cap has been incised with a
chisel; the same is true of the eyebrow at the point of its
nearest approach to the viewer. This virtuoso use of incision
to create the illusion of projection brings to mind Bernini's
remark to the Sieur de Chantelou that the sculptor was
often called upon to form things in an unnatural way in
order for them to appear lifelike. But the most dazzling
illusionism of this piece lies in the scoring of the back-
ground. In some ineffable fashion the moiré pattern of
chiselled indentations transforms the opaque medal surface
into the semblance of palpable atmosphere. The sculptor's
insistence on modelling the figure in three-dimensional
volume, when considered together with the prominence of
the lettering, suggests that this relief was executed for pres-
entation within an architectural framework of some kind.
One could imagine its commission from some institution
desirous to commemorate the patronage of the late pope of
venerated memory.

Cross-References: Chéron, Exh. no. 18; Guercino, Exh.
no. 26.

---

1) This biography, and the other biographies of popes for whom Bernini
worked, has been adapted from the excellent notes given by Samek Ludo-
vici ed., 1948, 204-5.
2) An analogous inscription is found on another unsigned plaque in this
exhibition, that of *Pope Pius V* (Exh. no. 56), which can safely be dated a
century after the death of Pius V.
3) If this bronze is correctly dated to the first half of the century, then its
influence on subsequent portrait medallions and plaques, such as can be
seen in this exhibition, cannot be overstated. At present, the earliest papal
medal to approach the dimensions of a plaquette is believed to be Berni-
ni's 1659 design for a portrait of Alexander VII with the reverse of Andro-
cles and the Lion (see Whitman with Varriano, 1983, no. 79; and *Bernini
in Vaticano*, 1981, no. 291), which measures 3 7/8 (9.8), less than half the
diameter of the work in question.

## 12. MELCHIORRE CAFÀ (Malta 1631 - 1667 Rome)

*Portrait Bust of Pope Alexander VII*
(Fabio Chigi, Siena 1599 - Pope 1655 - 1667 Rome)
Bronze. Height including base, 39 1/2 (100.3)
Signed and dated on reverse: *MELCHIOR. CAFA*
*MELITENSIS FAC. AN. DOM. MDCLXVII.*
Collections: Baron Gustave de Rothschild, Paris; Palais
Lambert, Brussels.
Reference: Witkower, 1959, 197-204; Wittkower, 1981, 243
The Metropolitan Museum of Art, New York, NY
(Edith Perry Chapman Fund, 1957.20)

Fabio Chigi was born in Siena in 1599 into a celebrated
family which had tendered important commissions to
Raphael in Rome during the Renaissance. Chigi's diplo-
matic talents were first recognized by Urban VIII. His astute
and tactful negotiation in Münster of the Peace of Westpha-
lia (1648) was the highpoint of Innocent X's foreign policy.
He received his Cardinal's hat in 1652, and was elected Pope
on April 7, 1655, assuming the name of Alexander VII.
Upright, pious, well intentioned, Alexander VII was of
unstable health, and his energies were drained by the con-
stant effort to contain the expansionist policies of Louis
XIV. Gian Lorenzo Bernini was fully rehabilitated during
this papacy, and was ceaselessly employed in great works
for the embellishment of St. Peter's and Rome.

The brief career of Melchiorre Cafà was filled with accom-
plishment and early recognition of his extraordinary tal-
ents. Edward Sammut has called him, with parochial bias,
"the great 'might have been' of Maltese art history."[1] Prior
to his untimely death in a workshop accident, Cafà had
already given every indication that he would become the
most influential sculptor in Italy during the second half of
the seventeenth century. He arrived in Rome as a youth and
entered the studio of Ercole Ferrata. Pascoli reports that
Cafà was universally well liked.[2] Indeed, his master seems
never to have resented his rapid ascent in the world of art.
Ferrata even completed two major compositions left unfin-
ished at Cafà's death, evidently endeavoring to work as
faithfully as he could in the style of his former pupil. Cafà
preferred to work in bronze as opposed to marble, for when
working in stone he found it difficult to restrain his innate
exuberance.[3] He practiced a lively Baroque style, which was
distinguished by a native strain of naturalism, as can be
clearly observed in this portrait bust of Alexander VII. Not
even Bernini would have indulged himself quite so
unabashedly in the characterization of the myriad wrinkles
on the pope's aged face.

This bust is unusual in that it is fully signed and dated in
the cast. To judge from the published documentation, the
prime cast of this bust is the gilded bronze now in the

Cathedral of Siena.[4] Cafà submitted his bill for that cast on
August 8, 1667. As it happened, the pope had died in May of
that year, and Cardinal Chigi appears to have been unen-
thusiastic about this expense.[5] A month later, on September
10th, Cafà's career was tragically ended. The terracotta
model for this bust is preserved in the Palazzo Chigi,
Ariccia; it was purchased from the painter, Michel Angelo
Marullo, in February, 1669.[6] Baldinucci, writing in the early
1680's, refers to the terracotta bust of the pope as one of the
principal works of Cafà's career, and remarks that many
casts had been taken from it.[7] In a recent publication of
Alexander VII's diary, there is a reference to the pope's
meeting on December 19, 1666, with a certain "Maltese" —
as was Cafà's sobriquet — and with the painter G.B. Gaulli
(Baciccio) with regard to the impending completion of a
"terracotta" and a "portrait in profile."[8]

For further information, the reader is referred to the intro-
ductory essay, *Notes on Four Papal Portrait Busts in
Bronze.*

---

1) Sammut in Malta, 1970, 59.
2) Pascoli, 1730-36, 258.
3) *ibid.*, 258.
4) Wittkower, 1959, p. 197ff., offers an hypothesis to the effect that the
Metropolitan Museum cast of this bronze must have preceded the gilt cast
now in the Siena Cathedral, which is specified in the contract of August
1667. He argues that, on the one hand, the cast in New York displays from
the reverse a repaired break across the chest which signifies that the cast was
unsuccessful and could not be submitted to the patron. On the other hand,
Wittkower makes the seemingly contradictory observation that the surface
of the New York cast was more carefully finished than that of the Siena cast.
It is difficult to reconcile these points with the proposition that the New
York cast was "unsuccessful." In any event, if the terracotta model was
almost finished in December of the previous year, it seems more likely that
Cafà had finished another cast prior to August, 1667, rather than between
that date and his death.
5) Golzio, 1941, 302, Doc. 3115. The artist's statement of expenses, includ-
ing recompense to the bronze caster, Giovanni Artusi, amounted to 150
scudi. He nobly left the matter of his own award to the discretion of his
patron, who responded with only 200 scudi in total.
6) Martinelli, 1956, 45 note 92. Wittkower, 1959, 204, reads this document to
mean that "Michel Angelo Marullo, pittore" was paid to *paint* the bust.
The minimal sum which was paid, 15 scudi, is evidence of the low esteem
in which clay models were held in comparison to finished sculptures in
more permanent materials. The inventories of the contents of Bernini's
house after his death treat the carloads of terracotta models and sketches
left by the artist as so much junk. *cf.* Borsi, 1981, 107.
7) Baldinucci, F. 1975 ed., V, 391 - 92. Pascoli, 1730, 257, repeats this
information essentially *verbatim.* An inferior cast, which displays some
variations from the terracotta in the folds of the mozzetta, was sold with
the von Dirksen Collection at Lepke, Berlin, April 1931, no. 464, pl. 57.
8) Morello in *Bernini in Vaticano*, 1981, 340: "fà finir la creta e la [...] del
Maltese, e di Baciccio, Gaulli, del n(ost)ro ritratto di profilo." The
lacuna makes this shorthand notation especially difficult to interpret: if
the missing word were *disegno* or *quadro*, then one could justly read
this passage as referring to a terracotta by Maltese and a drawing or
painting by Baciccio. We know from Pascoli, 1730-36, 258, that the two
artists were devoted friends.

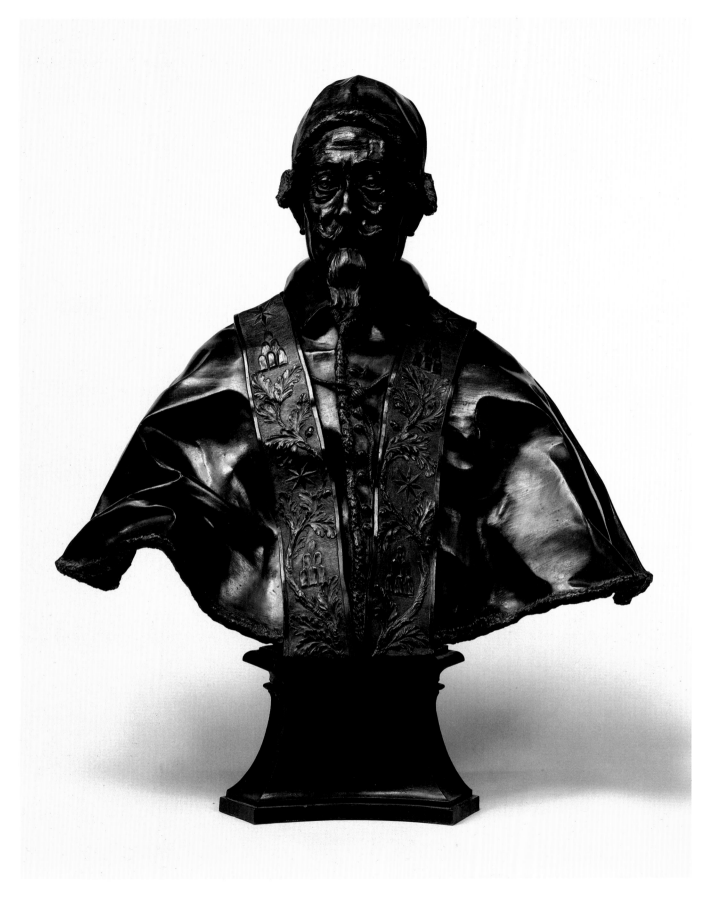

## 13. JACQUES CALLOT (Nancy 1592 - 1635 Rome)

*The Baptism of the First Son of Margherita of Austria
Queen of Spain*
Etching. 12 1/8 x 8 13/16 (30.8 x 22.4)
Signed at lower left, *I callot f*
[*Page opposite: The Presentation of the Infant Philip III to
the Bishop.* Etching by Antonio Tempesta.]
Bound in Giovanni Altoviti, *Essequie della sacra cattolica
e real maestà di Margherita d'Austria regina di Spagna,
celebrate dal Serenissimo don Cosimo II. gran duca di
Toscana.* Florence, 1612.
Reference: Russell, 1975, no. 9
Spencer Collection, The New York Public Library, New
York, NY, Astor, Lenox and Tilden Foundations
(Ital. 1612)

On February 6, 1612, solemn obsequies in observance of
the death of Margherita of Austria, Queen of Spain, were
celebrated in Florence at the Medici family church of San
Lorenzo. The deceased was the sister-in-law of Cosimo II,
Grand Duke of Tuscany, and no expense was spared in
the homage paid to the memory of another head of state
and a close relative. The Grand Ducal court as a rule was
punctilious in such demonstrations of noble etiquette, and
was especially addicted to the display of pomp as well.

The interior of San Lorenzo was transformed for Margher-
ita's ceremonies through the installation of black drapes,
fictive architecture, sculptures, and paintings according to
the design of Giulio Parigi, scenographer to the Medici
court. The expense and effort that were devoted to ephem-
eral decorations of this sort — the bulk of which were to be
discarded as soon as the occasion had passed — were
among the favorite extravagances of the Baroque era. Our
knowledge today of the catafalques, stage designs, parades
and other festivities of that time must be gleaned from
commemorative prints. Very often series of these prints
served to illustrate descriptive volumes called "festival
books." The Medici were responsible for a number of the
finest seventeenth-century festival books, including Alto-
viti's *Essequie* with engravings by Jacques Callot, Antonio
Tempesta, and Raffaello Schiaminossi, and the *Essequie
del Ser.mo Principe Francesco de' Medici* with a portrait by
Stefano della Bella, also in this exhibition.

The volume issued after the funeral of Margherita of Aus-
tria contains engravings based on the twenty-six paintings
of scenes from the life of the Queen which were arranged
as a frieze on either side of the church.[1] The paintings were
executed in tones of gray only, *en grisaille*, by Jacopo
Empoli and artists in his circle (art historians have yet to
distinguish their hands).[2] As separate entities the prints by
Callot, Tempesta, Schiaminossi, are rather colorless in
their own right. However, the illustrations and the bold

seicento typography are intermingled to make page lay-
outs of charming confusion.

This commission was crucial to the career of the young
Jacques Callot, for it served to introduce him to Medici
patronage. Born in Nancy, Callot had apprenticed for four
years after 1607 with the court medallist of the Lorraine.
He was then employed on the funeral book of Charles III
of Lorraine which was in preparation between May, 1608,
and July, 1610. This credential must have been well
received in Florence, since Callot was soon called there
from Rome for his contribution to the present work.[3]
Within a few years, the engraver's competence and confi-
dence increased sufficiently, so that he was able to produce
the compositions of his fantasy for which he is justly
famous today.

Cross-Reference: Della Bella, Exh. no. 20.

1) Vliegenthart, 1976, 80, observes that the historical paintings commis-
sioned by Michelangelo Buonarroti the Younger, 1615 - 22, in honor of his
famous namesake were deeply influenced by the decorative cycles for the
funerals of foreign sovereigns that had been celebrated at San Lorenzo in
preceding years. The scenes from the life of Margherita of Austria present
many analogues to the Casa Buonarroti paintings. The portrait of Gio-
vanni Altoviti can also be seen among the latter, and many of the same
artists participated in both projects.
2) The preliminary drawing, attributed to the "School of Empoli," is in
the Uffizi (n. 9359F): Florence, 1969, fig. 42. The grisaille painting is on
deposit at the Gallerie Florentine, inv. 7798.
3) This chronology, which reduces Callot's Roman period to a matter of
months, is from Rothrock with van Gulick, 1979, 17 and 32 note 1.

# ESSEQVIE DELLA

## 14. GIOVANNI BATTISTA CARACCIOLO
called Battistello (Naples 1578 - 1635 Naples)

*Portrait of a Girl Drawing and other Studies of Children*
Pen and brown ink on gray paper. 9 11/16 x 14 7/8 (24.6 x 37.8)
References: Gibbons, 1977, cat. no. 144.
The Art Museum, Princeton University, Princeton, NJ
(Dan Fellows Platt Collection, 48-592)

Giovanni Battista Caracciolo is appreciated as the first Neapolitan artist who responded to the drama and naturalism of the paintings executed by Michelangelo da Caravaggio in Naples in 1606-7.[1] Caracciolo's conversion had a decisive effect on his fellow painters, and under his influence Caravaggism took deeper root in Naples than it did in Rome, where the master had worked for fifteen years. Caravaggio did not paint any portraits in Naples; neither was portraiture a significant aspect of Caracciolo's oeuvre.

Thanks to the archival researches of Salazar in 1897 and Stoughton recently,[2] we know that Caracciolo married in 1598 and was the father of ten children (*pace* De Dominici, who wrote in 1743 that the artist was a solitary man and a bachelor[3]). Between 1602 and 1612 six sons and daughters were born into the family. This charming drawing undoubtedly reflects the situation in the Caracciolo household ca. 1620, when perhaps Chiara, who was born in 1604, could be seen studiously working on a drawing, while one of her brothers naps under a hat. Notwithstanding the family resemblances, it appears that the same boy has been drawn twice: in full face at the top of the sheet, and in right profile at the lower right.

1) For the most recent biography see Pierluigi Leone de Castris in Whitfield and Martineau, eds., 1982, 110 - 11.
2) Stoughton, 1978, 208 - 10; for the Salazar reference, 209 note 28.
3) De Dominici, 1742/43, II, 287.

219

## 15. LUDOVICO CARRACCI (Bologna 1555 - 1619?)

*Portrait of a Widow*
Oil on canvas. 39 1/4 x 30 1/2. (99 x 77)
References: Bologna, 1956, no. 67; Evans, 1969, no. 25 (with bibliography)
The Dayton Art Institute, Dayton, OH
Museum Purchase, (no. 58.15)

This portrait of a widow in prayer was first published as a work by Annibale Carracci, the younger and more famous cousin of Ludovico. Following the exhibition of this painting in Bologna in 1956, the correct attribution was proposed by Michael Jaffé and accepted by Denis Mahon, who specified a date of 1589-90. Indeed, the spiritual identity of this lady is described with a poignancy that seems wholly typical of Ludovico's art as distinct from Annibale's, who would have described the physical presence of the figure in more sensuous terms. Between the two careers of Ludovico and Annibale Carracci essentially every artistic current of consequence in the seventeenth century was anticipated. Ludovico's contribution to this equation was his discovery of a vein of religious expression that was not less profound or less mystical for its firm adherence to human experience.

The precocity of Ludovico's achievement in this light is brought out through the ease with which this pre-Baroque portrait can be inserted into the context of this exhibition. It antedates Rubens's *Portrait of Marchesa Brigida Spinola Doria* (Exh. no. 60), which is itself innovative on several grounds, by fully fifteen years. In his 1956 catalogue notes on *Portrait of a Widow*, Gian Carlo Cavalli distinguished between the style of this painting and coeval portraiture in terms that remain valid, notwithstanding the subsequent reattribution to Ludovico. Cavalli observed that this painting would be a valuable addition to an anthology of European portraiture of the later sixteenth century, and would not be diminished by the proximity of portraits by Mor, Pulzone, Clouet or Coello. "However, in contrast to those more rigid, even if elevated examples of parade portraiture, sacred and secular, here the tone is more human, less abstract. There emanates from it a symbolism of Christian devotion according to the tenets of the Counter-Reformation, and at the same time, the private character of a personal event."

Following Annibale's transfer into the international sphere of the Roman art world, Ludovico enjoyed nearly three decades of undisputed seniority in the Bolognese school of painting. He was free to exercise in his choice of commissions a personal commitment to complex, often erudite, themes of religious history. Portraiture occupies a minor place in his activity. It is consistent with Ludovico's personality that he has invested this portrait with a spiritual dimension of unusual prominence. The painting fulfills an intention which goes beyond the illustration of the widow's appearance and even beyond the interpretation of her character: the figure is depicted in an act that the viewer is urged to emulate. The widow acts in the role of intercessor, analogous to that of the donor figures found in earlier paintings of sacred subjects and anticipatory of countless devotional portraits of saints and martyrs in the century to come.

## 16. CARLO CERESA
(S. Giovanni Bianco 1609 - 1679 Bergamo)

*Portrait of a Lady*
Oil on canvas. 37 3/8 x 30 11/16 (95 x 78)
[Photograph before cleaning]
References: "I Pittori della Realtà in Lombardia." Palazzo Reale, Milan, 1953, 39, no. 44; Valsecchi, 1972, 24; Ruggeri, 1979, 179 and 182.
Suida Manning Collection, New York, NY

Carlo Ceresa was one of the rediscoveries in the landmark exhibition in 1953 of (in Roberto Longhi's words) "the Lombard painters of reality." The beginning of the seventeenth century had witnessed the activity of Michelangelo da Caravaggio, the greatest realist of them all. At mid-century, two painters in Bergamo sustained the Lombard strain of naturalistic observation: Carlo Ceresa and Evaristo Baschenis. The latter artist is widely regarded as the foremost Italian painter of still lifes.

Sir Ellis Waterhouse has written aptly on the portraiture in Bergamo during this period, and his comments are pertinent to this formidable picture of an unidentified lady. "Since the time of G.B. Moroni (d. 1578) there had been a more persistent demand for portraiture by the Bergamasque nobility than obtained in any other Italian city. Bergamasque society was highly cultured, exclusive of outside contacts, and became increasingly tinged with Spanish gravity. Costume and formality molded the character, and costume was mainly black and white. The portrait painter could only indicate character in these terms, which demand a nice sense of interval and pattern, and there is an obvious link between this type of portraiture and still life. Ceresa's masterpiece in this idiom ... is a study in black and white in which hands, face, and costume all count equally for the final effect."[1]

Indeed, the different styles of dress provide the principal means for the dating of Ceresa's portraits. Valsecchi[2] and Ruggeri[3] concur in a date of about 1650 for the present painting, since very nearly the same collar, cuffs and dress can be observed in a portrait by Ceresa from that year.

1) Waterhouse, 1969, 144.
2) Valsecchi, 1972, fig. 24.
3) Ruggeri, 1979, 182. Ceresa's portrait dated 1650 (private collection, Bergamo) is illustrated in color in fig. 74.

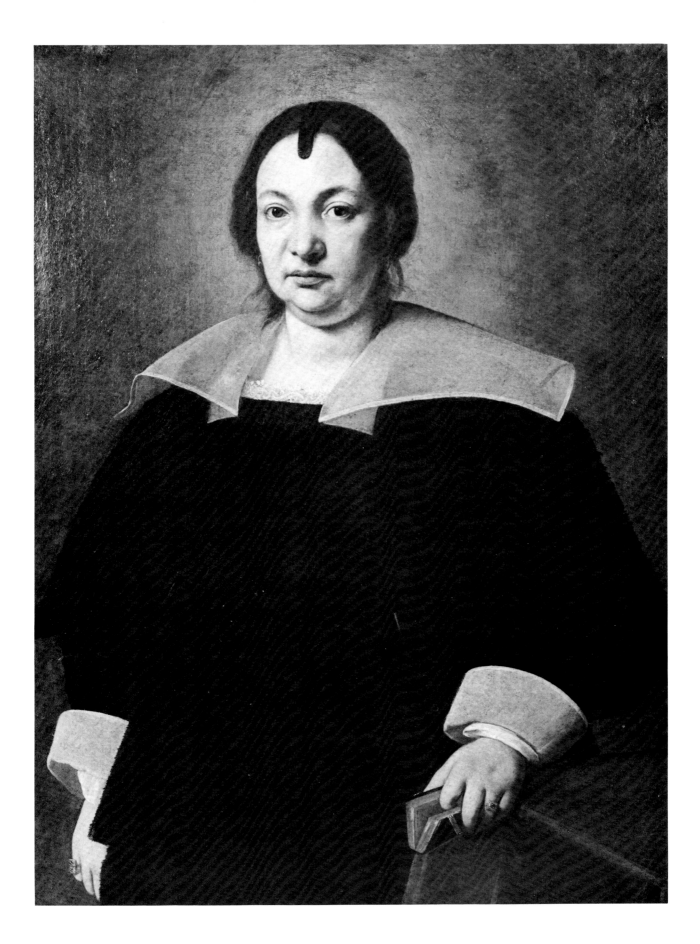

## 17. CARLO CERESA
(S. Giovanni Bianco 1609 - 1679 Bergamo)

*Portrait of a Young Girl*
Oil on canvas. 25 11/16 x 19 7/8 (65.2 x 50.5)
References: Zeri, 1976, no. 377; Ruggeri, 1979, 113.
The Walters Art Gallery, Baltimore, MD
(no. 37.608)

This charming portrait of a child was first recognized as the work of Ceresa in the list published by Fredericksen and Zeri.[1] The attribution was justified by Zeri in the subsequent catalogue of the Walters Art Gallery. The proposed date of ca. 1630 has been endorsed by Ruggeri on the basis of the Spanish taste of the girl's dress. The stiff white collar, the *golilla*, reached Lombardy from Spain after 1625.

Ceresa was a sympathetic portraitist of children, endowing them in his paintings with their own personalities. On at least one occasion he portrayed the features of his own children as the faces of cherubim in a religious composition.[2]

The importance of religious commissions to Ceresa's career has been rediscovered only within this decade. The catalogue by Ugo Ruggeri illustrated for the first time, many in color, Ceresa's numerous altarpieces. In 1983, when Luisa Vertova curated for the city of Bergamo a major exhibition of Ceresa's paintings, numerous altarpieces from outlying parishes and Bergamesque towns were installed alongside examples of the artist's portraiture.[3] As a result, Ceresa must be recognized as a religious painter of notable gifts with particular interest for the strict orthodoxy of his Counter-Reformation style.

The exhibition in Bergamo pointed out, moreover, the impressive consistency of Ceresa's production over the course of several decades. Vertova has refuted the undocumented notice that the young artist studied in Milan with Daniele Crespi.[4] The first works by Ceresa do not depend upon Crespi's models; instead they borrow motifs from an eclectic variety of prints.[5] Indeed, the extraordinary fidelity with which Ceresa re-created in Baroque terms the characteristic types and compositions of G.B. Moroni, the great painter of the late Renaissance, should be taken as evidence that Ceresa's training was oriented towards Brescia.

After 1633 Ceresa's mature style arrives suddenly. On the basis of a remark by F.M. Tassi, the biographer of Bergamesque painters, Vertova accepts the possibility of a sojourn in Venice as the catalyst for this development.[6] The probable influence of the Venetian painter Tiberio Tinelli on Ceresa's portraiture has been observed by several authors.

Cross-Reference: Tinelli, Exh. no. 73.

1) Fredericksen and Zeri, 1972, 51.
2) Vertova, 1983, 49.
3) *Carlo Ceresa un pittore bergamasco nel '600*, Palazzo Moroni and the Accademia Carrara, Bergamo, 1983. I would like to express my gratitude to Francesco Rossi for his kind assistance during my visit to the exhibition.
4) *ibid.*, 35.
5) *cf.* Rossi, "Tra Goltzius e Barocci, gli esordi di Carlo Ceresa," in *ibid.*, 25-31.
6) *ibid.*, 39.

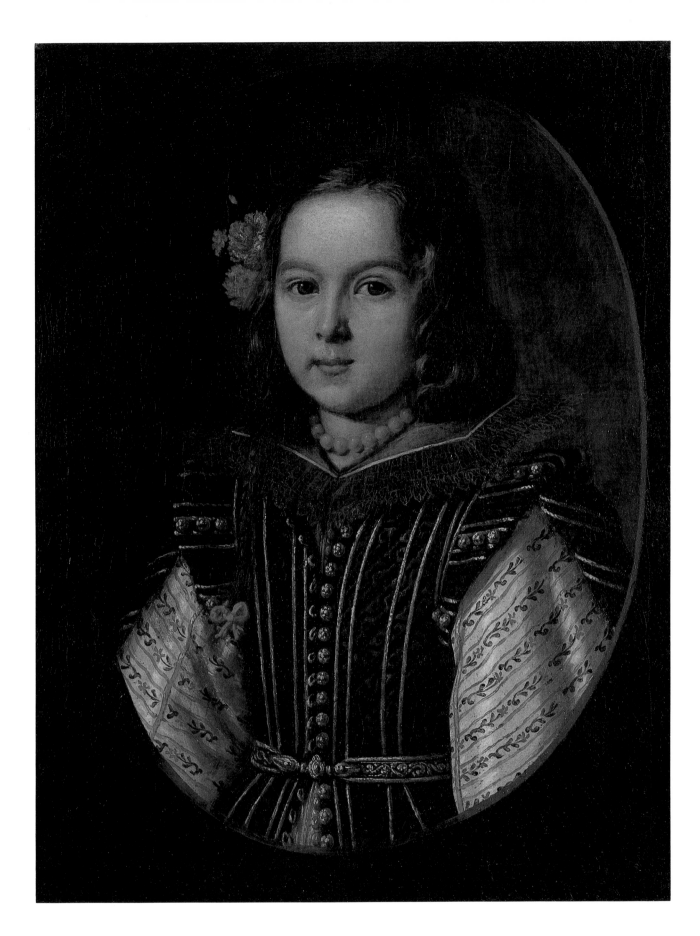

## 18. FRANÇOIS CHÉRON Lunéville 1635 - 1698 Paris)

*Portrait Medal of Gian Lorenzo Bernini*
Bronze. Hole at top. Diameter, 2 3/4 (7.2)
Signed, on the truncation, and dated on obverse: *F. Cheron. 1674.*
Signed on the reverse: F. CHERON.
References: Pollard, 1967, 98, pl. 5; *Five College Roman Baroque Festival*, Amherst, 1974, no. 55 (this example); *Bernini in Vaticano*, 1981, no. 324.
Michael Hall, New York, NY

Gian Lorenzo Bernini (1598 - 1680) was born in Naples, the son of Pietro Bernini, a Florentine sculptor of considerable reputation. His father transferred to Rome in order to attract the patronage of the new pope, Paul V. Before the conclusion of this papacy (1605 - 21), the prodigious son had become the most brilliant presence in contemporary Roman sculpture, and within the next few years Gian Lorenzo Bernini established his reputation as the most inspired sculptor since Michelangelo. Bernini's lifetime association with the Vatican and the person of every pope until Innocent XI Odescalchi (1676 - 89) began under the papacy of Urban VIII Barberini (1623 - 44). Throughout his lifetime, excepting only a few years following the controversial tenure of the Barberini, Bernini held unchallenged sway over Roman art and its patronage by the Vatican. As the greatest exemplar of the Baroque style in sculpture, architecture, and stage design — and the conjunction of the three — Bernini stands in the forefront of seventeenth-century art.

In 1674, on the occasion of Bernini's 76th birthday, Louis XIV commissioned his preferred medallist François Chéron, to execute this medal in honor of the artist.[1] Bernini's first biographer, Filippo Baldinucci, describes the work at length:

> One should not omit mention that the king [of France] in order to give new signs of his approval and esteem for our artist, had a beautiful medal struck with his portrait, on the reverse of which, one sees representations of Painting, Sculpture, Architecture and Mathematics with their appropriate and distinctive attributes, along with the motto: SINGULARIS IN SINGULIS, IN OMNIBUS UNICUS.[2]

Charles-Jean-François Chéron was trained by his father, who was engraver to the Duke of Lorraine. His arrival in Rome is first documented by his bronze medal of Clement IX Rospigliosi in 1669. Chéron continued in the employment of the Vatican under the papacy of Clement X Altieri. This portrait medal of Bernini was his most important work prior to being called to Paris in 1675 by the king. The forceful characterization of the Bernini portrait, combined with the attractive, pictorial composition on the reverse,

anticipate quite noticeably the mature formulations of Massimiliano Soldani Benzi. François Chéron was admitted into the French Academy in 1676, and he was continuously employed in the honored service of Louis XIV.

Cross Reference: Soldani Benzi, Exh. nos. 64, 65, 66.

---

1) In the previous year Bernini and his assistants had completed the monumental equestrian statue of the King of France, a project which had been initiated in 1669. As it happened, the statue never enjoyed the favor of its subject: it remained in Bernini's workshop after his death and did not reach France until 1685. The king thereupon engaged Girardon to transform the subject into *Marcus Curtius Leaping into the Flames* and placed the result in an obscure corner of the gardens at Versailles.
2) Baldinucci, F., 1975 ed., VI, 643.

## 19. PIETRO BERRETTINI DA CORTONA
(Cortona 1596 - 1669 Rome)

*Portrait of Cardinal Pietro Maria Borghese*
Oil on canvas. 52 3/4 x 38 3/4 inches. (134 x 98.4)
References: A.M. Clark, *Minneapolis Institute of Art Bulletin*, 1965, 39-41; Briganti, 1982, 349-50, no. A8.
The Minneapolis Institute of Art, Minneapolis, MN
Anonymous Gift (no. 65.39)

This Cardinal has been identified by Milton Lewine as Pietro Maria Borghese (1595 - 1642),[1] who was the heir of Cardinal Scipione Borghese, the noted patron of the arts during the first third of the Roman seventeenth century.[2] No particular relationship between the sitter and the artist has as yet come to light. In view of the rarity of portraits by Cortona and of his documented interest in the theory of artistic decorum,[3] the few surviving examples from his hand take on an added value to our studies of this major artist.

Lewine's suggested date of ca. 1635 for this portrait has been accepted by Briganti, which would place it during the height of the artist's activity for the Barberini pope, Urban VIII. Most of this decade was devoted to the execution of the allegorical frescoes in the grand salon of the Palazzo Barberini, as a result of which Cortona advanced to the head of the Roman school of painters. In view of the artist's extraordinarily imaginative treatment of space and movement in the Barberini ceiling (and, we may also mention, Cortona's innovative contributions to High Baroque architecture), it is remarkable the extent to which Cortona restrained his powers of invention on the few occasions that he turned his attention to portraiture. The essential format of *Cardinal Pietro Maria Borghese* hardly varies from the design favored by Tiberio Titi, the dull portraitist to the Medici Court during the first two decades of the century. On the other hand, Cortona can never be accused of merely resorting to formulae. This picture stands handsomely in the front rank of Baroque portraiture by virtue of the typical, if inimitable, vivacity of the painter's brush, which endows the subject in turn with much of the same good humor and intelligence. In this portrait Cortona therefore reconciles traditional composition with his Baroque vivacity of expression; the same strategy was employed with perhaps even more brilliant results by Bernardo Strozzi in Venice.

Cross-Reference: Strozzi, Exh. no. 71.

1) Gigli, 1958, 207-8, writes that Cardinal Pietro Maria Borghese died on June 15, 1642, at the age of forty-seven. He was buried with pomp in the Cappella Paolina, S. Maria Maggiore.
2) cf. Briganti, 1982, no. A8, for the scant references to date relative to this painting.
3) He was the author with a Jesuit, Ottonelli, of a tome on the subject, published in Florence in 1652. cf. Bibliography and references in the introductory essay on portraits of Counter-Reformation saints.

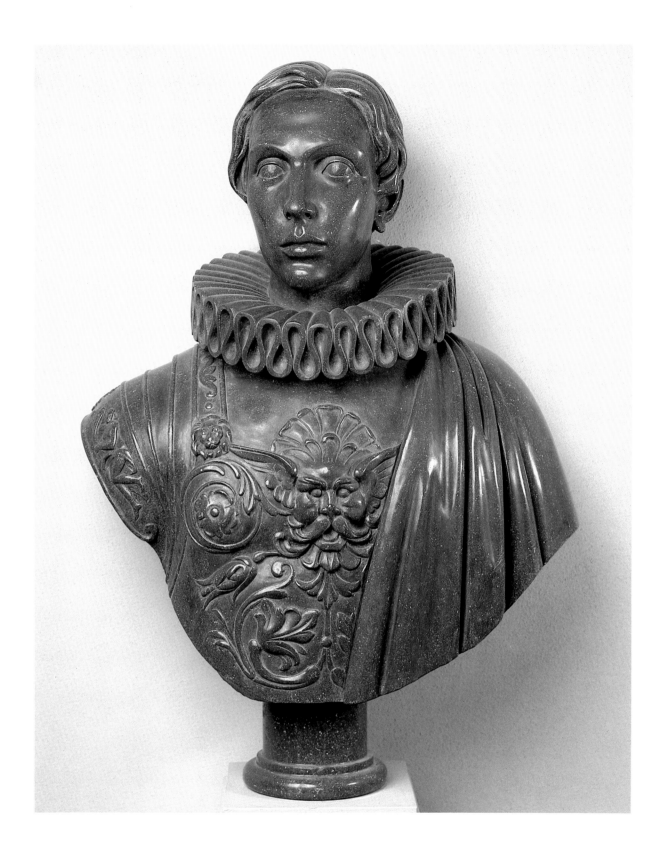

## 23. Attributed to **GIOVACCHINO FORTINI**
(Settignano 1673 - 1736 Florence)

*Portrait in Relief of Cosimo III de' Medici*
(Florence 1642 - Grand Duke of Tuscany 1670 - 1723)
Bronze bas-relief set on marble plaque in marble frame surmounted by a bronze cartouche with ducal crown.
Height, 12 (30.5).
References: Langedijk, 1981, I, 200.
The Walters Art Gallery, Baltimore, MD
(Inv.no. 54.1744)

The morbid personality of Cosimo III has been increasingly studied in recent years following two centuries of benign neglect.[1] Cosimo III presided fitfully over the inexorable decline of the once mighty duchy of Tuscany. It remains one of the most curious paradoxes of this period that Cosimo III, who could not manage affairs of state, succeeded handsomely in reversing the decline of the arts in Florence. Although reclusive and intolerant by nature, it was Cosimo III who overcame the provinciality of the Florentine school during the seventeenth century through his establishment of an academy in Rome. Sculpture and the minor arts especially flourished under the patronage of the Grand Duke, who exploited to the fullest the extraordinary talents of G.B. Foggini and Massimiliano Soldani Benzi.

This portrait in bronze relief of the aging Cosimo III deserves to be better known. The rich effect of contrasting marbles as a sculptural setting for darkly patinated bronze typifies the taste of Cosimo III, who must be credited with encouraging the development of the Florentine late Baroque in this direction.[2] Karla Langedijk has attributed this work to Giovacchino Fortini.[3] Fortini's contemporary, F.M.N. Gaburri, wrote a posthumous biography of the artist which is so extravagantly negative in its judgements that one imagines the intention was sardonic.[4]

Although he studied under Giuseppe Piamontini, Fortini continued the pattern established by the pupils of Foggini in sculpting in marble on a large scale, as well as casting bronze reliefs and medals. The influence of Massimiliano Soldani may be pointed out as well. The strength of the characterization of the Grand Duke — which must have elicited all of the artist's powers of invention — is unusual among the portraits attributed to Fortini. Most of the works by him that have been rediscovered to date display an incipient classicism and somewhat chilly surface quality, which are not in evidence in this bronze. The use of a marble with bronze cartouches to frame a bronze relief was a favorite device of Soldani's, doubtless influenced by Ciro Ferri's designs in S. Maria Maddalena de' Pazzi, Florence, 1684/85.[5] The use of a second marble as a field behind the bronze relief is exceptionally effective, as well as unprecedented.

Cross-References: Soldani (circle), Exh. no. 69; The Portraiture of Francesco Redi, Introduction.

1) Indeed the pertinent bibliography has grown too vast to cite, but for the convenience of English readers, the recent literature includes Cochrane, 1973; Detroit, 1974; Goldberg, 1983.
2) *cf.* Klaus Lankheit in Detroit, 1974, 23.
3) Langedijk, 1981, I, p. 200, "A bronze relief [of Cosimo III] mounted on marble in a marble frame merits special attention. It can be attributed to Foggini's assistant Giovacchino Fortini, who was later to succeed him as court architect. The basis for the attribution is Fortini's medal of Cosimo, which is dated 1720. The affinity between the relief and the medal is such that they can both be regarded as the result of the same sittings."
4) For example, Gaburri speaks of Fortini's performance on an important commission which "was judged by everyone to be extremely weak and of no intelligence," and of Fortini's funeral, whereafter the artist "left the reputation of being a less than mediocre *Professore*." For the original text, see Lankheit, 1962, Doc. 19.
5) *cf.* Lankheit, 1962, figs. 38 - 43 for the use of marble borders for Soldani's cycle of bronze reliefs of the Blessed Ambrogio Sansedoni, 1690's, in the Palazzo Sansedoni, Siena; *cf.* Detroit, 1974, nos. 81 a-d, for similar cartouches on the frames for Soldani's *Four Seasons* in the Bayerisches Nationalmuseum, Munich. For illustrations of the reliefs designed by Ferri, see Lankheit, 1962, figs. 5, 6, 9.

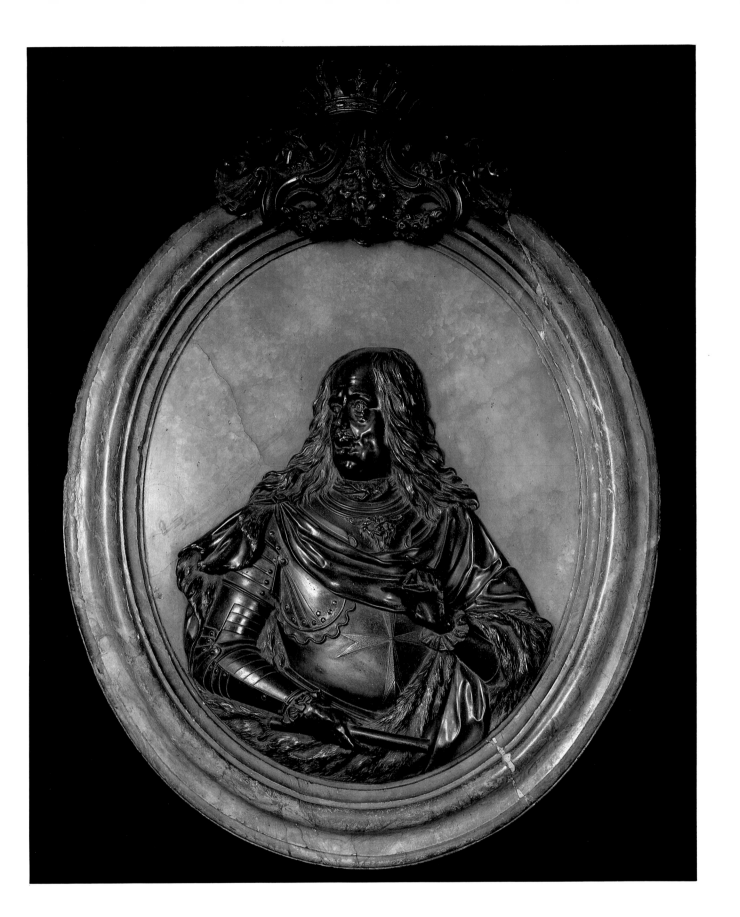

## 24. After ANTON DOMENICO GABBIANI
(Florence 1652 - 1726)

Etching by Fr. Antonio Lorenzini.
*Francesco Redi Crowned by the Muses*
Etching. 10 x 13 1/4 (25.4 x 33.7).
Inscribed, at lower left: *Ant. Dominicus Gabbiani inu. et delin.*
at lower right: *F. Ant. Lorenzini Min. Conu. inc.*
References: Viviani, 1928, part 1, tav. I.
Bound in F. Redi, *Sonetti,* Florence, 1702
New York Public Library, New York, NY, Astor, Lenox & Tilden Foundations
Spencer Collection

This allegorical print was published as the frontispiece to a posthumous edition of Redi's sonnets. Grand Prince Ferdinando de' Medici commissioned this publication as a memorial to Redi. Anton Domenico Gabbiani, Ferdinando's preferred artist,[1] was given the assignment to celebrate Redi's distinction and eternal fame in the realms of poetry, medicine, and philosophy. A melancholic Redi is depicted being crowned by Poetry at the foot of Mount Parnassus, where the Temple of Virtue stands. The other Muses attend nearby. Apollo traverses the sky in his chariot, accompanied by Mercury and personifications of timeless Fame. In the distance, Dante and Petrarch ascend another slope of Parnassus. The city of Florence is evoked by the River God Arno in the foreground.

The imagery in Gabbiani's design apparently reflects a passage from an elegy of Redi delivered by Anton Maria Salvini in Florence on August 13, 1699.[2] The preparatory study for this print was subsequently in the collection of Ignazio Hugford, who praises it at length in his 1742 biography of Anton Domenico Gabbiani, while he finds as much to condemn in its translation into print by Fr. Lorenzini.

> This noble drawing should have been engraved by some excellent burin, which would have conserved the nobility, the beautiful faces, the elegance of the contours, and all of the graduations of light and dark, which is not found in this print in comparison to the original drawing, which I own. But the absence at that time of talented engravers took its toll, because the print, as anybody can see, is in no way proportionate to the merit of such a beautiful work.[3]

In view of the manifest competence of this etching, we must conclude that Hugford's extreme dissatisfaction stems from the inappropriateness of Lorenzini's dry, rather colorless technique as a medium for the decorative, svelte style practiced by Gabbiani. The drawing, entitled *Monte Parnaso con le Muse che incoronano il dott. Francesco Redi,* was one of 115 works lent by Hugford to an exhibition in the Florentine cloister of SS. Annunziata.[4]

The life and portraiture of Francesco Redi (1626 - 1697), physician to the Grand Dukes of Tuscany, scientist, and poet, are the subject of an essay at the front of this catalogue.

1) Haskel, 1980, 233 and 404.
2) Redi, 1809, I, xli.
3) Hugford, 1742, 14-15.
4) Borroni Salvadori, 1974, 88 [1767, cat. no. 46].

## 25. VITTORE GHISLANDI, called Fra Galgario
(Bergamo 1655 - 1743)

*Portrait Miniature of a Man*
Oil on copper. 2 7/8 x 2 3/8 (7.3 x 6).
References: Exh. Duke University, 1966, no. 19.
Suida Manning Collection, New York, NY

Following their neglect during the nineteenth century, the plentiful portraits by Fra Galgario are once again highly regarded, although to this date they are hardly to be found outside of the Accademia Carrara, Bergamo, and private collections in Bergamo and Milan. Galgario's achievement is all the more impressive in that for forty years his sitters were confined to a small circle of Bergamasque nobility. Perhaps this circumstance was his inspiration to invent a novel brand of painting which combines portraiture and genre subjects.[1] Galgario's friend and biographer, Francesco Maria Tassi, describes the artist's success and method in the following terms: "It is impossible to describe how everyone ran to him for portraits or for those bizarre and extravagant heads which have always been sought after even beyond the Alps. He always took these from life, and used to do them with heads shaven clean, cocky caps, shirts undone at the neck, ruffled hair, hands on hips, with sashes across the body, and to impart more of a subject into them, he put brushes in their hands, statuettes, compasses, squares, rulers, and similar attributes of the fine arts."[2]

From Tassi's biography, we know that Vittore Ghislandi traveled to Venice about 1675, and at that time took vows as a lay brother attached to the convent of S. Francesco da Paola. Fra Vittore returned briefly to Bergamo about 1688, but made Venice his home throughout the last decade of the century. He worked with Sebastiano Bombelli, the leading portraitist in Venice at this time. Since none of Galgario's works from these years are known, it must be assumed that they remain to be separated from the pictures executed by his master. About 1702 Fra Galgario permanently settled in Bergamo, taking residence in the Galgario convent, whence his most common appellation. In 1717-18 he visited Bologna and received much applause from the local school. Roberto Longhi first observed that this contact with the fluent style of Giuseppe Maria Crespi made a substantial impression on the painter from Bergamo.[3]

Fra Galgario was a brilliant colorist, and the influence of Venetian colorism came increasingly to the fore with the passage of his career. He made a variety of harmonies personal to his work: blue and red, red and gold (in the same values favored in Venice by Bernardo Strozzi before him), blue and silver, dark umber and red.

Recently, the known paintings by Fra Galgario have been illustrated for the first time in a monograph.[4] As almost none of his works bear dates, an analysis of the artist's development has yet to be essayed. The exhibited portrait miniature is proposed as an attribution to Fra Galgario that would add two dimensions to our knowledge of his career: both the miniature format and the use of copper as a support have not previously been observed among his paintings.[5] However, not only is the palette distinctively Fra Galgario's, but the thickly daubed strokes are unmistakably his as well, for the artist's touch shows none of the fastidiousness of a specialist in miniatures.

1) Compare the two examples of such paintings that are illustrated in the Appendix, Nos. 39 and 40. The latter picture, in the collection of the North Carolina Museum of Art, Raleigh, depicts a young man in a dashing pose and fancy costume, both of which had been previously used by Fra Galgario in his famous portrait of *Count Giovanni Secco Suardo with a Servant* in the Accademia Carrara, Bergamo. (Illustrated in color in Gozzoli, 1981, 53.)
2) Tassi, 1793, II, 61.
3) In the catalogue to the exhibition in Milan in 1953, *I pittori della realtà in Lombardia.*
4) Gozzoli, 1981.
5) The attribution was first advanced by Robert L. Manning.

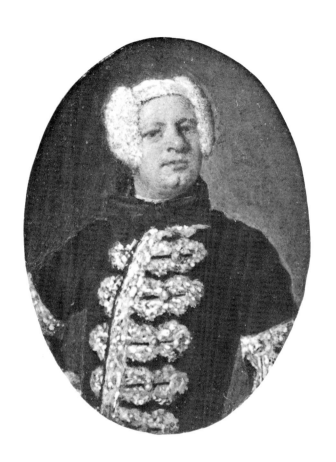

## 26. GIOVANNI FRANCESCO BARBIERI,
called **Guercino** (Cento 1591 - 1666 Bologna)

*Portrait of Pope Gregory XV*
(Alessandro Ludovisi, Bologna 1554 - Pope 1621 - 1623 Rome)
Oil on canvas. 51 1/4 x 37 1/2 (133.5 x 98)
References: Mahon, 1981, 230 - 35 (for complete history).
National Museum of American Art, Smithsonian Institution, Washington, DC
(Gift of Ralph Cross Johnson, 1919. 6.21)

The election of Cardinal Alessandro Ludovisi, Archbishop of Bologna, as Pope Gregory XV in February, 1621 ratified, so to speak, the ascendency of the Bolognese school in Rome. Arriving in May, the painter Guercino was in the front rank of the phalanx of artists who descended from Bologna to Rome. The reign of Gregory XV was not long. Nevertheless, Guercino had time to execute three important commissions before the pope's death on July 8, 1623: the famous fresco of *Aurora* in the Villa Ludovisi, an altarpiece of *The Burial and Ascension of Sta. Petronilla* for St. Peter's, and this portrait of the Pope himself.

As Denis Mahon has admirably recounted, Guercino's *Portrait of Pope Gregory XV* was remarked on by G. B. Passeri and C. C. Malvasia in their biographies of 1673 and 1678 respectively, then disappeared from critical view for two centuries. By 1854 the painting was in England, where G. F. Waagen cited it in the collection of Lord Ward as a portrait of a cardinal by Guercino. Within a few years the correct attribution had been exchanged for the grander name of Titian, and the picture was again "lost" until 1971 (although it was on public view in Washington, D.C. after 1919) when the artist and the subject of this portrait at the National Collection of Fine Arts were recognized by Frederick Cummings. Mahon confirmed the identification of this painting with Guercino's commission from Gregory XV.

Guercino painted very few portraits in his career, and the value of this rediscovery of a papal portrait executed in the robust early Baroque style of the young master cannot be overstated. At this early date of 1621/23, only a handful of artists — namely Rubens, Domenico Fetti, Van Dyck, and now Guercino — had painted portraits that fully broke with the stylistic abstractions of late sixteenth-century portraiture. Guercino was the first artist since Titian to exercise an uninhibited pursuit of psychological expressionism in the portrayal of a sovereign dignitary.[1]

Indeed, it was held by Passeri that Guercino had gone too far in his insistence on his personal preferences in style. Passeri wrote that Guercino's portrait was "not much appreciated, because his dark manner is contrary to the proper ordering of portraits, for which it is necessary to

achieve a likeness, to avoid shadows at all costs, and to try to give relief to the figure, through skillful posing, within its setting."[2] This prescription for success offers a fascinating reflection on the resiliency of the courtly tradition in portraiture, since it applies more aptly to the art of Antony Mor, active in the previous century, than to the styles on which the Baroque era was founded.

Cross-Reference: Rubens, Exh. no. 60.

---

1) The result is strikingly anticipatory of the twentieth-century portraits of a pope by the English painter, Francis Bacon (who could profitably study Guercino's).
2) This translation is adapted from Mahon's article cited above.

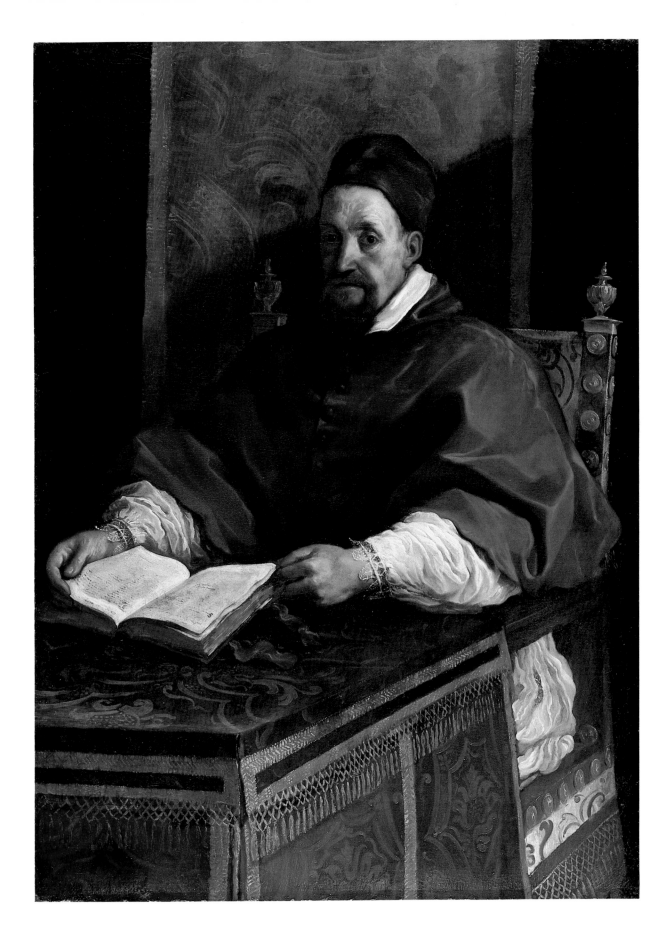

## 27. GIOVANNI FRANCESCO BARBIERI,
called **Guercino** (Cento 1591 - 1666 Bologna)

*Portrait of a Man Wearing the Order of the Golden Fleece*
Pen and brown ink on cream paper. 6 3/4 x 5 5/8
(17.2 x 14.7)
References: Oberhuber, 1977, no. 19.
Mrs. John H. Steiner, Larchmont, NY

The identification of this nobleman has posed some difficulty. As was pointed out in the catalogue to the 1977 exhibition of the Steiner collection, the ample features of this man closely resemble the medallic portraits in profile of Ferdinand Gonzaga, sixth duke of Mantua (1587 - 1626), and of his brother Vincenzo II (1594 - 1627), who succeeded him as seventh duke of Mantua. According to the same source, neither of these Gonzaga dukes were knights of the Golden Fleece *(Toison d'Or)*, although other members of the family were so decorated.

Despite this apparent contradiction, the portrait of Vincenzo II Gonzaga in particular is too recognizable in Guercino's drawing to be ignored. If the pendant of the Golden Fleece is inappropriate, we can assume that the error represents an honest misunderstanding by the artist, which may be taken, moreover, as an indication that this portrait was not drawn from life.

Indeed, the pose in strict profile, as well as the resemblance mentioned above, strongly suggest that the artist drew his portrait from one of the medals of Vincenzo II. Since the costume was not depicted on the medal, Guercino naturally had to improvise this aspect of his drawing, and it is only after three centuries that exacting art historians have exposed this inaccuracy.

The previous publication of this drawing pointed out its relationship to Guercino's caricatures and to the extensive production of such drawings by Agostino and Annibale Carracci. It is noteworthy that in the collection of the Albertina, Vienna, is a sheet of pen and bistre studies by Annibale Carracci of profile heads that are copied for the most part from antique cameos.[1] Annibale can be observed in the same creative process that we have postulated here for Guercino: by dispensing with the oval or round format and by introducing modelling in the round, both artists were able to transform the hard outlines of their prototypes into images of living, breathing persons.

Cross-Reference: Mola, Exh. no. 45.

1) Stix and Spitzmüller, VI, 1941, no. 114.

## 28. Attributed to **DOMENICO GUIDI**
(Torano, Massa Carrara 1628 - 1701 Rome)

*Portrait Bust of Pope Clement X*
(Emilio Altieri, Rome 1570 - Pope 1670 - 1676 Rome)
Bronze. 36 x 29 (91.4 x 73.6).
Collections: Baron Gustave de Rothschild, Paris; Palais Lambert, Brussels.
Minneapolis Institute of Arts, Minneapolis, MN.
(Acc. no. 59.7)

Emilio Altieri, a Roman, received his Cardinal's hat in November, 1669 from Clement IX, whom he reluctantly succeeded as pope in April, 1670 with the name of Clement X. He had previously served with the papal nunzio to Poland in 1623, and had filled the post of nunzio to the same country under Pope Alexander VII. Devout, unassuming, and circumspect, Clement X was, however, too aged and ill at the time of his election to manage alone the obligations of his office. He ceded effective control of the government to his nephew Cardinal Paluzzo Altieri who, although capable, was disliked by the populace, by the Curia, and by the foreign powers, all of whom transferred their enmity to the pope as well.

Domenico Guidi was first trained in Naples by Giuliano Finelli, his uncle, who had assisted Bernini in Rome. When Guidi came to Rome at mid-century he entered the workshop of Alessandro Algardi. Passeri informs us that Guidi was a highly skilled bronze caster, and that Guidi, Ercole Ferrata, and Girolamo Lucenti inherited the models and casts from Algardi's studio after their master's death in 1654. Guidi thereupon founded his own workshop, which produced competent sculptures in impressive quantity during the next half-century. In 1669, when Bernini invited him to carve one of the angels for the Ponte di S. Angelo, Guidi was described by a contemporary observer as one of the two best sculptors of the day in Rome.[1] According to Nicodemus Tessin the younger, who visited the sculptor's studio in 1688 (and found him eminently likable), Guidi had no competition at that date.[2] After his death, Guidi's name was all but forgotten. His oeuvre has been rediscovered in recent years in a series of articles by David Bershad.

This portrait bust of Clement X is not known in any other casts or versions in other media. The attribution to Guidi was suggested after its acquisition by the Minneapolis Institute by Merribell Parsons, then Curator of Decorative Arts. Indeed, Guidi's portraiture seems to hve been characterized by the kind of vacant, faintly pneumatic expression which this bust displays in comparison to the other papal busts in this exhibition. The curatorial files at the museum also record Anthony Clark's proposed attribution to Girolamo Lucenti. See the introductory essay, *Notes on Four Papal Portrait Busts in Bronze,* for information on several por-

traits of Clement X executed by Gian Lorenzo Bernini during the years 1676 - 1680. In the same essay, this bust is discussed in relation to a series of four papal bronzes executed by Lucenti ca. 1678 which were formerly in the Roman church of S. Maria di Montesanto. Visitors to the exhibition may wish to compare for themselves this bust attributed to Guidi with the bust of Clement IX attributed to Lucenti in this exhibition. Both of these attributions are provisional in view of our limited knowledge of these artists and of their casting techniques.

Cross Reference: Lucenti, Exh. no. 40.

1) Carlo Cartari, Archivist of the Castel S. Angelo, must have had an aerial view of the proceedings, as from September 1669 to May 1670 he recorded in his diary the arrivals of each of the eight sculpted angels on the bridge. Of Guidi and Alessandro Giorgetti, Cartari wrote that "each of these two artists are reputed to be the principal sculptors in Rome." D'Onofrio, 1981, 90 - 96, transcribes all of Cartari's comments about the ponte S. Angelo.
2) Sirén, 1914, 190: "He is considered by everyone to be the best man working in this science in Rome today."

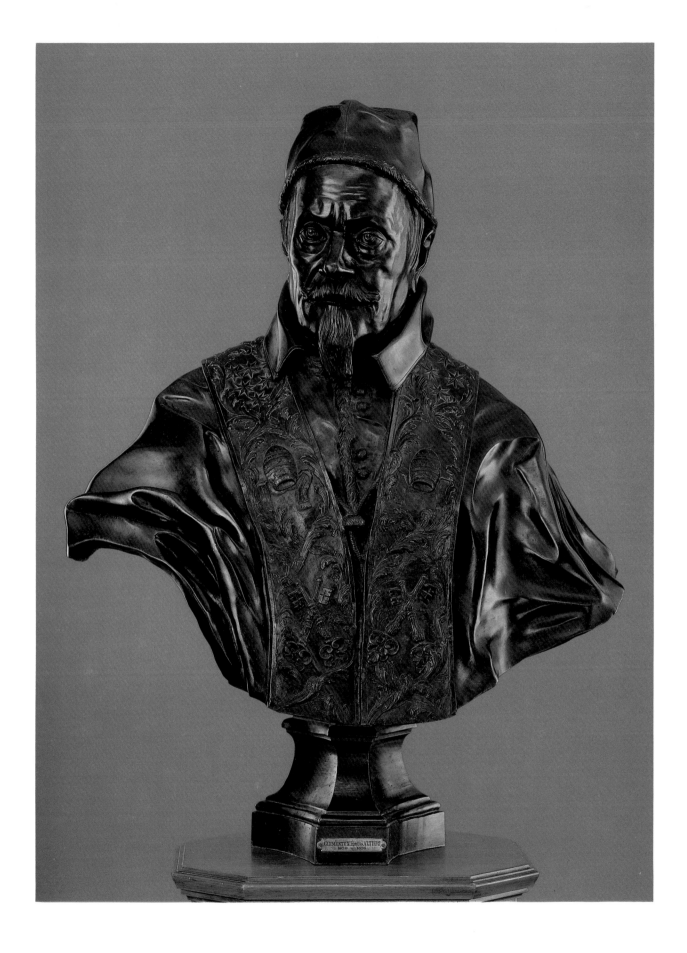

## 29. ALBERTO HAMERANI
(Rome 1620 - 1677 Rome)

*Portrait Medal of Clement X*
(Emilio Altieri, Rome 1590 - Pope 1670 - 1676 Rome)
*Reverse:* Saints Francis Borgia, Louis Bertrand, Cajetan
(Gaetano) of Thiene, Rose of Lima, and Philip Benizi
Receiving the Holy Spirit
Gilt Bronze, ring-mounted for suspension. 4.2 cm diam.
Signed on the truncation below the portrait:
*ALB. HAMERANVS.F.*
Dated on the obverse: *AN.II* [1671]
References: Hiesinger in Philadelphia, 1980, no. 115;
Worsdale in *Bernini in Vaticano*, 1981, no. 320 (silver
medal by Giovanni Hamerani of same design, 3.4 cm diam.)
Philadelphia Museum of Art, Philadelphia, PA
(Bequest of Anthony Morris Clark. 1978-70-44)

In 1671 Clement X authorized the simultaneous canoniza-
tions of five saints, four of whom (save only Philip Benizi)
were prominent figures of the Counter-Reformation. This
occasion recalled the canonization of five saints in a single
ceremony in 1622, and as on that date the churches of Rome
resounded with celebrations. The saints are portrayed on
the reverse of the medal, from left to right: St. Francis Borgia
(1510 - 1572), a Father General of the Order of Jesuits;[1] St.
Louis Bertrand (1526 - 1581), a Spanish Dominican, who
made many converts in South America; St. Gaetano of
Thiene (ca. 1480 - 1547), founder of the Order of the Thea-
tines;[2] St. Rose of Lima (1586 - 1617), the first native Ameri-
can to be canonized, who was a Dominican tertiary and
ascetic; and St. Philip Benizi (1233 - 1285), a head of the
Order of Servite friars, who declined the papacy.[3]

The significance attached to this event is reflected in the
several versions of this medal, some in silver and gold,
which were issued in that year. The inscriptions vary. Gio-
vanni Hamerani, the son of Alberto, cast a silver medal with
the same composition on its reverse. Worsdale mentions
this latter work as one "which might be based on designs by
Bernini."[4] Varriano notes the relationship of this reverse to
one drawn by Bernini for a medal of 1669.[5] The present
writer believes that the idiosyncratic physiognomies pre-
ferred by Lazzaro Baldi can be perceived in this design, and
would propose an attribution to that artist, a pupil of Pietro
da Cortona.[6]

The engraver, Alberto Hamerani, was the first Roman-born
son of a Bavarian family of specialists in the production of
medals and coins. Through the end of the eighteenth cen-
tury, one Hamerani after another directed the activities of
the papal mint. Alberto is documented as a goldsmith in
1662. In the course of his highly successful career, Alberto
executed medals for Queen Christina of Sweden and for
Popes Clement IX and Clement X. After his death he was
succeeded at the papal mint by his son, Giovanni Hamerani.

This exhibition includes portraits of Pope Clement X in a
free-standing bronze bust, a bronze plaque, and the present
medal. For further information the reader is referred to
Exh. nos. 28 and 41.

1) The crown at the feet of St. Francis Borgia, attired in the vestments of a
priest, refers to the titles he abdicated when he entered the Jesuit Order.
2) St. Gaetano is often portrayed, as here, writing the Rule of the Theatine
Order.
3) His attribute lies at his feet, the spurned papal tiara.
4) *Bernini in Vaticano*, 1981, 283.
5) Whitman with Varriano, 1983, 135.
6) For a discussion of Baldi's extensive involvement with the 1671 canoni-
zation decorations, see Casale, 1979, *passim*.

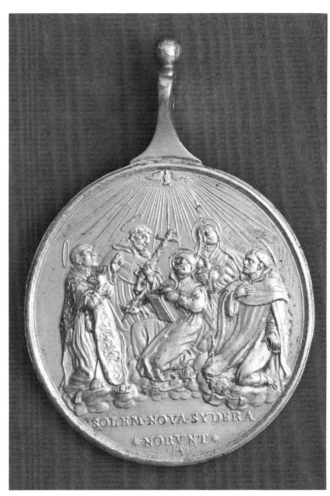

**30. GIOVANNI HAMERANI** (Rome 1646 - 1705 Rome)

*Portrait Medal of Lodovico Cardinal Portocarrero*
(1629 - 1709)
Bronze, struck. Diameter, 4.5 cm.
Signed and dated under the truncation on the obverse: *.IO. HAMERANVS.F.A MDCLXXVIII*
References: Norris and Weber, 1976, no. 110 (with reverse).
Bowdoin College Museum of Art, Brunswick, ME
(1966.114.53)

The most important of a family of goldsmiths, medalists, and seal engravers, Giovanni worked first with his father, Alberto, at the mint of Massa Carrara. He completed the coinage of Innocent XI in 1676, and replaced Girolamo Lucenti as medalist to the papal court in 1677. The history of papal medals at the end of the seventeenth century is synonymous with the production of Giovanni Hamerani. The engraver's son, Ermenegildo Hamerani (1683 - 1756), succeeded him at the papal mint in 1704 and was as prominent in his age as his father had been before him. Two other children were prominent medal engravers: Beatrice (1677 - 1704) and Ottone Hamerani (1694 - 1761). Beatrice Hamerani was the only woman to engrave a papal medal.

Ludovico Portocarrero (1629 - 1709) was made Cardinal in 1669. He was appointed provisional viceroy of Sicily in 1678, which must have provided the occasion for the striking of this medal. Within the same year, he was named archbishop of Toledo.

The comparison between this medal of Cardinal Portocarrero and the medal of Duke Francesco I Farnese that follows (Exh. no. 31) points up Hamerani's unfailing competence and remarkable versatility. The cardinal evidently had different demands than the duke. The former's portrait displays a modified naturalism and gives an unwitting impression of earnestness in the endless biographical notations. The duke, notwithstanding his youth, is presented with the idealized image of a ruler whose identification requires only the briefest statement of his title.

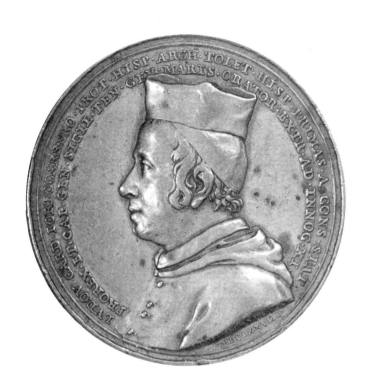

**31. GIOVANNI HAMERANI** (Rome 1646 - 1705 Rome)

*Portrait Medal of Francesco I Farnese* (1678 - 1727)
Bronze, struck. Hole at top. Diameter, 5.2 cm.
Signed on the truncation on the obverse: *HAMERANVS*.
Dated on the reverse (not illustrated): 1696.
References: Norris and Weber, 1976, no. 112, (with reverse, additional bibliography)
Bowdoin College Museum of Art, Brunswick, ME
(1966.130.4)

This medal portrays the young Francesco I two years after he assumed the title of Duke of Parma and Piacenza at the age of sixteen. The duke's luxurious locks and his garb of armor and sash hark back to antique prototypes, and were the standard medallic attributes of the ruling nobility at this date. The elegance of the design betrays a French taste, but has numerous Italian precedents, especially in the medals of Gioacchino Francesco Travani. Bernini's marble bust of Duke Francesco I d'Este (1650 - 51; Museo Estense, Modena) was the ultimate model for absolutist portraiture of this kind. On the reverse of the medal the regal attributes of Faith and Justice are represented.

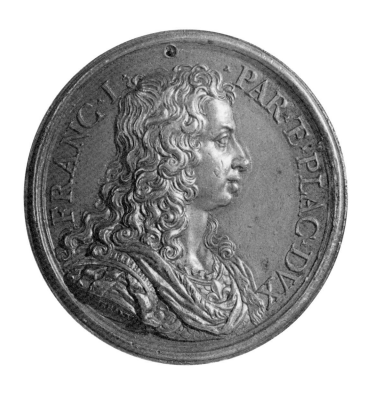

## 32. OTTAVIO LEONI (Rome ca. 1578 - 1630 Rome)

*Portrait of Giovanni Garzia Millini*
Black and white chalk on light blue paper
8 2/3 x 6 1/3 (21.1 x 16.0).
Inscribed on reverse: *Monś. G.B. Millini by Leoni*
References: Gibbons, 1977, no. 404.
The Art Museum, Princeton University, Princeton, NJ
(Inv. no. 48-750)

Formerly entitled *Portrait of a Man with a Moustache and Goatee, Reported to be G.B. Millini* on the basis of a later inscription on the reverse, the likeness in this drawing has been more precisely identified by Jennifer Montagu.[1] Cardinal Giovanni Garzia Millini died in October of 1629, and posthumously entered the history of art as the subject of an early masterpiece by Alessandro Algardi, namely the tomb and funerary portrait of Millini in the church of S. Maria del Popolo, Rome.[2]

Millini's age at his death has been variously reported as 66 or 68 years old.[3] If this identification is correct, then Leoni has portrayed him in middle age, prior to his elevation to Cardinal in 1606 by Urban VIII. As such, it is a fine example of the artist's early style, not to mention a compelling document of the naturalistic current in Roman art of the first decade of the seventeenth century. Leoni's technique is distinguished by its delicacy and restraint without sacrifice of an animated characterization.

For further information, see the introductory essay above, *Ottavio Leoni's Portraits 'alla macchia'*.

1) In correspondence with the Princeton Art Museum.
2) Heimburger Ravalli, 1973, figs. 31 - 32.
3) *cf. ibid.*, with Gigli, 1958, 107.

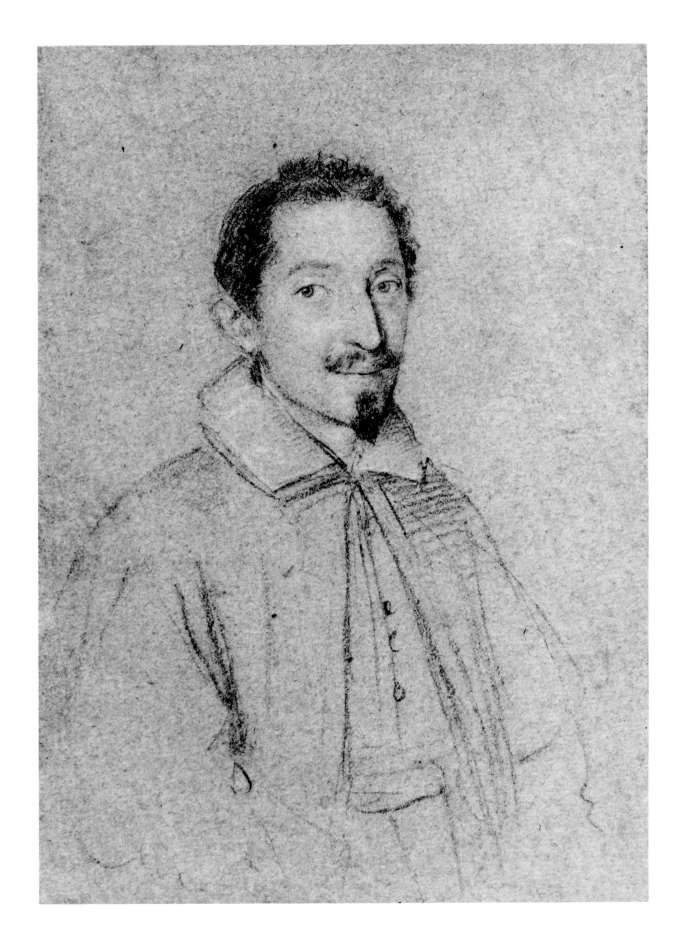

**33. OTTAVIO LEONI** (Rome ca. 1578 - 1630 Rome)

*Tommaso Salini and Two Other Portrait Studies*
Etching and engraving, 5 1/2 x 4 1/3 (14.2 x 11.0).
References: Bartsch, XVII, 7; Petrucci, 1956, 43 note 4
The Metropolitan Museum of Art, New York, NY
(Gift of Janos Scholz, 1954.612.2)

Entitled *Portrait of a Knight at Malta* by Bartsch, the principal subject of this print was erroneously identified by P.J. Mariette as Mario Nuzzi de' Fiori.[1] Petrucci corrected the identification to the painter Tommaso Salini, called Mao Salini, calling attention to a later state of this print in which the name is added along with a date, 1625.[2] Salini's friendship with Leoni is attested by several surviving portraits, including a drawing dated 1620 in this exhibition. Both the present etching and the drawing dated 1620 were based on Leoni's undated drawing of the same composition which is preserved in an album in the Biblioteca Marucelliana, Florence.[3] The vitality of the portrait in this etching is notably closer to the spirit of the drawing in Florence. Moreover, the oval format of the etched portrait directly reflects the unfinished margins in the Florentine drawing.

Petrucci pointed out the technical curiosity that the oval portrait of Salini is etched, while the two studies of heads in the margin are executed with an impressively "sweet" touch of the engraver's burin. The head of the girl at lower right derives in reverse from a dated drawing in The Rhode Island School of Design, Providence, of a girl named Madalena.[4] The RISD drawing is inscribed "di notte" (at night), and delicately conveys the sense of candlelight illuminating the girl's face from below. The same nocturnal effects can be discerned in this engraving of Madalena's features. The February, 1617 date of the RISD drawing and the 1620 date of the Metropolitan Museum drawing provide circumstantial support for the observation that this etching of Salini was probably executed prior to the date of 1625 which was added to a later state. By the middle of the 1620's Leoni had developed his mature technique in printmaking, in which he combined etching and stipple engraving. The most elaborate example of this technique is the artist's self-portrait, included in this exhibition (Exh. no. 39). The composition and broad style of the Salini etching are comparable to Leoni's first efforts in this medium, ca. 1615 - 20; the relative confidence in the handling suggests that it should be dated towards the end of that range.

1) Cited by Bartsch. *cf.* Buffa, 1983, 166.
2) Petrucci, 1956, 43 note 4.
3) Kruft, 1969, fig. 14.
4) Johnson, 1983, no. 9, repr.

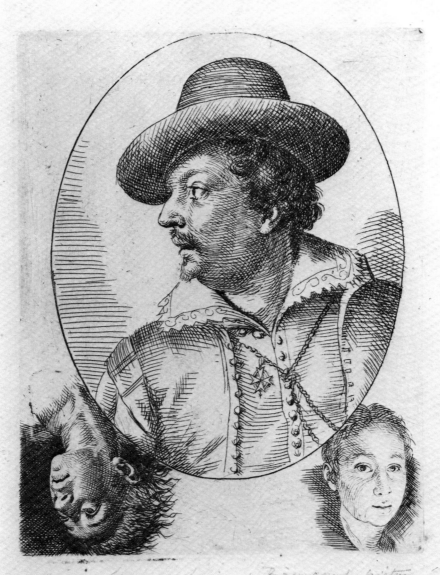

Thomas Salmon Bonarius pictor
1625.

W Les nows

**34. OTTAVIO LEONI -** (Rome ca. 1578 - 1630 Rome)

*Portrait of Tommaso Salini*
Black and white chalk on faded brownish paper.
8 7/8 x 6 3/4 (22.6 x 17.2).
Inscribed and dated at lower left: *174/ novembre* and at
lower center: *1620*.
Collections: Mr. and Mrs. Winslow Ames, Providence, RI.
The Metropolitan Museum of Art, New York, NY
(Gift of Mrs. Charles Slatkin 1954.612.1)

Born in Rome of Florentine parentage, Tommaso Salini,
called "Mao" Salini, was a painter in a loosely Caravag-
gesque style. As it happens, the earliest documented record
of Salini in his appearance as a witness against Caravaggio
in the libel suit brought by Giovanni Baglione in 1603.
Although he executed a few public commissions for altar-
pieces, Salini's activity as a painter of still lifes is more
appreciated today.[1]

Ottavio Leoni and Tommaso Salini were close friends, to
judge from the number of times that Leoni drew or etched
the latter's portrait.[2] The present drawing is evidently an
autograph replica of a less finished study of the same sitter
which is contained in an album of Leoni's drawings in the
Biblioteca Marucelliana, Florence.[3] Leoni also made an
etching based on the drawing in Florence. Despite the
sketchy tresatment of the clothes, this drawn portrait of
Salini appears elaborated and less vital in comparison to
the Marucelliana study and even to the etching. In this
instance, the inherent risks in Leoni's method of drawing
portraits "alla macchia," that is from memory as opposed
to from life, take their toll in immediacy.

For further information, see the introductory essay,
*Ottavio Leoni's Portraits 'alla macchia'.*

Cross Reference: Leoni, Exh. no. 33.

1) For references to Salini's career, *cf.* Spike, 1983, no. 12. The relationship
between Salini and Giovanni Baglione is discussed by Marini, 1982,
61 -74.
2) The first five prints listed by Bartsch, XVII, 247 - 48, 1-5 [cf. Buffa, 1983,
160 - 64] as portraits of an anonymous man are, in the opinion of the
present writer, portraits of Salini.
3) Kruft, 1969, fig. 14.

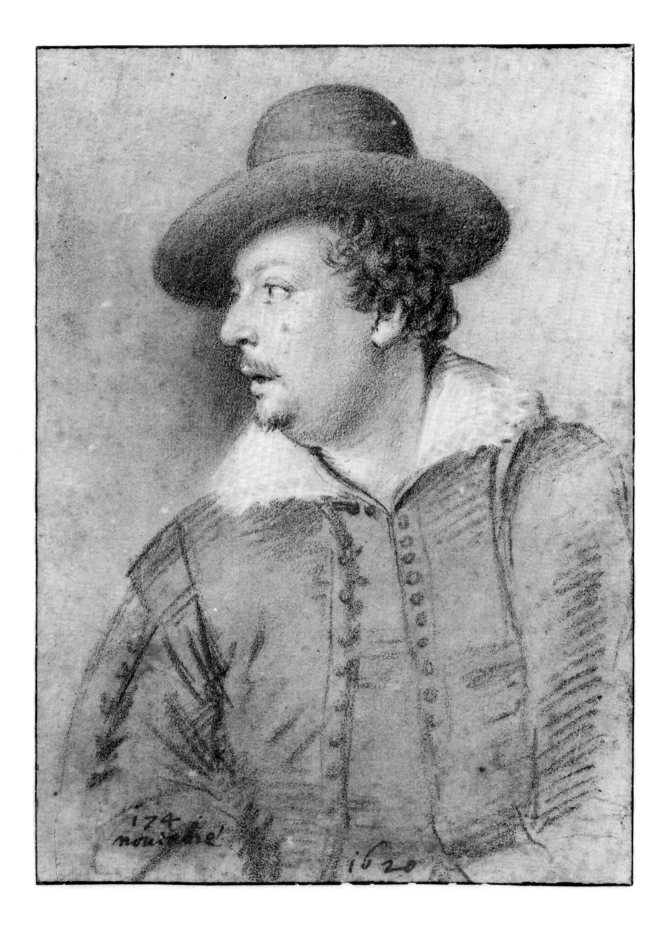

## 35. OTTAVIO LEONI (Rome ca. 1578 - 1630 Rome)

*Four Portrait Heads*
Etching. 4 1/8 x 7 1/8 (10.5 x 18.1).
The identifications along the upper margin are pen inscriptions in a seventeenth-century hand.
References: Bartsch, XVII, 13; Petrucci, 1956, 44 n. 12.
The Metropolitan Museum of Art, New York, NY
The Elisha Whittelsey Fund, 1967.797.28

This enigmatic print is a masterpiece of naturalistic portraiture. The faces of four friends are captured during a moment of ease; the older gentleman strikes a dignified pose, but even so seems to be in character. In accordance with the informality of the occasion, the artist has not taken the trouble to sign his name or to record his friends'. Bartsch followed P.J. Mariette in attributing this etching to Ottavio Leoni, which is self-evident, and in identifying the four subjects, from left to right, as D. Cosimo Orsini, Camillo Graffico, Sigismondo Laire, and Ludovico Leoni (the artist's father). However, the profile at the far right cannot be that of Ludovico Leoni, who wore an impressive beard, as we know from Ottavio's drawn and engraved portraits of his father (who died in 1612).[1]

The impression exhibited on this occasion bears across its surface the careful notations of a seventeenth-century collector, who set down his own annotations as follows: D. Cosimo Orsino ("who is an amateur of painting"), Cesare Bartolotti ("engineer"), Sigismondo Leier ("painter"), and Ottavio Leoni ("the artist"). Our unknown commentator thus agrees with Mariette's eighteenth-century perspective on the personalities of Orsini and Laire. In place of Camillo Graffico, an obscure engraver from Friuli, a certain Bartolotti of even greater obscurity is proposed. This question must remain open.[2] The identification of the profile portrait as our artist Ottavio Leoni is surely right. In this work he is younger and wears his hair less long than in the *Self-Portrait* of 1625, exhibited in this show. But his features compare closely with those in another self-portrait etching in which Leoni looks back over his shoulder.[3] In that etching, which is very similar in technique, Leoni's costume displays a cross as an emblem of his knighthood. Leoni was knighted during the papacy of Gregory XV, 1621 - 23, and the present print cannot have been executed many years distant from this period.

The uncalculated quality of the composition of these *Four Portrait Heads*, as well as the flowing strokes of the etching needle, recall the slightly earlier prints by the Venetian Palma Giovane. Early in the seventeenth century Palma was the most influential artist to make prints in significant numbers, including a manual of draftsmanship. He was also known for his keen interest in naturalistic portraiture, not to mention his many self-portraits.

Cross Reference: Leoni, Exh. no. 39.

1) Kruft, 1969, fig. 21, reproduces the drawing in the Biblioteca Marucelliana, Florence. For the print, see Buffa, 1983, 186.
2) A drawing of Camillo Graffico by Leoni is in the collection of the Louvre, Paris, but seems not to have been photographed.
3) Bartsch, XVII, 6. Illustrated in Buffa, 1983, 165.

D. Cosmo Orsino. | Cesare Bartolotti | Sigismondo Leier | Ottauio Leone
che si diletto di Pittura | Ingegniere. | Pittore. | Autore.

## 36. OTTAVIO LEONI (Rome ca. 1578 - 1630 Rome)

*Portrait of Cavalier Giovan Battista Marino*
Engraving. 5 1/2 x 4 1/3 (14.2 x 11.0).
Dated: 1623-1624
References: Bartsch, XVII, 30; Petrucci, 1956, 45 n. 21.
The Museum of Fine Arts, Boston, MA
(Harvey D. Parker Collection, P 13808)

The inquisitive, canny, and gaunt features in this portrait
are those of G.B. Marino, the foremost Italian poet of the
seventeenth century. Born in Naples in 1569, Marino
passed his life in acrimonious transitions between attach-
ments to various courts. In 1600 he fled from a legal action
in Naples to enter the service of the cardinal nephew of
Pope Clement VIII in Rome. In 1609 he was knighted by
the Duke of Savoy, and he remained in Turin until 1616.
Marino then entered the employ of Marie de' Medici,
Queen of France. In 1623 - 24, the two dates recorded on
Leoni's portrait, Marino made a triumphant passage
through Rome. Now quite ill, he returned to Naples
where he died the following year.

Marino's poetry caused a sensation in his own time. His
posthumous reputation rests on his paradoxical juxtaposi-
tions of fantasy and keen observation, intellectualism and
sensuality, eroticism and piety, all wrapped together in a
fabric of brilliant word-play. In short, his poetry was the
literary equivalent of the emergent Baroque style in the
pictorial arts, a coincidence to which he devoted himself.
The poet is most famous for his volume entitled *The
Gallery* (1620), which anticipated Malraux's "museum
without walls" by three centuries. The work is conceived
as a collection of paintings, some actual and some imagi-
nary, rendered in the form of his verse translations of the
viewer's experience of these paintings.[1]

The second Roman sojourn of Marino coincided with the
beginning of Leoni's intensive work on his portrait
engravings of famous men. In his biography of Leoni,
Baglione writes that this series was the chief concern of the
artist's last years.[2] Marino was himself an avid collector of
portraits (which figure prominently in *The Gallery*), and
their encounter must have encouraged Leoni in this pro-
ject.[3] The portraits in this series are distinguished from
Leoni's other prints by their ornamental moldings. Poets
and philosophers are portrayed in oval format, as is
Marino here.

1) In respect of his singular personality, this might better be stated as,
"*Marino's* experience of these paintings."
2) Baglione, 1642, 322.
3) *cf.* Fulco, 1979, 92.

Eques Joannes Baptista — Marinus Neapolitan°

s upioɣ — permissu

Eques Octauius Leonus, 1624 — Roman° pictor fecit 1623

**37. OTTAVIO LEONI** (Rome ca. 1578 - 1630 Rome)

*Portrait of a Youth*
Black chalk, heightened with red and white chalk on faded
blue paper. 8 x 5 7/8 (20.3 x 14.9).
Inscribed at lower left: *312/ novembre*
References: *European Drawings 1450 - 1900.*, exh. cat.,
Santa Barbara Museum of Art, CA, 1964, no. 46.
The National Gallery of Canada, Ottawa, ON
(Acc. 17575)

This portrait study of an unidentified young man is unu-
sual in certain respects in Leoni's oeuvre, but is not the less
impressive for it. For reasons outlined below, the work can
be dated to 1624. Comparison with Leoni's portrait of Gio-
vanni Garzia Millini in this exhibition (Exh. no. 32) of
perhaps fifteen years earlier points up a remarkable devel-
opment in Leoni's style. The breadth of handling in the
present drawing, as well as the apparent projection of the
sitter towards the viewer, are both qualities reflective of the
incipient Baroque style of the period. It seems likely that
this sheet represents an exchange of sorts between Leoni
and Gian Lorenzo Bernini. The younger artist, Bernini,
was certainly inspired by the precedent of Leoni's portrait
drawings in colored chalks. His drawings are, however,
imbued with a sense of movement and physical presence
that occurs only rarely in Leoni's work, as in the present
instance.

As pointed out by Susan Campbell in notes on file at the
National Gallery, this sheet can be safely dated to 1624,
since a drawing by Leoni in the British Museum bears the
number 311 and is dated *novembre 1624.* A drawing sold at
Christie's in 1977 was numbered 318 and dated *genaro 1625,*
likewise in the artist's own hand. For further information
on Leoni and for a partial list of his numbered drawings,
see the introductory essay, *Ottavio Leoni's Portraits 'alla
macchia'."*

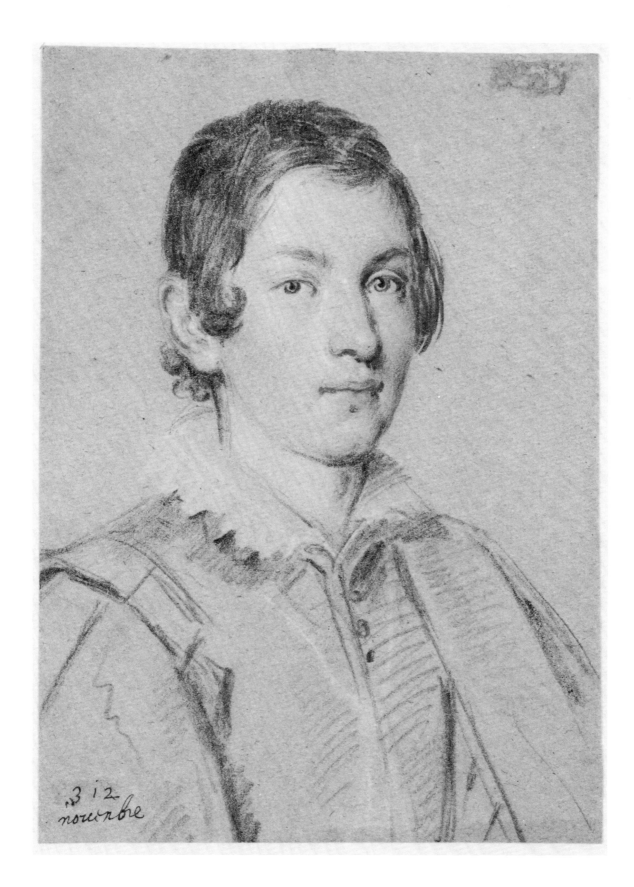

3 12
nouembre

**38. OTTAVIO LEONI** (Rome ca. 1578 - 1630 Rome)

*Portrait of Raffaello Menicucci*
Engraving. 5 5/8 x 3 3/4 (15.2 x 11.0) platemark
1625. State I/III.
References: Bartsch, XVII, 31, Schleier, 1965, fig. 2; Janson, 1980, 68 - 70.
Indianapolis Museum of Art, Indianapolis, Indiana
(Mr. and Mrs. Julius F. Pratt Fund, 79.137)

This exhibition includes three portraits of Raffaello Menicucci by different artists. Thanks to the biographical research of Erich Schleier, we can be sure that none of these images have quite the meanings that they present to any observer unacquainted with the ways of Menicucci. For a complete picture of this multi-dimensional personality, it is necessary to compare Leoni's portrait of Menicucci with the exhibited print by Claude Mellan and the painting by Valentin de Boulogne. The print by Leoni is dated 1625 and appears from the age of the sitter to be the earliest of these three portraits. Leoni portrays the youthful Menicucci in notable good health. He wears the cap and habit of an ecclesiastic, apparently of a Monsignor. In all, the shy good humor of our subject seems out of place in relation to the simple Latin legend which accompanies his name: "Famous throughout the World." Mellan's portrait of Menicucci is presumably a few years later. The identical Latin epithet graces the lower margin, but the sitter appears to have been treated somewhat unkindly by the passage of time. Curiously, Menicucci is no longer garbed as a priest, but as a gentleman. In the painting by Valentin, he wears the same attire, but assumes an arrogant expression. In this last work, Menicucci gestures commandingly to an architectural plan which is labelled *Rocca del Conte*, the "castle of the count." If Valentin had intended to identify Menicucci as an architect he would have presumably put into the subject's hand one of the traditional tools of that liberal profession in order to indicate that Menicucci had drawn the plan. In the absence of any other attribute, it would appear that the property to which Menicucci directs our attention is his own, which would suggest that he had adopted the title of count.

Cross-References: Mellan, Exh. no. 44; Valentin, Exh. no. 74.

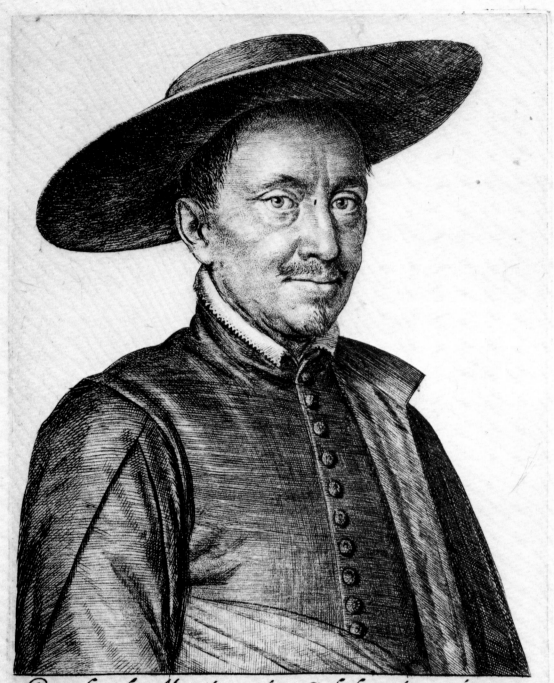

Raphael Menicuccius Celeberrimus in vtroq͛
Orbe Terrarum

Sup. pm.          Romæ 1625.          Ott. L. f

Insigne Geographico et mathematico

**39. OTTAVIO LEONI** (Rome ca. 1578 - 1630 Rome)

*Self-Portrait*
Engraving. 5 3/4 x 4 5/16 (14.5 x 11.0).
Dated: 1625.
References: Bartsch, XVII, 9.
The Museum of Fine Arts, Boston, MA
(Gift of Paul Sachs. M.26009)

Between 1621 and his untimely death in 1630, Ottavio Leoni invested his energy in a series of portrait engravings of famous and worthy men of his time.[1] The portraits in this series can be distinguished from Leoni's other prints by his use of ornamental moldings.[2] For his portraits of artists, Leoni adopted a twelve-sided frame, as is seen in this self-portrait; poets and philosophers are portrayed within ovals (compare the portrait of G.B. Marino, Exh. no. 36). An undated engraving of Paolo Giordano II, Duke of Bracciano, represents the sitter within the surround of a cartouche, which most likely indicates that had Leoni lived, the noblemen among his gallery would have been framed similarly.[3] Excepting the portrait of his father, Ludovico Leoni, all of the subjects in this series were living at the date of their portrait. In all, Leoni was able to complete eighteen works that can be ascribed to this gallery of virtuosi.[4]

This *Self-Portrait* by Ottavio Leoni represents his highest technical achievement in printmaking. In order to attain fine gradations of tone, Leoni was led to reinvent the technique of stippling, which is the use of the tip of the engraver's burin to pounce the copper plate. In his 1623 -24 portrait of Marino (Exh. no. 36) Leoni had almost mastered this device, but the stippling on the earlier print appears wooden in comparison to the astonishing subtlety of the work on the face in this self-portrait. In a later state of this print, shading is introduced into the background to the detriment of the work as a whole.

1) Baglione, 1642, 322.
2) The earlier literature does not draw any distinctions between Leoni's portraits "in frames" and his other portrait engravings.
3) I suspect that the portrait of Paolo Giordano II (Bartsch, XVII, 20) is the last engraving in this series that Leoni was able to complete based upon the following circumstances: it is the only undated work; it is the only portrait of a nobleman; the background is delicately stippled, as is found only in the later prints; and ca. 1629/33 Ippolito Leoni is documented in the archives of the Accademia di S. Luca, Rome, as resident in the house of the duke (Ann Sutherland Harris has kindly brought this unpublished document to my attention.)
4) For illustrations of Leoni's collected prints, see Buffa, 1983, 160 - 198.

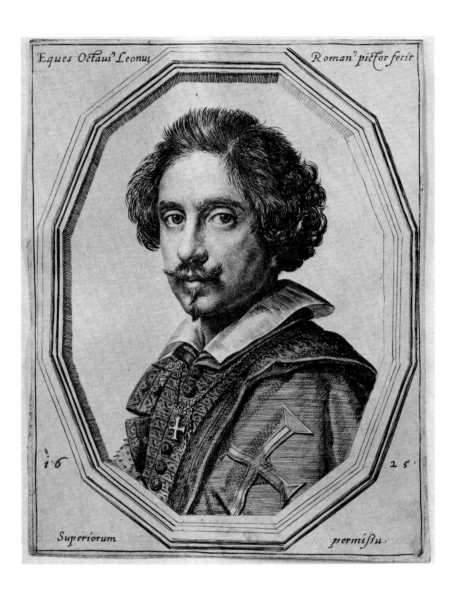

Eques Octaui Leonus                    Roman⁹ pictor fecit

16                                      25

Superiorum                             permissu

**40.** Attributed to **GIROLAMO LUCENTI**
(Rome ca. 1627 - 1698 Rome)

*Portrait Bust of Pope Clement IX*
(Giulio Rospigliosi, Pistoia 1667 - Pope 1667 - 1669 Rome)
Bronze. Height including base, 38 (96.5).
References: Detroit, 1965, no. 44
Collections: Baron Gustave de Rothschild, Paris; Palais
Lambert, Brussels.
Detroit Institute of Arts, Detroit, MI
(Founders Society Purchase, General Endowment Fund,
60.206)

Devout, erudite, and extraordinarily literate, Giulio Ros-
pigliosi, a native of Pistoia, was educated by the Jesuits in
Rome and later studied in Pisa. The brevity of his pontifi-
cate was deeply regretted. His career began under Urban
VIII with a series of administrative posts. Eventually he
rose to Archbishop of Tarso and nunzio to Spain at the
Court of Philip IV. Rospigliosi was a highly gifted poet.
As a young prelate in Rome, and later in Madrid, he
exerted decisive influence on the form of Baroque operatic
comedies with his librettos set to music by different com-
posers. Several of his compositions were staged by Bernini
in the theatre of Palazzo Barberini. Rospigliosi was created
Cardinal by Alexander VII on April 9, 1657, and was
elected pope in May of 1667, assuming the name of Clem-
ent IX. An astute administrator, Clement IX was able to
lower taxes, reduce the influence of the Jesuits, and to
quell the Jansenist controversy. He struggled in vain to
intercede effectively in the conflict between Spain and
France, which was resolved only after Louis XIV became
wary of the Triple Alliance of Holland, England and
Sweden.

Girolamo Lucenti was the son of Ambrogio Lucenti (died
1656), a specialist in bronze casting who had worked for
Bernini and Algardi in the execution of papal commis-
sions. Girolamo followed in his father's footsteps. After a
period in the workshop of Algardi (from which he inher-
ited some models), he is already documented in 1660 as
employed in casting bronze at the papal foundry.[1] During
the papacy of Clement IX, Lucenti was one of the sculp-
tors to whom Bernini entrusted the carving of an angel in
marble for the Ponte S. Angelo. Two of the numerous
medals and plaques cast by Lucenti are included in this
exhibition.

The attribution to Lucenti of this portrait of Clement IX
was advanced by Olga Raggio in 1965. At that time, Rag-
gio pointed out the close relationship of this bronze to a
plaster cast of a bust in the church of S. Maria di Monte-
santo, Rome. The series of papal busts that once stood in
that church are discussed at length in the introductory
essay, *Notes on Four Papal Portrait Busts in Bronze*. In
brief, when the new church of S. Maria di Montesanto
opened to worshippers in 1679, four bronze busts represent-
ing popes Alexander VII, Clement IX, Clement X, and

Innocent XI were situated in the choir on either side of the
High Altar. From a document of 1678, we know that the
first three bronzes had been cast by Girolamo Lucenti,
while the fourth, of Innocent XI, was at that moment
being made by one of the Travani family of sculptors.[2]
From the 1686 edition of F. Titi's Roman guidebook on-
wards, all four busts were credited to Lucenti.[3] At some
point during the nineteenth century, the bronzes were
removed and replaced by four plaster casts, one of which
represents Urban VIII, whose portrait did not figure in the
original decoration. Our introductory essay weighs the
evidence on both sides of the question as to whether the
exhibited busts of Clement IX and Clement X might be the
works formerly in S. Maria di Montesanto. Valentino
Martinelli cited in a publication of 1956 another cast of this
bronze (unillustrated) in the Rospigliosi collection, Rome,
which he proposed to identify as the bronze formerly in the
church.[4]

Recently, the attribution of this bust to Lucenti has been
persuasively seconded by H. Lee Bimm.[5] According to that
writer, the archives of the papal mint record a payment to
Lucenti for his execution in 1669 of a well-known medal of
Clement IX.[6] The portrait in profile is found on an
unsigned plaque in the Fogg Art Museum, Cambridge
(App. 17), as Bimm points out. The resemblances between
the profile and workmanship of the Detroit bust of Cle-
ment IX led Bimm to attribute, correctly it seems, all of
these works to Lucenti. In Bimm's view as well, the por-
trait which is reproduced in Lucenti's three bronzes of dif-
fering format was presumably drawn (or sculpted) by Ber-
nini,[7] who advised the pope, his friend of forty years, on all
artistic matters. Marc Worsdale likewise sees Bernini's
design in the portrait on the 1669 medal.[8]

Cross Reference: Guidi, Exh. no. 28.

1) This documentation was kindly brought to my attention by Jennifer
Montagu (in a letter, July 22, 1984).
2) Golzio, 1941, 126.
3) Titi, *Ammaestramento ... di pittura, scoltura et architettura nelle
chiese di Rome*, Rome, 1686, 356.
4) Martinelli, 1956, 48 note 96.
5) Bimm, 1974, 74-75.
6) Casts of this medal are illustrated in *Bernini in Vaticano*, 1981, no. 315;
Norris and Weber, 1976, no. 102.
7) Bimm, 1974, 74 - 75, postulates that the prototype was a lost marble
bust of the pope executed by Bernini, and he writes that such a work is
cited in several nineteenth-century inventories of the Rospigliosi
collection.
8) Worsdale in *Bernini in Vaticana*, 1981, 283. It should be pointed out
that Martinelli, 1956, figs. 23 and 26, in his captions to the photographs
of the plaster busts of Alexander VII and Clement X in S. Maria di Monte-
santo, expresses the supposition that the bronze originals were cast " after
Gian Lorenzo Bernini." Indeed, if someday it can be demonstrated that
Bernini designed the portraits and supervised their casting into bronze by
Lucenti, the question will be begged as to whom should be considered the
author of these works: Lucenti or Bernini?

**41.** Attributed to **GIROLAMO LUCENTI**
(Rome ca. 1627 - 1698 Rome)

*Portrait Medallion of Pope Clement X*
(Emilio Altieri, Rome, 1590 - Pope 1670 - 76 Rome)
Bronze, Diameter 12 1/2 (31.7).
The Metropolitan Museum of Art, New York, NY
(Rogers Fund 1907. 07.204.1)

Girolamo Lucenti became an engraver at the papal mint in 1668, second to Gaspare Morone Mola. His principal activity as a medallist occurred under Clement X, for whom he worked in competition with Gioacchino Francesco Travani. After 1670 Lucenti frequently prefaced his signatures with *Eques,* indicating that he was knighted about this time. During this same period, Lucenti was extensively employed by Bernini for the casting of bronzes in various projects, including the altar of the Cappella del Sacramento (1673 - 74) and the figure of Death on the tomb of Alexander VII (1676), both in St. Peter's.

This portrait medallion is distinctive for its size; no other casts are known. The attribution to Lucenti is supported by comparison with the profile portraits of Clement X that appear on the obverse of two medals by Lucenti of 1670.[1] The slender features of Clement X confirm that this medallion must have been designed at the outset of his papacy, since subsequent portraits depict him with full, sagging cheeks and chin. Bernini's drawing of the profile of the pope in all his corpulence and with crumpled cap was reproduced in reverse on two works dated 1673: a medal by Giovanni Hamerani and a coin, a silver *scudo,* engraved by Lucenti.[2]

Pope Clement X is also portrayed in this exhibition in a life-sized bronze bust. See Exh. no. 28 for biographical details.

Cross References: Guidi, Exh. no. 28; Hamerani, Exh. no. 29

1) Both of these medals are identified as having been executed during the first year of the papacy. The first is dated 1670 below the portrait; the reverse is inscribed *ROMA . RESVRGENS* and depicts SS. Peter and Paul; illustrated in Whitman with Varriano, 1983, no. 115. The second medal bears the reverse known as "the Lavanda" (*Bernini in Vaticano,* 1981, no. 321, repr.). Marc Worsdale published the document of payment to Lucenti of the Clement X with the "Lavanda;" *Bernini in Vaticano,* 1981, 283.
2) The drawing is illustrated by Sutherland Harris, 1977, no. 91. For a photograph of the Hamerani medal, with reverse of *The Church Standing,* see Whitman with Varriano, 1983, no. 119. For the Lucenti *scudo,* see Martinori, 1920, 11.

## 42. GIROLAMO LUCENTI (Rome ca. 1627 - 1698 Rome)

*Portrait Medal of Pope Innocent XI*
(Benedetto Odescalchi,
Como 1611 - Pope 1676 - 1689 Rome)
Bronze, without reverse. Diameter, 3 9/16 (9.0).
Signed below the truncation: LVCENTI
References: Norris & Weber, 1976, no. 105; Whitman with
Varriano, 1983, no. 122.
Bowdoin College Museum of Art, Brunswick, ME
(1966.113.21)

Pious, austere and resolute, Innocent XI has been called
"the greatest pope of the 17th century" on the basis of the
very qualities which have made him little known to histo-
rians of art.[1] After a century of continuous construction,
the hammers fell silent in St. Peter's during this papacy as
Innocent XI devoted himself to reestablishing the Church's
ministry to the poor and to his life-plan, the final repul-
sion of the Turks from Europe. This pope was the first to
reject nepotism. He refrained, moreover, from public dem-
onstrations of papal wealth. The Vatican treasury was
unstinting, however, in support of resistance against the
Turkish forces, who captured Hungary and laid siege to
Vienna in 1683. The personal diplomacy of the pope led to
the League of Warsaw, which made possible the near-
miraculous victory at Vienna by John Sobieski of Poland,
recognized as one of the turning points in modern history.
Pope Saint Innocent XI was canonized in 1956.

This portrait medallion of Innocent XI is undated, but
must have been cast almost immediately upon the pope's
election, which coincided with Lucenti's replacement at
the papal mint by Giovanni Hamerani. It is possible that
Lucenti paid the consequences of his association with
Bernini, for whom the austere pope had no use.[2] In any
event, this fine cast of Lucenti's medal displays his gifts
for sculpture on a miniature scale.[3] The artist's talents
seem to have been overly extended when he was called to
execute monumental commissions, for example the tomb
of Cardinal Gastaldi in the choir of S. Maria de' Miracoli
(1685 - 86).

1) von Matt and Kühner, 1963, 187.
2) Innocent XI is most often cited in the history of art in connection with
his distaste for the nudity of the personification of Truth in the tomb of
Alexander VII as designed by Bernini. In 1678 Lucenti was employed by
Bernini to cast bronze drapery for this figure. At this same time Lucenti
was replaced (at the instigation of the pope?) by Travani in the execution
of a bronze bust of Innocent XI for the church of S. Maria di Montesanto.
3) See Whitman with Varriano, 1983, no. 122, for a technical discussion of
this same cast.

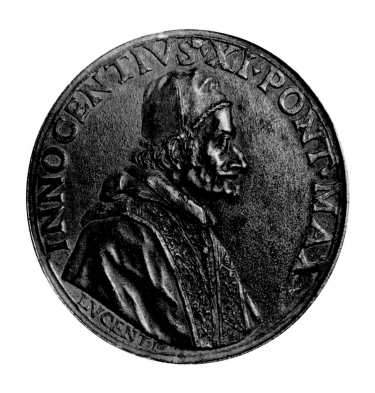

## 43. CLAUDE MELLAN (Abbeville 1598 - 1688 Paris)

*Portrait of Anna Maria Vaiani*
Engraving. 4 1/4 x 3 5/16 (10.8 x 9.2)
References: De Montaiglon, 1856, no. 256.
The Museum of Fine Arts, Boston, MA
(Harvey D. Parker Collection, P.4586)

The inscription informs us that the subject of this viva-cious portrait was a Florentine painter and printmaker, active in Rome during Mellan's sojourn in the Eternal City, (1624 - 36).

Our knowledge of the career of this woman artist is mainly confined to a passage in Baldinucci's biography of Gugli-elmo Cortese, called Il Borgognone (1628 - 1679): "He had already spent a number of years in Rome,[1] and had acquired a distinguished reputation as a painter, not to mention some money set aside, when he determined to settle down. Cortese therefore married a beautiful and virtuous girl, called Maria, the daughter of a Florentine painter named Vaiani, who had worked in the Vatican, and of a Milanese mother. The pair lived together for seven years without having children; after that time — this was still during the papacy of Innocent X (1644 - 1655) — Maria departed this life."[2]

Like Mellan, Vaiani engraved some plates for the catalogue of the antique statues in the Giustiniani collection, Rome. She was also among the artists (with Cortona and Lan-franco) who contributed to the illustration of a horticultu-ral study, *De florum cultura,* by G.B. Ferrari, Rome, 1633.[3]

1) ca. 1640. Waterhouse, 1976, 68.
2) Baldinucci, 1975 ed., V, 210.
3) Vaiani's engraving of a vase of flowers is found on p. 416.

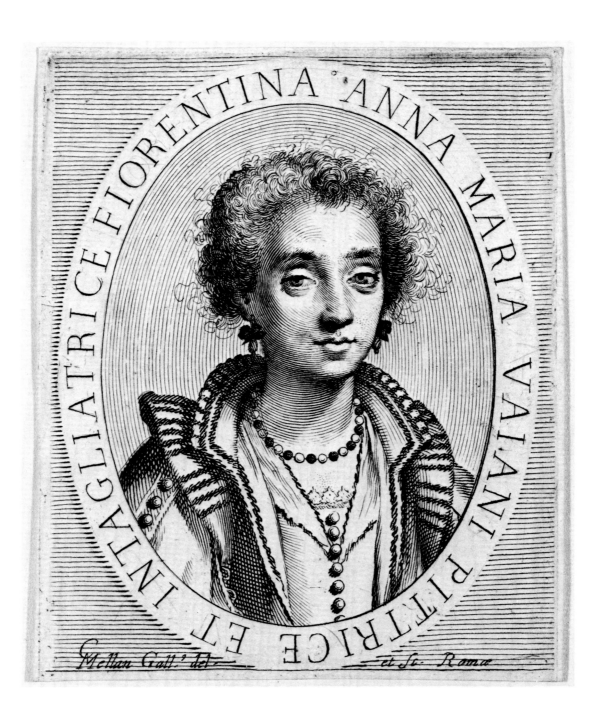

FIORENTINA·ANNA MARIA VAIANI PITTRICE ET INTAGLIATRICE

*Mellan Gall.ᵉ del.* *et Sc. Romæ*

## 44. CLAUDE MELLAN (Abbeville 1598 - 1688 Paris)

*Portrait of Raffaello Menicucci*
Engraving. 5 7/8 x 4 1/8 (15.2 x 10.1)
References: De Montaiglon, 1856, no. 213; Schleier, 1965,
fig. 3; Janson, 1980, 68 - 70.
The Metropolitan Museum of Art, New York, NY
(Harris Brisbane Dick Fund, 1917.3.756.1471)

Raffaello Menicucci was a buffoon at the papal court of
Urban VIII (1624 - 1644).[1] He must have enjoyed a particu-
lar vogue during the latter half of the 1620's: this engrav-
ing executed during Mellan's Roman sojourn of 1624 - 36,
is but one of three portraits of Menicucci in this exhibi-
tion, all of which are datable to that period. A comparison
of these three views of Menicucci reveals three distinct
interpretations of the man's personality and even his social
rank. Mellan's portrait conveys an unmistakable impres-
sion of some considerable turbulence lying beneath the
surface of this ego.

Erich Schleier has pointed out the existence of a biography
of Menicucci by Gian Vittorio Rossi, published in
Cologne in 1645.[2] One of Menicucci's particular obses-
sions, according to Rossi, was the idea of his own fame.
Indeed, Rossi writes that Menicucci's buffoonery was
famous in Rome and in Etruria. Menicucci claimed that
he had succeeded in attracting world-wide fame, which is
exactly the meaning of the Latin motto, *Celeberrimus in
utroq. orbe terrarum,* inscribed on the portrait prints by
both Mellan and Leoni.

Cross References: Valentin, Exh. no. 74; Leoni, Exh. no.
38.

1) These biographical notices are taken from the article by Erich Schleier,
1965, 82-83.
2) Jani Nicii Erithraei (i.e. Gian Vittorio de Rossi), *Pinacotheca Imagi-
num, Illustrium, doctrinae vel ingenii laude, virorum, qui auctore super-
stite, diem suum obierunt,* Cologne, 1645, Vol. I, ch. CLX, 296 - 300.

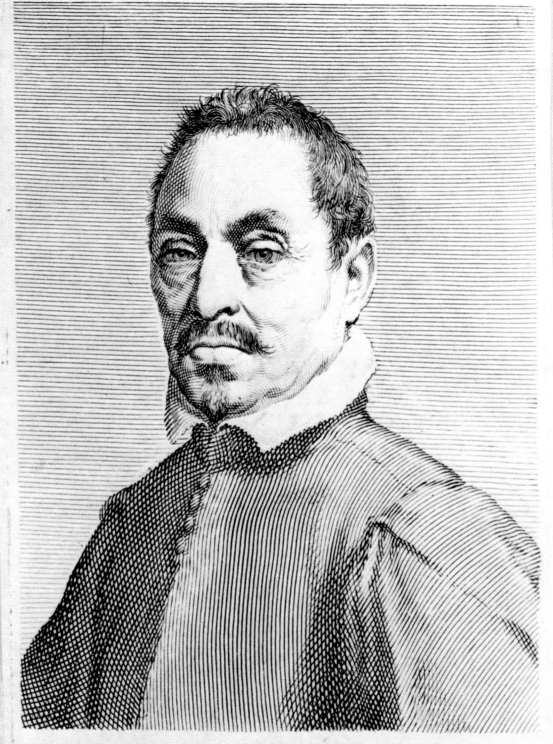

# RAPHAEL MENICVCIVS

*Celeberrimus in vtroq̃, orbe terrarum*

Romæ Sup. ym.                                    Cl. Meilan Gall' del et sculp.

## 45. PIER FRANCESCO MOLA
(Coldrerio 1612 - 1666 Rome)

*Caricature Portrait of a Man*
Pen and iron gall ink wash drawing. 4 9/16 x 3 3/4. (11.6 x 9.5).
References: Gibbon, 1977, no. 444.
The Art Museum, Princeton University, Princeton, NJ
(Dan Fellows Platt Collection, 48-759)

Under the influence of Guercino particularly, P. F. Mola produced a good many caricature drawings from which emerge a comic wit and a propensity for satire that are not usually seen in the artist's paintings. Most of Mola's and Guercino's caricatures beg the question as to whether they represent displays of pure invention or whether they are to be considered portraits in caricature style of actual persons. There is no other test to apply to this problem than our own subjective response. This drawing of a man (a cleric?) by Mola has been included in this exhibition on the assumption that the artist has endeavored to convey a recognizable likeness and even some insight into the character of one of his acquaintances, notwithstanding the free rein that artist gives to his bravura handling of the pen and brush. In fact, Mola's whimsical draftsmanship contributes materially to the impression that the viewer receives of the apparently mischievous personality of this man.

P.F. Mola was born in the canton of Ticino, but was raised and trained in Rome, where his father, G.B. Mola, was active as an architect. During lengthy sojourns in Bologna and Venice during the 1630's and 1640's Mola furthered his education with extensive studies of Venetian Renaissance paintings and of the figure style of Francesco Albani and other Bolognese painters. In Mola's mature style one can observe an absorbing tension between his sturdy figures and his dramatic, luxurious landscapes. The few known portrait paintings by him are admirable for their sharp, naturalistic observation.

Cross-Reference: Guercino, Exh. no. 27.

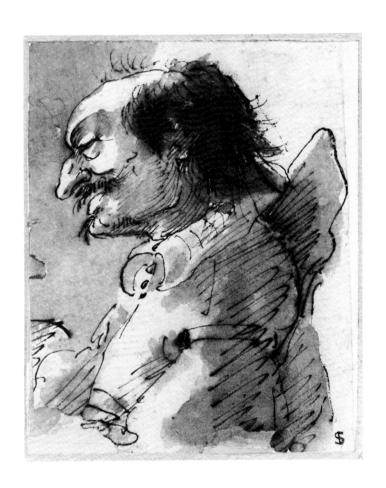

**46.** Attributed to **ANTONIO MONTAUTI**
(active in Florence and Rome 1709 - 1740)

*Portrait Bust of Francesco Redi*
Carrara marble. Height: 39 (99.1) including socle.
References: Lankheit, 1971, p. 39 note 10.
Michael Hall, New York, NY

The life and portraiture of Francesco Redi (1626 - 1697), physician to the Grand Dukes of Tuscany, scientist, and poet, are the subject of an essay at the front of this catalogue.

The present attribution of this prepossessing marble bust was advanced by Klaus Lankheit in a private communication to the lender. According to the contemporary testimony of F.M.N. Gabburri, Antonio Mantauti studied in Florence with Giuseppe Piamontini, who was in turn a faithful pupil of Giovanni Battista Foggini.[1] Mantauti began his career as a medalist and maker of bronzes. In 1733 he was called to Rome, where he was named architect of St. Peter's by Pope Clement XII in 1735.[2] Gabburri mentions several sculptures on religious themes but not any portrait marbles by Montauti. In recent years, busts by Montauti of Grand Duke Cosimo III and of Grand Duke Gian Gastone de' Medici have been identified by Lankheit and Karla Langedijk.[3] A signed bust of Antonio Magliabecchi is in the Biblioteca Nazionale, Florence.

Given the pose and animation of this bust — both inspired by Foggini's portraits — as well as the advanced age of the sitter as portrayed, it bears mention that Foggini is documented as the sculptor of two marble busts of Francesco Redi during the 1690's. Lankheit specifically rules out the identification of the present bust with the missing portrait of Redi in the series of *dottissimi uomini* or "learned men" sculpted 1693 - 1704 by Foggini for Lorenzo Bellini, another doctor at the Florentine court. However, this marble is not appreciably inferior in execution to some of the busts which Lankheit has identified with the Bellini commission and in which he has noted certain variances in quality.[4]

From Redi's account books we know that Redi himself commissioned Foggini in 1695 to sculpt a portrait in marble, which he placed in the atrium of his Villa degli Orti in Arezzo. According to Ugo Viviani, this bust was removed from the Villa degli Orti shortly before 1928, when it was replaced by a plaster copy.[5] Viviani's photograph of this plaster copy is not sufficiently clear either to confirm or to rule out the identification of the missing original with the marble in this exhibition.

1) Published in Lankheit, 1962, 228-9.
2) See Enggass, 1976, I, 189-92 for the most complete study on Montauti.
3) *ibid.*, 186-87, Abb. 190; K. Langedijk, 1981, I, 628-29, repr.; 1983, II, 970-71, repr.
4) Lankheit, 1971, 22.
5) Viviani, 1928, part 1, 90; part 2, tav. VII.

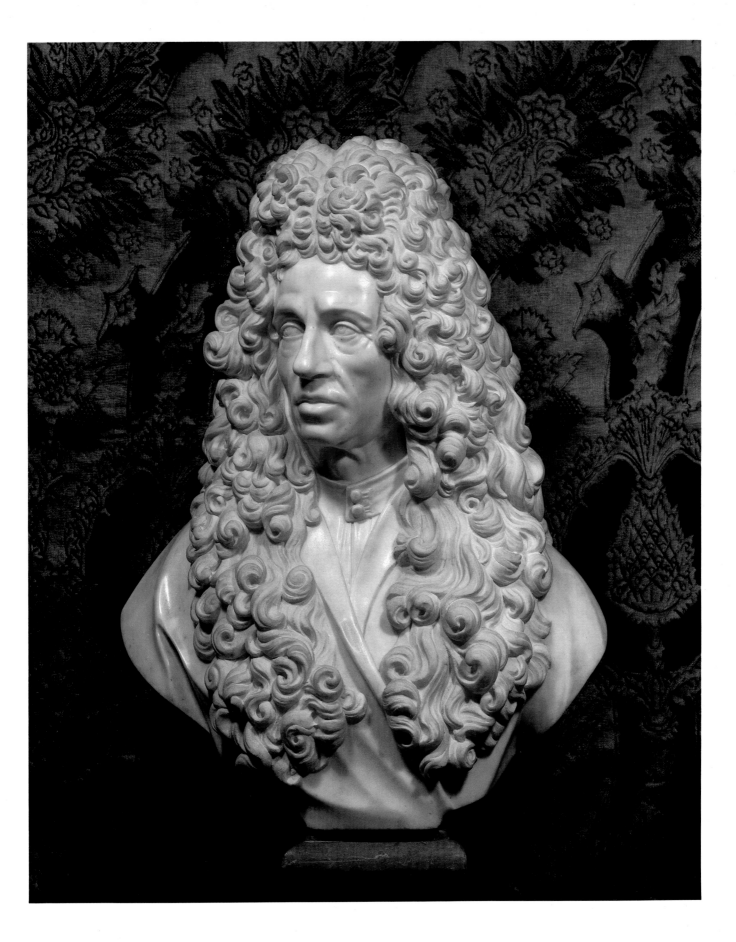

## 47. **PIETRO MUTTONI,** called Pietro della Vecchia
(Venice 1603 - 1678)

*Portrait of Erhard Weigel*
Oil on canvas. 47 x 39 1/2 (90 x 78)
Signed and dated: *Petrus Vechia Pic.r/1649.*
References: Venice, Ca' Pesaro, 1959, no. 100; Manning, 1964, no. 22; Manning, 1967/68, no. 32
The Chrysler Museum, Norfolk, VA
(Gift of Walter P. Chrysler, 71.614)

Erhard Weigel (1624 - 1699) was a German philosopher and mathematical prodigy. Here Pietro della Vecchia has portrayed the young man with the compass of a geometrician in one hand as he gestures with the other towards a tablet filled with his calculations. The artist's signature and the date, 1649, can be found in the midst of these numbers and signs.

Pietro Muttoni took his sobriquet, *della Vecchia* ("of the old times") from his artistic speciality, namely his fanciful imitations of early sixteenth-century Venetian paintings. In particular, della Vecchia painted dashing portraits of swaggering gallants. These figures of *bravi* were intended to satisfy some of the demand for the practically non-existent originals by Giorgione. Della Vecchia was most likely not chagrined if his creations were occasionally mistaken for works by Giorgione or Titian. Another aspect of his prolific production was likewise of his own invention: he painted countless scenes of huddled consultations among knobby-nosed philosophers, alchemists, and a panoply of monstrous colleagues.

In view of these urges towards necromancy, we can image that della Vecchia had some interest as well in the mystical symbolism of numbers with which the mathematics of the day was rife. Such an attitude is doubtless reflected in his respectful, even affectionate, portrayal of Weigel. The black-and-white photograph of the painting does not do justice to the work, since it does not convey the vivid tints and emphatic modelling which della Vecchia has employed to endow Weigel's head, shoulder, and hand with a forceful projection towards the viewer.

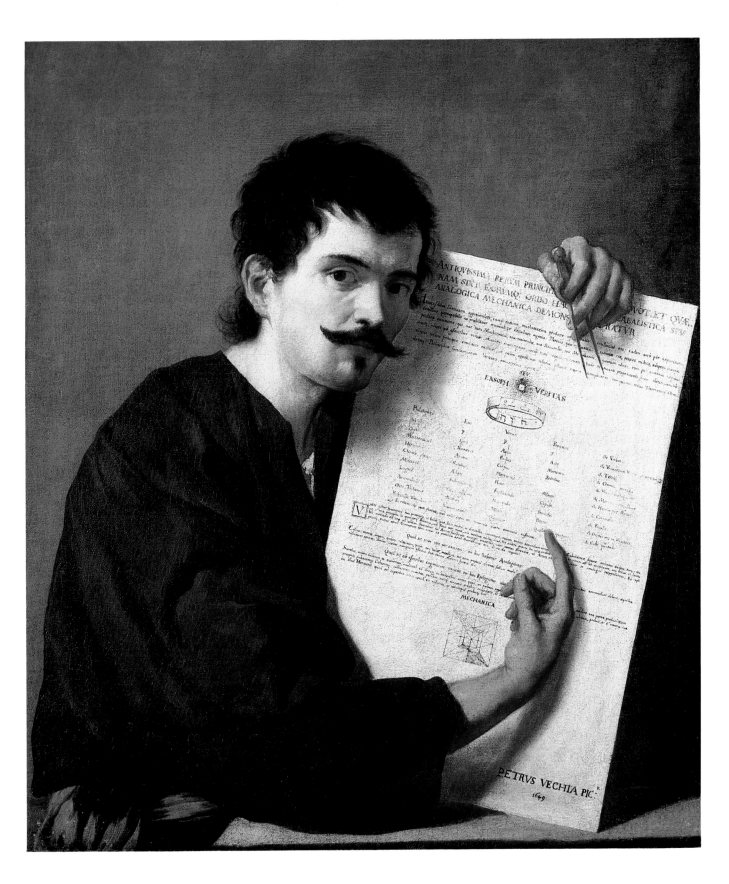

## 48. NEAPOLITAN SCHOOL, ca. 1630

*Portrait of Three Gentlemen*
Oil on canvas. 7 1/4 x 9 5/8 (18.4 x 24.5).
References: R. L. Manning, 1969/70, no. 26, repr.
Suida Manning Collection, New York, NY

This enigmatic picture, which is unusually small for a group portrait, continues to perplex fifteen years after the challenge of its attribution was put forward in the Finch College exhibition of "Sixty-six Paintings in Search of Their Authors". It seems clear only that these three Spanish grandees and their companion, a cross-eyed lad with his dog, were painted in Naples at some point between 1620 and 1640.

The Neapolitan character of this picture is confirmed by a slightly less strange group portrait, also small, which has been attributed to Aniello Falcone by Giuseppe De Vito (Fig. 9).[1] That other portrait does not resemble Falcone's certain works, but at least its Neapolitan origins are guaranteed by the view of the Certosa di San Martino in the background.

An hypothesis to explain the incongruous gathering in the present portrait would be that the three gentlemen are regents of a charitable foundation, and that one of them commissioned this painting as a keepsake. According to this view, the lad and dog are on hand as signs that the institution in question is a home for foundling children.

1) De Vito, 1982, Fig. 9. The painting was with the Galerie SanktLukas, Vienna, in 1970; 10 1/2 x 12 3/8 (26.5 x 31.5), on copper. The miniaturist technique suggests the authorship of Giovanna Garzoni, who worked for the Duke of Alcalà in Naples, 1630 - 31. I would like to thank Robert L. Manning for bringing this comparison to my attention.

## 49. PIETRO PAOLINI (Lucca 1603 - 1681)

*Portrait of a Man Holding a Dürer Frontispiece*
Oil on canvas. 49 7/8 x 40 3/4 (127 x 100.3)
References: Ottani, 1963, 26, pl. 10A; Spear, 1975, 224 and
note 46.
Memorial Art Gallery, University of Rochester.,
Rochester, NY
(Marion Stratton Gould Fund, 77.103)

The young man portrayed in this canvas is unidentified.
We may surmise from his study of a woodcut by Albrecht
Dürer that he is an amateur of the fine arts. Anna Ottani
Cavina was first to point out that this woodcut of the
"Man of Sorrows Seated" is the frontispiece to Dürer's
*Small Woodcut Passion* series, dated 1511. Filippo Baldi-
nucci, who compiled in 1681 an encyclopedia of artists'
biographies — with a natural emphasis on the local school
in Florence — devotes a lengthy article to Dürer, and
among the works he praises is this same woodcut.[1]

Baldinucci makes frequent reference to the uninterrupted
admiration in Italy for Dürer over the course of more than
one hundred seventy years and to Italian collections of the
German artist's prints and drawings. Indeed, in pointing
out the borrowings by Andrea del Sarto, Il Bacchiacca, and
Jacopo Pontormo from the capricious imagination of
Dürer — for so it seemed to Italians, at least — Baldinucci
postulates a Northern impetus to the painting of the first
Maniera in Florence which has yet to be appreciated by
historians of the early sixteenth century in Florence.[2]
Among seventeenth-century painters, Baldinucci singles
out the Dürer collection of Cesare Dandini who was
believed to own every one of the master's prints.[3]

Pietro Paolini was the leading artist in Lucca in Tuscany
during the seventeenth century. The available data relating
to Paolini's career points out his pride in the culture of his
native city, which is the theme in a way of this portrait of a
Lucchese collector of Dürer prints. If we look closely, we
can observe that Paolini has painted the sitter holding a
volume into which the woodcut has been pasted. This was
the customary means for preserving prints and drawings
(and in that era of non-acid paper, it was a very good
method). The other pages in the volume presumably held
still more prints of similar interest. In 1640 Pietro Paolini
was the prime mover behind the founding of an academy
of painting and drawing in Lucca, and he must therefore
have encouraged local collectors as best he could. It is
noteworthy in the present context that the pair of altar-
pieces by Paolini now in the Pinacoteca of Lucca reveal
that he actually paid homage to Dürer's compositional
complexities and extravagence of details in his paintings of
sacred subjects.

This painting is valuable as one of the rare first-rate exam-
ples of Caravaggesque tendencies in Italian portraiture.
Paolini's artistic formation took place from about 1619 to
1632 in Rome, where he was influenced mainly by two
followers of the realistic style of Michelangelo da
Caravaggio: Andrea Caroselli and Valentin de Boulogne.
After a visit to Venice, and with increasing fidelity to Caro-
selli, Paolini gradually cast off the unadorned manner of
Caravaggio in favor of a greater variety of colors and
ornamental details. However, this *Portrait of a Man*, with
its marked chiaroscuro, does not intimate those later
developments.

Cross Reference: Valentin, Exh. no. 74.

1) Baldinucci, ed. 1975, II, 10.
2) *ibid.*, 16 - 17.
3) *ibid.*, IV, 555-56.

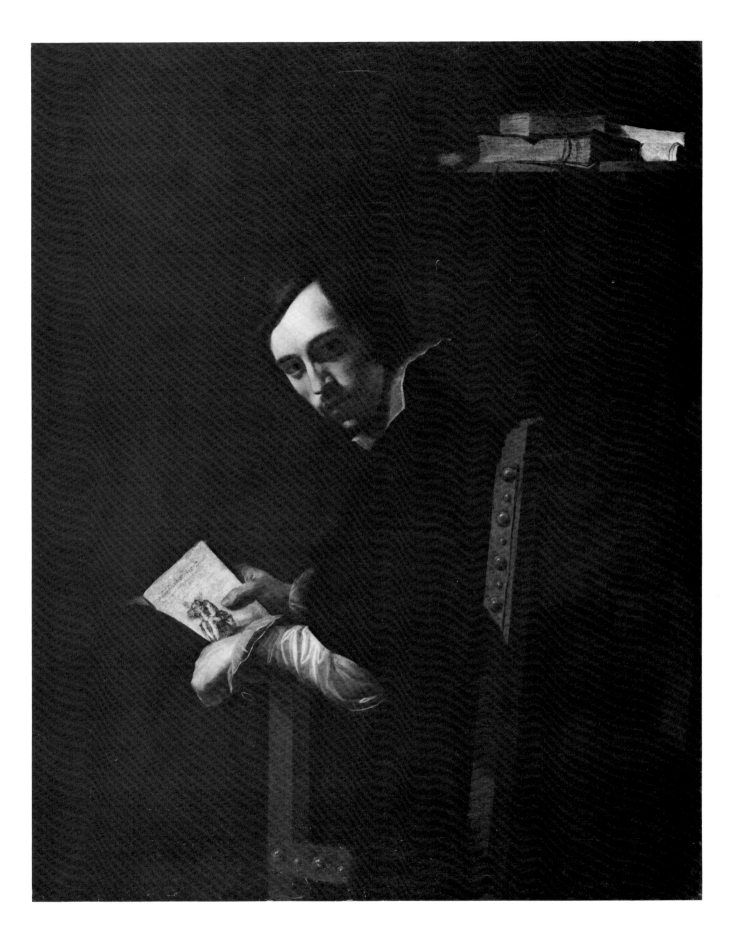

## 50. NICOLAS RÉGNIER (Niccolò Renieri)
(Maubeuge 1591 - 1667 Venice)

*Self-Portrait of the Artist at his Easel*
Oil on canvas. 43 1/2 x 54 1/8 (110.5 x 137.5)
Collections: Dr. Fritz Haussmann, Berlin (1931).
References: Voss, 1931, 167, repr. 161; Rosenberg, 1983, 44, fig. 28.
Fogg Art Museum, Cambridge, MA
(Gift of Mrs. Eric Schroeder, 1982.)

Two traditions of portraiture are impressively combined in this picture by Nicolas Régnier. Our attention is first directed to the life-size representation of a painter seated before his easel. From ample precedent, it is safe to conclude that Régnier has portrayed his own proud features in this guise. The strong contrast between his pale complexion and the tenebrous background insures that this passage is the primary focus of the composition. But in the next instant we see the canvas that rests on the easel. This painting within the painting is also a portrait. Moreover, the second portrait has been positioned so that its subject fixes his gaze upon us with a direct intensity that is no less commanding than Régnier's. The work becomes therefore a double portrait, specifically a *Freundschaftsbild* ("friendship picture") in which the portraits of artist and friend declare their intellectual and personal sympathies.[1] Alas, Régnier has not provided much evidence to enable us to identify the gentleman whom he has portrayed. The fur collar of his suit is an attribute of affluence but not necessarily of nobility. It is found more typically, but not exclusively, in Northern European dress at this date. The older age of the gentleman suggests the possibilities that the sitter is either the father of Régnier — although the familial resemblance is not compelling — or he might be Abraham Janssens, Régnier's master in Antwerp.[2] On the basis of style Herman Voss convincingly dated this painting to Régnier's activity in Rome in the early 1620's, at the outset of his independent career when he felt the influence of Michelangelo da Caravaggio the most strongly. This moment would be a likely time as well for Régnier to pay homage to Janssens, who was himself one of the first generation of Caravaggesque painters.

In recent decades art historical research has demonstrated beyond doubt that sixteenth- and seventeenth-century self-portraits of artists at work were executed as protestations to the effect that the art of painting was a liberal, not a mechanical (i.e. manual) art. The *Meninas* by Velàzquez (The Prado, Madrid) is the outstanding statement of this position. The present double portrait by Régnier appears to have been painted as a manifesto of the Caravaggesque attitude, which attempted to confute classical conceptions of artistic decorum. According to the prevailing pictorial logic of the day, Régnier should have indicated in some fashion, however subtle (a softening of focus, a hint of a surface reflection), that the portrait on the easel is more removed from reality than the image of the painter who made it. Régnier, it seems, disdained to make this distinction. As a follower of Caravaggio he thought it insignificant in comparison to the gulf which separates Nature, the supreme model, and its replication by the painter. The purpose of a portrait is to evoke the presence of a living person — on this point all Baroque theorists agree. The Caravaggesque point of view, for the exposition of which we have Régnier's picture to thank, is that the artist desires to render the likeness as faithfully as possible. If Régnier had qualified the portrait on the easel as an object of canvas and pigments, he would have been making a commentary on his own limitations. Nothing about his aggressive expression appears to be confessional, however. In fact, Régnier has evidently used his colors to point up a contradiction in the conventional theory: the portrait of his mentor is painted in vivid tints, while the remainder of the picture, including the self-portrait, is conceived in tones of gray or in shadow.

For all of the vehemence that we read in this early portrait by Régnier, his adherence to the cause of Caravaggism was not lasting. In 1626 he relocated in Venice, where he emerged as a painter of elegant ladies and luxurious fabrics on a par with his compatriot Simon Vouet and with the renowned Guido Reni of Bologna. Régnier's career thrived in this new incarnation. Boschini, the biographer of the Venetian seventeenth century, writes that Régnier's portraits (which have not as yet been reidentified) were admirable for their "reality and their elegance."[3]

Cross-References: Paolini, Exh. no. 49; Valentin, Exh. no. 74.

---

1) *cf.* Herrmann-Fiore, 1983, 32 note 19 for further references to *Freundschaftsbilder*.
2) The Genoese painter of the late sixteenth century, G.B. Paggi, portrayed his father in a canvas on an easel in this manner. For an illustration, see *ibid.*, fig. 8.
3) M. Boschini, *Carta del Navegar Pitoresco*, Venice, 1660, *sub voce*.

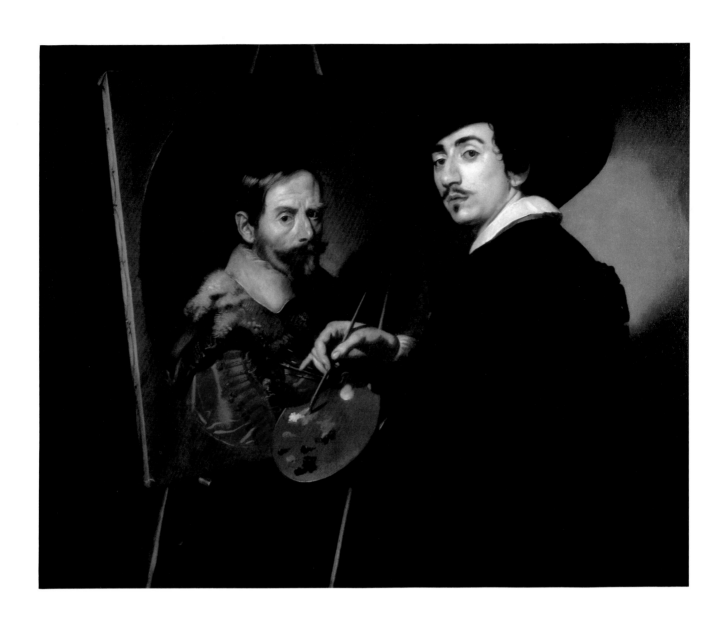

## 51. GUIDO RENI (Bologna 1576 - 1642 Bologna)

*Portrait of Cardinal Roberto Ubaldino*
Oil on canvas. 77 1/2 x 58 3/4 (196.8 x 149.2).

Inscribed, on letter in hand: All Ill$^{mo}$ et Rs$^{mo}$ S$^g$
Cardinalle Ubaldino

on left edge in architecture: questo quadro

on letter on table: All Ill$^{mo}$ R$^o$
d

Sig. Car d Vbaldi...

Provenance: Italy (Florence, Bologna, or Rome?), family of the sitter by 1635; England, said to have been bought from the Spada Palace, Rome, for Mr. Irvine through Mr. Yates (it is not mentioned in W. Buchanan, *Memoirs of Painting*, London, 1824, II, pp. 95-180); England, Dr. Somerville by 1821; England, George James Welbore, Baron Dover (1797-1833); to his wife, Lady Dover (Georgiana Howard, died 1880); to their son, Henry, Third Viscount Clifden (1863-95); London, Christie's, 6 May 1893, lot 29 (bought-in, £36.15); London, Robinson and Fisher, 25 May 1895, lot 731 (£430.10); London, Sabin (dealer); Newport, Rhode Island, Robert Goelet at Ochre Park until 1947; New York, Sotheby's, (Robert Goelet sale) 5-6 December 1947 (withdrawn; there are no paintings in this sale); Newport, Rhode Island, Salve Regina College until 1982; New York, Sotheby's, 21 January 1982, lot 87; Rome, Bracaglie (dealer); London, Colnaghi's (dealer).

References: Pepper, 1973, 636-37 note 32; *Los Angeles County Museum of Art Report, July 1, 1981 - June 30, 1983*, 1984, 24 and 27, repr. on cover; "Reni Reattributed", *Art & Auction*, July/August 1983, p. 14f.
M.83.109

Los Angeles County Museum of Art, Los Angeles, CA.
Purchased with funds provided by the Ahmanson Foundation (M83.109)

When later in his life Guido Reni's fame and success were assured, Louis XIII summoned the artist to France to paint his portrait. Reni, with typical bravado, declined, stating simply that he was not a painter of portraits. In spite of the artist's comment, however, Carlo Cesare Malvasia, Reni's friend and most important biographer, lists in the *Felsina pittrice, vite de' pittori bolognese* (1678) more than thirteen portraits by the artist.[1] The subjects of the paintings range from family members to famous *literati*, from wealthy nobles to the ecclesiastical hierarchy. Like many of his important Bolognese contemporaries, such as the Carracci, Domenichino, and Lanfranco, Guido seems to have executed portraits either out of simple affection or with vocal recalcitrance. As a result, there were very few portraits produced by these artists. The dates of the various portraits by Reni mentioned by Malvasia range within his most formative period, from his early sojourns in Rome when he executed a portrait of Cardinal Jacopo Sannesi (1609) to his final return to Bologna and the completion of the portrait of Cardinal Bernardino Spada (1631). Until recently only three of these portraits have been identified; those of Pope Gregory XV (1621) at Corsham Court, Wilshire; Guido Reni's mother (1630) in the Pinacoteca Nazionale, Bologna; and Cardinal Bernardino Spada (1631) in the Galleria Spada, Rome. To this number can now be added a fourth portrait, possibly Reni's most important, of Cardinal Roberto Ubaldino of about 1625, recently acquired by the Los Angeles County Museum of Art.

The *Portrait of Cardinal Roberto Ubaldino* is not cited by Malvasia. It is, however, mentioned by another of Guido's biographers, Filippo Baldinucci, whose monumental *Notizie de' Professori del Disegno* was published between 1681 and 1728.[2] Following the cleaning of the Los Angeles painting, which revealed the picture to be in an extraordinary state of preservation, scholars have been unanimous in their attribution of the painting to Reni; its design and facture place it firmly within Guido's work of the mid-1620s. In addition, the three inscriptions — two on the letters the Cardinal has received and one (in the upper right quadrant) virtually invisible to the naked eye and certainly never meant to be seen — are typical of Guido's handwriting known through drawings, letters, and official documents of various kinds.

More than anything else, it is Reni's ability to combine for his patron not only a depiction of a particular individual but also his station in life, and on a monumental scale, that impresses the viewer. Relying on the formulae of official state portraiture developed by Raphael and Titian, both of whom Reni esteemed above all other artists, Guido also reveals his awareness of contemporary developments in the genre such as Van Dyck's *Portrait of Cardinal Guido Bentivoglio* painted in Genoa in 1623 (Palazzo Pitti, Florence) or even his *Portrait of Signor Pallavicini* (J. Paul Getty Museum, Malibu), although Van Dyck's exuberant style would have been anathema to Guido's own personal vision of imaginative classicism and academic perfection.

Little is known of the sitter, Cardinal Roberto Ubaldino, except for the various upward leaps which his decidedly successful career took. (He was a cousin of Pope Leo XI whose tomb for St. Peter's Ubaldino commissioned from Alessandro Algardi in 1634).[3] In 1615 he was made Cardinal and eight years later was named Papal Legate to Bologna, a position he occupied until Bernardino Spada replaced him in 1627. Ubaldino subsequently returned to Rome where he

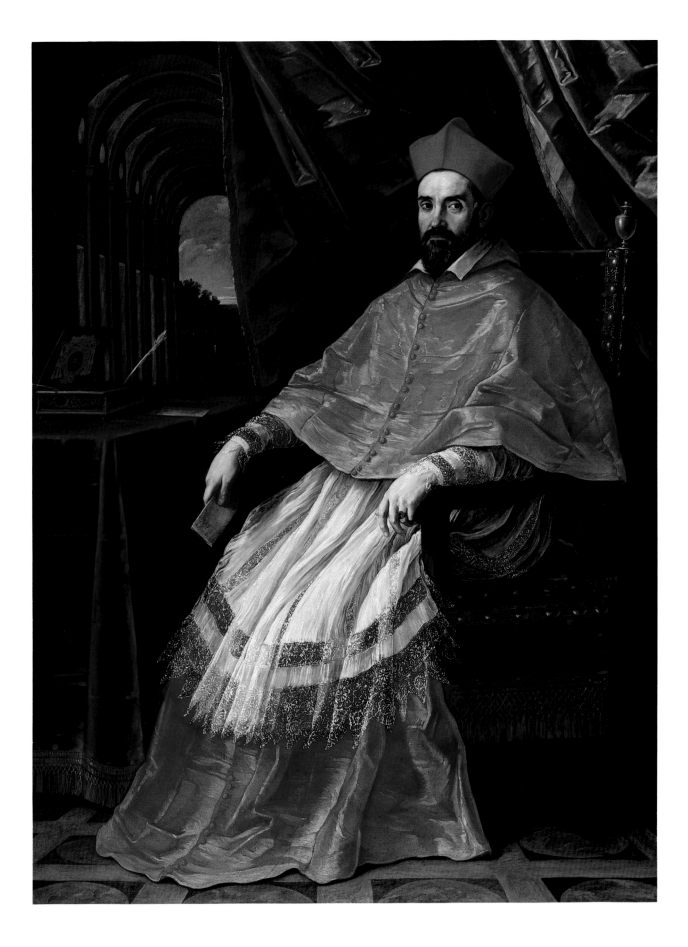

died in 1635.[4] It was during Ubaldino's tenure in Bologna that he met Guido Reni and commissioned the artist to paint his portrait.

Reni's Ubaldino is shown seated in a velvet armchair, having just pushed himself away from his draped writing desk. He holds one letter addressed to him, while another letter lies on the table in front of the inkwell which bears his insignia. He confronts the viewer directly but unemotionally, perhaps too aware that he is being recorded for posterity. The satin curtain enclosing the space in which he sits is pulled back on the left to reveal a colonnaded arcade leading to a fountain within a carefully manicured private garden. Ubaldino's station in life is embodied in the garments he wears, and Guido has depicted them with characteristic luxuriousness. The watered silk of his mozzetta and cassock provide a foil for the *punto in aria* lace alb; the painted lace virtually shimmers on the surface of the red silk. Emerging from these elegant materials are the Cardinal's hands, one holding his bid for immortality (the letter with his name on it), the other casually resting on the arm of the chair. The opalescent tones of flesh are built up of layer upon layer of green, pink, cream and white, in Reni's unique method of applying pigment. The cascade of fabric reaches a crescendo in Ubaldino's head, which is framed within the darkest purple of the curtain; its presence is underscored by the red hat and white collar of the alb. But the painting is not just an effigy whose various accoutrements define his social position. Ubaldino's bearded face is strong, assured, self-confident. The artist never lets the viewer forget the personality of the sitter, however unrelenting it may be within the symphony of delicate reds and purples. Ubaldino's presence is not merely seen, it is palpably felt. Together, the sitter and the painter have created a masterpiece of formal state portraiture.

1) Malvasia, 1980, p. 114.
2) 1688, IV, p. 328. I use the edition of Florence, 1772, XII, pp. 87-88. Baldinucci's citation actually refers to a studio replica dated 1625. This painting, formerly in the possession of Ugo Minerbetti, Florence, by 1690 later passed to Benjamin Guinness, London, who moved to Mignano Montelungo, Italy. It was destroyed by bombardment 8 December 1943. I presume the Los Angeles painting to have been completed just before this version was executed. For the replica, see Waterhouse, 1938, no. 282, and more recently Baccheschi, 1973, 84, 104, no. 118.
3) Heimburger Ravalli, 1973, 33, 82-84.
4) Romano, 1856, LXXXI, 491-492.

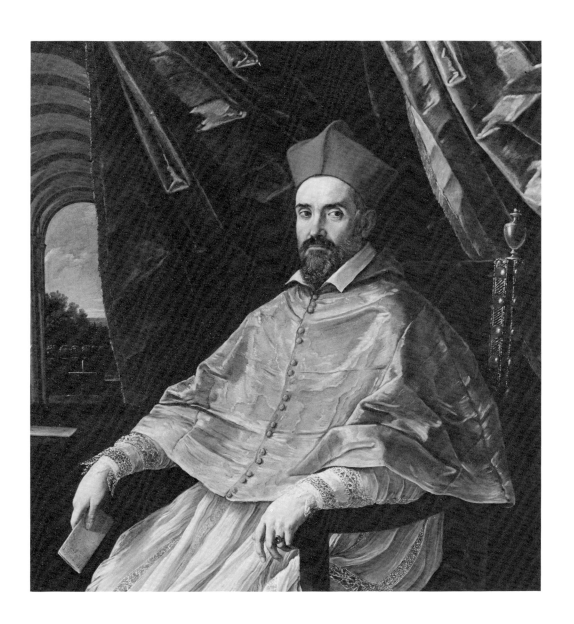

## 52. JUSEPE DE RIBERA (Játiva 1591 - 1652 Naples)

*Portrait of a Knight of Santiago*
Oil on canvas. 57 1/2 x 42 (146.0 x 106.6).
References: Spinosa, 1978, no. 134; Felton, 1982, no. 24.
The Meadows Museum, Southern Methodist University,
Dallas, TX
(1977.2)

The identity of this redoubtable Captain General in the
service of the King of Spain has not yet been determined.
Felton has tentatively suggested that the portrayed may be
the Count of Monterray, Viceroy of Naples from 1631 - 37,
who was also a Knight of Santiago, but the available record
of Monterray's appearance neither confirms nor denies this
conclusion. On the basis of style, the portrait can be dated to
this period with some certainty.

Jusepe de Ribera was born in the region of Valencia, Spain,
but is already documented in Rome in 1615. He was among
the first followers of the naturalistic style of Michelangelo
da Caravaggio, and he remained essentially faithful to this
attitude through three decades of productive activity in
Naples. Portraiture does not comprise a major aspect of
Ribera's career, a regrettable omission. The few portraits
from his hand reveal him to have been a portraitist of
genius. As we can see in this portrait of a Knight of Santi-
ago, Ribera was able to put his extraordinary powers of
description to work for a keen, even fearless, psychological
penetration.

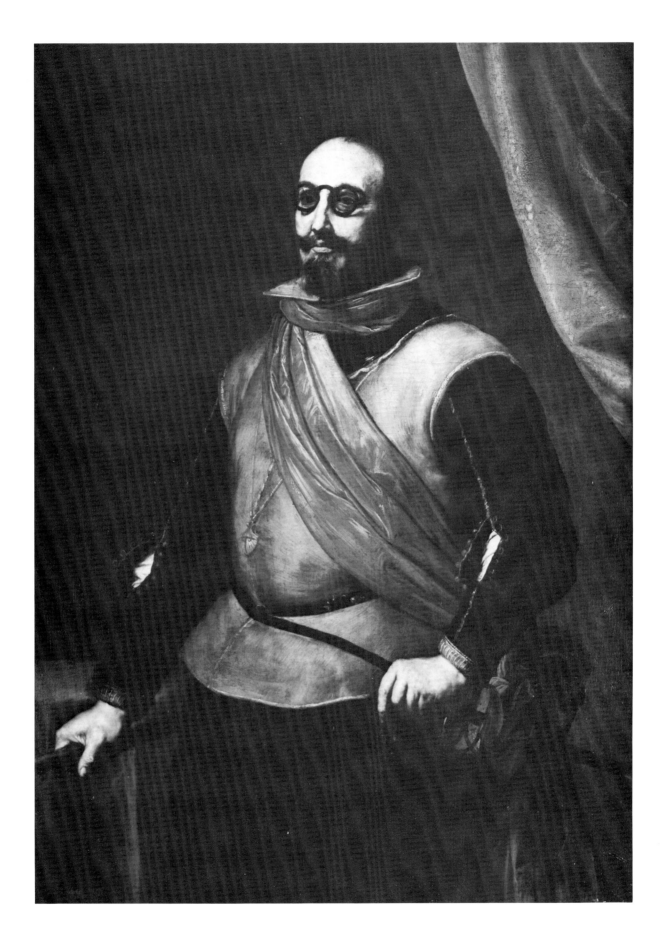

*Portrait Plaque of Alexander VIII*
(Pietro Ottoboni, Venice 1610 - Pope 1689 Rome)
Cast bronze, without reverse. Diameter 6 3/8 (16.3).
Dated 1689, obverse, below
References: Norris and Weber, 1976, no. 137; Whitman with
Varriano, 1983, no. 133.
Bowdoin College Museum of Art, Brunswick, ME
(Molinari Collection, 1966.121)

The election to the papal throne of the kind-hearted Vene-
tian, Pietro Ottoboni, represented a broad appeal for relief
from the contentious, intellectually rigorous personality of
his predecessor, Innocent XI. Certainly the new pope's love
of public spectacles endeared him to the Romans during his
brief pontificate. However, Alexander VIII is mainly recalled
today for his unsuccessful policy of appeasement towards
the hegemonic policies of Louis XIV and his reintroduction
of the nepotistic system of papal government.

The inscription on this unsigned medallion refers to
Alexander VIII's election on October 6, 1689. As Whitman
notes, this piece has been carefully worked to distinguish
between the polished surface of the relief portrait and the
roughened field of the disc. In addition, some detail has
been incised after the casting, for example the seams on the
pope's skullcap. The same author suspects the author of
this piece may be found among the younger members of
the Travani family of medallists and bronze casters, or per-
haps with Giuseppe Ortolani, a Venetian who served the
pope in Rome.

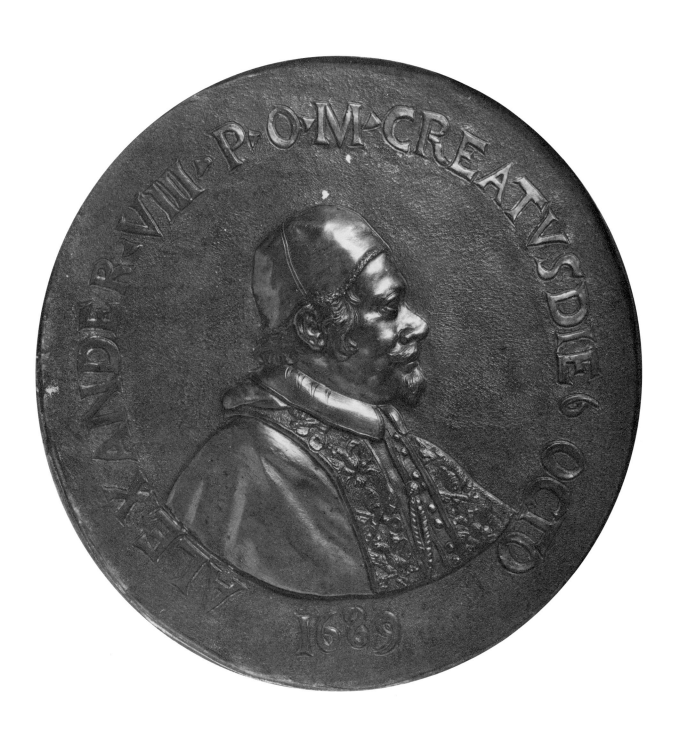

## 54. ROMAN SCHOOL, ca. 1680

*Portrait Bust of a Man*
Terracotta. 32 x 27 (81.2 x 68.6)
Unpublished.
Michael Hall, New York, NY

During the seventeenth century the use of terracotta evolved into one of the most representative forms of sculpture. However, the medium was almost always regarded as a way station en route to the creation of a sculpture in the more durable materials of marble or bronze. The subject of this portrait bust has not as yet been determined, nor can its authorship be established with greater specificity than that of a sculptor active in Rome about 1680. However, by fortunate circumstance a marble version is known; its existence in the Cleveland Museum of Art (Appendix no. 4) has been pointed out by Henry Hawley.[1]

It is hoped that this first publication and exhibition of the terracotta will lead to the clarification of its relationship to the Cleveland marble. Presumably, one of the three possibilities obtains: first, the terracotta served as a preliminary sketch or *bozzetto;* second, the terracotta was perhaps made as a replica of the marble as part of the process of casting a version in bronze; and third, the sculptor might have modelled the terracotta as a studio record of the marble. The liveliness of the handling of such details as the collar, which appears to flutter in a stiff breeze, could be evidence that the terracotta was the sculptor's first, more ambitious design. The marble differs from the terracotta in a notable respect: its reverse is carved to allow the work to be set on a pedestal and viewed from three sides. The terracotta appears to have been intended for frontal viewing and there are indications on its unfinished back that in the past it has been set into a wall as opposed to mounted on a socle. The relatively fragile medium of terracotta rules out the possibility that the terracotta was sculpted for insertion in a tomb or other public memorial. Sometimes, terracottas were painted with simulated bronze patinas. With such treatment this portrait bust could have made an impressive adornment within a niche or over the door of a palace salon.

David C. Ditner has pointed out the similarities in style between the Cleveland marble and the portrait sculptures executed ca. 1680 in the church of Gesù Maria, Rome, by Ercole Ferrata and others.[2] Ditner reasonably proposes a tentative attribution for the Cleveland bust to a sculptor in the circle of Ferrata. Pending further investigation into the still uncharted territory of Roman Baroque sculpture by artists other than Bernini and Algardi, the same assignation can be applied to the terracotta. This thesis gains further support in Schlegel's attribution to Ferrata of a portrait bust of comparable character in the Berlin Sculpture Gallery.[3]

1) In conversation with the owner, 1983.
2) In conversation, June, 1984. I would like to express my gratitude to David Ditner for his very helpful consultation on this and other questions concerning portrait sculptures.
3) Schlegel, 1978, I, no. 12, fig. 22. The Berlin bust is executed in marble in high-relief.

152

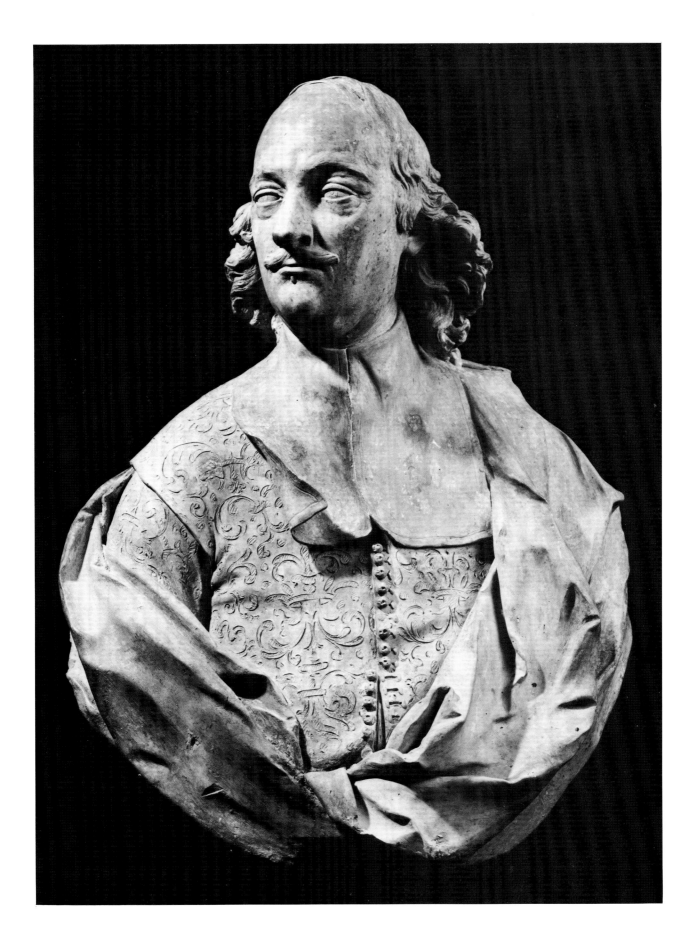

## 55 & 56. ROMAN SCHOOL,
possibly Hamerani workshop, ca. 1676

**55.** *Portrait Plaque of Pius V*
(Antonio Michele Ghislieri, Bosco/Alessandria 1504 - Pope
1566 - 1572 Rome. Beatified 1672; Canonized 1712)
Gilt Bronze. Diameter 7 (17.8).
Philadelphia Museum of Art, Philadelphia, PA
(Bequest of Anthony Morris Clark, 1978-70-127)

**56.** *Portrait Plaque of Innocent XI*
(Benedetto Odescalchi, Como 1611 - Pope 1676 - 1689
Rome. Canonized 1956)
Cast bronze, light brown patina. Diameter 7 (177)
Michael Hall, New York, NY
References: Hiesinger in Philadelphia, 1980, nos. 116 A&B
(Philadelphia Museum casts).

These large decorative plaques are catalogued together
because of the probability that they were issued in tandem.
The plaques are of the identical size and format, and their
subjects are historically related: Pope Innocent XI, elected
1676, was outspoken in his admiration of the Counter-
Reformation Pope Pius V, who was beatified in 1672.[1] The
gilt plaque of Pope Pius V from the Philadelphia Museum
of Art indeed entered that collection with a gilt bronze cast
of the Innocent XI. It is exhibited with a different cast of
the Innocent XI portrait, so that the viewer may compare
the different effects of the gilding with the unusually fine
patina of the bronze.

In the absence of a signature and any documentation for
either of these plaques, the attribution must remain open.
Given the known pattern of medallic issues under Innocent
XI, the current assignation to the ambience of the Hamerani
is well justified.[2] In the opinion of Hiesinger, "their style
and exceptionally severe workmanship are not unlike the
work of Giovanni Martino Hamerani."[3]

It is worth noting that the broad, almost simplistic quality
of the Pius V portrait compares rather closely in style with
the equally curious portraits of Innocent XI that Giovanni
Hamerani engraved on the coins minted by that pope.[4] On
the other hand, the portrait on this plaque of Innocent XI
reflects a markedly more sophisticated model than is ever
found on Hamerani's signed medals. Indeed, the richly
movemented surfaces suggest the possibility that it repro-
duces a portrait drawing by Gian Lorenzo Bernini.

Cross References: Lucenti, Exh. no. 42; Rusconi, Exh. no.
61.

1) Lavin, 1981, 43-44.
2) *cf.* Fischer, 1969, no. 456.
3) Hiesinger, in Philadelphia, 1980, nós. 116 A&B.
4) *cf.* the illustrations in Martinori, 1920, 60-61, 66-67. This scholar com-
ments, 59, "The collected coinage of Innocent XI is perhaps the most
interesting of the pontifical series for its abundance, *bizzaria*, and richness
of strikes, all impressed with Baroque style in various and elegant forms."

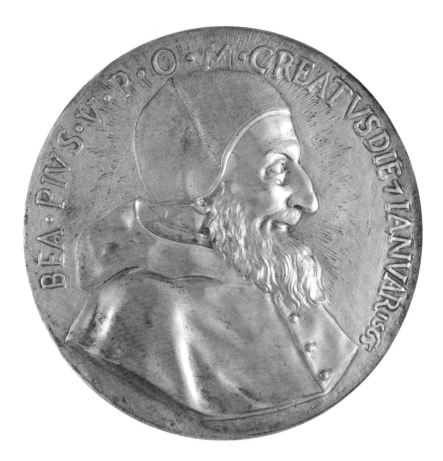

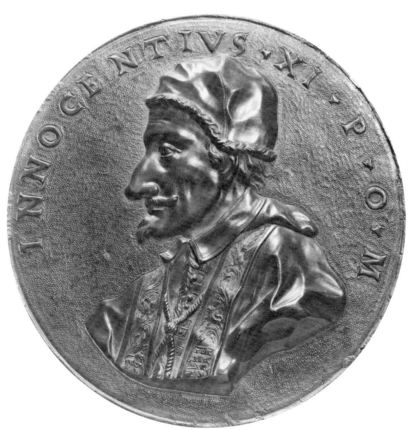

## 57. SALVATOR ROSA
(Arenella (Naples) 1615 - 1673 Rome)

*Portrait of Lucrezia as Poetry*
Oil on canvas. 45 5/8 x 37. (104 x 91)
References: Salerno, 1963, 35, 186, 116f, 315; London, 1973, no. 10; Salerno, 1975, no. 33.
The Wadsworth Atheneum, Hartford, CT
(The Ella Gallup Sumner and Mary Catlin Sumner Collection, 1956.159)

Lucrezia Paolina del fu Silvestro was the Florentine model, mistress and life-long companion of the artist. The personal life of Salvator Rosa, like his career (the two can only be distinguished with difficulty), was beset with adversities and vindications of operatic dimension. Rosa must have met Lucrezia in 1640 soon after his arrival in Florence. He was forced to leave Rome, having earned the enmity of Gian Lorenzo Bernini whom he had made the subject of an ill-considered satire. A son, Rosalvo, was born to Salvator and Lucrezia before August, 1641. The parents could not legally marry, as the first husband of Lucrezia was still living. However, their forced alternative of communal living was illegal under the laws of the church.

After Rosa's return to Rome in 1649, his caustic satires, both literary and pictorial, once more excited his antagonists. The birth in 1655 of a second son out of wedlock, Augusto, brought matters to a head. Early in 1656, under the threat of denunciation to the Inquisition, Rosa was compelled to send Lucrezia and their children away from Rome to Naples. A letter written by Rosa to his friend G. B. Ricciardi in February, 1656, cries out in anguish and self-recrimination.[1] In August of the same year, his beloved son Rosalvo contracted the plague and died in Naples.

The date of the reunion in Rome of Rosa and Lucrezia is not known. As the stricken Rosa lay dying in 1673, his friends organized a ceremony of matrimony between the two at his bedside. Augusto, aged eighteen, supervised the construction of a monument over his father's grave in the church of Sta. Maria degli Angeli, Rome.

The identification of Lucrezia as the model for this painting and of her role as a personification of poetry are due to two complementary pieces of evidence. An inscription on the reverse of the old relining of this canvas states that the subject is "'La Ricciarda,' the favorite of Salvator Rosa depicted as a sibyl for the Niccolini in Florence." Since Lucrezia can only be described as Rosa's "favorite," we must presume that "La Ricciarda" represents a misreading of her name as it perhaps appeared on the reverse of the original canvas.

It is curious that none of the seventeenth-century sources for Rosa's activity — which are extensive — mention this painting in the Palazzo Niccolini. However, that family lent a painting of this description, entitled *Poetry*, to an exhibition at S.S. Annunziata, Florence, in 1767, together with a pendant *Self-Portrait* of Rosa as a philosopher.[2] The self-portrait is now in the National Gallery of Art, London.[3]

The apparent ages of Lucrezia in the Hartford portrait and of the beardless Rosa in the London *Self-Portrait* confirm the impression conveyed by the artist's portrayal of Lucrezia, namely that the picture was executed about 1640 during the time of their mutual discovery. The dryness of the London *Self-Portrait* has been remarked on by Salerno.[4] In contrast, the painting of Lucrezia is vibrant in color, brushstroke and spirit.

It seems most likely that Lucrezia is envisioned as *Poetry*, which makes a more satisfactory companion than would a sibyl to Rosa's self-portrayal as a philosopher. Rosa's poetic gifts were considerable and a source of pride to him. Indeed, his literary accomplishments greatly facilitated his entry into intellectual circles in Florence.

1) Published in translation in Enggass and Brown, 1970, 132-33.
2) *cf.* Levy, 1971, 200-201.
3) Salerno, 1975, color plate 8.
4) *ibid.*, no. 32.

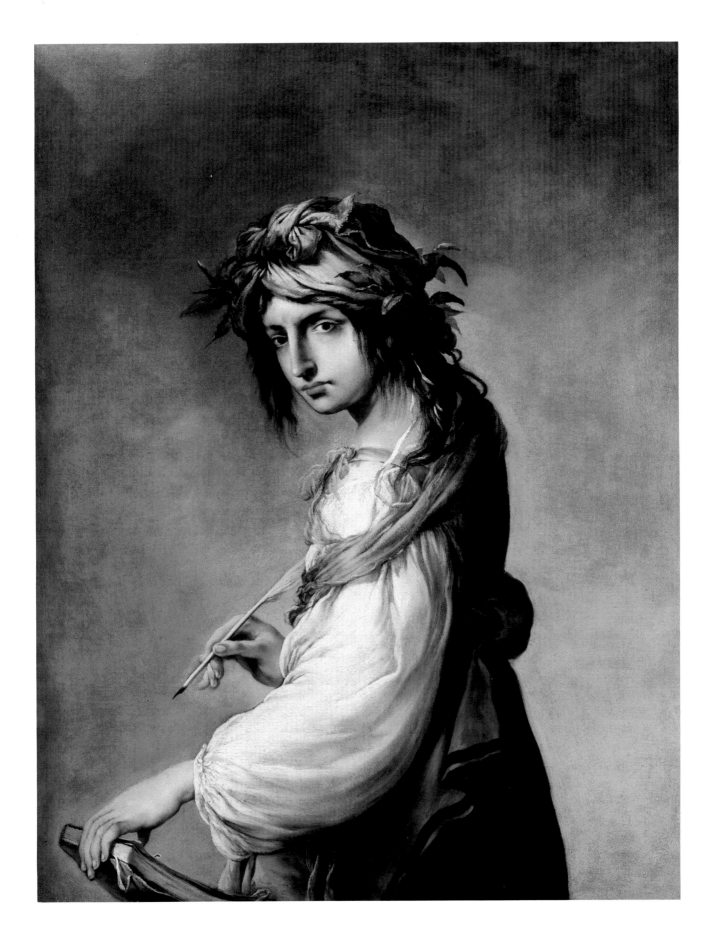

## 58. SALVATOR ROSA

(Aranella [Naples] 1615 - 1673 Rome)

*Portrait of Giovanni Battista Ricciardi*
Oil on canvas. 39 x 31 1/4 (99.1 x 79.4)
Inscribed at lower left, *Salvator Rosa dipinse nell'eremo e dono a Gio Batt Ricciardi suo armico.*
Collections: G. B. Ricciardi, Pisa (Inventory 1687).[1]
References: Salerno, 1963, 50, 123, 318; London, 1973, no. 22; Salerno, 1975,
The Metropolitan Museum of Art, New York, N.Y.
(Bequest of Mary L. Harrison, 1921.105)

A philosopher is represented in the act of writing on top of a skull the Greek words, "Behold, Whither, When." He wears a funerary garland of cypress; a tear is paused on his cheek.[2] Beneath the skull there is a volume, on the spine of which the name of Seneca is dimly legible. In all, this image is a letter-perfect exposition of two tenets of stoic philosophy: the active contemplation of death and its inevitability, and remorse over the vanity of man.

The paintings and writings of Salvator Rosa are replete with stoicisms of this kind. The artist's particular commitment to the present work is made explicit by the inscription on the shred of paper at lower left: "Salvator Rosa painted this in the Hermitage and gave it to his friend Giovanni Battista Ricciardi." On the basis of these lines, the painting has been traditionally described as a self-portrait by Rosa. However, archival documentation has recently confirmed Federico Zeri's intuition in 1967 to the effect that the subject is actually G.B. Ricciardi (1623-1686).[3]

The 1687 inventory of the estate of Ricciardi does not cite attributions for the numerous paintings, but the New York portrait is unmistakably present as the "large picture in a frame of white wood in which a philosopher writes on top of a skull." The specific history of the New York picture, including an exact transcription of Rosa's dedicatory lines, has been found by Ubaldo Meroni in a late seventeenth-century manuscript by Giovanni Cinelli Calvoli, an acquaintance of both Rosa and Ricciardi. Cinelli writes that Rosa gave his friend many valuable paintings, among them "a beautiful picture in which Ricciardi in philosopher's garb is portrayed in the act of contemplating a human skull upon which are written the words ... [as above]."[4]

G. B. Ricciardi was one of the foremost literary figures of his time in Florence. In 1673 he was granted the chair of moral philosophy at the University of Pisa. In a letter of 1688, Francesco Redi mentions that Ricciardi left at his death many manuscripts, both "moral and satirical."[5] Ricciardi was an amateur of painting and an advocate of stoic philosophy; he was probably Rosa's closest confidante as well. It is not clear whether the hermitage, or retreat, mentioned in

the inscription refers to Ricciardi's villa of Strozzavolpe or to that of their mutual friend, Giulio Maffei, at Monterufoli near Volterra. Rosa visited both places often during the later 1640's, the probable date of this homage to his friend.

Portraits occupy a privileged position in Rosa's work, and a separate study of them is long overdue. He evidently declined to accept commissions for portraits, but he painted numerous ones of himself and of his immediate circle as expressions of his personal sentiments. This exhibition includes the portraits of the most intimate companions in his life, Lucrezia and G. B. Ricciardi. These paintings are also exemplary of Rosa's portraiture in that their interpretations are enriched by allegory.

1) The references to paintings are transcribed in *Fonti per la Storia della Pittura*, 1978, 93-95.
2) The painting has been cleaned by the Metropolitan Museum of Art for the benefit of this exhibition. I am grateful to Keith Christiansen for calling to my attention this tear, which had been painted over, and also for pointing out that Rosa had himself painted out the name of Seneca, which now appears on the book as a pentimento.
3) *cf.* London, 1973, no. 22.
4) *Fonti, op.cit.,* 105.
5) Redi, *Opera Omnia*, Naples, 1758, I, 198-99.

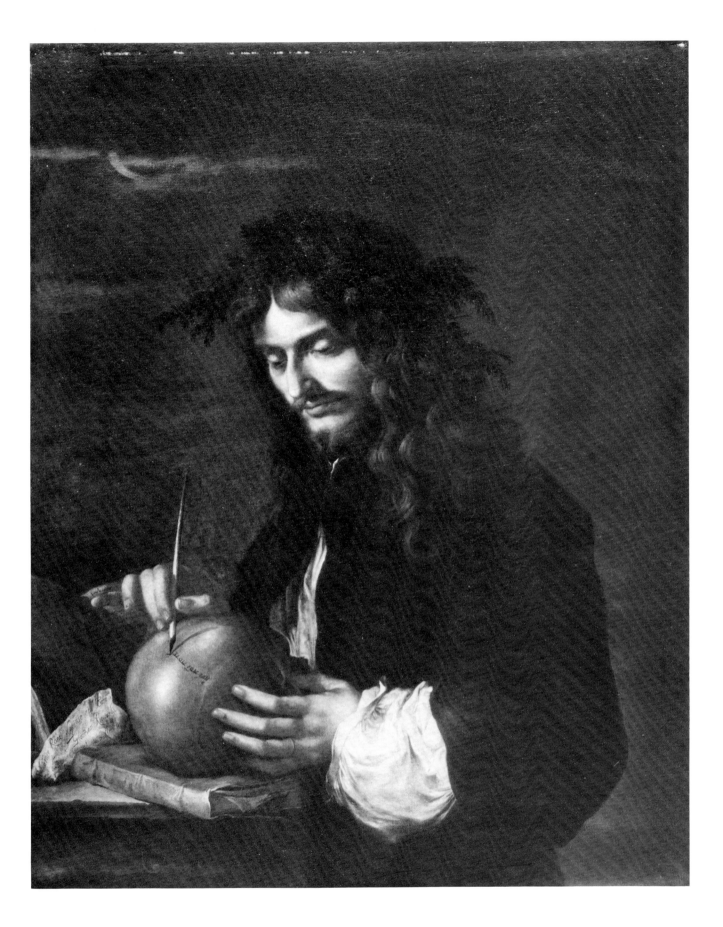

## 59. PETER PAUL RUBENS
(Siegen, Germany 1577 - 1640 Antwerp)

*Study for the Portrait of Marchesa Brigida Spinola Doria*
Pen and brown ink, over indications in black chalk. 12 x 7.
(31.5 x 17.8)
References: Jaffé, 1977, 77 and 115, note 22; Genoa, 1977-78,
176 note 23; Morgan Library, 1979, no. 10; Denison and
Mules, 1981, no. 58.
The Pierpont Morgan Library, New York, N.Y.
(Gift of a Trustee, 1975.28)

This drawing was made by Rubens towards the conclusion
of his preparatory studies for his portrait of the Marchesa
Brigida Spinola Doria seen in this exhibition. The outlines
of the figure and of the architecture were traced first in
black chalk, then defined in pen and ink, and in brown
wash added with a brush. As Rubens worked on this draw-
ing he had the eventual painting in his mind's eye, for
with his pen he inscribed color notes (in Flemish) in three
places: on the cornice at left and on the first capital
("gold") and on the drapery wrapped about the columns
behind the figure ("red").

From our historical perspective it is fitting that these
memoranda all pertain to the architectural setting for this
full-length portrait. During his residence in Genoa in 1606,
Rubens painted portraits of the local nobility in which he
revived the expansive and architectonic style of Venetian
Renaissance portraiture as seen in the paintings of Veronese
and Titian. Although he was not one to underestimate his
own genius, Rubens could hardly have imagined that this
solution, as propagated in numerous works by his pupil
Anthony van Dyck, would become the standard of court
portraiture from that day forward.

Müller-Hofstede has pointed out that the upright stance
and three-quarters view in which Rubens has posed the
Marchesa were not innovative *per se*. For example, they
directly recall the contemporary portraits by Frans Pour-
bus, Rubens' compatriot and colleague in the service of the
Mantuan court.[1] There is even a reminiscence of Pourbus's
idealized style in the perfect curves of Brigida Spinola
Doria's face. However, the piquant characterization of her
intellect and wit and the evocation of a grand terrace as a
metaphor for her nobility are purely Rubens and the incip-
ient Baroque. During the nineteenth century, the painting
was drastically cut down on all sides. This drawing is the
only autograph record of the artist's conception of the
spatial ambience around the figure.[2]

The drawing and the canvas have never previously been
exhibited together. If we assume that Rubens retained the
drawing for his own reference, then the two works were
probably not seen in the same collection even at the time of
their execution. In addition to this unprecedented oppor-

tunity to observe the artist's development of the portrait, the
direct comparison of the two should allow us to reach a
conclusion as to whether Rubens' drawing reproduces the
face of the Marchesa or that of one of her ladies-in-waiting
who was asked to stand in during the laborious posing.
Scholars are divided on this point.[3] The present writer
subscribes to the view that the lady in the drawing is older
than the Marchesa's twenty-two years. It seems possible,
despite the difference in scale, to distinguish between the
amiability of the lady in the drawing and the altogether
more complex shadings of beauty and power in the oil of
the Marchesa Doria.

1) Müller-Hofstede cites the 1650 portrait by Pourbus of the *Infanta Mar-
gherita Gonzaga* in his article on Rubens' Italian portraits. See Eisler, 1977,
notes 3 and 17, for this and other references to the painting of *Brigida
Spinola Doria.*
2) The painting was reproduced in its original state in a lithograph by P.F.
Lehnert. *cf. ibid.,* text fig. 21.
3) Denison and Mules, 1981, no. 58, follow Jaffé in the position that
"perhaps the face in the drawing could be Brigida's own, not yet glamour-
ized for the painting." They cite the contrary opinion of Norris, Held and
Müller-Hofstede, to which can be added those of Eisler, *op.cit.* ("A young
stand-in was used for the Marchesa's pose") and Giuliana Biavati, in
Genoa, 1977-78, 176 note 23.

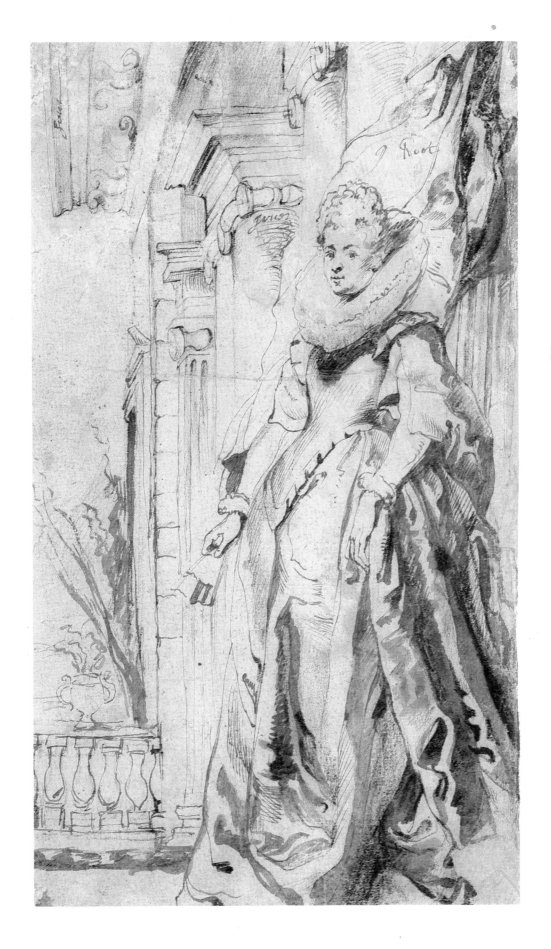

## 60. PETER PAUL RUBENS
(Siegen, Germany 1577 - 1640 Antwerp)

*Portrait of Marchesa Brigida Spinola Doria*
Oil on canvas. 60 x 38 7/8. (152 x 98.7)
References: Eisler, 1977, 101-3; Genoa, 1977-78, 150, 152-53.
The National Gallery of Art, Washington, DC
(Samuel H. Kress Collection 1961 K2187)

The Marchesa Brigida Spinola Doria was born in Genoa in 1583, the daughter of Gaspare Spinola and Maria Doria. In 1605 she married her cousin, Giacomo Massimiliano Doria. Following the early death of her husband, the Marchesa became the second wife of Gianvincenzo Imperiale when she married again some years later. Her personal history thereby came to encompass nearly the whole constellation of the first families of Genoa.

Rubens painted a number of prominent ladies during his Genoese sojourn of 1606. The portrait of Brigida Spinola Doria is the only one upon which he inscribed the name of the sitter. This and another portrait dated 1606 constitute the sole documentary proof of Rubens' presence in Genoa at that time.[1] The name and date and the age of the Marchesa, twenty-two years, were cut off the painting at lower left (and copied on the reverse) when the picture was reduced during the nineteenth century from a full-length portrait amid architecture to a half-length. The original composition is preserved in Rubens' preparatory drawing, which is exhibited together with the painting for the first time. The Marchesa was, in fact, twenty-three years old in 1606 when Rubens completed his canvas. The discrepancy between her actual age and that given in the artist's inscription may be taken as circumstantial evidence to support the hypothesis that this portrait represents her in her wedding dress of the year before.[2] In any event, Rubens recorded the Marchesa's great beauty for posterity. Biavati remarks that the artist seems to reveal in her extraordinary expression his psychological involvement with the affecting personality of this lady.[3] If any single quality sets Baroque portraiture apart from that of other epochs it is this ineffable sense of intellectual exchange between the portraitist and the portrayed. Notwithstanding the jewelry and similar finery in which the Marchesa is draped, Rubens has represented her face as the window of her soul, not as a facade. Indeed, Rubens' powers of interpretation tend to support the position of those critics who see the features of a different individual, perhaps a kindly lady-in-waiting, in his preparatory drawing.[4] Viewers are invited to compare for themselves the features of these two portraits during this unprecedented occasion of their joint exhibition.

Cross-References: Strozzi, Exh. no. 71; Van Dyck, Exh. no. 75.

1) Genoa, 1977-78, 151.
2) Eisler, 1977, 102 (and 103 note 19 for the contrary view).
3) In Genoa, *op.cit.*, 150.
4) See the previous entry for references.

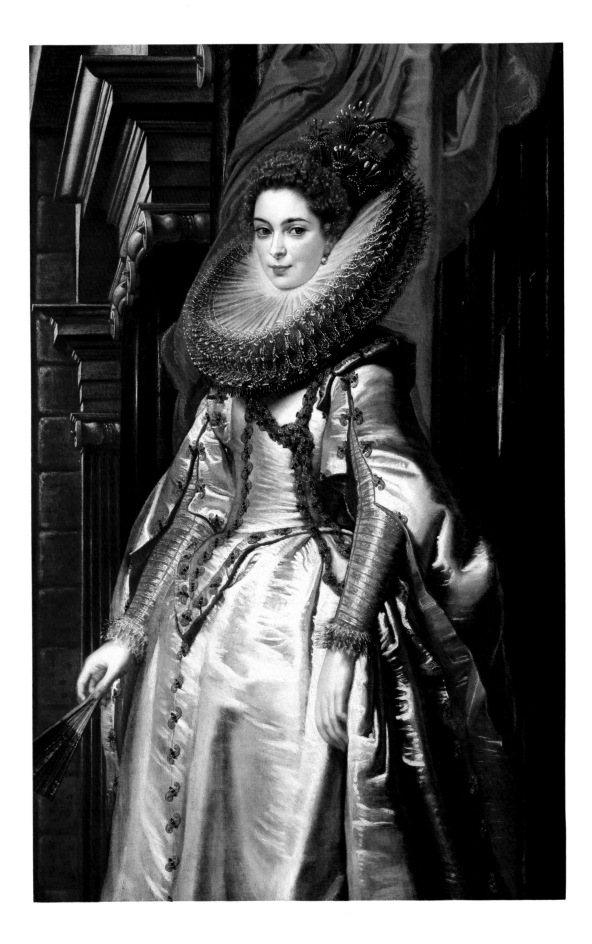

**61.** Attributed to **CAMILLO RUSCONI**
(Milan 1658 - 1728 Rome)

*Portrait of Pope St. Pius V*
(Antonio Michele Ghislieri, 1504 - Pope 1566 - 1572)
Gilt-bronze in relief on an ornamental bracket. Ht: 25 1/2
(64.7)
Collections: David-Weil collection (sale, Drôuot, Paris,
June 15, 1971, no. 98).
References: J.D. Draper in Metropolitan Museum of Art,
1975, 245.
Metropolitan Museum of Art, New York, NY
(Ann and George Blumenthal Fund, 1972.86)

The Dominican priest and High Inquisitor, Fra Michele
Ghislieri, was already a principal actor in the unfolding
drama of the Counter-Reformation when he was elected
pope in January, 1566. Two years before, the previous pope,
Pius IV, had ratified the Tridentine decrees calling for the
internal reform of the Roman Church. It fell to the new
pope, who took the name of Pius V, either to enact these
laws or to allow them to lapse into dead letters.

The ascetic and devout Pius V initiated the reform with his
own person: he rejected nepotism and rigorously separated
the fortunes of his relatives from that of the papal treasury.
His personal retinue was reduced to an essential few like-
minded followers. Pius V called on the cardinals to adopt
his practices, and he reorganized most of the offices of the
Vatican administration. Perhaps the most consequential of
the pope's reforms were his efforts to unify the liturgy of the
world-wide Roman Catholic church: every diocese and
religious order that had not had its own liturgy for at least
two hundred years was instructed to adhere to the Breviary
and the Missal published in 1568 and 1570.

Pius V devoted himself to the propagation of his faith and
to his spiritual pastorship of the faithful. The government
of the papal states was not a priority of his tenure, nor were
the intrigues of foreign policy. However, the threat of Turk-
ish invasion in the Mediterranean compelled his response,
and Pius V deserves most of the credit for forging the Holy
League of the Vatican, Spain, and Venice which routed the
Turkish fleet at Lepanto on October 7, 1571.

The cult of the future Saint Pius V was initiated immedi-
ately upon his death, and gathered impetus from the ven-
eration of the Counter-Reformers during the seventeenth
and early eighteenth centuries. This grandiose portrait of
Pope St. Pius V in gilt-bronze high relief has been dated by
James David Draper on the basis of its late Baroque style to
the period of the saint's canonization in 1712.[1] Draper has
tentatively attributed the design to Camillo Rusconi, then
the leading sculptor in Rome.

Rusconi had arrived in the Eternal City during the early
1680's, when he entered the workshop of Ercole Ferrata.

One of his steadfast patrons was Cardinal Giovanni Fran-
cesco Albani, who as Pope Clement XI would proclaim the
canonization of Pius V. Rusconi emerged into the forefront
of sculpture in Rome with the support of the painter Carlo
Maratti, who succeeded Gian Lorenzo Bernini as the out-
standing presence in Roman art. Indeed, Rusconi carved
sculptures after Maratti's designs, and through their col-
laboration the Roman Baroque style that Bernini had
invented was decisively tempered by the introduction of a
classical reserve and idealism.

The original destination of this portrait in high relief
remains to be determined. Portrait sculptures of this kind
were invariably set into niches or other ornamental archi-
tectural constructs, often in series with other portraits. For
instance, in the Baroque period high relief busts of saints
and popes were very commonly arranged in series above
choir seats or confessionals in churches.

The Baroque ornamentation of choir stalls and confes-
sionals evolved into a major art form in the Catholic
churches of Belgium under the influence of Duquesnoy,
the Flemish sculptor who was active in Rome.[2] By coinci-
dence, Pope St. Pius V was especially venerated by Domin-
icans in Belgium, because of his actions to suppress unor-
thodox doctrines in that country. This circumstance is
relevant to the present discussion, because a mid-seven-
teenth-century portrait bust of Pius V in the Antwerp
church of St. Paul represents him with the same downward
attitude and copious beard.[3] Earlier portraits of Pius V
accentuate a gaunt appearance and a narrow chin beard.
The Antwerp bust is not attributed, but its style is clearly
Italian in origin, permitting the conclusion that Rusconi,
or whoever the sculptor may have been, depended upon an
established iconography for the creation of this bronze
relief.[4]

Cross-Reference: Roman School, Exh. no. 56.

1) In curatorial notes on file at the Metropolitan Museum of Art. I would
like to thank James Draper for making these notes available to me and for
other valuable assistance.
2) For copious illustrations, including portraits of Pius V in high relief, *cf.*
Zajadacz-Hastenrath, 1970, *passim.*
3) For an illustration, see Colleye, 1935.
4) Works by Rusconi in bronze are not known, a circumstance that runs
counter to the attribution to him of this relief.

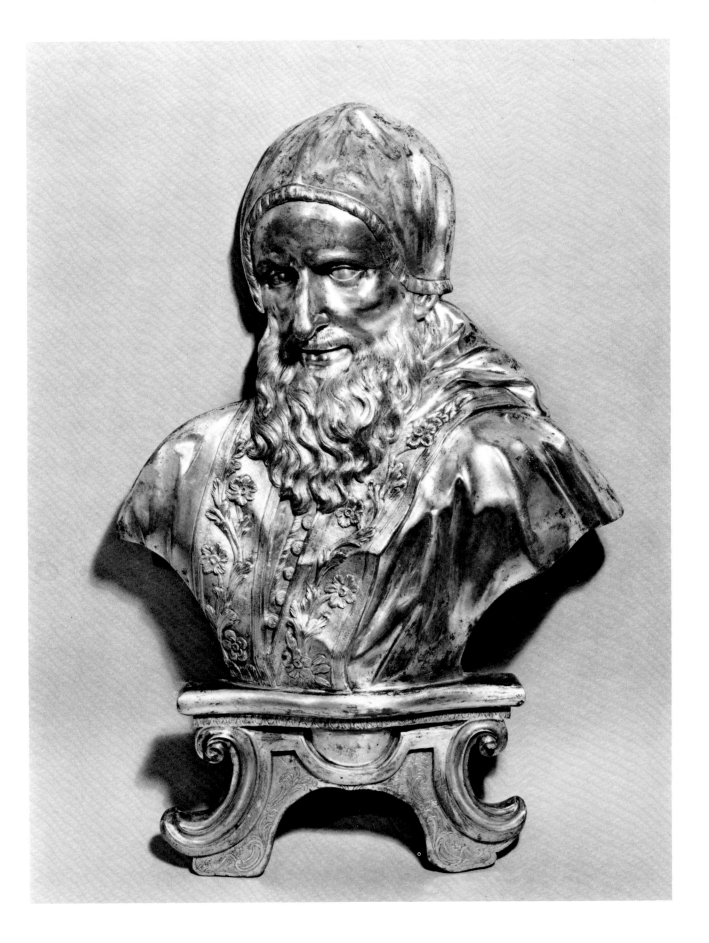

## 62. FERDINAND DE SAINT-URBAIN
(Nancy 1658 - 1738)

*Portrait Medal of Alexander VIII*
(Pietro Ottoboni, Venice 1610 - Pope 1689 - 1691 Rome)
Bronze, struck. Diameter 2 9/16 (6.4).
Signed with initials and dated on the reverse: *S V 1700*.
References: Fischer, 1969-70. no. 264, (another cast); Norris
and Weber, 1976; no. 115; Whitman with Varriano, 1983,
137, (another cast).
Bowdoin College Museum of Art, Brunswick, ME
(Molinaro Collection, 1966.113.41)

This medal was commissioned by Cardinal Pietro Otto-
boni in commemoration of his great-uncle, Alexander VIII,
whose patronage had established Ottoboni's fortune. The
reverse of this medal represents an intermediate stage in the
construction of the pope's tomb in St. Peter's. Although the
plans were presumably drawn up upon the death of Alex-
ander VIII in 1691, construction did not begin until about
1696 and was not finished until 1725. The tomb design by
Carlo Enrico Sanmartino and sculptures by Angelo de'
Rossi have won little admiration.[1]

For a portrait of the pope with a more youthful appearance,
the visitor may compare the anonymous medallion in this
exhibition (no. 53, with biographical notes). The benign,
somewhat trivial expression of Alexander VIII in Saint-
Urbain's medal strongly recalls the numerous busts exe-
cuted of the pope from life by Domenico Guidi.[2] The use of
free-standing sculptures as models for medallic portraits
must have been a much more common practice than is
presently recognized in the literature.

Ferdinand de Saint-Urbain was born in Nancy. He trained
as an engraver of dies and medals in Munich (1671) and in
Italy. After 1673 Saint-Urbain was director of the papal mint
in Bologna; he was chief engraver at the papal mint in
Rome from 1683 - 1703, when he returned to Nancy. The
remainder of his career was passed as medallist and
engraver at the mint of the Duke of Lorraine.

1) For illustration of the reverse of this same strike, see Norris and Weber,
1976, no. 115.
2) Compare the photographs in the Appendix to this catalogue, nos. 11
and 12.

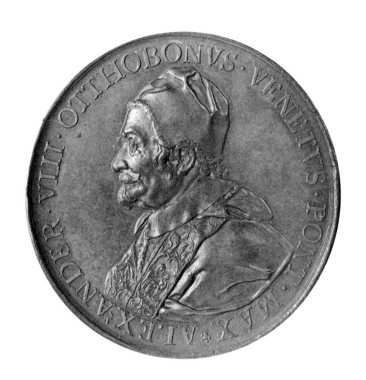

**63. GIOVANNI BATTISTA SALVI,** called Sassoferrato
(Sassoferrato 1609 - 1685 Rome)

*Portrait of Cardinal Paolo Emilio Rondanini*
Oil on canvas. 88 1/4 x 64 7/16 (221 x 62.5)
References: Tomory, 1976, no. 150.
The John and Mable Ringling Museum of Art, Sarasota, FL
(State no. 128)

This unforgettable portrait of a mid-seventeenth century cardinal occupies the other side of the balance, so to speak, from the seductive images contributed to Italian Baroque portraiture by Bernini, Strozzi, and others, as well as by the Flemings, Van Dyck and Rubens. In most contexts the modern student is inspired to praise the powerful capacity of Baroque art to encompass both naturalistic description and an exaltation of the human spirit. On occasion, when these two impulses coincide in a single work, as they do in this portrait of a corpulent Cardinal Paolo Emilio Rondanini by Sassoferrato, the result elicits our ambivalence, a mingling of awe and dread, which equally pertains to the Baroque.

Paolo Emilio Rondanini (Rome 1617 - 1668) was born into a distinguished family to whose name he brought added luster through a brilliant ecclesiastical career. The Rondanini were faithful to the Barberini cause, a strategy that was magnificently fulfilled upon the election of Pope Urban VIII in 1624. Sir Ellis Waterhouse first identified the subject of this portrait.[1] Peter Tomory proposed that the military encampment in the background probably alludes to Rondanini's service as Treasurer to the Vatican during the War of Castro in 1642. A year later, he received his cardinal's hat from Urban VIII. Tomory has proposed a date of ca. 1651 for this portrait but Sassoferrato's artistic development has not yet been sufficiently unravelled to assist in this question. In view of the allusion to an event of the 1640's it seems likely that the commission was inspired by Rondanini's elevation to Cardinal. In 1653, Innocent X named him Bishop of Assisi, a position in which he worked diligently; this date must constitute the *terminus ante quem* for the portrait, which does not contain any reference to this honor.

The prominence afforded to the Raphaelesque painting on the wall behind the seated Rondanini is one of several striking aspects of Sassoferrato's portrait. Indeed, there exists a curious disjunction on several levels between the ideal imagery of Madonna and Child and the worldly immensity of the cardinal: together they constitute an incongruence worthy of De Chirico. Sassoferrato was principally active as a copyist of Raphael; however, the precise source for the picture behind Rondanini is not known. Sylvia Ferino Pagden has kindly brought to this reviewer's attention a painting of this same composition in the Brera Museum, Milan, which she attributes to a copyist after Giulio Romano.[2] The Brera picture entered that collection

in 1811 from the church of S. Francesco in the town of Sassoferrato. Given this coincidence and the fact that no analogous work by Raphael is cited in the Rondanini inventories published by Salerno,[3] we must consider the unexpected possibility that the artist painted this composition into Rondanini's portrait based on his knowledge of a Raphael (as the attribution must then have been) in his native town. No connection between the Rondanini family and the artist's namesake locality is known.

1) Cited in Tomory, 1976, no. 150.
2) Illustrated in *Raffaello a Brera*, 1984, fig. 33, 113-114.

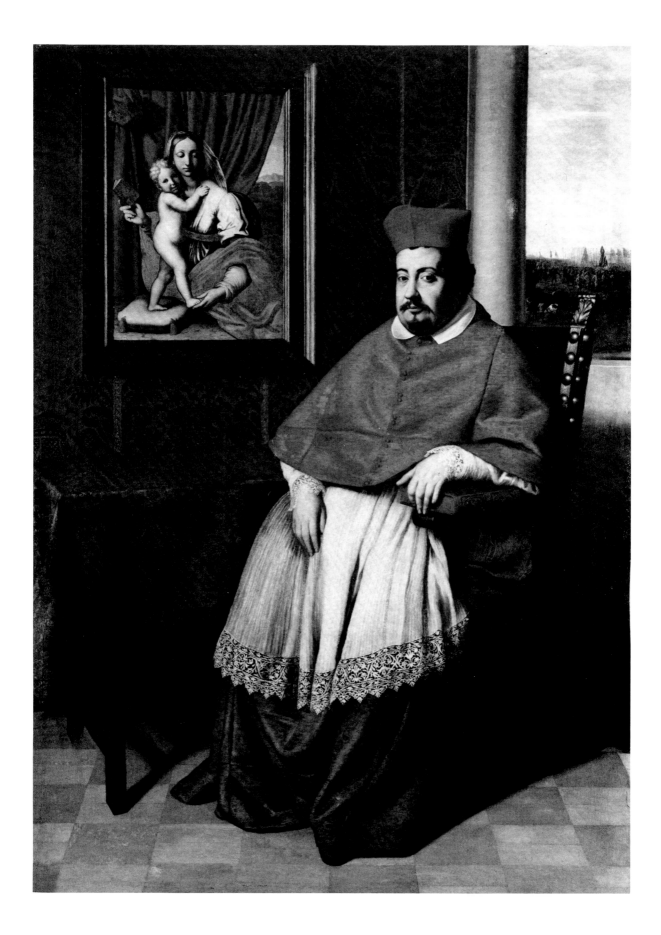

## 64. MASSIMILIANO SOLDANI-BENZI
(Montevarchi 1656 - 1740 Florence)

*Portrait Medal of Francesco Redi*
Bronze, solid cast; liver brown natural patina with traces of
thin black lacquer. Diameter 3 1/2 (8.7).
Signed and dated on the obverse: *M.SOLD.1684*
Signed and dated on the reverse: *M.S.F.1685*
References: Keeble, 1982, cat. 74, 158-9.
Royal Ontario Museum, Toronto, ON
ROM L971.23.7 On loan from the Ontario Heritage Foun-
dation; From the collection of Margaret and Ian Ross

Massimiliano Soldani-Benzi, sculptor and medallist, is cred-
ited with reviving the art of medal casting at the end of the
seventeenth century. After completing his studies in Rome
and France, Soldani returned to Florence about the year
1682. Cosimo III immediately employed him in the minting
of silver coins for the duchy[1] and in the composition of
portrait medals in bronze.

Soldani's medals executed in 1684 - 85, including portraits
of Francesco Redi, Grand Duke Cosimo III, and the Grand
Duchess Vittoria della Rovere, established the pattern for
his mature work in this art.[2] Soldani's medals are typically
large. The sitter is depicted in right profile, and the inscrip-
tion is clearly separated from the portrait. The composi-
tions on the reverse are invariably figurative and are distinc-
tive for their pictorial qualities. For his medal reverses
Soldani drew full-length figures which fill the surface.
Their style was influenced by Ciro Ferri, the guiding spirit
of the Florentine academy in Rome.

The medal of Francesco Redi stands apart in Soldani's
oeuvre by virtue of the inspired decision — whether the
artist's, the patron's, or the subject's is not known — to cast
three different reverses in respect of Redi's equal merits in
Philosophy, Poetry, and Medicine. We know from a letter
written by Redi in April, 1685, that the Grand Duke had
commissioned these medals from Soldani.[3] The result,
which Lankheit has called "perhaps the most beautiful of
Soldani's medals," represented a dramatic improvement
over the portrait of Redi which the artist had executed much
earlier in his career (Figs. 3 and 4).

The specimen in this exhibition refers to Redi's immortal
fame as a philosopher. On the medal reverse, Athena,
patroness of Science, pins the discomfited figure of Time to
the ground as she hands a laurel wreath to a woman robed
in veils. This woman, who sits atop a globe, has been
variously interpreted as one of the Fates[4] or Fame.[5] She
points to a temple where a snake can be seen eating its own
tail, a symbol for eternity.

The Philosophy is the only reverse of the Redi medal that
is dated. Soldani's idiosyncratic rendering of the number
"5" has in the past led to some difficulty in recognizing of
this date. Since the obverse and the reverse were cast separ-

ately and then fused to make a single medal, the two dates
of 1684 for the portrait and 1685 for the allegory are not
contradictory.

The life and portraiture of Francesco Redi (1626 - 1697),
physician to the Grand Dukes of Tuscany, scientist, and
poet, are the subject of an essay at the front of this catalogue.

1) Lankheit in Detroit, 1974, nos. 85b-c.
2) *ibid.,* nos. 89 - 91, for illustrations.
3) Redi, 1811, viii, 161.
4) Keeble, 1982, no. 74.
5) Delitalia, 1970, 132. The veil, although lifted, and the globe may alterna-
tively identify her as Fortune.

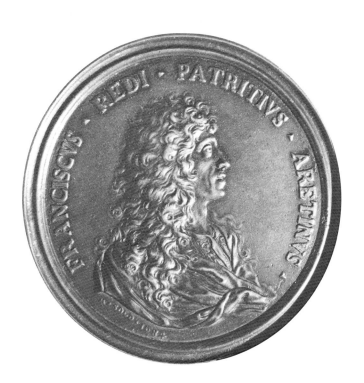

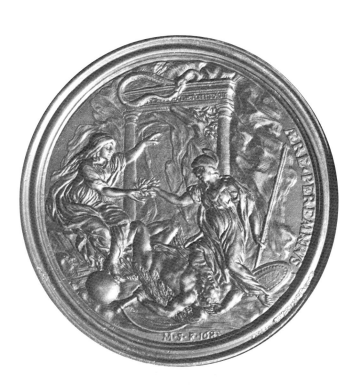

## 65. MASSIMILIANO SOLDANI-BENZI
(Montevarchi 1656 - 1740 Petrolo)

*Portrait of Vincenzo Viviani and Allegorical Reverse*
Pink wax on slate in original frames.
Inside diameter, 7.6 cm.
Signed and Dated: *M.S. 1685.*
References: Lankheit in Detroit, 1974, no. 93; Keeble, 1982,
no. 75.
Royal Ontario Museum, Toronto, ON
(Gift of Margaret and Ian Ross. ROM 972.446a-b)

These paired reliefs in wax were made by Soldani to be models for the obverse and reverse of a portrait medal of Vincenzo Viviani (1622 - 1703). Such models are rarely preserved. In a certain sense they are the sculptor's original work of art, of which the casts in bronze or other metals are reproductions. This composition of Viviani is especially notable because no casts are known, nor do any seem to have been taken from it. In size, format, date, and subject, this medal would have been a fitting addition to the medallic iconography of the Medici court which Soldani had begun to compile in the previous year. The visitor may wish to compare this wax *modello* with the same artist's contemporary medal in bronze of Francesco Redi and to weigh their respective merits as different stages within a single process. The bronze, of course, has the great advantage of durability.

Vincenzo Viviani was the most famous mathematician of his day in Italy, the last pupil and biographer of Galileo, and mathematician and architect to Ferdinando II and Cosimo III, Grand Dukes of Tuscany. The inscription on this wax *modello* does not mention Viviani's name but identifies him through these titles.[1] Baldinucci, in writing at length about Viviani's accomplishments, informs us that his modesty made him reluctant to have his portrait made.[2] When Viviani first sat for Sustermans at the behest of the Grand Duke, he posed in his normal apparel. The result greatly dissatisfied his patron, and Sustermans was dispatched again this time to portray the great mathematician in suitable finery. Since Viviani's place at court was firmly established, the absence of casts from these wax reliefs would seem to mean that it failed to please either the patron or the sitter. Confirmation of a sort is provided by Foggini's medal of Viviani, dated 1701.[3] In that portrayal Viviani's wishes may have been satisfied: on the recto he is simply dressed, and the verso represents an emblem of geometry, rather different in effect from the philosophical swoon depicted by Soldani in his proposal for the reverse, exhibited here.

Cross Reference: Soldani, Exh. no. 64.

1) *FERD.II.AC.COS.III.MM.ETR.DVCVUM.MATHEMATICUS.* Lankheit, 1971, figs 7-9, confirms the identification through comparison with other portraits of Viviani.
2) Baldinucci, F., 1975 ed., IV, 501-502.
3) For an illustration, see Cantelli, 1979, no. 75.

## 66. MASSIMILIANO SOLDANI-BENZI
(Montevarchi 1656 - 1740 Petrolo (Florence)) (models).

Engraved by Giovanni Battista Guglielmada.
*Portrait Medal of Queen Christina of Sweden*
(Stockholm 1626 - Queen 1644 - Abdicated 1654 - 1689
Rome)
Reverse (not illustrated): A male personification of Rome.
Inscribed: *POSSIS NIHIL VRBE ROMA VISERE MAIVS.*
Bronze. 2 7/16 (6.3)
References: Bildt, 1908, 91-93 (fig. 51 for illustration of
reverse); Stockholm, 1966, no. 782 (silver version).
Michael Hall, Esquire, New York, New York

Queen Christina of Sweden was the daughter and heir of
Gustavus Adolphus, the mighty warrior of Protestant
Europe.[1] With his death in 1632 at the battle of Lützen,
Swedish expansionism in Central Europe came to an end.
A regency government was established, and a thorough
and far-ranging course of education in the humanities and
in statesmanship was initiated for his child, Christina.

In 1644 Christina came of age and ascended the throne of
Sweden. Fluent in the languages of modern Europe, she
spoke Latin as if she had been raised by the ancients. The
nineteen year-old queen continued her avid studies after
her coronation, which was thought peculiar for a head of
state, and she soon acquired a wide reputation for her
erudition. Foreign philosophers and poets were invited to
her court: Descartes came in 1649 and drew up the rules of
an academy. Christina's library and collections of coins
and medals were among the finest of the day.

There were no advance indications or evident motivation
for the queen's announcement to the Privy Council in
August, 1651 of her intention to abdicate. Her councillors
and ministers were dumfounded; after prolonged entreaties
they persuaded her to reconsider. Three years later in June,
1654 the Queen could not be deterred a second time. At the
age of twenty-seven she resigned her crown. Christina
would not divulge her reasons for abdication, but her ensu-
ing actions revealed them with perfect clarity. The
sovereign of one of the Protestant powers of Europe had
secretly converted to Roman Catholicism. Christina quietly
sent her books and paintings abroad and followed them to
live for the rest of her life in Rome.

Christina's momentous decision made her at once the most
reviled name in Northern Europe and the personification
of the victorious Counter-Reformation in the South. Pope
Alexander VII directed Bernini to rebuild the Porta del
Popolo into a triumphal arch for the Queen's entrance
into Rome in 1655. During the next several decades
Christina moved in the political and cultural circles of
Rome, often controversially but always with impressive

self-confidence. The convert Queen of Sweden thus became
one of the quintessential personalities of the Roman
Baroque.

After her arrival in Italy, Christina occasionally commis-
sioned portrait medals of herself as befitted a sovereign (for
so she was still recognized by other nobility). After a time
the idea came to her to compile a medallic series devoted to
her life, a competitive counterpart to the *Histoire Metal-
lique* of Louis XIV. It seems that her dear friend Gian
Lorenzo Bernini could not, at his advanced age, devote the
attention that would be required by the project. However, a
suitable alternative was on hand. Since 1678 Massimiliano
Soldani-Benzi of Florence had been in Rome, supported by
the Grand Duke Cosimo III in order to pursue his training
as a sculptor and medallist. An exchange of letters between
Cosimo III and Christina in April, 1681 bears testimony to
their conflicting intentions for Soldani's services.[2] Chris-
tina envisioned a total of more than 100 medals. The
young artist was able to mold casts for six portrait faces
and thirteen allegorical medal reverses (one of these is
dated 1681) before his recall to Florence. In 1682 Soldani
was sent to France for some months to study at the mint of
Louis XIV.

After his departure, Soldani's designs for Christina were
engraved onto dies for the purpose of striking (or impress-
ing) medals, as opposed to casting them in bronze. To the
best of our knowledge, G.B. Guglielmada, an unimagina-
tive but admirably proficient engraver, was entrusted with
this process. The Christina medals by Soldani, either as
casts or as strikes engraved by Guglielmada (and presuma-
bly minted by Hamerani at the papal *zecca*), have always
been recognized as medallic achievements of the highest
order. Soldani's portraits of Christina suitably idealize her
notably plain features into a heroine of antiquity. The
reverse of this medal, like others in the series, celebrates
Christina's mystical communion with the Eternal City of
Rome. DeBildt concluded of the Christina series, "It is rare
to find united a modeler like Soldani, an engraver like
Guglielmada, a minter like Giovanni Hamerani, guided
by a taste and a knowledge like that of Christina."[3]

---

1) The notes on Christina's biography are adapted from the article by
Curt Wiebull in Stockholm, 1966, 30-39.
2) Cosimo's secretary Bassetti wrote on 8 April, 1681 (Lankhert, 1962, Vol.
172); for an English translation see Goldberg, 1983, 165. Christina replied
on the 26th of the month; *cf.* Bildt, 1908, 78-79.
3) Bildt, 1908, 86.

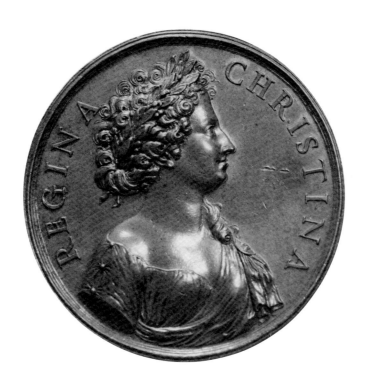

## 67. Circle of **MASSIMILIANO SOLDANI-BENZI**
(Montevarchi 1656 - 1740 Petrolo)

*Portrait Medal of Cosimo III de' Medici*
(1642 - Grand Duke of Tuscany 1675 - 1723)
Gilt Bronze, struck. Diameter, 5.8 cm.
Dated: 1678.

References: Norris and Weber, 1976, no. 148, with reverse; Visonà, 1976, p. 60, figs. 5 and 6 (different strike, attributed to "the style of Giovacchino Francesco Travani"; Langedijk, 1981, I, pp. 631-2, no. 29, 108 (a later strike with the date crudely enlarged): *q.v.*, for additional bibliography.
Bowdoin College Museum of Art, Brunswick, ME
(Molinari Collection, 1966.124.7)

The long-lived Grand Duke is here portrayed in his mid-thirties, prior to the onset at the turn of the century of his spectacular baldness. This is one of the first portraits of Cosimo III. As Prince he sat in 1661 and 1666 for Giovacchino Francesco Travani.[1] Upon his succession to the throne of Tuscany in 1670, Cosimo was portrayed with somewhat pinched features in a relatively unsuccessful medal by François Chéron.[2] The present portrait, which also appears on two variant medals of perhaps slightly earlier date,[3] provides a markedly more impressive image of the young Grand Duke. This profile bust projects strongly within the restrictive format of the medal, emphasizing the expansive curves of the sitter's chest, abundant tresses and double chin. The medal's reverse represents the plan of the monastery built for the Spanish order of the Frati Alcantarini adjacent to Cosimo's favorite villa, L'Ambrogiana. Cosimo III and his daughter Anna Maria Luisa were particularly devoted to the cult of St. Peter of Alcantara (canonized 1669), confessor of S. Teresa of Avila.[4]

Pending the discovery of documentary evidence, the attribution of this medal must remain vexed. In recognition of his service to the sitter, Norris and Weber assign its authorship to the circle of Soldani-Benzi, although its date falls into the apprenticeship of that artist. In every respect of design and technique this medal pertains to the Hamerani workshop in Rome, as Visonà indicated. Indeed, its author may well be Giovanni Hamerani. The illusionism of the reverse (on which the edge of the paper appears to curl) directly recalls the many such novelties designed by Gian Lorenzo Bernini for medals during this period.

Cross Reference: Hamerani, Exh. nos. 30 and 31.

1) K. Langedijk, 1981, I, nos. 29,117-118.
2) *ibid.*, no. 29,112; *cf.* Norris and Weber, 1976, no. 256, repr.
3) *ibid.*, nos. 29,107 and 29,107 variant, repr.
4) G. Ewald in Detroit, 1974, no. 141.

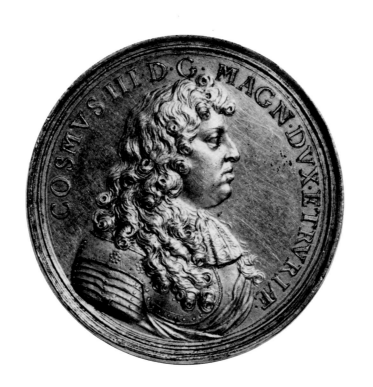

## 68. FRANCESCO SOLIMENA
(Canale di Serino 1657 - 1747 Barra [Naples])

*Portrait of Diego Pignatelli D'Aragona, Duke of
Terranova and Monteleone*
Oil on canvas. 23 x 18 (58.4 x 45.7)
References: Baetjer, 1980, 102; Spinosa, 1979-80, under no.
77.
The Metropolitan Museum of Art, New York, NY
(Rogers Fund, 1967.102)

At the close of the seventeenth century Francesco Solimena
succeeded Luca Giordano as the dominant presence in the
Neapolitan school of painting. Solimena's artistic forma-
tion had included a period of immersion during the early
1690's in the decorative style of Giordano. His mature
works after 1700, however, are firmly based on a naturalis-
tic foundation inspired by the High Baroque paintings of
Mattia Preti. During the last three decades of his life, Soli-
mena was arguably the most famous artist in Europe and
was frequently engaged for portraits by local nobility, as
well as English lords on the Grand Tour. This overlooked
aspect of the artist's production was one of the major
rediscoveries of the recent exhibitions of Neapolitan
eighteenth-century paintings.[1]

This canvas is the preparatory sketch for one of the artist's
masterpieces of portraiture, a full-length canvas at present
in a private collection in Rome. Bernardo De Dominici,
the contemporary and admiring biographer of Solimena,
described the finished portrait a few years after its execu-
tion as "among the most beautiful" of the mature works by
the painter.[2] Nicola Spinosa has convincingly dated the
portrait and this *bozzetto* to 1731/32 on the basis of the
duke's costume.[3] He is portrayed in the full regalia of a
Knight of the Toison d'Or, which was granted him by
Emperor Charles VI Habsburg in that year. Diego Pigna-
telli d'Aragona (1687 - 1750) was committed to the Austrian
cause in Naples, and fiercely, if vainly, resisted the entrance
of Charles Bourbon in 1734.

This dashing picture represents in the present context the
advent of eighteenth-century modes of portraiture, and
offers a valuable contrast to the High Baroque style that is
mostly in evidence in this exhibition. By the fourth decade
of the new century, the attributes and ambience of the
sitter are as important to the interpretation as is his like-
ness. The painting is as much the portrayal of an interior,
a place, as it is of a person. This conception of portraiture
was practiced with great distinction by Pompeo Batoni in
Rome. The portrait of Count Lodovico Vidmano by Tibe-
rio Tinelli constitutes a High Baroque anticipation of this
development. It is significant, above all, that Solimena
made use of a preparatory sketch in order to assist his

comprehension of the space and the arrangement of lights
and darks in the full-length portrait on a grand scale (134 x
87 inches).

Cross-Reference: Tinelli, Exh. no. 73.

1) *cf.* the excellent texts on Solimena by Nicola Spinosa in the two cata-
logues, *Civiltà del '700 a Napoli 1734-1799*, Naples, 1979-80; and *The
Golden Age of Naples: Art and Civilization Under the Bourbons 1734-
1805*, Detroit and Chicago, 1981.
2) De Dominici, 1742, III, 605.
3) Spinosa, 1979/80, no. 77, repr.

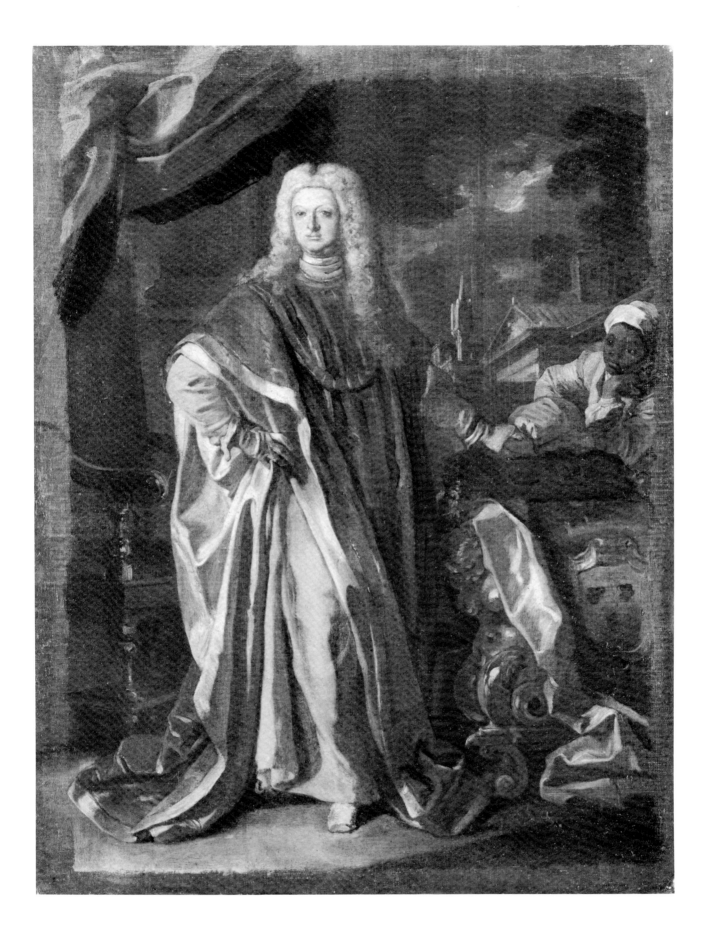

**69.** Attributed to **FRANCESCO SOLIMENA**
(Canale di Serino 1657 - 1747 Barra [Naples])

*Portrait of a Nobleman*
Oil on canvas. 50 x 39 3/4 (127.0 x 101.0).
References: Manning, 1962 (II), no. 37; Manning, 1967/68, no. 50.
Chrysler Museum at Norfolk, VA
(Walter P. Chrysler, Jr., loan, L79.249)

This unidentified nobleman is a fine example of eighteenth-century portraiture in Naples. The costume and noble mien of the sitter are presented with calculated elegance, but distinctive to the Neapolitan school are the finely observed details. The sense of an actual person is never sacrificed in favor of abstract idealization. The treatment of the drapery is uncharacteristic of Solimena, and it is possible that this portrait was in fact executed by an artist in the circle of that master; Giuseppe Bonito (1707 - 1789) comes first to mind.

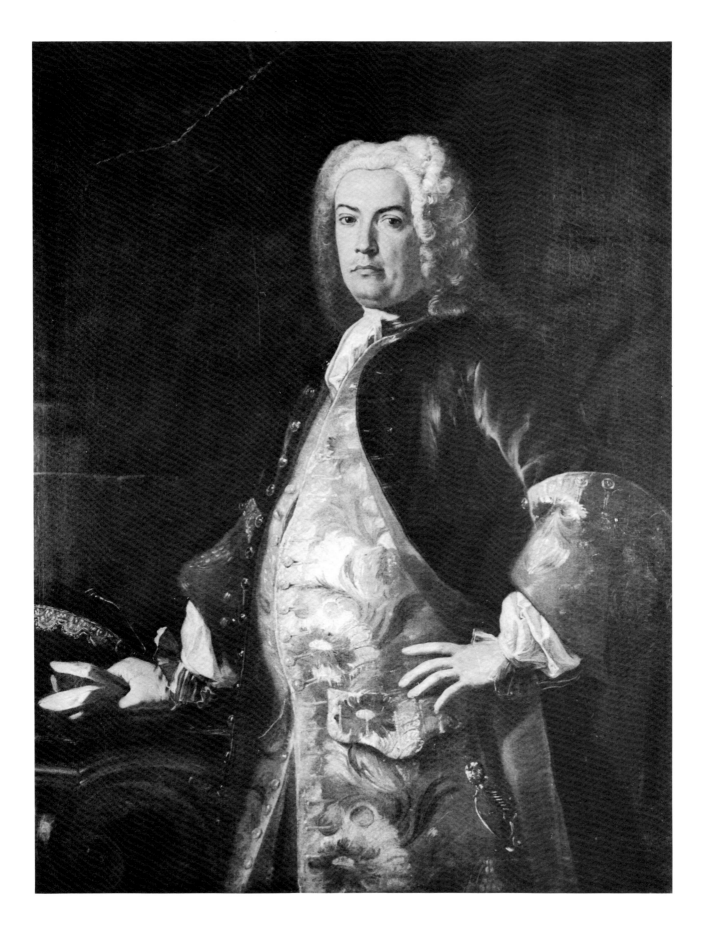

## 70. MASSIMO STANZIONE

(Orta de Atella ca. 1585 - ca. 1658 Naples)

*Portrait of a Lady in Peasant Dress*
Oil on canvas. 46 3/4 x 38 1/4 (118.7 x 97.2).
Signed with a monogram, at left: *EQ. MAX.*
References: Causa, 1972, Laura Giusti in Whitfield and
Martineau, eds., 1982, no. 158.
The Fine Arts Museums of San Francisco,
San Francisco, CA
(On deposit at the de Young Memorial Museum from the
Hispanic Society of America, NY, since 1941.)

The Cavalier Massimo Stanzione vied with Jusepe de Ribera during the 1630's and 1640's for the leadership of the Neapolitan school of painting. From our present perspective, Ribera was in every respect the more considerable artist; however, Stanzione was the more imitated. In the course of his career, he seems to have covered most of the feasible stylistic bases, from a Caravaggism learnt from Caracciolo to an impressive capacity to paint in the manner of Guido Reni.[1] It is reflective of the meager documentation for Neapolitan Baroque painting that very few particulars about Stanzione's life and training have come down to us, not even the precise dates of his birth and death.[2] A good many portraits by Stanzione are mentioned in early records, but only a handful have been identified.[3] An interesting portrait of the Englishman Jerome Bankes is at Kingston Lacy.[4]

The present *Portrait of a Lady in Peasant Dress* is the artist's masterpiece in portraiture. Indeed, it is one of the most admired pictures in his sizeable oeuvre. The brilliant colors and rich costume have no parallel in contemporary Neapolitan portraiture, which had to contend with the somber style favored by the Spanish nobility. It must be assumed that this fancy dress, which appears stiff with silver thread, was made for a special occasion or festival. The captive rooster may someday provide the explanation.

Cross Reference: Ribera, Exh. no. 48.

1) De Dominici, 1742/43, III, 58, reports that Gaspar Roomer called him the "Neapolitan Guido Reni."
2) Recently, Giuseppe De Vito, 1982, 65, has called attention to a nineteenth-century reference to a painting signed and dated 1658 (G. Nobili, *Descrizione della Città di Napoli*, Naples, 1863, II, 588. De Dominici, 1742/43, III, 44 and 66, who is almost never right about such matters, gives Stanzione's dates as 1585 - 1656.
3) See L. Giusti in Whitfield and Martineau, eds., no. 158.
4) *ibid.*, no. 160.

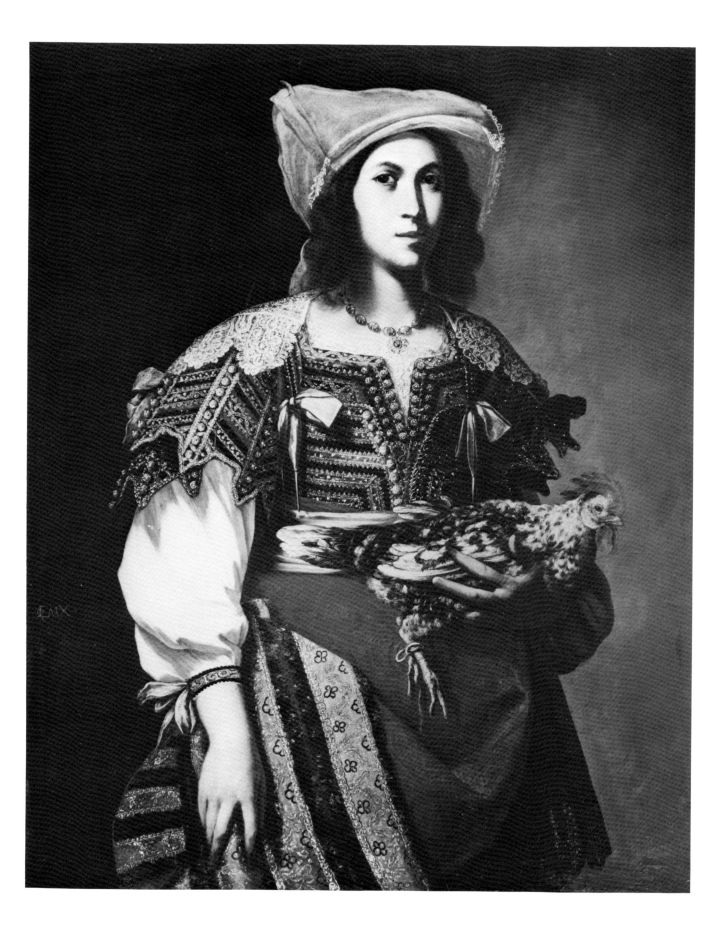

## 71. BERNARDO STROZZI (Genoa 1581 - 1644 Venice)

*Portrait of Bishop Alvise Grimani*
Oil on canvas. 57 3/4 x 37 3/8 (146.7 x 94.9)
References: Mortari, 1966, 66, 125, 193; Shapley, 1979,
*sub voce.*
The National Gallery of Art, Washington, DC
(Samuel H. Kress Collection, 1961. No. 1403)

The Grimani belonged to the old nobility of Venice, count-
ing many doges and procurators among their ancestors.
Although the picture is not inscribed, the sitter's name was
discovered by William E. Suida on an old copy.[1] Alvise
Grimani (died 1656) was appointed bishop of Bergamo in
January, 1633, which was presumably the occasion for the
commission of this portrait. The subject directly engages
and commands the viewer's attention through his intense
gaze. The book of scriptures is not only an attribute, but
also a solid presence that the bishop grasps with the same
conviction with which he regarded its contents. No
expanse of the canvas is passive or static. The filigrees of
the linen alb naturally inspired a bravura display of
brushwork. Strozzi, however, used his nervous, flickering
brush stroke in every passage, including the hands and the
scarlet *mozzetta,* to enliven the picture surface.

In the course of his prolific career, Strozzi painted every kind
of subject matter. He was principally a painter of religious
themes, but portraits by him are frequently encountered.
The portrait of Bishop Alvise Grimani is considered one of
the pinnacles of Strozzi's achievement in this sphere. Not by
chance does the painting exemplify the Rubensian approach
to portraiture. Strozzi, a Capuchin friar, studied in his
native Genoa under Pietro Sorri, a Sienese follower of Fede-
rico Barocci. At just that moment, 1596, a masterpiece by
Barocci was installed in a chapel of the Duomo in Genoa. In
1605 Peter Paul Rubens sent from Rome his painting of
*The Circumcision* for the Genoese church of S. Ambrogio.
Rubens himself passed through Genoa in the following
year. Among the works executed by the Fleming in Genoa
were the earliest examples of Baroque portraiture — one of
which is represented on the cover of this catalogue. Strozzi
seems to have been the only Genoese painter to assimilate
Rubens' new mode of portraiture.[2] Strozzi, like every other
painter in Genoa, was fully impressed as well by the por-
traits painted during the 1620's by that younger Fleming,
Anthony van Dyck. When he relocated in Venice during the
winter of 1630-31, Strozzi imported into Venetian painting a
forceful interpretation of Rubens' style, as Domenico Fetti
of Rome had done in 1621. The influences from abroad to
which Strozzi became attuned at the onset of his develop-
ment were to continue into his later career. Indeed, a stylis-
tic analysis of his lifetime production reads like a *Künstler-
lexicon.*

Cross-References: Rubens, Exh. nos. 59-60; Tinelli, Exh.
no. 73; Van Dyck, Exh. no. 75.

1) This copy is now untraced. For the Suida reference, *cf.* Shapley, 1979,
437 note 7.
2) Franco Sborgi in *La Pittura a Genova e in Liguria dal Seicento al
primo Novecento,* 1971, 303. This judgment is admittedly provisional in
view of our limited knowledge of seventeenth-century Genoese portrait-
ure prior to 1622.

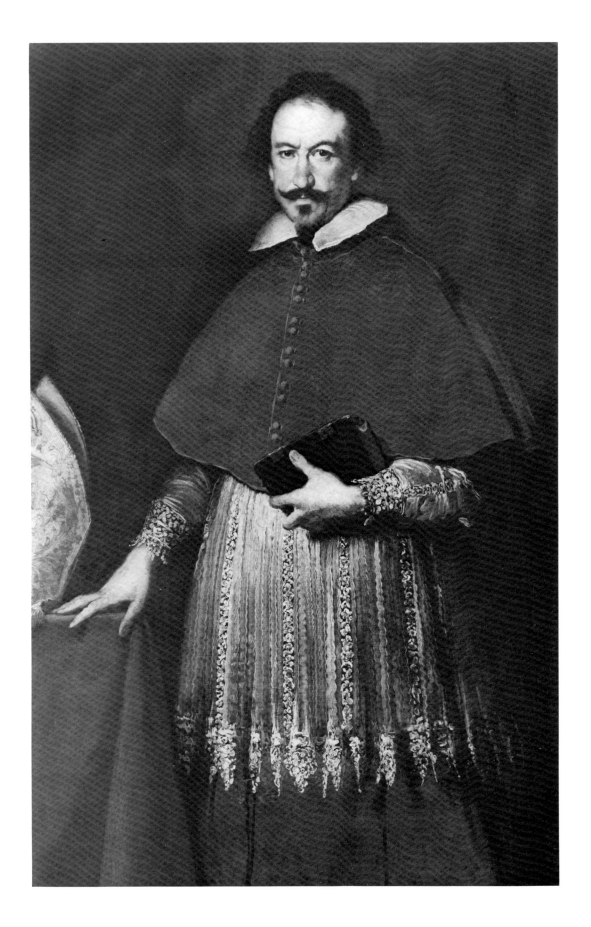

## 72. GIORGIO TASNIÈRE
(Besançon ca. 1632 - 1704 Turin)

*Equestrian Portraits of Francesca di Valoys, Duchess of Savoy, and Maria Giovanna Battista, Duchess of Savoy*
Engraving. 9 3/4 x 10 (24.7 x 25.3) (platemark)
After a drawing by G.B. Brambilla of a painting by C.C. Dauphin
References: Cicognara 3982.
Bound in Amedeo di Castellamonte, conte. *La Venaria Reale. Palazzo di piacere e di caccia ideato dall'Altezza Reale di Carlo Em. II., Duca di Savoia, Re di Cipro.* Turin, 1672.
The New York Public Library, Spencer Collection, Astor, Lenox and Tilden Foundations, New York, NY

The Court of Savoy produced towards the close of the seventeenth century one of the most lavish festival books of the Baroque age, *La Venaria Reale*.[1] The occasion was the completion of the pictorial decorations of the Duke's "palace of pleasure and the hunt" (the words used in the actual title) which were divided among paintings of hunting scenes, mostly by the itinerant Jan Miel, and equestrian portraits by various court artists of the ruling family and their principal retainers.

The Savoy fashions in dress and in art were very much in the French taste at this date, and most of the artists represented in *La Venaria Reale*, excepting Miel, were originally from France. The polyglot name of Giorgio Tasnière reflects a personal history of this kind. Tasnière engraved sixty-seven of the seventy-one plates in this volume, including the double equestrian portrait seen here.

The two ladies in the engraving were originally portrayed in a painting by C.C. Dauphin (whereabouts unknown). Their portraits and the portrait of Carlo Emanuel II, Duke of Savoy, which is found on the preceding page, provide us with a revealing glimpse into the decorum of court portraiture during this epoch. In the exhibited print, both Francesca di Valoys and Maria Giovanna Battista are properly identified as the Duchess of Savoy because the former was the Duke's first wife and is portrayed posthumously. The lady who rides at the side of Carlo Emanuel II in another double equestrian portrait in this book is Christina of France, the Duke's mother. The frontispiece of *La Venaria Reale* presents a portrait of Maria Giovanna Battista, Duchess of Savoy, in the guise of Diana, goddess of the hunt. The print reproduced in this catalogue points up the ameliorating approach taken by Dauphin in his description of the Duchess's appearance as compared to the frontispiece engraving by A. De Pienne after G.F. Sacchetti.

1) The imprint is dated 1674, but the actual date of publication was 1679.

186

C. Delphinis pinx.   G. B. Brambel del. G. Suchiero sculp. Taur.

FRANCESCA DI VALOYS DVCHESSA DI SAVOIA. MARIA GIOANNA BATTISTA DI SAVOIA DVCHESSA DI SAVOIA

## 73. TIBERIO TINELLI (Venice 1586 - 1638)

*Portrait of Count Ludovico Vidmano*
Oil on canvas. 81 1/8 x 54 1/8 (206.0 x 137.4).
Signed: at lower left, *.TINELLI*
References: Shapley, 1979, *sub voce.*
The National Gallery of Art, Washington, DC

This canvas appears to be the full-length portrait by Tinelli which is singled out for praise in *Le Maraviglie dell'arte,* 1648, by Carlo Ridolfi: "Then he portrayed Baron Giovanni Vidmano and his sons, the Counts Giovanni Paolo and Ludovico, one in three-quarter length, the other full-length in a landscape leaning against a pedestal, holding a stick and dressed for travel, in this picture one sees a movement which, though feigned, deceives the eye."[1] Giovanni Vidmano, né Widmann, was a German trader who amassed a fortune in Venice after 1586. His sons inherited a million ducats in 1636. They were admitted into the Venetian nobility following their donation towards the war of Candia in 1646. The Palazzo Vidmano, with facade by Longhena, was noted for its collection of paintings and sculptures.

During the first third of the seventeenth century, Tiberio Tinelli was the unchallenged portraitist of fashion in Venice.[2] (The situation changed somewhat with the arrival of Bernardo Strozzi in 1631.) Tinelli was a pupil of the local artists Giovanni Contarini and Leandro Bassano, but his portraiture is justifiably linked to the style of Anthony van Dyck, who briefly visited Venice in 1622. Full-length portraits and signed works by Tinelli are both rare.[3] This portrait of Count Ludovico Vidmano has attracted comment throughout its history for its singular anticipation of eighteenth-century compositions of the "Grand Tour." The fragments of classical monuments to one side and the pastoral landscape to the other are intended as reflections on the subject's intellectual attainments. In true Baroque style, however, the setting is subordinated to the figure, and the tension between the halves of the composition enhance the impression of an active state of mind.

1) Ed. 1924, II, 280. Quoted in the original and in English translation by Shapley, 1979, 460 and 458.
2) *cf.* Macandrew, 1967, 270.
3) The only other signed works of known whereabouts are in American public collections and are illustrated below in the Appendix nos. 56 and 57. The portrait of Francesco Querini in the collection of Dartmouth College underscores Tinelli's absorption of Tintoretto's legacy as a painter of portraits.

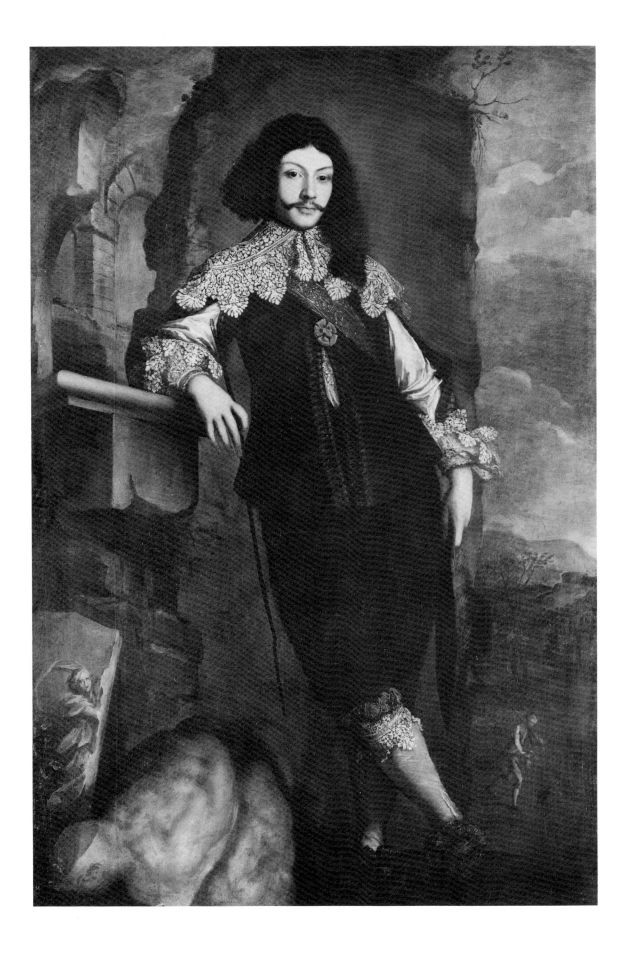

## 74. VALENTIN DE BOULOGNE
(Coulommiers-en-Brie 1590 - 1632 Rome)

*Portrait of Raffaello Menicucci*
Oil on canvas. 31 1/2 x 25 5/8 (80 x 65)
References: Schleier, 1965, 78 - 86; Cuzin, 1975; Janson, 1980, 68 - 70.
Indianapolis Museum of Art, Indianapolis, IN
(Delavan Smith Fund, No. 56.72)

The subject of this portrait calls the viewer's attention to a paper upon which an architectural plan can be seen along with the explanation, *Rocca del Conte,* the "castle of the count." It would seem that artist and sitter were satisfied that this sole attribute would serve to identify the aggressive personality in question. Indeed, Erich Schleier was able to demonstrate that this swarthy character is Raffaello Menicucci, whose portrait was engraved by Ottavio Leoni and Claude Mellan, both of whose works are exhibited on this occasion.

From a 1645 biography of Menicucci by Gian Vittorio Rossi, and other sources, Schleier was able to draw a compelling literary portrait of this singularly Baroque personality.[1] "Menicucci was born in Monte San Sabino in southern Tuscany near Arezzo. He had a natural ability to produce comic effects, make people laugh, compose offhand verses and *bons mots*. He was not only a rather brilliant buffoon, but a sort of parasite, who tried with intelligence and cleverness to get introduced to the leading society and become acquainted with the ruling dukes and princes in order to build up a social position and a large fortune. So he was, at least for some time, in the service of the Grand Duke of Tuscany, though Rossi also states that he was well known in Rome, and Mariette called him buffoon of Pope Urban VIII ... Rossi states that Menicucci adopted — in need of a decent rank — the title of a Count! ... And Rossi points out Menicucci's neurotic and extreme wish for fame and reputation by telling amusing stories of what happened at the court of Florence. Menicucci shocked people by going to parties and dinners without being invited or by arriving much too early, when the lady was still occupied with the preparations, and in the meantime entertaining those who happened to be present with talks about his extraordinary fame, fancied or real." There arose, Rossi informs us, the usage of "fama menicuccia" to describe any occurrence of stupendous fame.

The authorship of this portrait of Raffaello Menicucci eluded scholars until 1975, when Cuzin put forward the correct name of Valentin. The portrait is described in unmistakable terms and assigned to Valentin in the seventeenth-century inventory of Cardinal Mazarin. So Menicucci's fame was known in France. It is interesting, and possibly a reflection of the French bias of the court of Pope Urban VIII, that Menicucci should have had his portrait drawn in Rome by two expatriate Frenchmen, Valentin and Mellan. Portraits by the former are rare, and the present picture qualifies as a valuable example of the Caravaggesque approach to portraiture as well. We sense that the assertive personality of Menicucci and his forcefully rendered face have been captured for eternity without caricature and without embellishment. Valentin had arrived in Rome at least by 1612, and was among the first generation of followers of Caravaggio's naturalistic style. Through their paintings of drinking parties and tavern banquets, Valentin and the Italian artist Bartolomeo Manfredi gave rise to the misconception that genre subjects of this kind had played a major part in Caravaggio's own oeuvre, which in reality was predominantly religious in theme after 1600.

Cross-References: Leoni, Exh. no. 38; Mellan, Exh. no. 44.

1) Jan Nicii Erithraei (i.e. Gian Vittorio de Rossi), *Pinacotheca Imaginum, Illustrium, doctrinae vel ingenii laude vivorum, qui auctore superstite, diem suum obierunt.* Cologne, 1645, Vol. I, ch. CLX, 296 - 300.

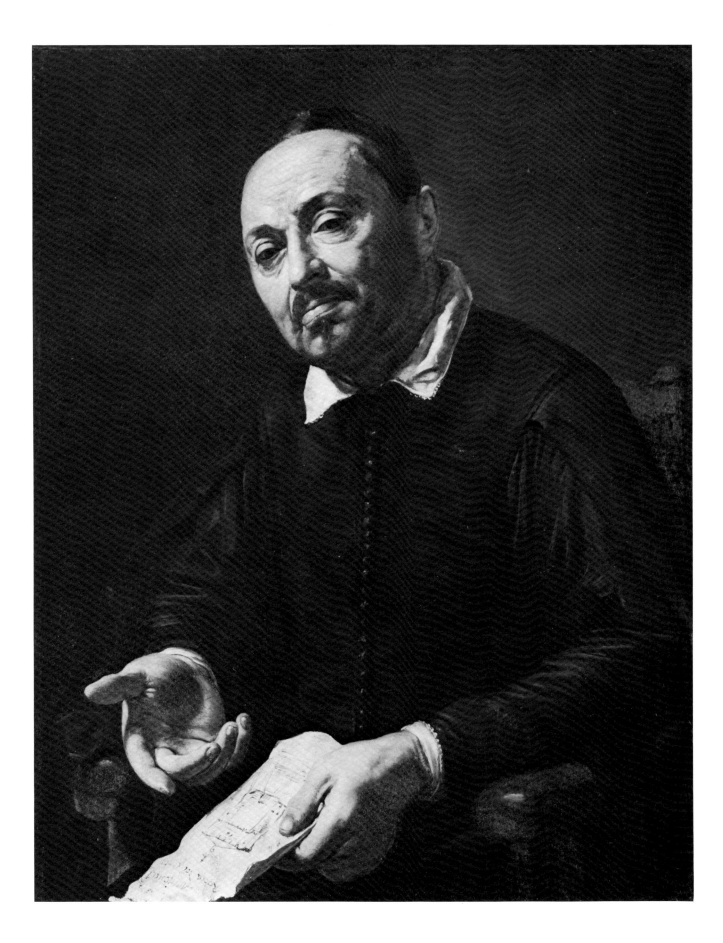

## 75. ANTHONY VAN DYCK
(Antwerp 1599 - 1641 London)

*Portrait of a Lady in Black, White, and Gold*
(Doña Polyxena Spinola Guzman de Leganés)
Oil on canvas. 43 3/16 x 38 3/16 (97 x 109.7)
References: Eisler, 1977, 115-16.
National Gallery of Art, Washington, DC
Samuel H. Kress Collection, 1957 (1375)

In his recent catalogue of paintings in the Kress Collection (excluding the Italian school), Colin Eisler has placed the traditional identification of the lady in this portrait into doubt. According to Eisler, a portrait of another lady by van Dyck in the Prado Museum, Madrid, has an older history as a portrait of Dõna Polyxena Spinola Guzman de Leganés. The daughter of the Genoese general Ambrogio Spinola, Polyxena Spinola was married in 1628 to the Marquès de Leganès, ambassador of Philip IV to the Genoese republic. The wedding took place in Madrid. The Marquès de Leganès accompanied the Spanish army to the Netherlands in 1630. It is not known whether Polyxena followed at any time thereafter; she died in Spain in 1638.

Scholars are agreed that the Kress picture is a fine example by van Dyck from his second Antwerp period, following his return from Italy in 1627 and prior to his departure for England in 1632. This thesis is supported by the northern costume in which the lady is attired. Eisler is the first scholar to question the traditional identification of the Kress painting; he points to the citation of a portrait of Polyxena Spinola by van Dyck in a 1680 inventory of the Doria collection in Genoa. If, however, the present portrait is the former Doria painting, then van Dyck must have executed the commission in Antwerp for the benefit of Genoese relations.[1]

The intermittent activity of van Dyck in Genoa between November 1621 and July 1625 was of lasting consequence to the history of portraiture, not only in Italy but in all of Europe. The ancient nobility of Genoa took van Dyck immediately into their service. No doubt he benefited from long memories of the Genoese sojourn of his master, Rubens, in 1606. In fact, van Dyck developed a schema for the aristocratic portrait from the same sources as had Rubens before him, and took inspiration as well from the portraits that Rubens had left in Genoa.

The grand style of van Dyck's Italian period has long been appreciated in America, and a number of important examples grace American museums. Unfortunately, the premium placed on these portraits has precluded their inclusion in this exhibition. The relationship between the present portrait and van Dyck's Genoese pictures can be outlined without difficulty. Van Dyck's mature portrait style of both these periods derives from his seamless recon-

ciliation of four distinct impulses: two of these are his observations of Venetian Renaissance prototypes, specifically the grand trappings of Veronese's portraits and the direct observation found in Titian's. From Rubens, van Dyck learned the Baroque quality of immediate, sensuous presence. His personal sensitivity for introspective expression and for selective enhancement, while preserving the likeness, completes the prescription. In contrast to the generous colorism of the Veronesian portraits that van Dyck painted in Genoa, the Kress portrait of Dona Polyxena Spinola and other pictures following his return to Antwerp are nearer to Titian in their concentration on the personality of the sitter as well as in the relatively muted palette. The imposing physicality of the figure represents van Dyck's continual reference to Rubens's example.

The political and economic exchanges between Antwerp and Genoa make it probable, of course, that the subsequent developments in van Dyck's portrait style were made known in Genoa through actual examples. In this connection it is noteworthy that G.B. Carbone, the most faithful Genoese follower of van Dyck, typically employs subdued color values and somber backgrounds in his portraits, which are rather similar in effect to the Kress collection picture.

Cross-Reference: Rubens, Exh. nos. 59 and 60.

---

1) Eisler, 1977, 115-116, also reports that a portrait of this composition appears in a view painted by David Teniers the Younger, 1653, of the gallery of Archduke Leopold Wilhelm.

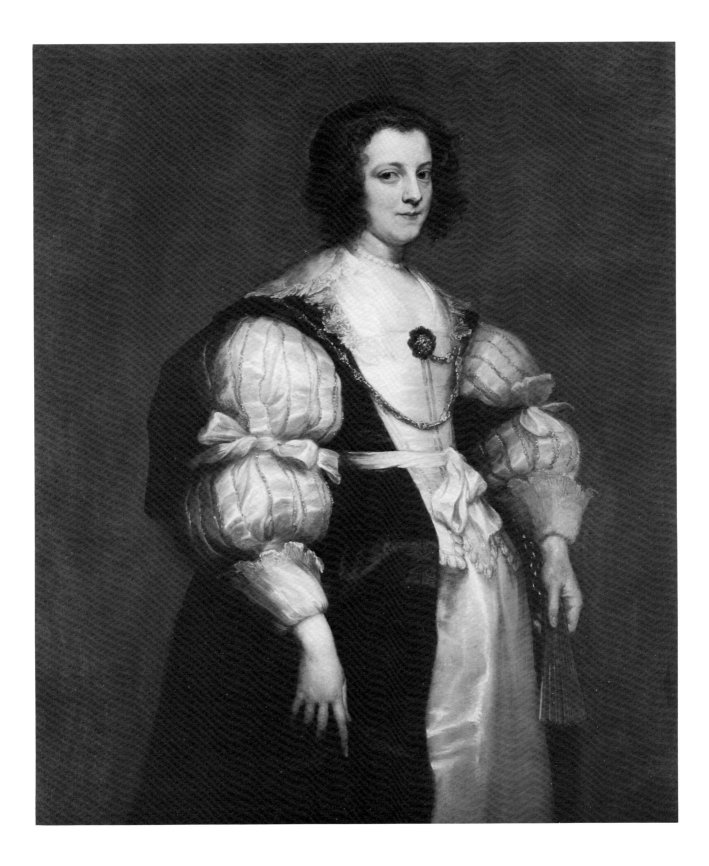

# Bibliography

*Abecedario de P.J. Mariette.* de Chennevieres, Ph. and de Montaiglon, A., eds. Paris, 1854-1856, III.

Abromson, M. C. *Painting in Rome during the Papacy of Clement VIII (1592 - 1605).* New York, 1981.

Aleandri Barletta, E. "Note sul Clemente X di G.L. Bernini." *Commentari.* XVI, 1965, 282-6.

Amadei, G. and Marani, E. *I Ritratti Gonzagheschi della Collezione di Ambras.* Banca Agricola Mantovana, Mantua, 1980.

*Art & Auction,* New York, July/August 1983.

Attwater, D. *The Penguin Dictionary of Saints,* London, 1965.

Azzopardi, Fr. J., ed. *The Church of St. John in Valletta, 1578 - 1978.* Exh. cat., St. John's Museum, Valletta, 1978.

Baccheschi, E. *L'Opera completa di Guido Reni.* Milan, 1973.

Bacou, R. *The Famous Italian Drawings from the Mariette Collection at the Louvre in Paris.* Milan, 1981.

Baetjer, K. *European Paintings in the Metropolitan Museum of Art.* New York, 1980.

Baglione, G. *Le vite de' pittori, scultori, architetti ed intagliatori, dal pontificato di Gregorio XIII dal 1572, fino a'tempi di Papa Urbano VIII nel 1642.* Rome, 1642.

Baldinucci, F. *Notizie de'professori del disegno da Cimabue in qua.* 5 vols., Florence, 1847; [Barocchi, P. ed., with 2 vols. of Appendices, Florence, 1975.]
————. *Vocabolario toscano dell'Arte del Disegno.* Florence, 1681.

Baldinucci, F.S. *Vite di Artisti dei Secoli XVII-XVIII, Prima Edizione Integrale del Codice Palatino 565.* Matteoli, A., ed. Rome, 1975.

Bartolotti, F. *La Medaglia Annuale dei Romani Pontefici da Paolo V a Paolo VI, 1605-1967.* Rimini, 1967.

Bartsch, A. *Le Peintre-graveur.* ed. Leipzig, 1854-76.

Bean, J. *17th-Century Italian Drawings in the Metropolitan Museum of Art.* New York, 1979.

Bean, J. and Stampfle, F. *Drawings from New York Collections, II: The Seventeenth Century in Italy.* New York, 1967.

Bellori, G.P. *Le vite de' pittori scultori ed architetti moderni.* Rome, 1672. [ed. 1976 Torino].

*Bernini in Vaticano.* Exh. cat., Vatican, 1981.

Bershad, D.L. "A Series of Papal Busts by Domenico Guidi." *The Burlington Magazine,* 112, 1970, 805-809.
————. "Two Additional Papal Busts by Domenico Guidi." *The Burlington Magazine,* 115, 1973, 736-739.
————. "Some New Documents on the Statues of Domenico Guidi and Ercole Ferrata in the Elizabeth chapel in the Cathedral of Breslau (now Wroclaw)." *The Burlington Magazine,* 118, 1976, 700-703.
————. "Domenico Guidi: Some New Attributions." *Antologia di Belle Arti,* 1, 1977, 18-28.

*Biblioteca Sanctorem.* Rome, 1968.

Bildt, C. de. *Les Medailles romaines de Christine de Suède,* Rome, 1908.

Bimm, H.L. "Bernini papal portraiture: a medallion and a missing bust." *Paragone,* no. 293, 1974, 72-76.

Blunt, A. *Guide to Baroque Rome.* New York. 1982.

Blunt, A., and Cooke, H.L. *Roman Drwings of the XVII & XVIII Centuries in the Collection of Her Majesty the Queen at Windsor Castle.* London, 1960.

Bologna, Palazzo dell'Archiginnasio. *Maestri della pittura del seicento Emiliano.* Exh. cat., 1959.

Bologna, F. *Francesco Solimena.* Naples, 1958.

Borromeo, Card. Federico. *De Pictura Sacra.* Translation and edition, C. Castiglione. Sora, 1932.

Borroni, Salvadori F. "Le esposizione d'arte a Firenze 1674-1767." *Mitteilungen des Kunsthistoriches Institutes in Florenz,* XVIII, 1974, 1 - 166.

Borsi, F. *et. alia. Gian Lorenzo Bernini: Il testamento, La casa, la raccolta dei beni.* Florence, 1981.

Borsook, E. "Feste ed Apparati Medicei da Cosimo I a Cosimo II." *Arte Illustra* III, 1970, nos. 27-29, 132-37.

Bosio, Mons. L. *Mostra Iconografica Aloisiana.* Exh. cat., Nobile Collegio delle Vergini di Gesù, Citta di Castiglione delle Stivere, 1968.

Briganti, G. *Pietro da Cortona*. Florence, 2nd, ed. 1982.

Brown, J. *Jusepe de Ribera: Prints and Drawings*. Exh. cat., The Art Museum, Princeton University and Fogg Art Museum, Harvard University, 1973/74.

Brugerolles, E. *De Michel-Ange à Gericault, Dessins de la Donation Armand-Valton*. Exh. cat., École Nationale Superieure des Beaux-Arts, Paris, 1981.

Bruhns, L. "Das Motiv der Ewigen Anbetung in der Römischen Grabplastik des 16., 17. und 18. Jahrhunderts." *Römisches Jahrbuch für Kunstgeschichte*, IV, 1940, 253-432.

Buchowiecki, W. *Handbuch der Kirchen Roms*. Vienna, 1967-74.

Buffa, S., ed., *The Illustrated Bartsch (XVII), 34*. New York, 1982.
—————. *The Illustrated Bartsch (XVII), 38*. New York, 1983.

Bush, V. The Colossal Sculpture of the Renaissance. [Phd Diss. 1967]. New York, 1976.

Butzek, M. "Die Papstmonumente im Dom von Siena." *Mitteilungen des Kunsthistoriches Instituts in Florenz*, XXIV, 1980.

Byam Shaw, J. *The Italian Drawings of the Lugt Collection*. Paris, 1983.

Campori, G. *Raccolta di cataloghi ed inventarii inediti*. Modena, 1870.

Canestro Chiovenda, B. "Cristina di Svezia, il Bernini, il Gaulli e un libro di appunti di Tessin d.y." *Commentari*, XVII, 1966, 171-181.
—————. "Ancora del Bernini, del Gaulli e della Regina Cristina." *Commentari*, XX, 1969, 223-36.

Cantelli, G. *Una raccolta fiorentina di medaglie tra `600 e `700*. Florence, 1979.

Casale, V. "La canonizzazione di S. Filippo Benizi e l 'Opera di Baldi, Berrettoni, Garzi, Rioli, Maratti." *Antologia di Belle Arti*. III, no. 9-12, 1979, 113-31.

Casanova, M.L. *S. Maria di Montesanto e S. Maria dei Miracoli*. Le chiese di Roma Illustrate - 58. Rome. n.d.

Causa, R. *La pittura del seicento a Napoli dal naturalismo al barocco*. Naples, 1972.

Chappell, M. "Le Bellezze di Artimino: una nota sull'attribuzione." *Prospettiva*, no. 25, 1981, 59-64.

Châtelet, A. *Disegni di Raffaello e di Altri Italiani del Museo di Lille*. Exh. cat., Gabinetto Disegni e Stampe degli Uffizi, XXXII, Florence, 1970.

Ciardi, R.P. *Giovan Ambrogio Figino*. Florence, 1968.

Cicognara, C. *Cataologo Ragionato dei Libri d'Arte e Antichitá*. Pisa, 1821.

Cinotti, M. *Michelangelo Merisi detto il Caravaggio*. Bergamo, 1983.

Clark, A.M. "Eight Seventeenth and Eighteenth Century Paintings." *Minneapolis Institute of Arts Bulletin*, Vol. LIV, 1965, pp. 39-41.

Cochrane, *Florence during the Forgotten Centuries*. Chicago, 1973.

Cole, R. "Francesco Redi (1626-1697), Physician, Naturalist, Poet." *Annals of Medical History*. 1926, 347-59.

Colleye, H. *Les Eglises Baroques d'Anvers*. Brussels, 1935.

Collobi, L.R. *Disegni della Fondazione Horne in Firenze*. Exh. cat., Palazzo Strozzi, Florence, 1963.

Dartmouth College, New Hampshire. *Selections from the Collection of Esther S. and Malcolm W. Bick*. Exh. cat., 1971.

De Dominici, B. *Vite de' pittori, scultori ed architetti napoletani*. 3 vols. Naples, 1742/43.

Delitalia, F. "Le Medaglie di Massimiliano Soldani per Francesco Redi." in *Some Roman Seventeenth Century Portrait Medals*. Udine, 1970.

Denison, C. and H. Mules. *European Master Drawings: 1375-1825. The Pierpont Morgan Library, New York*. Oxford, 1981.

De Rossi, G.G. *Disegni di Vari Altari e Cappelle nelle Chiese di Roma*. n.d.

*Dessins Francais et Italiens du XVI et du XVII siécle dans les Collections Privées Francais*. Exh. cat., Galerie Claude Aubrey, Paris, December 1971.

Detroit, Detroit Institute of Arts. *Art in Italy: 1600-1700*. Exh. cat., 1965.
—————. *The Twilight of the Medici*. Exh. cat., 1974.

De Vito, G. *Ricerche sul `600 napoletano.* Milan, 1982.

D'Onofrio, C. *Gian Lorenzo Bernini e gli angeli di ponte S. Angelo storia di un ponte.* Rome, 1981.

Dobroklonski. *Catalogue of Italian Drawings of the 17th and 18th Centuries in the Hermitage.* [in Russian], Leningrad, 1961.

Dworschak, F. "Der Medailleur Gianlorenzo Bernini." Ein Beitrag zur Geschichte der Italienischen Barockmedaille." *Jahrbuch der Preusszischen Kunstsammlungen,* Bd. 55, 1934, 27-41.

Duke University, Durham, NC. *Eighteenth Century European Paintings from the Collection of Robert L. and Bertina Suida Manning.* Exh. cat., 1966.

Eisler, C. *Paintings from the Samuel H. Kress Collection. European Schools excluding Italian.* Oxford, 1977.

Emiliani, A. *La Pinacoteca Nazionale di Bologna.* Bologna, 1967.

Enggass, R. "Algardi's Portrait Bust of St. Philip Neri." *Arte antica e moderna.* no. 11, 1960, 296-99.
——————. *The Painting of Baciccio, Giovanni Battista Gaulli.* University Park, Pa., 1964.
——————. "Laurentius Ottoni Rom. Vat. Basilicae Sculptor." *Storia dell'arte.* 15/16. 1972, 158-86.
——————. *Early Eighteenth Century Sculpture in Rome.* 2 vols. University Park, 1976.

Enggass, R. and Brown, J. *Italy and Spain 1600-1750 Sources and Documents.* Englewood Cliffs, N.J., 1970.

*European Drawings 1450-1900.* Exh. cat., Santa Barbara Museum of Art, Ca., 1964.

Evans, B.H. *Fifty Treasures of the Dayton Art Institute.*, 1969.

Evelyn, J.E. S. de Beer, ed. *The Diary of John Evelyn.* 6 vols., Oxford, 1955.

Fagiolo dell 'Arco, Maurizio and Marcello. *Bernini una introduzione al gran teatro del barocco.* Rome, 1967.

Fagiolo dell Arco, M. and Carandini, S. *L 'Effimiero Barocco.* 2 vols., Rome, 1977.

Faldi, I. *Galleria Borghese. Le sculture dal secolo XVI al XIX.* Rome, 1954.

Felton, C. and William B. Jordan, ed. *Jusepe de Ribera lo spagnoletto 1591-1652.* Exh. cat., Kimbell Art Museum, Fort Worth, Tx., 1982.

Ferro, F.M. *Fra Galgario.* Milan, 1966.

Ferretti, L. padre. *San Carlo Borromeo.* Turin, 1923.

Fischer, J. *Sculpture in Miniature: The Andrew S. Ciechanowiecki Collection of Gilt and Gold Medals and Plaquettes.* Exh. cat., The Museum of Fine Arts, Houston, Texas. 1969/70.

*Five College Roman Baroque Festival,* Exh. cat., Amherst College, Smith College, Mount Holyoke College, 1974.

Florence, Gabinetto Disegni Stampe degli Uffizi. Gaeta Bertelà, G. and Pietro Tofani A., eds. *Feste e Apparati Medicei da Cosimo I a Cosimo II.* Exh. cat., 1969.

Florence, Palazzo Vecchio. *Mostra del ritratto italiano dalla fine del sec. XVI all 'anno 1861.* Exh. cat. 1911.

*Fonti per la Storia della Pittura e della Scultura Antica, VIII. Serie Documentaria. Lettere e Altri Documenti intorno alla Storia della Pittura.* Ubaldo Meroni, ed., Monzambano, 1978.

Fraschetti, S. *Il Bernini.* Milan, 1900.

Friedlander, W. *Caravaggio Studies.* 1974.

Fredericksen, B. B. and F. Zeri. *Census of Pre-Nineteenth-Century Italian Paintings in North American Public Collections.* Cambridge, Ma., 1972.

Freedberg, S.J. *Painting in Italy 1500 to 1600.* Baltimore, Md., Rev. ed. 1975.

Fulco, G. "Il sogno di una 'galeria': nuovi documenti sul Marino Collezionista". *Antologia di Belle Arti.* nos. 9/12, 1979.

Galassi Paluzzi, C. "Un bozzetto di Alessandro Algardi per l 'urna di S. Ignazio al 'Gesu." *Roma. Rivista di studi e di vita romana,* anno III, 1925, 17-18.

Gamba, C. "Il ritratto fiorentino." *Il ritratto italiano dal Caravaggio al Tiepolo alla mostra di Palazzo Vecchio nel MCMXI.* Bergamo, 1927.

Gealt, A. *Italian Portrait Drawings, 1400-1800 from North American Collections.* Exh. cat., Indiana University, 1983.

Genoa. *Mostra dei Pittori Genovese a Genova nel '600 e nel '700*. Exh. cat., 1969.

Genoa. *Rubens e Genova*. Exh. cat., 1977-1978.

Gibbons, F. *Catalogue of the Drawings in the Art Museum, Princeton University*. 2 vols. Princeton, NJ, 1977.

Gilbert, C. "Baroque Painters of Italy." in *Bulletin of the Ringling Museum*, I, March 1961.

Gigli, G. *Diario Romano (1608-1670)*. G. Ricciotti, ed., Rome, 1958.

Goldberg, E.L. *Patterns in Late Medici Art Patronage*. Princeton, 1983.

Golzio, V. "Le chiese di S. Maria di Montesanto e di S. Maria dei Miracoli a piazza del Popolo in Roma." *Archivi*, VIII, 1941, 122-48.
————. *Seicento e Settecento*. 2 vols. Turin. 3rd rev. ed., 1968.

Gozzoli, M.C. *Vittore Ghislandi detto Fra' Galgario*. Bergamo, 1981.

Grisebach, A. *Römische Porträtbüsten der Gegenreformation*. Leipzig, 1936.

Hager, W. *Die Ehrenstatuen der Päpste*. Leipzig, 1929.

Hager, H. "Zur Planungs und Baugeschichte der Zwillingskirchen auf der Piazza del Popolo". *Römisches Jahrbuch für Kunstgeschichte*, XI, 1967/68, 189 ff.

Haidacher, A. *Geschichte der Päpste in Bildern*. Heidelberg, 1965.

Hawley, H.H. "Alessandro Algardi's Pope Innocent X." *Bulletin of The Cleveland Museum of Art*, 49, April 1962., 80-82.

Haskell, F. "Pierre Legros and a Statue of the Blessed Stanislas Kostka." *The Burlington Magazine*, XCVII, September 1955, 287-288.
————. "The Role of Patrons: Baroque Style Changes." in *Baroque Art: The Jesuit Contribution*. Wittkower, R. and Jaffe, I., eds., New York, 1972, 51-62.
————. *Patrons and Painters*. New Haven, 2d ed. 1980.

Haskell, F. and Nicholas Penny. *Taste and the Antique*. New Haven, 1981.

Heikamp, D. "La Medusa del Caravaggio e l 'armatura dello Scia Abbâs di Persia." *Paragone*, no. 199, 1966, 62-76.
————. "Federico Zuccari a Firenze 1575-1579. I." *Paragone*, no. 205, 1967, 44-67.

Heimbürger Ravalli, M. *Alessandro Algardi Scultore*. Rome, 1973.

Heinz, G. and Schütz, K. *Porträtgalerie zur Geschichte Österreichs von 1400 bis 1800*. Kunsthistorisches Museum, Vienna, 1976.

Hermann-Fiore, K. "Due artisti allo specchio. Un doppio rittratto del Museo di Würzburg attributo a Giovanni Battista Paggi." *Storia dell 'Arte*. 1981, 29-38.

Hibbard, H. "Ut picturae sermones: The First Painted Decorations of the Gesù." in *Baroque Art: The Jesuit Contribution*. Wittkower, R. and Jaffe, I., eds., New York, 1972, 29-50.

Hugford, I. *Vita di Anton Domenico Gabbiani, pittor fiorentino*. Florence, 1742.

Imbert, E. and Morazzoni, G. *Le Placchette Italiane Secole XV-XIX Contributo alla Conoscenza della Placchetta Italiana*. Milan, n.d. [ca. 1948].

Jenkins, M. *The State Portrait: Its Origin and Evolution*. New York, 1947.

Johnson, D.J. *Old Master Drawings from the Museum of Art, Rhode Island School of Design*. Exh. cat., Providence, R.I., 1983.

Keeble, K.C. *European Bronzes in the Royal Ontario Museum*. Toronto, 1982.

Kenner, F. "Bildnissmedaillen der Spätrenaissance." *Jahrbuch der Kunsthistorischen Sammlungen des Allerhöchsten Kaiserhauses*. Bd. 12, 1891, 84-164.

Keutner, H. *Sculpture Renaissance to Rococo* (vol. 3, *A History of Western Sculpture*, J. Pope-Hennessey, ed.). London, 1969.

Kitson, M., ed. *Salvator Rosa*. Exh. cat., Hayward Gallery, Arts Council of Great Britain, London, 1973.

König-Nordhoff, U. *Ignatius von Loyola*. Berlin, 1982.

Konrad, M. "Antwerpener Binnenräume in Zeitalter des Rubens." in Clemen, P. ed., *Belgische Kunstdenkmäler*, II, 1923, 185-242.

*Kunst um Karl Borromäus. Alfred A. Schmid zum 60. Geburtstag*. Luzern, 1980.

Kruft, H.-W. "Ein Album mit Porträtzeichnungen Ottavio Leonis." *Storia dell 'Arte*, IV, 1969, 447-58.

*La Pittura a Genova e in Liguria dal Seicento al primo Novecento.* Genoa, 1971.

Langedijk, K. *The Portraits of the Medici 15th-18th Centuries.* 1981, I and 1983, II.

Lankheit, K. *Florentinische Barockplastik.* Munich, 1962.
—————. "Eine Serie von Uomini Famosi des Florentinischen Barock." *Pantheon.* XXLX, 1971, 22-39.

Larsen, E. "Van Dyck's English Period and Cavalier Poetry." *Art Journal*, Spring 1972, no. 3, 252-260.
—————. *L'opera completa di Van Dyck 1613-1626.* Milan, 1980.

Lavin, I. "On Illusion and Allusion in Italian Sixteenth Century Portrait Busts." *Proceedings of the American Philosophical Society*, Vol. 119, no. 5, 1975, 353-62.
—————. *Bernini and the Unity of the Visual Arts.* 2 vols., New York, 1980.

Lavin, I., ed. *Drawings by Gianlorenzo Bernini from the Museum der Bildenden Künste Leipzig, German Democratic Republic.* Exh. cat., Princeton, NJ, 1981.

Lavin, M.A. *Seventeenth-Century Barberini Documents and Inventories of Art.* New York, 1975.

*Le Cabinet d'un Grand Amateur P.J. Mariette 1649-1774.* Exh. cat., Musée du Louvre, Paris, 1967.

Levey, M. *National Gallery Catalogues. The Seventeenth and Eighteenth Century Italian Schools.* London, 1971.

Liverani, G. *Il Museo delle Porcellane di Doccia.* Milan, 1967.

Longhi, R. "Ultimi Studi sul Caravaggio e la sua cerchia." *Proporzioni.* I. 1943, 5-63.
—————. "Volti della Roma Caravaggesca." *Paragone*, no. 21, 1951, 35-9.
—————. "Il vero Maffeo Barberini del Caravaggio." *Paragone*, no. 165, 1963, 89-91.

*Los Angeles County Museum of Art Report, July 1, 1981 - June 30, 1983*, Los Angeles, Ca., 1984.

Macandrew, H. "Vouet's Portraits of Giulio Strozzi and its Pendant by Tinelli of Nicolo Crasso." *The Burlington Magazine.* CIX, no. 770, May 1967, 266-71.
—————. *Italian Drawings in the Museum of Fine Arts Boston*, Boston, 1983.

Mahon, D. *Il Guercino dipinti.* Exh. cat., Palazzo del 'Archiginnasio, Bologna, 1968.
—————. "Guercino as a Portraitist and his Pope Gregory XV". *Apollo.* 113, April 1981, 230-235.

Mahon, D. and Sutton, D. *Artists in 17th-Century Rome.* Exh. cat., Wildenstein & Co., London, 1955.

Mâle, E. *L'Art Religieux après le Concile de Trente.* Paris, 1932.

Malvasia, C.C. *Felsina pittrice, vite de' pittori bolognese.* Bologna, 1678.
—————. *The Life of Guido Reni.* [Translated by Catherine and Robert Engass] University Park, Pa., 1980.

Mancini, A. *Considerazione sulla pittura.* Edited by A. Marucchi and L. Salerno. 2 vols. Rome, 1956/57.

Manning, R.L. *Venetian Painting of the Eighteenth Century.* Exh. cat., Finch College Museum of Art, New York, 1961.
—————. *Bolognese Baroque Painters*, Exh. cat., Finch College Museum of Art, New York, 1962.
—————. *Neapolitan Masters.* Exh. cat., Finch College Museum of Art, New York, 1962 (II).
—————. *Genoese Painters.* Exh. cat., Finch College Museum of Art, New York, 1964.
—————. *Venetian Baroque Painters.* Exh. cat., Finch College Museum of Art, New York, 1964.
—————. *Italian Renaissance and Baroque Paintings from the Collection of Walter P. Chrysler, Jr.* Exh. cat., Norfolk Museum of Arts and Sciences, 1967-68.
—————. *Sixty-six Paintings in Search of Their Authors.* Exh. cat., Finch College Museum of Art, New York, 1969/70.

Manning, R.L. and B. Suida. *Genoese Masters: Cambiaso to Magnasco, 1550-1750.* Exh. cat., Dayton, Ohio, Art Institute, 1962.

Mantua, Palazzo Ducale. *Mostra Iconografica Gonzaghesca.* Exh. cat., 1937.

Marabottini Marabotti, A. "Il naturalismo di Pietro Paolini" in *Scritti di Storia dell 'Arte in Onore di Mario Salmi.* I. Rome, 1963, 307-324.

Marini, M. *Io Michelangelo da Caravaggio.* Rome, 1974.
—————. *Caravaggio e il naturalismo internazionale.* Turin. 1981.

Martin, J.R. *Baroque.* New York, 1977.

Martinelli, V. *I. ritratti di pontefici di G.L. Bernini.* Rome, 1956.
—————. "Andrea Bolgi a Roma e a Napoli." *Commentari.* X, 1959, 152-3.
—————. "I disegni del Bernini". *Commentari.* I, 1950, 172-86.

Martinori, E. *Annali della Zecca di Roma (1669-1689).* Rome, 1920.

von Matt, L. and Kühner, H. *The Popes.* New York, 1963.

Meroni, Ubaldo. "Salvator Rosa: autoritratti e ritratti di amici." *Prospettiva.* 1981, no. 25, 65-70.

Metropolitan Museum of Art, *Notable Acquisitions 1965 - 1975.* New York, 1975.

Middeldorf, U. "Review of Imbert and Morazzoni", a.d., in *Art Bulletin.* XXX, June 1948, 151-56.

Middeldorf, U. and Stiebral, D. *Renaissance Medals and Plaquettes,* Florence, 1983.

Minneapolis, *Sculpture from the David Daniels Collection.* Exh. cat., The Minneapolis Institute of Arts, 1979-80.

Moir, A. *The Italian Followers of Caravaggio.* Cambridge, Mass., 1967.

Montagu, J. "Massimiliano Soldani's 'Venus Plucking the Wings of Cupid'." *Bulletin of The National Gallery of Canada.* 1974, no. 24, 22-34.
—————. "Alessandro Algardi and the Statue of St. Philip Neri." *Jahrbuch der Hamburger Kunstsammlungen.* 22, 1977, 75-100.

de Montaiglon, A. *Catalogue raisonné de l'oeuvre de Claude Mellan d'Abbeville, précédé d'une notice sur la vie et les ouvrages de Mellan par P.J. Mariette.* Extract from "Mémoires de la Societé impériale d'emulation d'Abbeville." Abbeville, 1856.

*Mostra di Opere d'Arte restaurate nelle province di Siena e Grosseto, II - 1981.* Exh. cat., Pinacoteca Nazionale, Siena.

Muñoz, A. "La scultura barocca a Roma, IV - Le statue onorarie". *Rassegna d'Arte,* XVII, 1917, 131-47.

Naudeus, G. *Instructions Concerning Erecting of a Library: Presented to My Lord the President De Mesne.* [Translated by J. Evelyn] Cambridge, 1903.

Nava Cellini, A. "Per l 'integrazione e lo svolgimento della ritrattistica di Alessandro Algardi" *Paragone.* no. 177, 1964, 15-36.

Neumann, E. "Das Figuren relief auf der Urne des Hl. Ignazio im römischen Gesù, *Pantheon.* 1977, 318-328.

Newcome, M. *Genoese Baroque Drawings.* Exh. cat., University Art Gallery, Binghamton, N.Y., 1972.
—————. "Genoese Artists in the Shadow of Castiglione." *Paragone,* no. 391, 1982, 24-36.

Nibby, A. *Rome nell 'Anno MDCCCXXXVIII.* vols. I-II. Rome, 1839.

Nicolson, B. *The International Caravaggesque Movement.* Oxford, 1979.

Nissman, J. *Florentine Baroque Art from American Collections.* Exh. cat., Metropolitan Museum of Art, New York, 1969.

Norris, A.S. and Weber, I. *Medals and Plaquettes from the Molinari Collection at Bowdoin College.* Brunswick, Maine. 1976.

Oberhuber, K., ed. *Renaissance and Baroque Drawings from the Collections of John and Alice Steiner.* Exh. cat., Fogg Art Museum, Cambridge, Mass., 1977.

Orlandi, P.A. *Abecedario pittorico dei professori più illustri in pittura, scultura, e archittura.* Florence, 1788.

Ottani, A. "Per un caravaggesco toscano: Pietro Paolini (1603-1681)," *Arte antica e moderna.* 21, 1963, 19-35.
—————. "Integrazioni al catalogo del Paolini." *Arte antica e moderna.* 30, 1965, 181-87.

Ottonelli, G.D. and da Cortona, P. *Treatise on Painting and Sculpture, Their Use and their Abuse.* Florence, 1652, [1973 ed.]

Pacelli, V. "Processo tra Ribera e un committente". *Napoli Nobilissima.* XVIII, January-February 1979, 28-36.

Pallucchini, R. *Fra Galgario (1655-1743) nelle collezioni private Bergamasche.* Exh. cat., Galeria Lorenzelli, Bergamo, 1967.

Paris, Louvre. *Le Cabinet d'un Grand Amateur P. J. Mariette.* Exh. cat., 1967.

Parma Armani, E. "I Quadretti di San Filippo Neri e un'ipotesi per Bartolomeo Cavarozzi Disegnatore." in *Studi di storia delle arti,* Università di genova, istituto di storia dell 'arte, 1977, 131-48.

Pascoli, L. *Vite de' pittori, scultori d'architetti moderni.* 2 vols. Rome, 1730-36.

Passeri, G.B. *Vite dei pittori, scultori ed architetti che anno lavorato in Roma morti dal 1641 al 1673.* Edited by J. Hess. Leipzig and Vienna, 1934.

Pastor, L.B. *Storia dei Papi dalla fine del medioevo.* [Italian version of Mons. Prof. Pio Cenci] Rome, 1943.

Pecchiai, P. *Il Gesù di Roma.* Rome, 1952.

Peluso, J.F. "Sculptural and Pictorial Evidence for Dating a Bernini Painting." *Gazette des Beaux-Arts.* XC, 1977, 151-54.

Pepper, D. S. "Guido Reni's 'Il Diamante'; A New Masterpiece for Toledo." *The Burlington Magazine.* CXIV, October 1973, 636-37.

Petrucci, A. *Il Caravaggio acquafortista e il mondo calcografico romano.* Rome, 1956.

Philadelphia, Pa. *A Scholar Collects: Selections from the Anthony Morris Clark Bequest.* [U.W. Heisinger and A. Percy, eds.] Exh. cat. Philadelphia Museum of Art, 1980.

Pietrangeli, C. *Guide Rionali di Roma Rione VI - Regola, I.* Rome, 1980.

Pigler, A. *Barockthemen.* 2nd ed. 3 vols. Budapest, 1974.

Pio, N. *Le vite di pittori scultori et architetti.* Edited by C. Enggass and R. Enggass. Vatican City, 1977.

Pollak, O. *Die Kunsttätigkeit unter Urban VIII Vol. I: kirchliche Bauten und Paläste,* Vienna, 1928.

Pollard, C. *Some Roman Seventeenth Century Portrait Medals.* Udine, 1967.

Pope-Hennessy, J. *Catalogue of Italian Sculpture in the Victoria and Albert Museum.* 3 vols. 1964.
——————. *Italian High Renaissance and Baroque Sculpture.* New York, rev. ed., 1970.

Potterton, H. *Venetian Seventeenth-Century Painting.* Exh. cat., National Gallery, London, 1979.

Providence, R.I. *The Portrait Bust Renaissance to Englightenment.* Exh. cat., 1969.

*Raffaello a Brera.* Exh. cat., Milan, 1984.

Ragghianti Collobi, L. *Disegni della Fondazione Horne in Florence.* Florence, 1963.

Ranke, L. *The History of the Popes, their Church and State, and especially their conflicts with Protestanism in the Sixteenth & Seventeenth Centuries.* [Translated by E. Foster] 3 vols. London, 1853.

Redi, F. *Bacco in Toscana. Ditirambo di Francesco Redi Accademico della Crusca con le Annotazioni.* Firenze, 1685.
——————. *Osservazioni intorno agli Animali Viventi...Firenze,* 1684.
——————. *Lettera intorno ... occhiali. Firenze,* 1678.
——————. *Opera omnia di Francesco Redi.* Milan, ed. Classici. 1809 *seq.*
——————. *Experiments on the Generation of Insects.* 1668. [English translation by M. Bigelow], 1909.

Ricci, C. "Statue e Busti di Sisto V." *L'Arte.* XIX, 1916, 163-74.

Riccòmini, E. *Ordine e Vaghezza: La Scultura in Emilia nell 'etá Barocca.* Bologna. 1972.

Richter, G.M.A. *The Portraits of the Greeks.* London, 1965.

Romano, G.M. *Gizionario di erudizione storico-ecclesiastico.* Venice, 1856.

Rome, Palazzo delle Esposizioni. *Il seicento europeo.* Exh. cat., 1956/57.

Rosenberg, P. *France in the Golden Age: Seventeenth Century Paintings in American Collections.* Exh. cat., New York, 1982.

Rosenberg, P. "France in the Golden Age: A Postscript." *The Metropolitan Museum of Art Journal,* 1984, 23-46.

Rothrock, O.J. with van Gulick, E. "Seeing and Meaning: Observations on the Theatre of Callot's *Primo Intermezzo. New Mexico Studies in the Fine Arts,* IV, 1979, 16-35.

Rudolph, S. "Mecenati a Firenze tra Sei e Settecento II: Aspetti dello Stile Cosimo III." *Arte ilustrata.* no. 54, 1973, 213-30.
——————. "Un Capolavoro di Carlo Maratti Dimenticato in Toscana." *Mitteilungen des Kunsthistorisches Institutes in Florenz.* XXII, 1978, 253-264.

Ruggeri, Ugo. *Carlo Ceresa Dipinti e Disegni.* Bergamo, 1979.

Russell, H.D. *Jacques Callot Prints & Related Drawings.* Exh. cat. National Gallery of Art, Washington, D.C., 1975.

Salerno, L. *L'opera completa di Salvator Rosa.* Milan, 1975.

Samek Ludovici, S., ed. *Vita di Bernini scritta da Filippo Baldinucci.* Milan, 1948.

Schiavo, A. *The Altieri Palace.* Rome, 1965.

Schlegel, U. *Die italienischen Bildwerke des 17. und 18. Jahrhunderts.* Die Bildwerke der Skulpturengalerie. Berlin Band I. 1978.

Schleier, E. "The Menicucci Portrait Restudied". *Bulletin of the Herron Museum of Art.* Indianapolis, Ind., 1965.

Shapley, F.R. *Paintings from the Samuel H. Kress Collection: Italian Schools XVI-XVIII Century.* London, 1973.
——————. *Catalogue of the Italian Paintings.* National Gallery of Art, Washington, D.C., 1979.

Singer, H.W. *Allgemeiner Bildniskatalog.* VIII, Leipzig, 1933.

Sirén, O. *Nicodemus Tessin d. y:s studieresor i Danmark, Tyskland, Holland, Frankrike och Italien.* Stockholm, 1914.

Soprani, R. and Ratti, C.G. *Vite de' pittori, scultori, ed architetti genovesi.* Genoa, 1769.

Spear, R.E. *Caravaggio and His Followers.* Rev. ed. New York, 1975.

Spike, J.T. "Documents for Mattia Preti and the Renovation of the Chapel of France, 1663-1668, in the Co-Cathedral of St. John, Valletta." *Storia dell' Arte,* no. 35, 1979, 5-10.
——————. *Italian Baroque Paintings from New York Private Collections.* Exh. cat., Princeton, N.J., 1980.
——————. *Italian Still Life Paintings from Three Centuries.* Exh. cat., Old Masters Exhibition Society of New York, 1983.

Spinosa, N. *L'opera completa del Ribera.* Milan, 1978.
——————. *Civiltà del '700 a Napoli 1734 - 1799.* Naples, 1979-80.
——————. *The Golden Age of Naples: Art and Civilization under the Bourbons 1734 - 1805.* Detroit and Chicago, 1981.

Stewart, J.D. "Hidden Persuaders: Religious Symbolism in van Dyck's Portraiture." *RACAR.* X, 1, 1983, 57-68.

Stix, A. and Spitzmüller, A. *Beschriebener Katalog der Handzeichnungen in der ... Albertina. Die Schulen von Ferrara, Bologna, etc.* Vienna, VI, 1941.

Stockholm. *Christina Queen of Sweden.* Exh. cat., 1966.

Stoughton, M. "Giovanni Battista Caracciolo: New Biographical Documents", *The Burlington Magazine.* CXX, April 1978, 204-15.

Sutherland Harris, A. *Andrea Sacchi.* Princeton, N.J., 1977.
——————. ed., *Selected Drawings of Gian Lorenzo Bernini.* New York, 1977.

Thiem, C. *Florentiner Zeichner des Frühbarock.* Munich, 1977.
——————. "Kompositionsentwürfe des Cosimo Gamberucci" *Mitteilungen des Kunsthistoriches Institutes in Florenz.* 1974, XVIII, 3, 383-92.

Thomas, T.H. "Ottavio Leoni - A Forgotten Portraitist." *Print Collector's Quarterly.* VI, 1916, 322-73.

Titi, F. *Studio di pittura, scoltura et architettura nelle chiese di Roma.* Rome, 1674.
——————. *Ammaestramento ... di pittura, scoltura et architettura nelle chiese di Roma.* Rome, 1686.

Tomory, P. *Catalogue of the Italian Paintings before 1800. The John and Mable Ringling Museum of Art.* Sarasota, Fla. 1976.

Toronto, Royal Ontario Museum. *Florentine Baroque Bronzes and Other Objects of Art.* Exh. cat., 1975.

Toronto, Art Gallery of Ontario. *The Arts of Italy in Toronto Collections 1300-1800.* Exh. cat., 1981/82.

Turner, N. *Italian Baroque Drawings.* London, 1983.

Tuttle, P. "Investigation of Renaissance Casting Techniques of Incuse-Reverse and Double-Sided Medals." [unpublished typescript], 1984.

Valletta, Malta. *The Order of St. John in Malta.* Exh. cat., 1970.

Valsecchi, M., *Un Incontro Bergamasco Ceresa - Baschenis.* Exh. cat., Galleria Lorenzelli, Bergamo, 1979.
——————. ed. *Il seicento lombardo, catalogo dei dipinti e delle sculture.* Exh. cat., Palazzo Reale, Milan, 1973.

Vasser College, Poughkeepsie, N.Y. *Vasser Centennial.* Exh. cat., 1961.

Venice, Ca 'Pesaro. *La pittura del seicento a Venezia.* Exh. cat., 1959.

Vertova, L. *Carlo Certosa un pittore bergamasco nel '600 (1609-1679).* Bergamo, 1983.

Vienna, Kunsthistorisches Museum. *Porträtgalerie zur Geschichte Österreichs von 1400 bis 1800. Katalog der Gemadegalerie.* 1976.

*Villa e Paese. Dimore nobili del Tuscolo e di Marino.* Exh. cat. Rome, Museo di Palazzo Venezia, 1980.

Visoná, M. "La Via Crucis del Convento di San Pietro d'Alcantara presso la Villa l'Ambrogiana a Montelupo Fiorentino." in *Kunst des Barock in der Toskana.* Munich, 1976, 57-69.

Viviani, U. *Arezzo e gli Aretini.* 1921.
——————. *Vita, Opere, Iconografia, Bibliografia ... e libro inedito dei "Ricordi" di Francesco Redi.* 2 vols., 1928-31.
——————. *La Vacchetta (Libro di Ricordi) di Francesco Redi, Vita ed Opere ineditie di Francesco Redi.* Part 3, 1931.

Vliegenthart, A.W. *La galleria Buonarroti, Michelangelo e Michelangelo Il Giovane.* Florence, 1976.

von Platen, M. ed. *Queen Christina of Sweden: Documents and Studies.* Stockholm, 1966.

Waterhouse, E. *Seventeenth Century Art in Europe,* Exh. cat., Royal Academy of Arts, London, 1938.
——————. *Italian Baroque Painting.* 2nd ed. London, 1969.
——————. *Roman Baroque Painting.* Oxford, 1976.

Weihrauch, H.R. *Die Bildwerke in Bronze und in anderen Metallen.* Bayerisches Nationalmuseum München, Kataloge Band XIII, 5. Munich 1956.

Whitfield, C. and Martineau, J. ed. *Painting in Naples 1606-1705 from Caravaggio to Giordano.* Exh. cat., Royal Academy of Arts, London, 1982.

Whitman, N.T. with Varriano, J.L. *Roma Resurgens Papal Medals from the Age of the Baroque.* Exh. cat., University of Michigan Museum of Art, Ann Arbor, 1983.

Wittkower, R. *Gianlorenzo Bernini The Sculptor of the Roman Baroque.* Ithaca, NY, 3rd ed. 1981.
——————. *Art and Architecture in Italy 1660 to 1750.* 3rd rev. ed. Baltimore, Md., 1973.
——————. "Melchiorre Cafa's Bust of Alexander VII." *The Metropolitan Museum of Art Bulletin,* XVII, 1959, 197-204.

Zajadacz-Hastenrath, S. *Das Beichtgestühl der Antwerpener St. Pauluskirche und der Barockbeichstuhl in den Südlichen Niederlanden.* Brussels, 1970.

Zeri, F. *Italian Paintings in the Walters Art Gallery.* Baltimore, Md., 1976.

# Appendix

**1. Gian Lorenzo Bernini,** *Pope Gregory XV,* bronze, without base 22 3/4 x 24 3/4 x 11 (60.3 x 62.9 x 27.9), Museum of Art, Carnegie Institute, Howard A. Noble Fund, 1983, Pittsburgh, Pennsylvania.

**2. Gian Lorenzo Bernini,** *Monsignor Francesco Barberini,* marble, 31 1/8 x 26 x 10 1/2 (79.1 x 66 x 26.7), National Gallery of Art, Samuel H. Kress Collection, 1961, Washington, D.C.

**3. Gian Lorenzo Bernini,** *Pope Urban VIII,* marble, 37 1/4 (94.7), The National Gallery of Canada, Ottawa.

**4. Attributed to Ercole Ferrata,** *Bust of a Man,* marble, 32 1/8 x 27 3/4 x 19 3/4 (81.5 x 70.4 x 50.1), The Cleveland Museum of Art, The Thomas L. Fawich Memorial Collection, Cleveland, Ohio.

**5. Ferrucci Del Tadda,** *Bust of Francesco di Ferdinando I de'Medici,* porphyry, without base 27 x 21 (68.6 x 53.3), Virginia Museum, The Williams Fund, Richmond, Virginia.

**6. Giuliano Finelli,** *Cardinal Scipione Borghese,* marble, with base 39 (99.1), The Metropolitan Museum of Art, Louise Eldredge McBurney Gift, 1953, New York, New York.

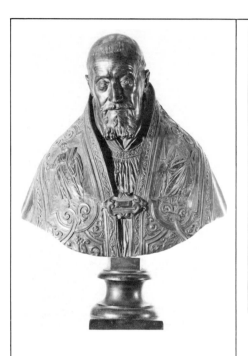

1

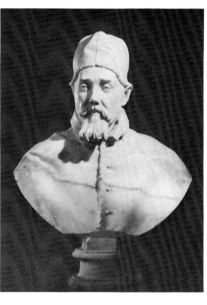

3

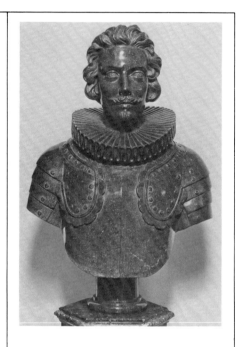

5

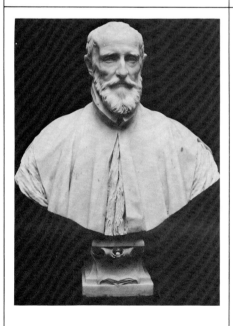

2

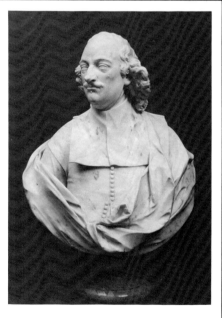

4

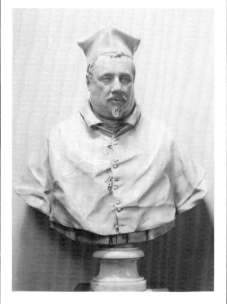

6

**7.** Giovanni Battista Foggini, *Ferdinando II de'Medici, Grand Duke of Tuscany*, marble, 31 1/4 (79.4), National Gallery of Art (Widener Collection), 1942, Washington, D.C.

**8.** Giovanni Battista Foggini, *Vittoria della Rovere*, marble, 32 5/8 x 28 x 13 3/8 (83 x 71.2 x 34), National Gallery of Art, Widener Collection, 1942, Washington, D.C.

**9.** Attributed to **Giovanni Battista Foggini**, *Grand-Duke Cosimo III*, polychrome terracotta, 11 5/8 (28.5), Fogg Museum, Harvard University, Alpheus Hyatt Fund, Cambridge, Massachusetts.

**10.** Giovanni Battista Foggini, *Cosimo III de'Medici, Grand Duke of Tuscany*, marble, 28 7/8 x 25 x 15 15/16 (73.3 x 63.5 x 40.5), National Gallery of Canada, Ottawa.

**11.** Attributed to **Domenico Guidi**, *Pope Alexander VIII*, marble, 30 (76.2), The Detroit Institute of Arts, Gift of Founders Society, William C. Yawkey Fund, Detroit, Michigan.

**12.** Attributed to **Domenico Guidi**, *Pope Alexander VIII* (side view), marble, 30 (76.2), The Detroit Institute of Arts, Gift of Founders Society, William C. Yawkey Fund, Detroit, Michigan.

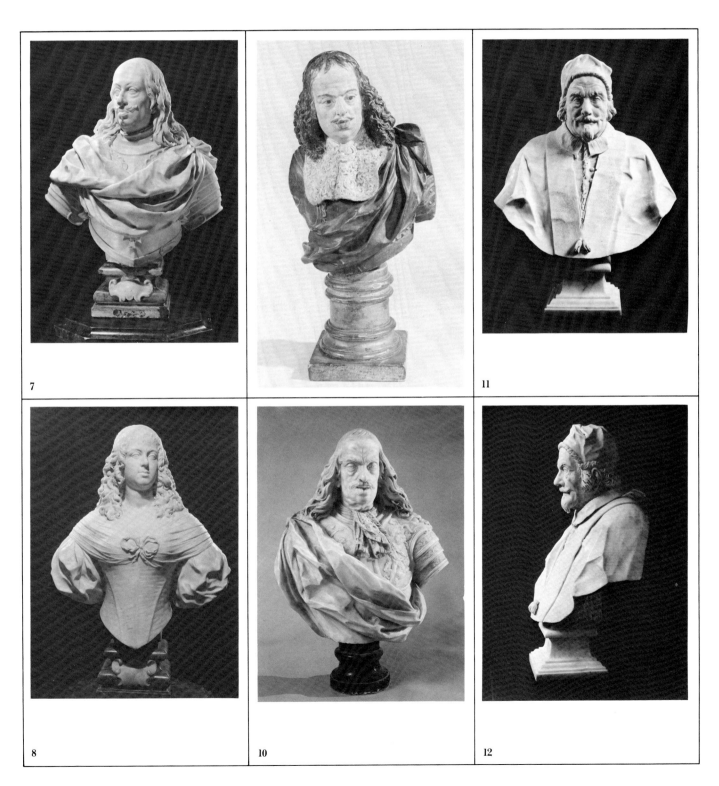

7

8

10

11

12

**13.** Attributed to **Domenico Guidi,** *Pope Alexander VIII,* gilded terracotta, without base 29 (73.7), Los Angeles County Museum of Art, William Randolph Hearst Collection, Los Angeles, California.

**14. Johann Jakob Kornman,** *Bust of Paolo Giordano II Orsini, Duke of Bracciano,* bronze, gilded and silvered details, 7 1/4 (18.4), The Metropolitan Museum of Art, The Jack and Belle Linsky Collection, New York, New York.

**15. Italian School,** c. 1600, *Portrait of a Nobleman,* wax, molded in high relief and polychromed, box 10 7/16 x 8 1/4 (26.5 x 21), Walters Art Gallery, Baltimore, Maryland.

**16. Italian Anonymous,** c. 1670, *Cardinal Scipione D'Elci,* bronze, 9 (22.9), Paul Magriel Collection, New York, New York.

**17.** Attributed to **Girolamo Lucenti,** *Portrait Medallion of Pope Clement IX,* bronze, diameter 12 1/8 (30.8), Fogg Art Museum, Harvard University, Alpheus Hyatt Fund, Cambridge, Massachusetts.

**18. Francesco Mochi,** *Cardinal Antonio Barberini, the Younger,* marble, without base 32 3/4 (83.2), The Toledo Museum of Art, Gift of Edward Drummond Libbey, Toledo, Ohio.

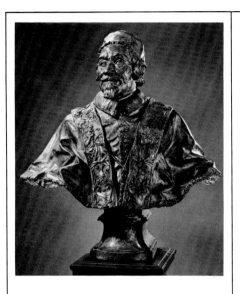

13

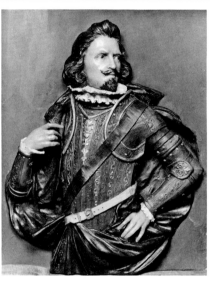

15

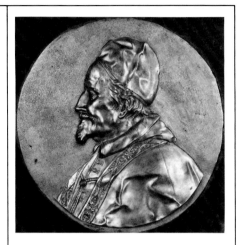

17

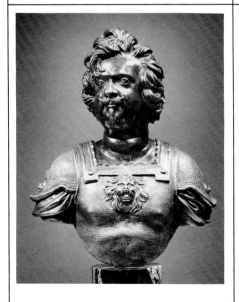

14

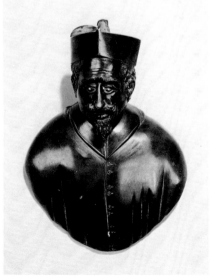

16

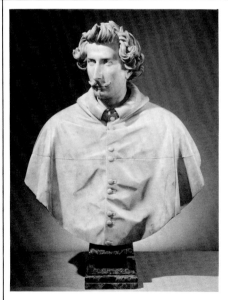

18

19. Attributed to **Pietro Paolo Naldini**, *Bust of Bartholomeo Ruspoli*, gilt bronze, with base 31 1/2 (79.4), Los Angeles County Museum of Art, William Randolph Hearst Collection, Los Angeles, California.

20. Probably by **Lorenzo Ottoni**, *Cardinal Raimondo Capizucchi*(?), marble, 39 (99.1), The Metropolitan Museum of Art, Purchase, 1920, Joseph Pulitzer Bequest, New York, New York.

21. Attributed to **Lorenzo Ottoni**, *Pope Clement XI*, terracotta, 34 x 31 x 16 (86.4 x 78.7 x 40.6), Virginia Museum, Museum Purchase, 1965, Richmond, Virginia.

22. **Gabrielle Renzi**, *Princess Anna Colonna Barberini*, gilt bronze and black marble, figure 31 3/4 x 25 1/2 x 23 (80.6 x 64.8 x 58.4), Albright-Knox Art Gallery, Charles Clifton and Edmund Hayes Funds, 1946, Buffalo, New York.

23. **Gian Lorenzo Bernini**, *Sisinnio Poli*, black, red and white chalk on light brown paper, 10 9/16 x 8 1/8 (26.8 x 20.6), The Pierpont Morgan Library New York, New York.

24. **Gian Lorenzo Bernini**, *Cardinal Scipione Borghese*, graphite and red chalk, 9 7/8 x 7 1/4 (25 x 18.4), The Pierpont Morgan Library, New York, New York.

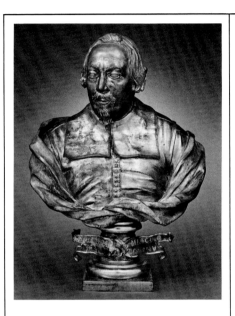

19

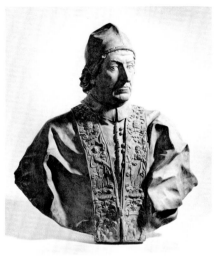

21

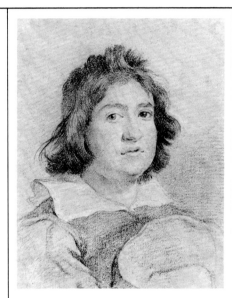

23

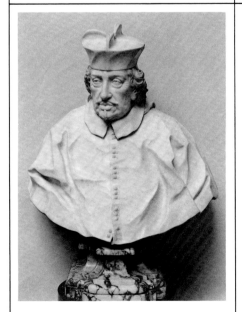

20

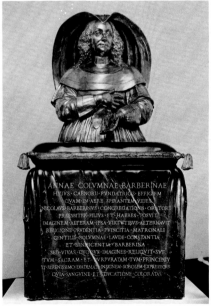

22

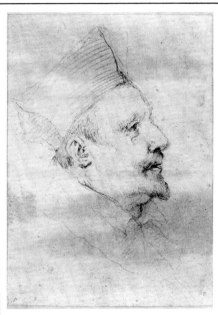

24

**25.** Ottavio Leoni, *Monsignor Porta*, black chalk, highlighted with white, on gray paper, 8 9/16 x 6 1/4 (21.7 x 15.9), The Pierpont Morgan Library, Janos Scholz Collection, New York, New York.

**26.** Ottavio Leoni, *Cardinal Francesco del Monte*, black chalk, heightened with white, on blue paper, 9 x 6 1/2 (22.9 x 16.5), John and Mable Ringling Museum of Art, Sarasota, Florida.

**27.** Ottavio Leoni, *Pietro Altemps*, black and white chalk on blue paper, 9 1/8 x 6 1/8 (23.2 x 15.6), The Pierpont Morgan Library, New York, New York.

**28.** Ottavio Leoni, *Portrait of a Young Girl*, black chalk on blue paper turned gray, 9 1/8 x 6 1/8 (23.2 x 15.6), Museum of Art, Rhode Island School of Design, Anonymous Gift, Providence, Rhode Island.

**29.** Ottavio Leoni, *Portrait Sketch of a Young Lady*, pencil and crayon, 7 3/4 x 10 1/4 (19.7 x 26), Museum of Art, Rhode Island School of Design, Gift of Mrs. Gustav Radeke, Providence, Rhode Island.

**30.** Ottavio Leoni, *Settimia Manenti Salermitano*, red and black chalk on blue paper, 9 1/4 x 6 1/4 (23.5 x 15.9), The Pierpont Morgan Library, New York, New York.

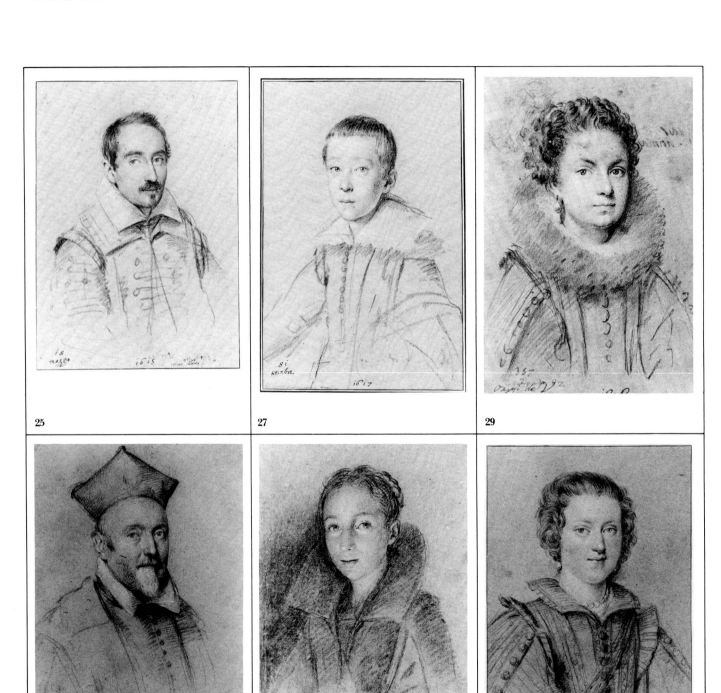

25

27

29

26

28

30

**31. Ottavio Leoni,** *Angela Calzettara*, black chalk highlighted with white, 8 11/16 x 6 1/2 (22 x 16.5), Stanford University Museum of Art, Anonymous Gift, Stanford, California.

**32.** Attributed to **Ippolito Leoni,** *Portrait of a Lady*, black chalk highlighted with white on gray paper, 5 13/16 x 4 1/8 (14.7 x 10.5), John and Mable Ringling Museum of Art, Sarasota, Florida.

**33. Sassoferrato** (Giovanni Battista Salvi), *Portrait of a Woman*, black and white chalk on blue paper, 8 1/16 x 7 (20.5 x 17.8), The Pierpont Morgan Library, New York, New York.

**34. Giovanni Battista Gaulli** (Baciccio), *Cardinal Jacopo Rospigliosi*, oil on canvas, 28 9/16 x 23 1/2 (72.5 x 59.7), Robert and Catherine Enggass Collection

**35.** Follower of **Giovanni Battista Gaulli** (Baciccio), *Cardinal Alderno Cybo (?)*, oil on canvas, 35 1/2 x 27 5/8 (90.2 x 70.2), Museum of Art, Rhode Island School of Design, Providence, Rhode Island.

**36. Giovanni Bernardo Carbone,** *Portrait of a Gentleman*, oil on canvas, 48 1/4 x 28 1/4 (122.6 x 97.2), Indianapolis Museum of Art, Delavan Smith Fund, Indianapolis, Indiana.

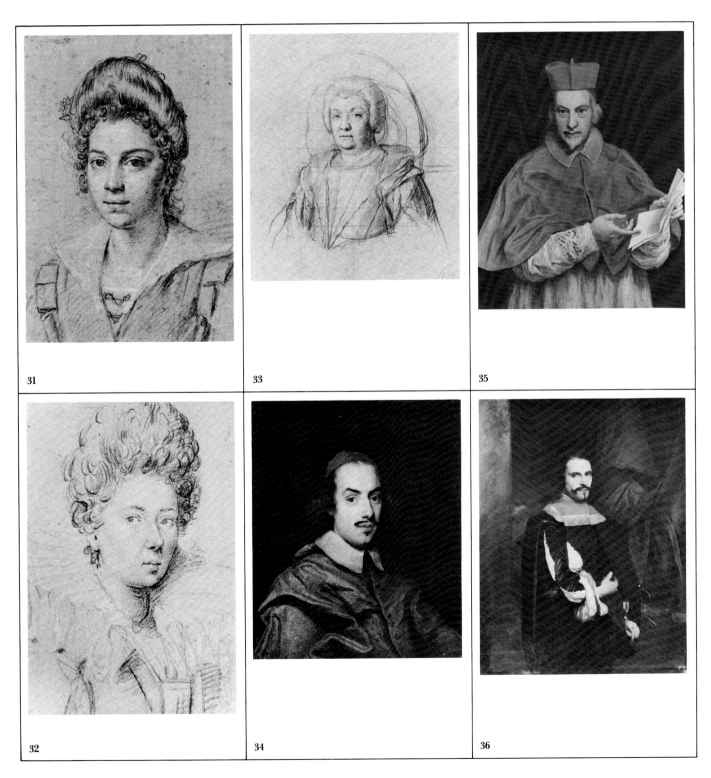

31

33

35

32

34

36

**37.** Attributed to **Niccolò Cassana,** *Self-Portrait,* oil on canvas, 28 1/2 x 24 (72.4 x 61), Doris Huberth Schriever Collection.

**38. Carlo Ceresa,** *Lorenzo Ghirardello,* oil on canvas, 44 x 37 (112 x 94), Museum of Fine Arts, Boston, Ross Collection, Gift of Denman W. Ross, Boston, Massachusetts.

**39. Vittore Ghislandi (Fra Galgario),** *Portrait of a Young Artist,* oil on canvas, 30 x 24 1/2 (76.2 x 62.2), Museum of Art, The University of Arizona, Gift of Samuel H. Kress Foundation, Tucson, Arizona.

**40. Vittore Ghislandi (Fra Galgario),** *Portrait of a Pupil as a Gentleman,* oil on canvas, 55 x 39 3/4 (139.7 x 101), North Carolina Museum of Art, Gift of Samuel H. Kress Foundation, Raleigh, North Carolina.

**41. Guercino (Giovanni Francesco Barbieri),** *Cardinal Francesco Cennini,* oil on canvas, 46 1/4 x 37 7/8 (117.4 x 96.2), National Gallery of Art, Samuel H. Kress Collection 1961, Washington, D.C.

**42. Circle of Pietro da Cortona,** *Portrait of an Ecclesiastic,* oil on canvas, 38 x 28 7/8 (96.5 x 73.3), The Wadsworth Atheneum, Ella Gallup Sumner and Mary Catlin Sumner Collection, Hartford, Connecticut.

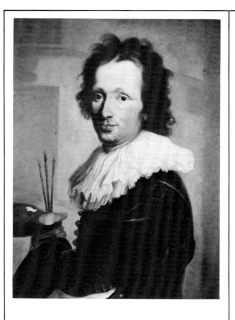

37

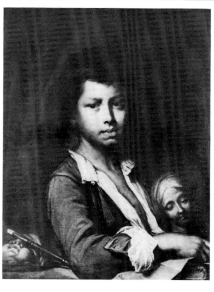

39

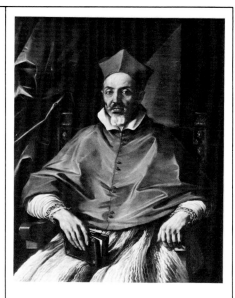

41

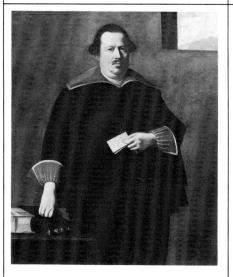

38

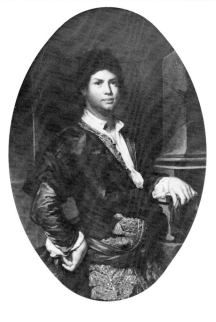

40

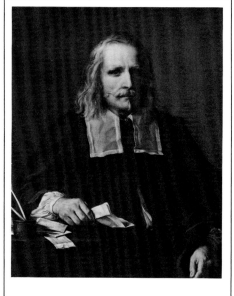

42

**43. Italian Anonymous (Roman),** c.1620, *Portrait of a Lady,* oil on copper, approximately 2 1/2 x 2 (6.4 x 5.1), Suida Manning Collection, New York.

**44. Italian Anonymous,** 17th century, *Portrait of a Man,* oil on canvas, 40 x 32 1/2 (101.6 x 82.6), The Chrysler Museum, Museum Purchase, Norfolk, Virginia.

**45. Giovanni Lanfranco,** *Self-Portrait,* oil on canvas, 25 x 20 (63.5 x 50.8), Columbus Museum of Art, Museum Purchase, Derby Fund, Columbus, Ohio.

**46. Lorenzo Lippi,** *Self-Portrait,* oil on canvas, 26 x 19 1/2 (66 x 49.5) (unframed), Washington County Museum of Fine Arts, Hagerstown, Maryland.

**47. Luigi Miradori** (il Genovesino), *A Cleric of the Pueroni Family,* oil on canvas, 55 1/2 x 37 13/16 (141 x 96), The Hispanic Society of America, New York, New York.

**48. Mattia Preti,** *Portrait of the Grand Master of the Knights of Malta, Martin de Redin,* oil on canvas, 36 1/4 x 28 7/8 (82.1 x 73.3), The Art Institute of Chicago, Gift of Mrs. Sterling Morton, Chicago, Illinois.

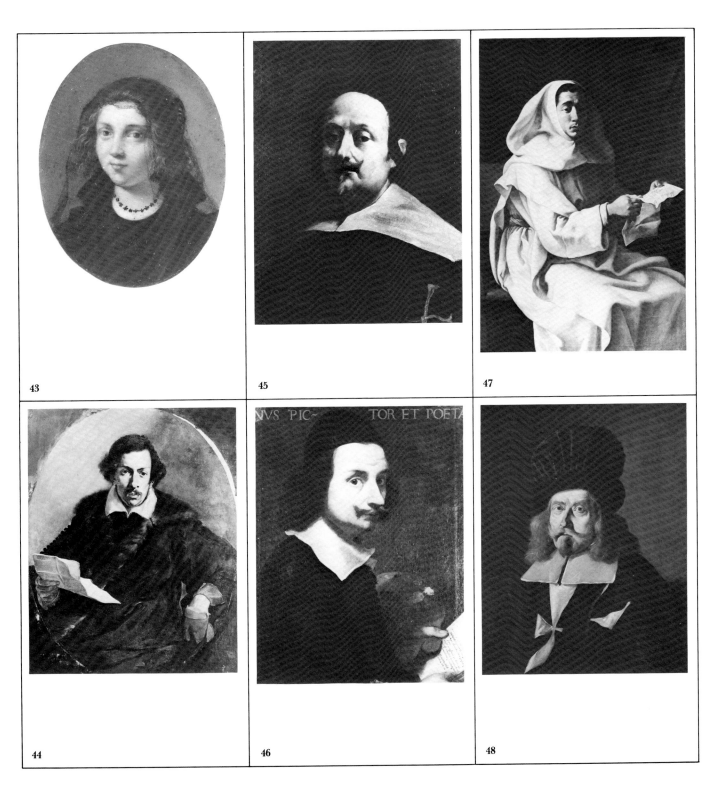

43

45

47

44

46

48

**49.** **Jusepe de Ribera**, *Giovanni Maria Trabaci, Choir Master, Court of Naples*, oil on canvas, 30 3/8 x 24 5/8 (77.2 x 62.5), The Toledo Museum of Art, Gift of Edward Drummond Libbey, Toledo, Ohio.

**50.** **Salvator Rosa**, *Allegory of Study*, oil on canvas, 54 5/16 x 38 1/8 (138 x 96.6), John and Mable Ringling Museum of Art, Sarasota, Florida.

**51.** **Andrea Sacchi**, *Marcantonio Pasqualini Crowned by Apollo*, oil on canvas, 96 x 76 1/2 (243.8 x 194.3), The Metropolitan Museum of Art, Enid A. Haupt Gift, Gwynne Andrews Fund, and Purchase, 1871, by exchange, New York, New York.

**52.** **Andrea Sacchi**, *Marcantonio Pasqualini Crowned by Apollo* (detail), oil on canvas, 96 x 76 1/2 (243.8 x 194.3), The Metropolitan Museum of Art, Enid A. Haupt Gift, Gwynne Andrews Fund, and Purchase, 1871, by exchange, New York, New York.

**53.** Attributed to **Andrea Sacchi**, *Portrait of a Cardinal*, oil on canvas, 51 x 38 (129.5 x 96.5), The National Gallery of Canada, Ottawa.

**54.** **Bernardo Strozzi**, *Portrait of a Gentleman*, oil on canvas, 46 1/2 x 35 1/2 (118.1 x 90.2), North Carolina Museum of Art, Given in honor of Rachel Maxwell Moore, Raleigh, North Carolina.

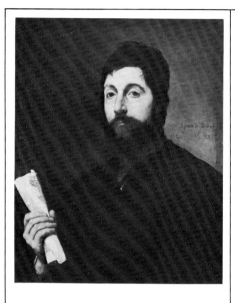

49

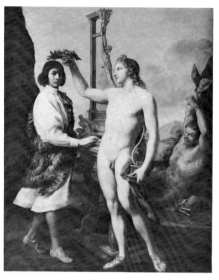

51

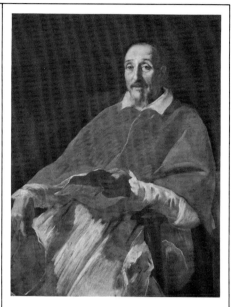

53

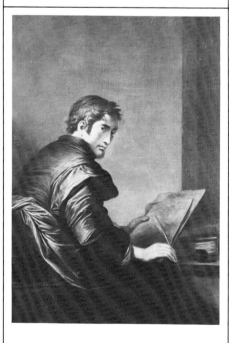

50

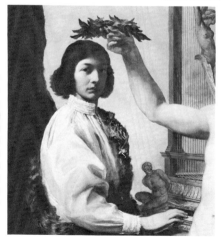

52

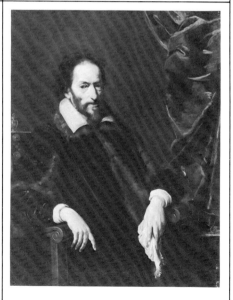

54

**55. Justus Sustermans,** *Giancarlo di Cosimo II*, oil on canvas, 80 x 44 (203.2 x 111.8), The Baltimore Museum of Art, Bequest of Jacob Epstein, Baltimore, Maryland.

**56. Tiberio Tinelli,** *Marcus Antonius Viari*, oil on canvas, 26 x 31 1/2 (66x80), Wadsworth Atheneum, Hartford, Connecticut.

**57. Tiberio Tinelli,** *Francesco Querini*, oil on canvas, 48 x 39 1/4 (121.9 x 99.7), Hood Museum of Art, Dartmouth College, Gift of Mrs. Eleanor St. George in memory of her husband, Charles St. George, Hanover, New Hampshire.

**58. Anthony Van Dyck,** *Marchesa Elena Grimaldi, Wife of Marchese Nicola Cattaneo*, oil on canvas, 97 x 68 (246.4 x 172.7), National Gallery of Art, Widener Collection, 1942, Washington, D.C.

**59. Anthony Van Dyck,** *Agostino Pallavicini*, oil on canvas, 85 x 55 1/2 (215 x 141), The J. Paul Getty Museum, Malibu, California.

**60. Anthony Van Dyck,** *Clelia Cattaneo, Daughter of Marchesa Elena Grimaldi*, oil on canvas, 48 1/8 x 33 1/8 (122.2 x 84.1), National Gallery of Art, Widener Collection, 1942, Washington, D.C.

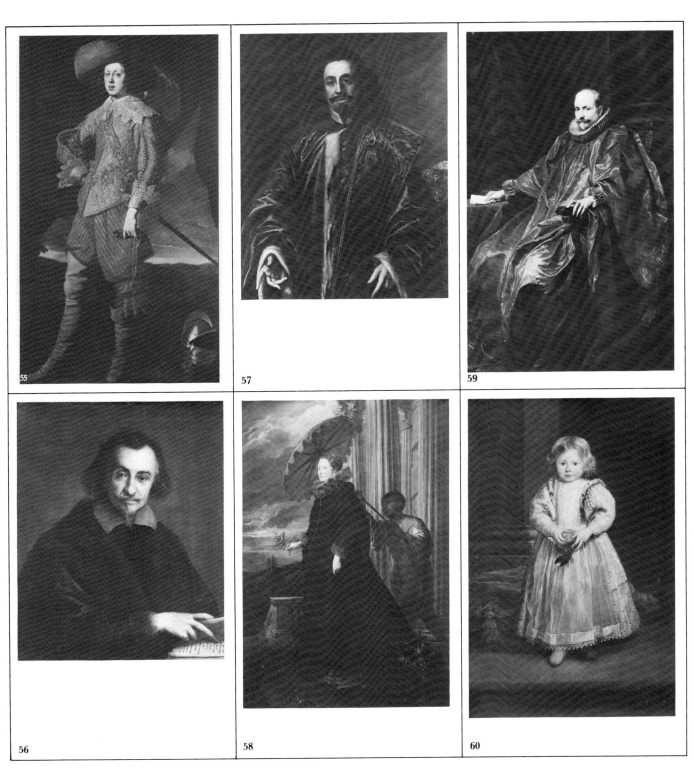

**61. Anthony Van Dyck,** *Filippo Cattaneo, Son of Marchesa Elena Grimaldi,* oil on canvas, 48 1/8 x 33 1/8 (122.2 x 84.1), National Gallery of Art, Widener Collection, 1942, Washington, D.C.

**62. Anthony Van Dyck,** *Marchesa Balbi,* oil on canvas, 72 x 48 (182.9 x 121.9), National Gallery of Art, Andrew W. Mellon Collection, 1937, Washington, D.C.

**63. Anthony Van Dyck,** *Paola Adorno, Marchesa di Brignole Sale,* oil on canvas, 90 7/8 x 61 5/8 (230.8 x 156.5), The Frick Collection, New York, New York.

**64. Diego Rodriguez de Silva y Velazquez,** *Juan de Pareja,* oil on canvas, 32 x 27 1/2 (81.3 x 69.9), The Metropolitan Museum of Art, Fletcher Fund, Rogers Fund, and Bequest of Miss Adelaide Milton de Groot (1876-1967), by exchange, supplemented by gifts from friends of the Museum, 1971, New York, New York.

**65. Jacob-Ferdinand Voet,** *Cardinal Francesco Nerli,* oil on canvas, 49 1/2 x 37 1/2 (127 x 95), Los Angeles County Museum of Art, Gift of Shickman Gallery, Los Angeles, California.

**66. Jacob Ferdinand Voet,** *Anna Caffarelli Minuttiba,* oil on canvas, 37 1/2 x 32 1/2 (95.3 x 82.6), The Fine Arts Museums of San Francisco, M.H. de Young Endowment Fund, San Francisco, California.

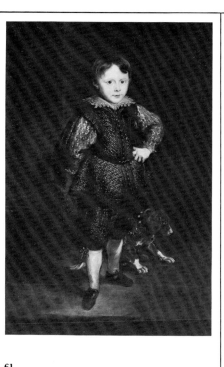

61

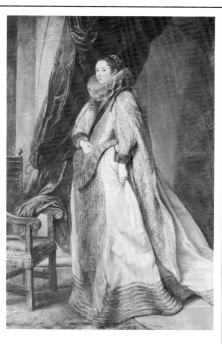

63

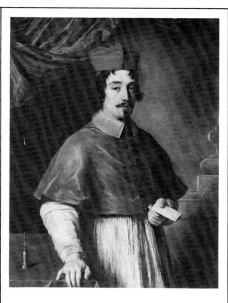

65

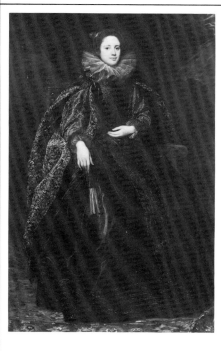

62

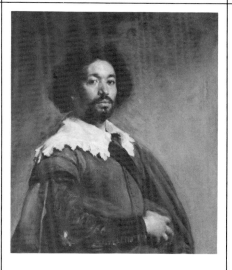

64

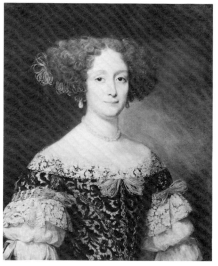

66